SECOND EDITION

MORE
THAN
YOU SEE

A GUIDE TO ART

SECOND EDITION

MORE THAN YOU SEE

A GUIDE TO ART

FREDERICK A. HOROWITZ
Washtenaw Community College

Harcourt Brace College Publishers
Fort Worth Philadelphia San Diego
New York Orlando Austin San Antonio
Toronto Montreal London Sydney Tokyo

~~ To my ~~
FATHER AND MOTHER

Acquisitions Editor: Cynthia Kumagawa
Manuscript Editors: Joan Harlan, Cindy Simpson
Production Editor: Jennifer Johnson
Designer: Linda Wooton Miller
Art Editor: Judith Frazier
Production Manager: Diane Southworth

Cover: Jan van Eyck, *A Man in a Red Turban*, 1433. Tempera and oil on panel, approx. 10″ × 7 1/2″, with frame 13″ × 10 1/4″. Reproduced by courtesy of the Trustees of the National Gallery, London.

A sharply turned head, an arresting gaze, a flamboyant red turban, and a day's stubble on the chin are brought together in this meticulously rendered portrait. No one knows the identity of the man, but the keen look that returns our own suggests that the painting is a self-portrait. Van Eyck placed on the frame the year, month, and day of its completion — October 21, 1433 — adding the motto "Als ich kan" ("As [best] I can").

ISBN: 0-15-564081-X

Library of Congress Catalog Card Number: 91-77136

Printed in the United States of America

PREFACE

Many people think of art as a painting hanging in a museum they never visit. Others may enjoy art but feel they don't know very much about it. All of us have looked at a painting or sculpture and wondered: What does it mean? Why was it made? What can it mean to me? We may have been delighted by what we saw and wished we knew more about it. We may also have felt puzzled and unsure of ourselves. Most of us have found ourselves wondering: What is art? What makes a work of art good, and how can I tell? We may have looked at buildings downtown or in our neighborhood and wondered: Why do they look like that? We may ask ourselves how seriously to take art, and we may even wonder whether we need it at all. ¶ This book is an attempt to link the reader to the world of art—a world that is accessible, enjoyable, and endlessly fascinating. It is based on the assumptions that there are no wrong responses to art and no bad reasons for liking it. ¶ In this book we will focus on the visual arts: painting, sculpture, architecture, crafts, and photography. But we will also consider commercial and popular art, such as ads, films, and television. For the most part, our concern will be with the art in museums and galleries, although we will also look at art found outside museums. We will focus primarily on painting, because in Western civilization painting has been the main vehicle of serious artistic production. In an attempt to understand the art we will take into account the attitudes and philosophies of the artists themselves. And we will pay attention to the influence of the culture on art. Although we will concentrate on the art of Western civilization, we will frequently move outside the world of the European–American fine arts tradition. The reader should recognize that *all* of art is, after all, our

inheritance. There is no single approach to art. This book will open to the reader the many ways that people have responded to art. The thoughtful reader will be alert to the many meanings that works of art can hold and to the many ways that he or she can be drawn to art personally.

The first part of the book presents the various forms of art. Chapters 1 and 2 stress the depth and breadth of art. Chapter 3 considers the powerful hold that images have on the imagination, and the compelling appeal of the subject matter. Chapter 4 introduces the formal analysis of paintings, and Chapter 5 goes on to take a closer look by comparing related images. Chapter 6 completes the investigation of images by explaining traditional painting techniques and the various means used to create visual illusions. Chapter 7 explores the three-dimensional worlds of architecture and sculpture. Chapter 8 seeks to compare and contrast functional, handcrafted objects of traditional cultures with those of modern industrial design. Chapter 9 provides a discussion of photography that completes the first section of the book.

While the early chapters focus primarily on the form of works of art, or how the art looks, Chapter 10 introduces consideration of the cultural context as an approach to art. Chapters 11 and 12 move beyond traditional representational art to consider the background and aims of abstract and postmodern art. Chapter 13 discusses the subjective nature of these recent developments in art and prompts an investigation of the ever-changing relationship between art and society. Chapter 14 brings us to yet another vital artistic expression: folk art.

The last part of the book introduces more theoretical issues. Chapter 15 invites the reader into the experience of the artist through a discussion of artistic creativity. Chapter 16 further examines the ways that artists have been educated in various cultures, thereby extending our understanding of art and creativity and their relationship to the culture. Chapters 17 and 18 explore questions of meaning and issues of art evaluation. These chapters include two thumbnail surveys of Western art history—Chapter 17 focuses on the changing content of art and Chapter 18 relates the sequence of artistic styles. Chapters 19 and 20 conclude the book by providing some practical information and suggestions: Chapter 19 helps the reader get more out of a museum visit and Chapter 20 encourages the reader to observe what is close at hand both esthetically and critically.

Those familiar with the first edition of this book will note that this edition has five new chapters: Chapter 5, "Looking over the Artist's Shoulder"; Chapter 8, "Designed for Use"; Chapter 9, "Photography"; Chapter 14, "Folk Art"; and Chapter 16, "Artists' Education." A time line has also been added to show the sequence of styles in Western art. In addition, the text has been reworked and rearranged, and updated to incorporate more recent works of art. This edition will reflect even further the cultural diversity that characterized the first edition.

In consonance with the aim of presenting a balanced and inclusive approach, the reader will find a presentation of current social and cultural critiques of art in Chapter 17. These critiques are applied to works of art in several places throughout the book, and the first half of Chapter 20 investigates design and advertising from their perspective.

TO THE READER

From time to time we all need to escape the rational and systematic modes of thinking that we use when reading a newspaper, shopping for groceries, or balancing a checkbook. We need to speculate, to daydream, or to reflect over things in a free-form way. All of us require the refreshment and self-renewal provided by the open-ended exercise of our minds. ¶ As children, our lives were enriched by the powers of fantasy and imagination. Through fantasy we made sense out of the world around us. Fantasy gave us pleasure. It transported us to cloud castles in the sky and enabled us to dwell in the pictures of a book. Imagination kept our senses open and connected us to things. We pondered the patterns in a leaf or on a frosty window pane; we were intrigued by a color, enchanted by a glowing light, mystified by a distant sound. Experiences such as these were rich and satisfying because our imagination gave them meaning. ¶ Later we began to see things from other people's points of view and to encompass other people's values. We learned the habit of relating our experiences to larger schemes of things. We learned to categorize experience. Our reactions became more pragmatic and objective. These new ways of thinking enabled us to survive in an adult world. But they also narrowed the range of our responses to that world. And they inhibited the personal growth uniquely provided by the activity of fantasy and imagination. ¶ As adults, we tend to associate imagination with childhood and childish things. But imagination is crucial in adult experience as well. Imagination is a way of thinking. It is creative. It lifts us out of routine and keeps us fresh, open, and flexible. It is the source of invention, insight, humor, and romance. ¶ We carry into adulthood the impulse to explore, to discover, to be touched

deeply by what we experience, and to respond. It is here that art can be of use to us, for art, nourishing the imagination, helps us fulfill these needs. Art is not a gloss on life or a diversion from it. Art speaks to our central concerns as human beings. Through our contact with art we can continue to reach beyond ourselves and to develop ourselves throughout our lives.

Art can't be known by how you define it, nor is it a body of knowledge that you learn. How many facts, names, or dates we know about art is relatively unimportant. What counts is that we open up to art, experience it, and enjoy it. This book is about how that can happen.

CONTENTS

SECOND EDITION

MORE THAN YOU SEE

A GUIDE TO ART

Look at those lines. They are not tricks. They are real and they work and they make you think. I am giving you more than you see because it is always changing. It is alive.

— Josef Albers

1
MAKING CONNECTIONS WITH ART

N o child has ever had to take a course in art appreciation. Children make connections with things they see and touch in a way that is immediate and strong. As adults, our relation to art may be more tenuous. What fascinated us as children now seems naive and uninteresting. And what we see in museums or in reproductions is often confusing and difficult to understand. The old, happy rapport with pictures may seem a thing of the past. ¶ My purpose in this book is to help you make connections with art. The experiences of our childhood show us that such connections are possible, that art can touch us and nourish us. We can connect with art as adults, too, but in order to do so we will probably have to relinquish the idea that only art that speaks to us directly and immediately is worth looking at. ¶ Works of art that challenge our understanding may also have

something to offer us. The strangeness of their appearance or the unfamiliarity of their content may make it impossible for us to grasp all at once what they are about. Ideas contained within works of art take time to unfold. But if we are open-minded and willing to reflect on what we have seen, we will establish a relationship with it. ¶ Even art that is familiar may contain meanings of which we are unaware. Magazine covers and advertising images often impart messages that promote conformity to social and sexual roles and attitudes. Our investigation of art will show us how to discover and interpret these messages too. All images have meanings. To understand them gives us a surer grasp on who we are, and helps us to understand the culture in which we live. ¶ Art does more than provide a comforting world in which to find refuge. It broadens our

horizons. It can connect us to people in other times and places. It makes us more aware, and compels us to explore our own minds and experiences.

I will not argue on these pages for an indiscriminate appreciation of art. Not all art is of equal value. Certainly, not all art that is obscure is good. But a painting or a sculpture that simply states what we already know and like may not provide us with much nourishment. The most rewarding experiences in art are, I believe, those that extend vision and awareness.

INVESTIGATING ART

All of us have had the experience of being unsure of what we think about a work of art, or unsure of how to put what we do think into words. Works of art that look strange, whether abstract or representational, present problems to anyone who confronts them for the first time. Our familiar guidelines may suddenly seem irrelevant. What's going on here, we ask. Can I understand it? Can it mean anything to me?

Some of the discussions you will read later in this book will help guide your investigation of art. They will set out for you some of the possible approaches to art that can help you to get the most out of it. But for now I will make a few general suggestions that you may find useful, whatever it is you are looking at.

When you look at a work of art, allow yourself time. Make yourself stay there. Give yourself ten minutes. Get comfortable, and just look at it. Don't look for anything in particular. Don't try to think. It may seem a little crazy, but if you do this, things will start to pop out at you. You will find yourself seeing more and more.

To build further upon the experience, talk about what you see. Toss around your thoughts and ideas with other people. Don't hesitate to ask questions about what you see. What do you notice? Why? What seems unusual?

Talking and also writing about what you see helps you to discover and to refine your thoughts. In discussing a piece, try not to rely on other people's words and phrases. Don't try to sound like an art critic. Speak or write in the language you know. Find the words that have meaning for you — that come out of your life and out of the experiences you bring to the piece.

Try to be as accurate as you can by using words that are as precise as you can find. If you take an art course, your instructor, or other students, can help you by insisting on clarity when you are vague. In time, you may come to need terms that art critics use. The terminology of art critics and historians can serve as a useful tool to help you to see more clearly and to communicate more accurately. Like any tool, however, it should be used properly.

If you think something you see is good, it's not enough for you to say so and let it go at that. Deciding whether it's good or not could conceivably be an end point in a discussion. More interesting, and certainly of more use to you and the others you are speaking to, is to know *why* you think it's good. Your interest ought to be placed in what's going on in it, in what you've discovered, rather than in whether you label it good or not.

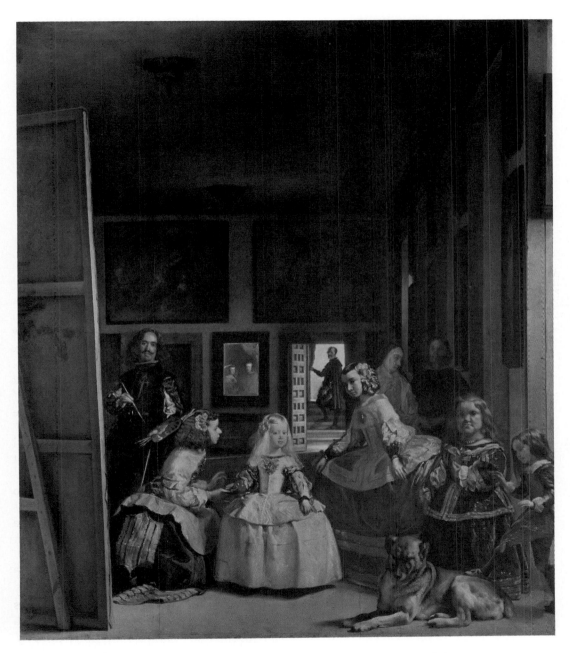

1-1
Diego Velázquez, *Las Meninas*, 1656. Oil on canvas, approx. 10'5" × 9'. Museo del Prado, Madrid.

Often the very first word that comes into your mind carries the greatest significance for you. Trust it. Don't worry about what somebody else would say. For no matter how far-fetched it may seem it carries with it the truth of your experience. There's no such thing as a wrong reaction to art.

One word of caution: when you talk or write about a work of art, *look* at it carefully. Make sure there is a basis in the work itself for what you are saying. Bouncing your pet theories off a painting may be fun, but you risk missing out on what the painter is trying to tell you.

Certainly, reading about the piece, its social background, or about the artist can illuminate it for you and provide a foundation for a better understanding of it. There are times when no amount of guesswork can disclose the meaning of a piece, and only a history book or an anthropological study can provide the keys to understanding.

But it's impossible for anyone to know *all* there is to know about a work of art. Meanings in art just don't stay put. Over time, old associations may be lost. Perspectives change, new meanings are discovered, theories and opinions are revised. Meanings, in art at least, are multiple and always open to discussion.

Consider, for example, Velázquez's *Las Meninas* (*The Maids of Honor*, Fig. **1-1**). Here we see the young princess, Margarita, peering out at us inquisitively, surrounded by her attendants (the *meninas*), the king and queen reflected in a mirror, and the painter himself at work. One can approach this painting simply by exploring the questions it raises: Who is the real subject or subjects? Why does the painter appear in the scene? Why might Velázquez have wanted to convert a royal portrait into this intimate, casual domestic scene? Basically these questions are asking: What's going on here? What is this painting about? What was the painter trying to say? Your own exploration of these and other questions will begin to uncover the content this painting holds.

Works of art speak to us through images, not words. So we will want to ask of this (or any other work of art): What did the artist do to make me see, feel, and understand? How does the organization of the piece communicate its meanings? How does the technique shape our reactions? Clearly, *Las Meninas* has more to say to us, and we will return to this painting later.

Your investigation of a work of art will often reveal many aspects and many levels of meaning. The more of these you discover, the stronger your connection to it will be. Like the human personality, a work of art has depth and can hold many surprises.

The contemplation of art is a way of contemplating life, for all of life finds expression in art. That is why the contemplation of art is limitless—and also, why it is rewarding.

2
WHAT IS ART,
AND WHERE DOES IT FIT IN?

W hat is art? How can it be identified? What sets it apart from other things? Consider the following: ◆ If we think of art as an expression of beauty, we shall discover much art that seems indifferent to beauty. ◆ If we think of art as a means of self-expression, we shall discover art in which self-expression was discouraged. ◆ If we think of art as existing purely for its own sake, distinct from practical activities, we shall discover it in societies where it is so integrated into everyday life that there is no word for it in the language. ◆ If we think of art as a form of communication, we shall find art that is purely decorative. ¶ It is this diversity of forms and functions that makes art difficult to see as a whole. ¶ Attempts to define art bring with them an infinite train of questions, and raise lengthy theoretical problems. It's just plain hard to pin art down to

certain characteristics and then draw a line around them. I'm not sure I could say with certainty what things are art and what things are not. I know that some works puzzle me and make me question the assumptions I have made about art. Definitions of art are widening today, partly because we are learning more about the art of other cultures, but mostly, I think, because many contemporary artists are forcing back the boundaries of art in their work. They are breaking old rules and giving us something new and different. Some people, confronting the new, are quick to say that what they see is not art. My own tendency is to say: It's art. I might not like it. I might think it's terrible. But if someone who did it, did it to be art, and calls it art, I'll go along with it. Why not? Maybe one of us will know a little better next time.

A DEFINITION OF ART

Any definition of art should be understood to be a concept, rather than a fact. With that, I'll suggest that art can be

♦ an object

♦ a certain quality in things

♦ an experience

2-1
Rembrandt van Rijn,
*The Shooting Company
of Captain Frans
Banning Cocq (Night
Watch)*, 1642. Oil on
canvas, approx. 12′8″ ×
16′6″. Rijksmuseum,
Amsterdam.

And, whatever its form, it must originate in the mind.

Examples of the first category would be Rembrandt's *Night Watch* (Fig. **2-1**), an African mask, or the Statue of Liberty. They are *objects* intended to be considered as works of art.

Some things not intended as art objects may be regarded as art because of their esthetic quality—that is, a quality of attractiveness or beauty—or their

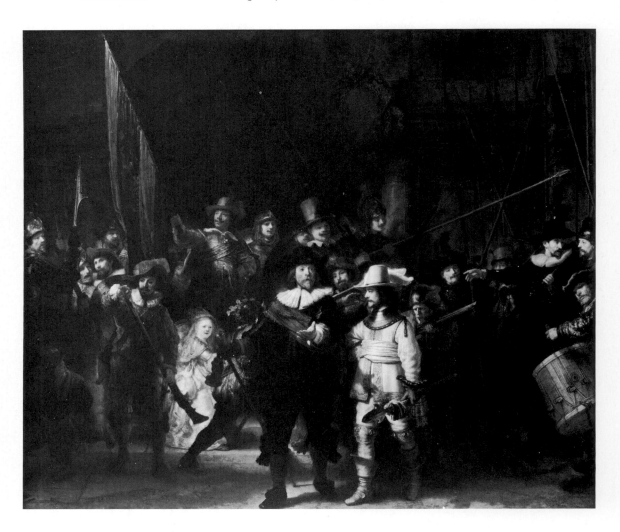

high level of creative or technical excellence. It is a *quality in them* that demands that they be considered art. Things in this category are not generally found in museums, though they sometimes wind up there. They are, for the most part, out in the wide world: the Brooklyn Bridge (Fig. **2-2**), a spacecraft, or a Shaker pitchfork, for example, may be seen as works of art.

Recent developments in art—which I shall talk about later in detail—have compelled the recognition of art as *experience* rather than object. Some art is

2-2
The Brooklyn Bridge. Designed by John Roebling. Completed 1883.

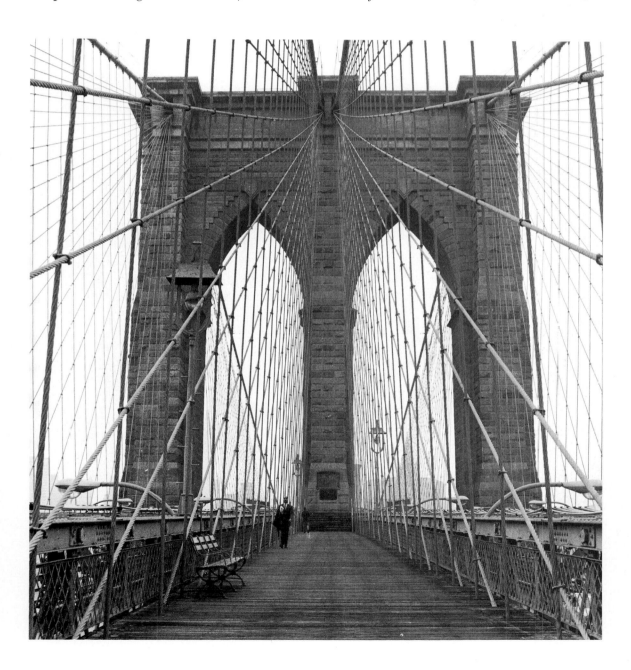

less a thing that we can look at or touch than a process, an activity, or an idea. It may have no esthetic quality at all. For example, Douglas Huebler's *Variable Piece 4/Secrets* (Fig. **2-3**) involved an idea, a Xerox machine, and nearly 1,800 individuals and their secrets. Huebler completed the piece later by publishing the secrets, with surnames edited, in a book. Without the participants, this intriguing piece would have had no existence.

2-3
Douglas Huebler,
*Variable Piece
4/Secrets*, 1973.

**VARIABLE PIECE 4
NEW YORK CITY.**

Visitors to the SOFTWARE exhibition are invited to participate in the transposition of information from one location to another by following the procedure described below:

1. Write or print on this paper an authentic personal secret that you have never revealed before: of course, do not sign it.
2. Slip the paper into the slot of the box provided at this location. Complete the exchange of your secret for that of another person by requesting a photo-copy of one previously submitted.

(To insure your anonymity incoming secrets will remain within the box for 24 hours before being removed to be photo-copied and joining the "library" of secrets for future exchange.)

May 1969 Douglas Huebler

Forms on which the above directions were printed were made available to all visitors at the exhibition SOFTWARE (Jewish Museum, NYC, September 16-November 8, 1970).

Nearly 1,800 "secrets" were submitted for exchange and have been transcribed exactly as written except that surnames have been edited: all are printed in this book and join with this statement as final form of this piece.

March, 1973 Douglas Huebler

Finally, art originates in human beings. Certainly nature, or machines, or chance, or accident can play their parts. Art need not be entirely man-made. But it must have arisen out of someone's mind, or fancy, or intuition, or imagination. Even if it is only a matter of making us think about something in a new way by presenting it in a new way, someone has changed it for us, and thereby converted it to an art object. Originating in human experience, any work of art, whatever its content or its form, refers us back to humanity.

Every work of art is a distillation of ideas. Thus, a work of art is, inevitably, expressive; it makes a statement of some kind. Whatever the intentions of the artist, the work will tell us something about him or her. It will also reveal something about the society of which the artist was, or is, a part. Accordingly, we may think of art as a record of human experience.

For the artist, art is a way of seeing, and a way of interpreting and expressing what is seen. But it is not like science, which seeks facts and general principles. Art is intuitive and subjective, and thus the experiences it presents, though they may be shared, are one-of-a-kind.

Art has to do with imagination. It carries us beyond our everyday reach and puts us in contact with something outside, as well as within, ourselves.

Given this, can any art be remote or irrelevant? If art seems remote, it is perhaps because the context out of which it sprang is as yet unknown to us. Art is diverse, rich, and varied because human experience is diverse, rich, and varied. There is much in it to experience: would we wish it otherwise?

THE MANY FUNCTIONS OF ART

Art has had many different functions in human history. Each society defined its own purposes for art and produced an art suited to those purposes. For the ancient Romans, art served as a vehicle of propaganda: their sculptures proclaimed victories, and their buildings extolled the power of the State. Among Indians of the Northwest coast, totem poles relate histories, and at the same time serve as a means of establishing rank on the social scale. For ancient Egyptians, paintings and sculptures, often sealed in tombs away from human sight, served magical purposes. The elaborate system of symbolism developed in the art of medieval Europe communicated church histories and theological concepts. In modern societies like our own, art serves different and sometimes contradictory purposes. One artist paints in order to communicate a message to his audience, while across the street another paints in order to please himself. A third artist explores shapes and colors; a fourth illustrates books.

A list of the ways that art has functioned would have to include the following. (You may find this list surprisingly long; even so, perhaps you can add to it.) Art functions as

- an agent of magic (to ensure a successful hunt, to perpetuate the soul after death, to triumph over an enemy, to cure disease, to protect)

- an aid to meditation
- a ritual object
- a record (of events, objects, situations)
- a memorial
- a substitute for the real thing; a stand-in, or symbol
- a souvenir
- propaganda (to impress, to persuade, to change thinking or behavior)
- communication (of stories, ideas, events)
- an agent of social control
- a way of honoring someone
- entertainment, amusement, diversion
- a means of moral improvement
- education
- a means of self-expression
- self-revelation
- a release of emotions
- exploration of vision
- a reflection and interpretation of life
- an expression of beauty
- decoration or embellishment
- monetary investment
- a status symbol

One can see from this list that the functions of art are wide ranging. But this is not surprising. Art is as broad as human experience. *All* of art comes out of life, and is bound up with life. Art is meaningful, but meaningful in ways that differ from society to society, from time to time, and from person to person.

3
THE POWER OF IMAGES

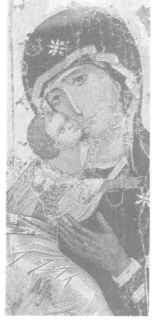

Have you ever watched someone put a lump of clay on a potter's wheel and form a pot out of it? Or seen a glassblower create a vase out of shapeless, molten matter? The transformation of the material into the object is smooth and gradual. It is hard to say just when we stop thinking of the clay or glass as "material" and begin to think of it instead as a pot or a vase. Most likely it is when we first perceive the form of the object that our focus on the material begins to slip away and we cross over from looking at material to looking at a "thing." ¶ If you have ever watched someone painting a picture, you will have noticed something similar. At first you will see only colored dabs and marks on the canvas, but at some point these marks are transformed into an image, as if by magic. The marks are no longer marks, at least not unless we think about them. In the hands of the artist they appear to *become* what they represent. ¶ The transformation of materials in the work of painters

is especially uncanny, for it is not objects that they make, but images — images altogether unrelated to the material out of which they are made. The clay of a pot or the glass of a vase is never very far from our consciousness when we look at these objects. The material of a sculpture generally asserts itself upon us. But in a painting we may gaze contentedly at the trees and never see the paint. ¶ Images can be so compelling that we sometimes react to them as though they were the real thing. Those reactions can be quite automatic. For example, if an artist sketches a portrait, we might say that it looks like him or her; but if we get just a bit carried away, we might exclaim, "It's him!" or "It's her!" almost as if a duplicate of the person had been created while we watched. ¶ Similarly, a child drawing with crayons "makes a man" or "makes a house." When I collect my students' drawings I am likely to say "turn in your flowerpots here," or "put your eggs

11

there." We frequently refer to Michelangelo's *David*, to Leonardo's *Mona Lisa*, or to the Statue of Liberty as though they were the people themselves, and not images of them. Of course this is just a kind of verbal shorthand, but it does reveal an attitude.

Images are potent things. Because it is so easy to forget that they are illusions and to confuse them instead with the real thing, they can provoke intense reactions. Children who draw their teacher's face on the blackboard or embellish political posters with mustaches understand this very well. From the Middle Ages and the Renaissance come accounts of artists who got back at their enemies by exaggerating their features or by painting their faces on characters in Hell. Caricature was used as an ideological weapon during the Protestant Reformation, when scathing depictions of Catholic clergy were circulated. Thomas Nast's cartoons of the 1870s attacking "Boss" Tweed, a corrupt New York politician, led to Tweed's downfall.

In 1831 in France, Charles Philipon published a drawing representing King Louis Phillippe as a pear—in French slang, a "fathead" (Fig. **3-1**). Later that year, for "crimes against the person of the king," he was fined and sentenced to six months in prison. In 1832, Honoré Daumier spent five months in prison for his scatological drawing of the king. Both artists' drawings were published in Philipon's weekly, *La Caricature*. The weekly newspaper was seized by the government 27 times during its four years of publication for the political cartoons it carried; later, from 1835 to 1848, political caricature was banned in France.

3-1
Charles Philipon,
Les Poires
("Metamorphosis of
the Pear") from
Le Charivari, 1834.
Revised version of a
drawing made by
Philipon at his trial.

"Can I help it if His Majesty's face is like a pear?"

—Charles Philipon, at his trial in 1831

IMAGES IN THE PAST

History provides countless examples of the power that images have held, and continue to hold, for all human beings. From antiquity come stories of realistic images with astonishing, even miraculous powers. In the first century A.D. Pliny recounts the story of grapes painted by the Greek artist Zeuxis, which were so lifelike that sparrows pecked at them, and of a horse painted by Apelles that caused real horses to neigh. Ku K'ai-chih, a fourth century Chinese painter, was reported to have pierced his portrait of a young girl with a thorn, causing her to fall ill. When he removed the thorn, she became well again.

Throughout medieval Europe, many stories circulated that attested to miraculous powers held by images of holy persons. Sudden cures, military victories, or rescues were attributed to these images. Some were even said to speak. These images were carefully treated and regarded with reverence.

The *Madonna Enthroned*, a mural depicting the Madonna and her heavenly court (Fig. **3-2**), was painted on the wall of the council chamber in the city hall

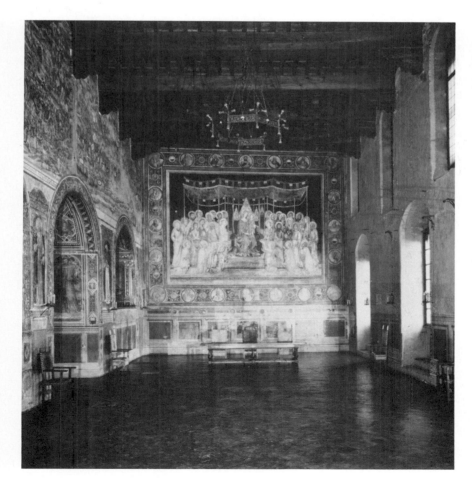

3-2
Simone Martini.
Madonna Enthroned,
1315. Fresco. Palazzo
Pubblico, Siena.

of Siena, Italy, by Simone Martini. The Madonna was the patron saint of Siena. The presence of the Queen of Heaven and her retinue in the room where the city fathers deliberated on the course of their republic suggests an invocation to her wisdom and guidance, and demonstrates the belief in the influence of images on human affairs.

Paintings showing famous historical judgments were placed in Flemish law courts in the fifteenth century to remind judges of their responsibilities. Today, paintings of Washington and Lincoln hang in courthouses, and busts of Homer and Shakespeare keep watch in school libraries. The Statue of Liberty in New York harbor and the statue of Lincoln in the Lincoln Memorial are objects of patriotic veneration to many people. Images are still used in public and religious ceremonies and are carried in processions, both secular and religious.

The oldest images we know of were almost certainly believed to have had magical powers. Painted on the walls of caves during the Old Stone Age, these images, which depict the large mammals on which people depended for food, may have been part of a hunting ritual (Fig. **3-3**). It is unlikely that they were made simply to be admired objectively for their beauty. Any such detached considerations of beauty—which we call "esthetic"—would very likely have been subordinated to feelings of awe called up by the mysterious power of the image.

Ancient civilizations continued to regard art as having magical properties. In Assyria, gods and animals carved on walls protected the king. In Egypt, paintings and sculptures were conceived of as repositories for the souls of departed individuals. Objects were painted on the walls of tombs to be utilized in the afterlife (Fig. **3-4**).

3-3
Two Cows, detail from the ceiling of Axial Gallery, Lascaux, *c.* 15,000–13,000 B.C., approx. life size. Dordogne, France.

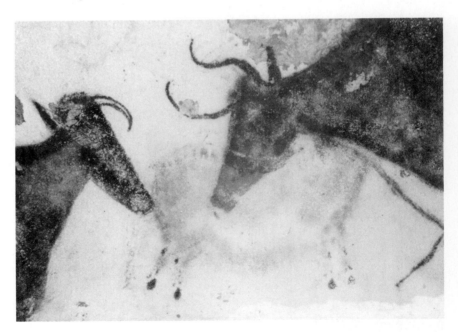

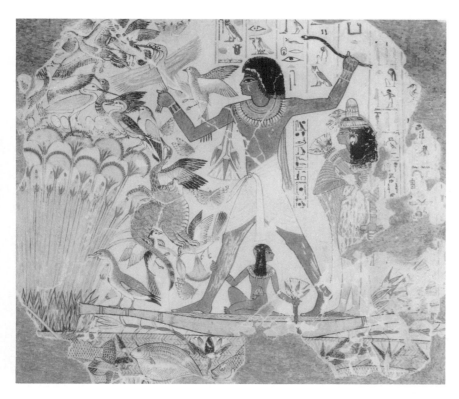

3-4
Theban Tomb of
NebAmun (unlocated),
c. 1450 B.C., British
Museum. Courtesy of
The Oriental Institute,
University of Chicago.

Throughout the ancient world, statues were worshipped as gods. The commandment against graven images, reiterated throughout the Bible, indicates how widespread — and appealing — the practice of image worship must have been. The development of a more lifelike art in Greece was accompanied throughout the Classical period by a belief in the supernatural properties of images. In late antiquity, people believed that spirits could inhabit images. Christians regarded these spirits as malevolent and feared them. The notion of resident evil spirits clung to three-dimensional sculpture in particular, and may account, in part, for the preference for two dimensions in early Christian art.

Because the art of Greece and Rome was associated with pagan beliefs and demonic magic, the explicit naturalism that characterized it was suspect by Christians. Accordingly, in the Middle Ages, the Church encouraged the development of a less representational and more abstract and symbolic art.

In the early Middle Ages, images of Christ, the Madonna and Christ Child, and saints, mainly in the form of panel paintings, were introduced in the Eastern (Byzantine) Roman Empire. These images, called *icons*, were placed in homes as well as churches. Icons were considered to be holy, and many were believed to have protective powers.

The *Vladimir Madonna* (Fig. **3-5**) was brought to Russia from Constantinople. In times of crisis it was carried in procession by the faithful; its miraculous powers were believed to have saved Vladimir, Kazan, Moscow, and other Russian cities from invasion.

3-5
Vladimir Madonna,
twelfth century.
Original dimensions of
panel approx. 21″ ×
30″. State Historical
Museum, Moscow.

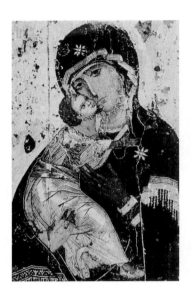

Because people venerated icons with an intensity verging on idolatry (worship of idols), images—paintings, sculptures, and mosaics—were actually banned in the eighth century throughout the Byzantine Empire. Later, images were reinstated when the Church was convinced that they would function to direct the consciousness of the worshippers beyond the images to what they represented. Defenders of pictures had to argue that images were semblances and not the real thing.

The controversy over images stirred the Islamic world as well. In the eighth century, an edict banned all representations of human forms. The Moslem antagonism toward figurative representation persisted from time to time and in certain areas and accounts for the predominance of abstract and nonfigurative forms in Islamic art.

Because images frequently served as links to the supernatural world, the depiction of such figures as gods, kings, and saints was a very serious matter. Often, exact and highly detailed descriptions governed the appearance of these figures. To deviate from these prescribed formulas would at times have been considered heresy.

In Egypt, where a highly conservative artistic tradition existed for thousands of years, a codified system of proportions determined precisely the appearance of the king and the gods. Such a system is called a *canon*. Only by correct execution of the image according to the prescribed rules could effectiveness be ensured. Curiously enough, the canon was relaxed for depictions of lesser personages. Was it because it didn't matter as much if the magic didn't work to preserve them? Or perhaps because the more dignified, formalized treatment was reserved for those who were special?

Buddhist art in Tibet also has canonical measurements and elaborate directions for picturing the vast number of deities. These directions, set out in the sacred scriptures, prescribe the colors of the gods' bodies and their halos, as well as their clothes, their positions and gestures, and other identifying attributes. The images functioned as aids to meditation, and the artists, who were monks, were obliged to show these characteristics plainly (Fig. **3-6**). Any deviation was considered a sin. So rigidly controlled was this art that images were often printed from wood or metal blocks, and compositions changed little over centuries.

Christian art was devoted to communicating sacred histories and religious concepts. To this end, an intricate system of *iconography* (the specific image and its meanings) was developed during the Middle Ages by artists repeating limited subject matter over a long period of time. This iconography amounted to a pictorial language in which the meanings of numerous symbols and the attributes identifying holy figures were precisely fixed and became traditional (for

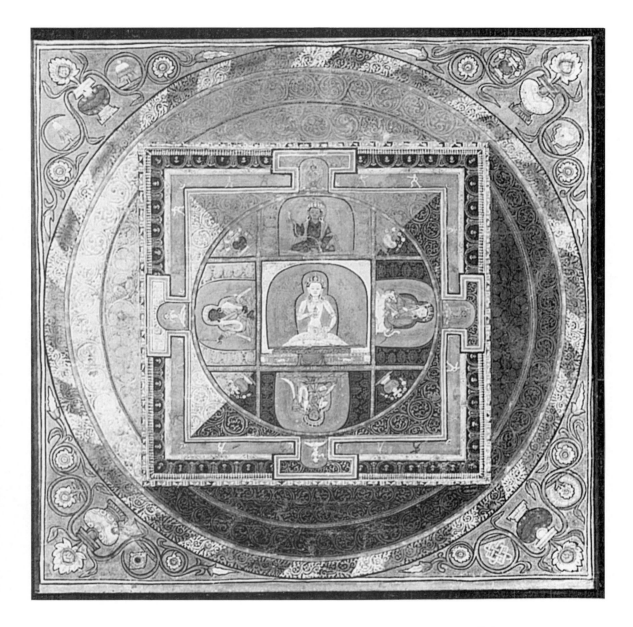

example, see Fig. 7-13). Byzantine artists developed a formula for the depiction of the head of Christ, both to maintain the dignity of the image and to ensure that it would be recognizable wherever it appeared. These rules were intended to preserve the holiness of the image.

The strong feelings that made images the focus of veneration in the ancient and medieval worlds made them targets of violence as well. The anxiety over idolatry was so intense that it led to the destruction of Christian, Jewish, and Moslem art during the controversies of the eighth century. Similarly, throughout

3-6
Mandala of Vajrasattva, Nepal, fourteenth century. Opaque watercolor on cotton, 15½″ × 15½″. The Brooklyn Museum, acc. 81.10 (purchase E. C. Woodward Fund).

the Middle Ages, Christians, believing it an act of piety to destroy pagan idols, deprived posterity of countless Greek and Roman statues. In late medieval Italy we find painted images of the Devil scratched with knives or stones. These actions were probably motivated by intense religious feelings, and were not likely thought of as desecrations.

The onslaught against images extended to modern times. Protestant reformers of the sixteenth century, equating statues and images in churches with idolatry, encouraged their destruction. Violent attacks on images broke out in Germany, Switzerland, France, the Netherlands, Scotland, and England. English Puritans in the sixteenth and seventeenth centuries whitewashed over murals, hauled what art they could out of churches, and managed to destroy a great deal of the medieval art of England and Ireland. During the French Revolution, zealous anti-Royalist crowds attacked statues of Old Testament kings that had lined the portals of St. Denis, Notre Dame, and Strasbourg cathedrals since the twelfth and thirteenth centuries. Some of the statues were completely destroyed, while others were, like their human counterparts, merely beheaded.

All of this suggests an attitude toward images that is quite a bit removed from the more objective, esthetic attitude typically taken toward works of art today. Those readers who regard art as something to be enjoyed will have to imagine the depth of feeling that images have inspired in those who believed in their powers. Other readers may themselves have experienced the wondrous power of images to evoke a sense of awe in the minds and hearts of the faithful.

IMAGES TODAY

Today, images still have the power to elicit a variety of responses. Consider, for instance, how you treat a photograph of someone you know, such as a boyfriend or a girlfriend. Because you care about that person, chances are you treat his or her photograph with respect. You provide it with an attractive frame and put it in a good spot. You may even find yourself smiling at it.

But if your boyfriend or girlfriend breaks up with you, you may want to take that miserable photograph and tear it to pieces, as though the photograph were actually the person. In twentieth-century Sicily, the statue of a local saint was pitched over a cliff when the saint was thought to have answered prayers for an end to a drought with a devastating rainstorm. Coaches of opposing teams are burned in effigy at pep rallies on college campuses, and political leaders are similarly disposed of by impassioned adversaries. The overthrow of a dictator will be accompanied by the toppling of his statue in a public square. Throughout 1990, statues of Marx and Lenin were dismantled in the newly democratizing countries of Eastern Europe. In 1991, following the liberation of their country in the Persian Gulf War, bitter Kuwaitis took out their fury on images of Saddam Hussein (Fig. 3-7).

Cinematic statements of human experience are exceptionally believable and persuasive. Anyone who goes to the movies is aware of the capability of this art to

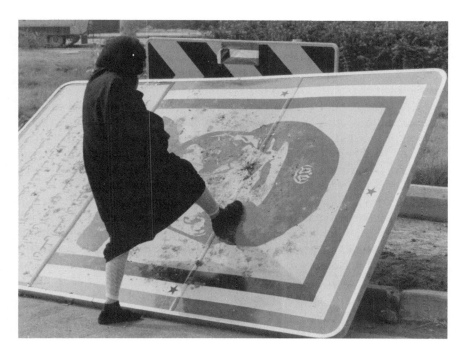

3-7
Kuwaiti woman
stomping a portrait of
Saddam Hussein of
Iraq, 1991.

arouse a whole range of feelings and to powerfully communicate ideas about matters that affect us. Movies and television are experienced as a reality to which we belong for a while.

The lifelike character of the cinematic image tends to obliterate the distinction between actor and role. Ancient Greek myths tell of people who fell in love with statues; today, people fall in love with screen idols. Actors who play the part of doctors on television receive letters asking them for medical advice and even get invitations to speak at medical school commencements. For example, actor Robert Young, who played Dr. Marcus Welby on television, was the principal speaker at the 1973 commencement of the University of Michigan Medical School.

Images on television and in still photography influence our purchases and our votes. Photographic images create an aura of desirability around an object by associating it with fun, friendship, romance, sophistication, or good looks (Fig. **3-8**). "Image makers" are hired to sell cars, clothes, and candidates. "Photo opportunities" for politicians are carefully staged. Beautiful scenery, nostalgic images of hometown life, and American flags have been used in recent years to cast an allure around candidates for the American presidency. The size of the advertising business today testifies to the extraordinary power of images to affect our thinking and our behavior.

Pop stars on magazine covers, in ads, and in music videos glamorize looks, clothes, and lifestyles. Interpreting these images is not always easy, however. For example, in recent years pop star Madonna has attracted a great deal of attention

3-8
Courtesy of Prince
Matchabelli.

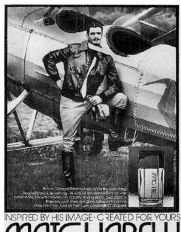

INSPIRED BY HIS IMAGE · CREATED FOR YOURS

and a lot of controversy over just what her "image" does project. Is her image liberating to women, or is it just another version of the sex-object stereotype?

How do you respond to a work of art? For many people, the first and most lasting response may be to its subject matter. What else accounts for the popularity of reproductions of celebrities, sporting events, pets, and scenes of natural beauty? More than just *reminders* of the real thing, they function as stand-ins. A poster of W. C. Fields brings his presence into your room and cheers you up. A photograph of the Rocky Mountains, taped to the wall of an office, allows you to escape the tedium for a moment or two. A painting of a clipper ship at sea, of the festive mood of a holiday with the family, or of an appealing face reaches out to you and draws you into its charmed embrace.

But this is not all there is to it. Enjoying the subject matter does not necessarily mean appreciating the art. In order to get the most out of a work of art, we would have to look at it in a different way. And that is what we shall take up next.

4
READING PAINTINGS

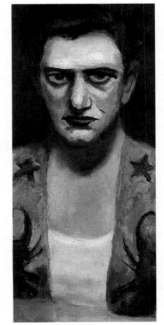

I t is just about impossible *not* to react to the content of a painting or sculpture. But if you react only to the *images* that you see, your enjoyment of art is likely to be less than it could be. Subject matter is only one aspect of what makes a painting or a sculpture appealing. Why let it have all your attention when there is so much more to enjoy? ¶ If you want to get more out of a representational painting or sculpture, start with this simple observation: the image you see is not the same as reality, or even a reproduction of reality, but an *interpretation* of reality. Once you accept that, your understanding of paintings and sculptures will deepen. Ironically, when your relationship to the piece becomes more detached and objective, you will begin to become involved with what you see in a stronger way. You will begin to look *beyond* the image and see the piece as a work of art. ¶ Getting past your initial response to

an image is not that difficult. To begin, let's consider a very lifelike image: the motion picture image. ¶ It's easy to think of movies as windows through which we look at reality. Most filmmakers do everything they can to make us forget we're watching a movie. They want us to be so involved that it feels real. As a consequence we are not likely to notice the way the movie has been put together. Usually it takes a second viewing of a film to notice the various techniques that were used to get us so involved. On second viewing we begin to recognize the significance of the opening shot, or the effect of closeups, camera angles, or lighting, to notice the telescoping of time in the telling of the story, or the effect of the music on our perception of the story and the characters. Seeing a movie over again helps us to realize that its elements were consciously selected and composed. ¶ Moreover, if we test a movie's

characters and story against our own experiences, we may well conclude that the movie is *not* like life. I suspect that if movies simply imitated life, most of us would find them unbearably dull. Does this surprise you? Think about having to sit through two hours of somebody's unedited home movies.

Like films, realistic paintings have always been enjoyed for their lifelike quality. But our receptiveness to illusion tends to blind us. As we saw in the last chapter, we are apt to forget the paint when we look at the trees. We don't see that a painting, like a movie, is a fabrication. Consequently, we may not recognize what the artist has put into it. Painters, like filmmakers, are apt to convince us that they duplicate life in their art. We assume that artists simply record on canvas what they see. This is the fundamental misunderstanding that undermines the appreciation of paintings.

DECISIONS

A little reflection will show that painters cannot just indiscriminately put down what is in front of them. After choosing what to paint, they must decide what view to take, how much of it to include, and what to leave out. Will the subject be close or far away? In the center or to the side? How do artists treat the objects that are being painted? Should every detail be included? Or are only general shapes suggested? What degree of clarity will there be? Will all of the painting be sharp and clear or will one part be brought into focus? How visible will the brushstrokes be? How large or small will the painting be?

4-1
The Parthenon, source photo. New York State Office of Parks, Recreation and Historic Preservation, Bureau of Historic Sites, Olana State Historic Site, Taconic Region.

You can't assume that what you see in a painting just happened to be there looking like that when the painter came along. A painter may spend a lot of time composing the subject matter. Preparatory drawings for figure compositions reveal that artists often arrange and rearrange figures many times before they are satisfied. It takes imagination to give a scene unity and still have it look natural. Still lifes, which typically look casual, require that the artist combine objects in an interesting way. When painting a landscape, the artist can choose the time of day, the weather, and the season of the year. If there are people, the artist must decide who they will be, what they will do, and where they will be placed. If the people were not in the original scene, or if the artist rearranges the rocks and trees, or makes the mountains loftier, who would know? Even a painter working from a photograph, as many have done in the last hundred years, is likewise free to deviate from the model (for examples, see Figs. **4-1** to **4-4**).

These are some of the *conscious* decisions that an artist makes. Artists make *unconscious* decisions as well. An anecdote quoted by the art historian Heinrich Wolfflin in *Principles of Art History* speaks to this point. It tells of four young painters who agreed to paint the same landscape as exactly as possible and then to compare

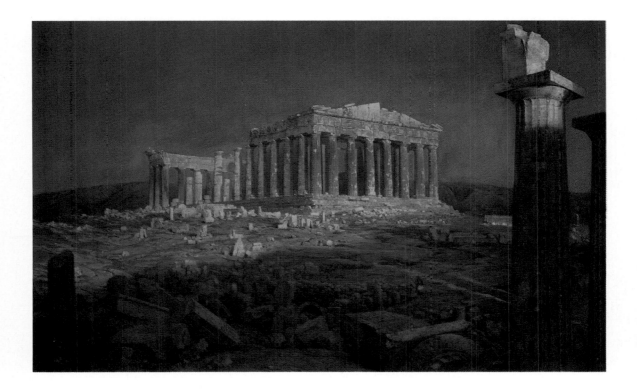

4-2
Frederic Church, *The Parthenon*, 1871. Oil on canvas, 44³/₁₆″ × 72⅛″. The Metropolitan Museum of Art, New York. (Bequest of Maria De Witt Jesup, 1915.)

their paintings. When they looked at the results they were astonished to see how different each painting was from the other, "as different as the personalities of the four painters."[1]

In everyday life, our personality emerges and makes itself known through each decision that we make. The car we choose, our clothes, the way we wear our hair, the way we speak, and the very words we use are expressions of who we are. Listen to a few people describe an event, or a movie they have seen, and you will likely hear very different accounts — as different as are their personalities.

Inevitably, paintings, at least those produced since the late Middle Ages, reveal the personality of the artist as much as they reveal the subject. Therefore, it's more accurate to regard them as personal statements than as reproductions. We should understand the subject to be a point of departure for the painting. Every representational painter must, of necessity, decide what to select from the infinite possibilities presented by the subject. The form the painting takes is determined by the selections that are made and thus must be seen as an expression of the artist's personality. The artist's interests, feelings, and attitudes — conscious and unconscious — will determine the appearance of the painting at least as much as the subject itself.

Simply thinking of a painting as a mechanical reproduction, imagining that the artist is merely a good eye and an expert hand, limits our grasp of it. In order to appreciate a painting you need to ask certain questions about it, questions that can reveal how *unlike* its probable model or subject it is. These questions

4-3
Ben Shahn, *New York City, c.* 1932. Silver print, approx. 7″ × 10½″. Courtesy of the Fogg Art Museum, Harvard University. (Gift of Mrs. Bernarda B. Shahn.)

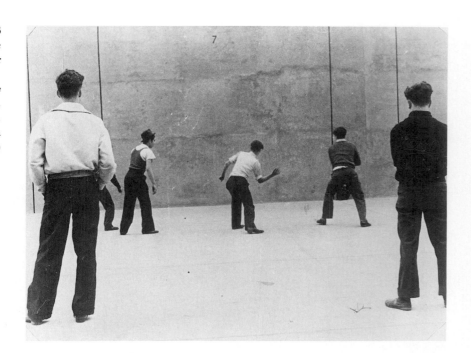

4-4
Ben Shahn, *Handball*, 1939. Tempera on paper over composition board, 22¾″ × 31¼″. Collection, The Museum of Modern Art, New York. (Abby Aldrich Rockefeller Fund.)

can direct you to the choices the artist made when creating the painting, and can help you to see why those choices were made.

THE ELEMENTS OF FORM

Color

When you are viewing a painting, look at the elements of form: color, light, texture, volume, shape, line, composition. Isolate each one in turn. With color, for example, ask yourself: Are the colors light or dark? Bright and intense or dull and grayed? Bluish or orangey? Are they pastel? Do they contrast highly with each other or are they closely related? Do they have sharp, clear edges? Rough edges? Soft edges? Do they merge into each other? Do they overlap one another or do they blend? Are the colors opaque or transparent? Are they glossy or matte? How are they distributed? Which colors are grouped together? Which colors draw attention to themselves? Which colors seem to move toward you? Which colors seem to recede?

The distinctive use of color is easy to recognize in Frederic Church's *The Parthenon* (Fig. 4-2) and Vincent van Gogh's *Starry Night* (Fig. **4-5**). How realistic is the color in *Starry Night*? In *The Parthenon*? What effect do these colors have on your perception of the subject?

We tend to think of color in terms of hue, such as red, green, or blue. But color is more than that. Painters rarely use colors as they come out of the tube, preferring instead to mix them to create distinctive colors and to adjust them carefully to each other. In a good painting, colors are orchestrated so that the effect of all the colors together will be more striking than individual colors here and there.

Light

Color affects the character of the light in a painting. Because light is impalpable, as well as inevitable, it is often overlooked. Yet its role, however subtle, is likely to be an important one. Ask yourself: Is the light bright or dim? Is it even or contrasting? Is it direct or reflected, or a combination of these? Does the light sparkle, shine, or glow? Can you tell its color? How is it used? Does it direct your attention to something? Does it suppress something?

How would you describe the light in El Greco's *View of Toledo* (Fig. **4-6**)? Now compare it with Church's use of light in *The Parthenon* (Fig. 4-1). What effect does the light have on your feeling about the subject?

Texture

The texture of a painting is determined primarily by the kind of paint used and how it is applied. Does the paint look thick or thin? Is it rough or smooth? Dense or watery? Now look at the brushstrokes. The brushstrokes that are used define

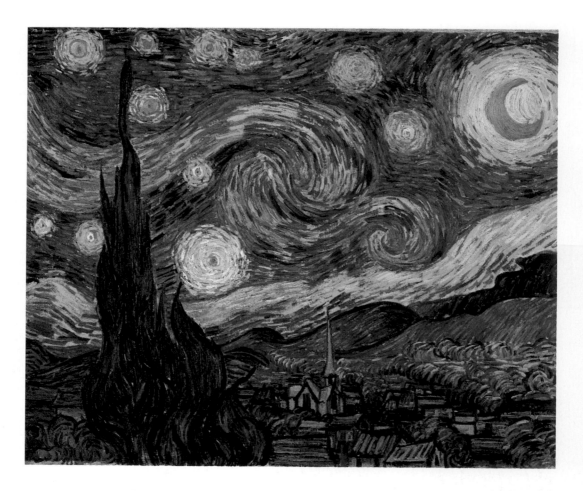

4-5
Vincent van Gogh,
Starry Night, 1889. Oil
on canvas, 29″ × 36¼″.
Collection, The
Museum of Modern
Art, New York.
(Acquired through the
Lillie P. Bliss Bequest.)

the objects that you see. Are the objects sharp and clear or soft and indistinct? Do the brushstrokes simplify the objects or show things in exacting detail? Are the objects loosely painted or carefully rendered? Did the painter use long, wavy strokes, or short, choppy ones? Can you see the strokes at all? Or do they blend into each other and become invisible? Does the paint create blobs? Ridges? Flat patches? Stains?

What kind of paint was used? Oil, acrylic, tempera, watercolor, or something else? What particular effects are achieved by the kind of paint used? How was the paint applied? By brush? By palette knife? By airbrush? Was it poured on? Sponged on? Rolled on?

Texture is also affected by the surface on which the artist paints. Since the Renaissance, most artists have used canvas. For special effects, some artists use a rough textured surface such as burlap or handmade paper, or a smooth surface such as masonite, plastic, or glass.

What texture do you find in Van Gogh's *Starry Night* (Fig. 4-5)? How would you describe the brushstrokes? How are they arranged? What feeling do they bring to the painting?

Volume

Painters create the illusion of solid forms, or volumes, in their paintings. Although volumes in the real world are typically self-contained, measurable, and have weight, they may take on remarkably different aspects in a painting. Ask yourself: Are the volumes hard, clear, and distinct? Or soft, vague, and ephemeral? Are they thick and bulky, or thin and attenuated? Are they rounded or angular? How are the volumes created? By light and shadow? By color changes? By the use of lines? Are the volumes fully rounded? In low relief? Or do the figures and objects seem flat?

Raphael's *Madonna and Child and St. John the Baptist* (Fig. **4-7**) and Max Beckmann's *Begin the Beguine* (Fig. **4-8**) contain strongly contrasting volumes. How solid do these volumes seem to be? What techniques were used to create these volumes? How do the volumes affect the sense of reality in each painting?

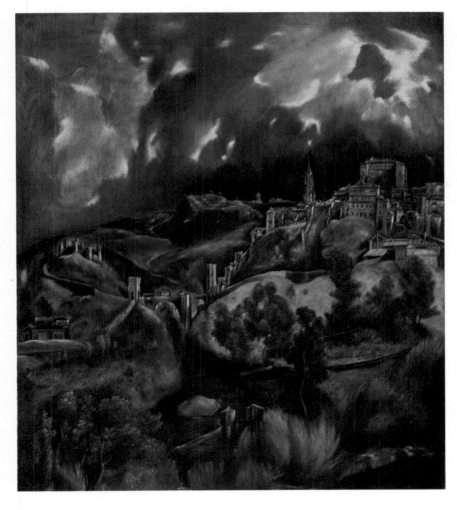

4-6
El Greco, *View of Toledo, c.* 1597. Oil on canvas, 47¾" × 42¾". The Metropolitan Museum of Art, New York. (Bequest of Mrs. H. O. Havemeyer, 1929. The H. O. Havemeyer Collection.)

Shape

We can interpret the figures and objects we see in a painting as volumes. We can also see them as shapes. Shapes are flat, self-contained areas made up of objects or clusters of objects. The areas around or between the objects may also be identified as shapes. These so-called negative shapes can be just as important to the composition of the painting as the objects themselves.

Try to identify the shapes you see. Are they curved or straight edged? Geometric or free form? Simple or fussy? Are they graceful? Do they feel choppy? Are they regular in size and similar in shape, or are they varied? Are they few or many? Are their edges hard or soft? Are they easy to identify and define, or do you have difficulty seeing them?

In Raphael's *Madonna and Child and St. John the Baptist* and Max Beckmann's *Begin the Beguine* there is a strong interest in shape. Can you identify some of these shapes? What words would you choose to describe them?

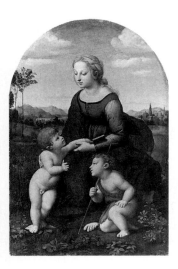

4-7
Raphael Sanzio,
*Madonna and Child and
St. John the Baptist*,
1507. Oil on panel, 48″
× 31½″. Louvre, Paris.

Line

The edges of shapes can be seen as lines. Ask yourself: Are the lines straight or curved? Long or short? Are they choppy? Smooth? Wobbly? Thick or fine? If straight, do they make sharp angles? If curved, are the curves busy or simple? Do the lines bring movement into the painting? Are the lines clear and well-defined or soft and blurry? Are there lines at all?

Look again at the paintings by Raphael and Beckmann. Are the lines actually painted in, or are they implied? What is the character of the lines in each? What movement do they bring?

Compositional Lines

Paintings are often organized within units — shapes or clusters of shapes — separated by lines, actual or implied. These lines, which we may call compositional lines, give the painting order, structure, and coherence. At the same time, they guide the eye through the painting.

Compositional lines are the skeletal elements of a painting. Sometimes these lines are called *axes*. If the composition is balanced on either side of the compositional line, the line is regarded as an *axis*.

Look for the major compositional line along which the picture seems to be arranged. It is likely to be the first line you notice. What drew your attention to it? Is it horizontal? Vertical? Diagonal? Curved? How does it function? Does it separate something? Does it draw your attention to something? Does it have a dual function? Does the painting contain two or more of these lines? What is their relationship?

If the major compositional line is horizontal, it will tend to give a calm quality to the painting. Vertical lines are assertive, dignified, and uplifting. Curves give movement to a painting; diagonals inject excitement. These reactions are probably rooted in human psychology.

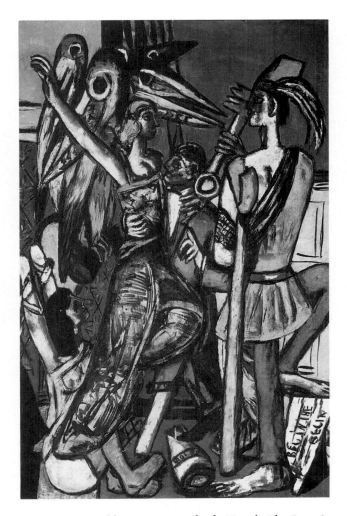

4-8
Max Beckmann, *Begin the Beguine*, 1946. Oil on canvas, 69⅝" × 47⅜". The University of Michigan Museum of Art.

The major compositional line in Leonardo da Vinci's *The Last Supper* (Fig. 4-9) and in Peter Paul Rubens's *The Elevation of the Cross* (Fig. 4-10) is not hard to find. How appropriate is each to the subject? Is it echoed by others in the composition? For vertical compositional lines, see Jan van Eyck's *Giovanni Arnolfini and His Bride* (Fig. 17-14).

Combinations of compositional lines may structure a painting along an X form or a spiral; they may build along diagonals or curves, or create more stable shapes: rectangular, square, or pyramidal. Identifying these shapes will help you to see the composition of the painting.

In *Madonna and Child and St. John the Baptist* (Fig. 4-7), Raphael organizes figures and clothes in a shape approximating a pyramid. This shape, geometrical, symmetrical, and stable, helps to create the feeling that the painter has gathered random movements into a moment of perfection.

Can you pick out the major compositional lines in Thomas Eakins's painting *The Biglin Brothers Turning the Stake* (Fig. 4-11)? Which seem to be the most important? What relationship do they have to one another? How did Eakins use

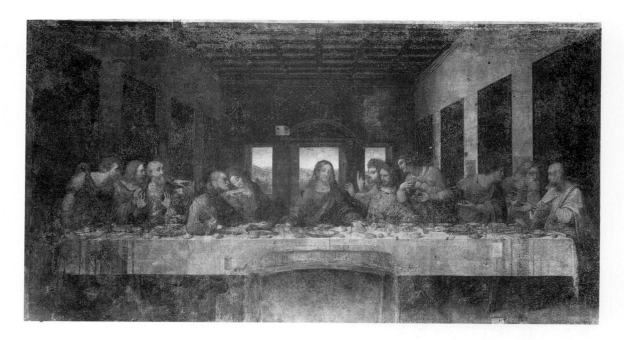

4-9
Leonardo da Vinci, *The Last Supper*, c. 1495–1498. Fresco, 15¼' × 29¼'. Santa Maria delle Grazie, Milan.

them to compose the painting? Where do they direct you to look? What shapes are created by combinations of these lines? What feelings do these shapes bring to this sporting scene?

Composition

Comparing Eakins's painting to a popular sporting print (Fig. **4-12**) should convince you that composition matters. Composition refers to how a work of art is put together, or organized. Shapes and compositional lines are important elements of composition. Even color and light may be used as compositional devices. Since representational paintings often look so natural, our tendency is to overlook composition and to take for granted the placement of the various elements in the painting. By studying the roles played by color, light, shapes, and compositional lines, you can see that they act to draw your eye through the painting in an orderly way: emphasizing that which is important and subordinating that which is less important. Ultimately, the purpose of composition is to give form to an idea as clearly and as forcefully as possible.

When you look at a painting, notice where your eye comes to rest. This is called the *focal point*. Typically this will be the most important part of the painting, the key area that is the heart of the painting. Ask yourself why your eye rests at that place. What path or paths directed your eye to it? What keeps your eye there?

A painting may have more than one focal point or none at all. Does more than one place hold your eye? Does that add to the effect of the painting, or does it detract from it?

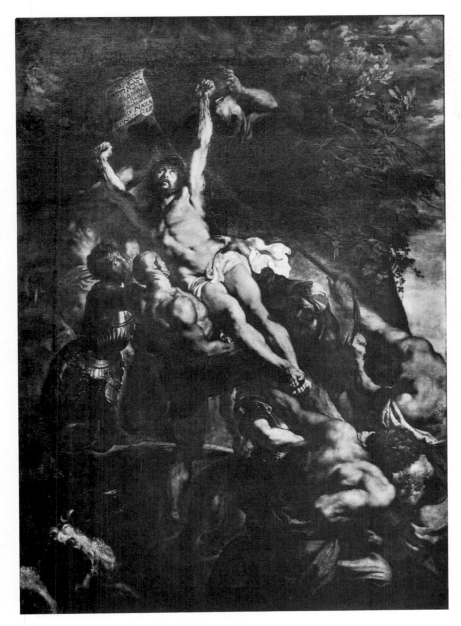

4-10
Peter Paul Rubens, *The Elevation of the Cross, c.* 1610–1611. Oil on panel, 15'2" × 11'2". Antwerp Cathedral.

Where is the focal point in Giotto's *The Lamentation* (Fig. **4-13**)? In Jacques Louis David's *Oath of the Horatii* (Fig. **4-14**)? How do line, color, and light bring your eye to the focal point? What else is used to focus your attention?

Composition has to do with the selection and arrangement of elements. What the painter selects to paint is important, but where that element is placed in the

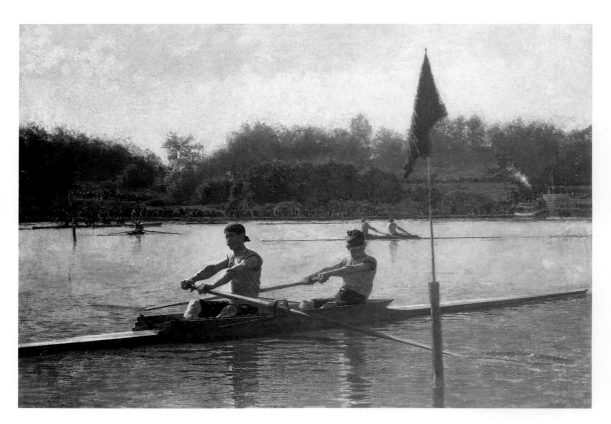

4-11
Thomas Eakins, *The Biglin Brothers Turning the Stake*, 1873. Oil on canvas, approx. 40¼″ × 60¼″. The Cleveland Museum of Art. (Hinman B. Hurlbut Collection.)

4-12
Currier and Ives, Great Five Mile Rowing Match for $4000 & the Championship of America. Courtesy of the Library of Congress.

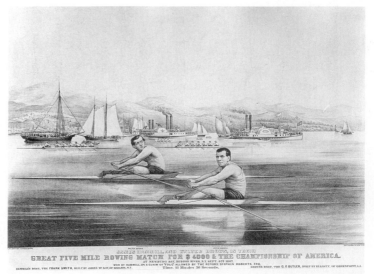

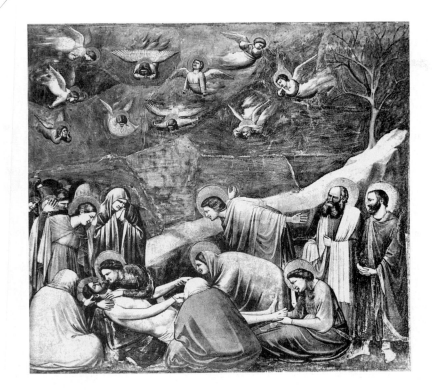

4-13
Giotto, *The Lamentation*, c. 1305. Fresco. Arena Chapel, Padua.

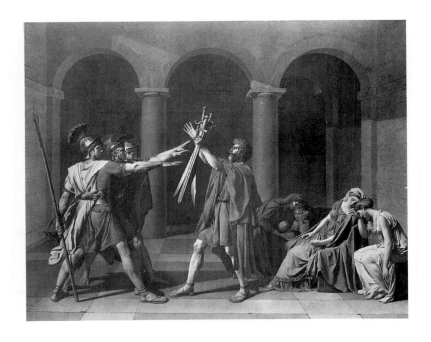

4-14
Jacques Louis David, *The Oath of the Horatii*, 1784. Oil on canvas, approx. 10' × 14'. Louvre, Paris.

picture can be just as important. For example, a figure shown close up will be imposing; a figure painted in the distance will be less so. A figure placed at the edge of the picture will have a different feeling from a figure located in the center.

Do you look up, down, or across at the figure in a portrait? Are the still-life objects placed below you on a table or elevated to eye level? Is the horizon of the landscape high, or is it low? Do you get a bird's-eye view? Are you near or far? Do you seem to be standing at the center of things or off to one side? Your distance from the subject, and the point of view that you are given, establishes a particular psychological relationship with what is in the painting.

What is the relationship of the main figures to the background? How important is the setting? How much of the background do you see? How much detail is given around the figure?

Consider Walt Kuhn's *Clown with Folded Arms* (Fig. **4-15**), Hyacinthe Rigaud's portrait of *Louis XIV* (Fig. **4-16**), and John Sloan's *The Wake of the Ferry II* (Fig. **4-17**). Where is each figure placed? How close are we to each? How important is the background? As a consequence of these choices, what relationship is established between you and the person in the painting?

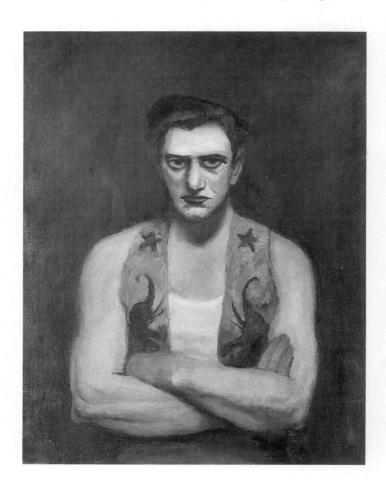

4-15
Walt Kuhn, *Clown with Folded Arms*, 1944. Oil on canvas, 30″ × 25¼″. Temple Fund Purchase 1945.8. Courtesy of the Pennsylvania Academy of the Fine Arts, Philadelphia.

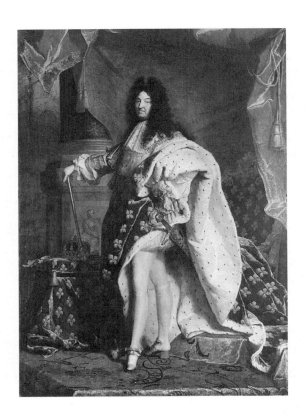

4-16
Hyacinthe Rigaud,
Louis XIV, 1701. Oil
on canvas, approx. 9'2″
× 5'11″. Louvre, Paris.

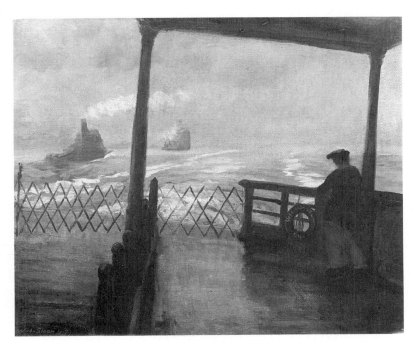

4-17
John Sloan, *The Wake
of the Ferry II*, 1907.
Oil on canvas. 26″ ×
32″. The Phillips
Collection,
Washington, D.C.

Surface Pattern

Figures and objects are arranged beside each other on the flat surface of any painting. Figures and objects may also appear to be located in receding space. It is useful to keep these two situations distinct when investigating composition. The pattern of a painting, its arrangement of shapes and lines on the surface, is one thing; depth is another.

Paintings are structured in various ways with regard to surface and space, and these structures affect the character of the painting. Let's start with the surface pattern. Look at the way the left and the right sides of a painting relate to each other. Is the painting symmetrical, that is, evenly balanced? Is it asymmetrical, that is, do contrasting shapes and colors act as weights and balances, forces and counterforces? Does the painting seem to build up gradually as your eye moves into it from the side? Are the figures and objects crowded? Comfortable? Spread out? Isolated?

Study the arrangement of figures and setting in Duccio's *Nativity* (Fig. **4-18**) and in Fra Angelico's *The Annunciation* (Fig. **4-19**). How carefully are the figures placed? What is their relationship to the setting? How does each composition convey the story?

The surface pattern of a painting may suggest a rhythm to you. You may also discover rhythms within distinct areas of the painting. Rhythm is created by the repetition of similar shapes, lines, or colors, just as the repetition of a beat creates rhythm in music. Rhythms knit together the various parts. Though they

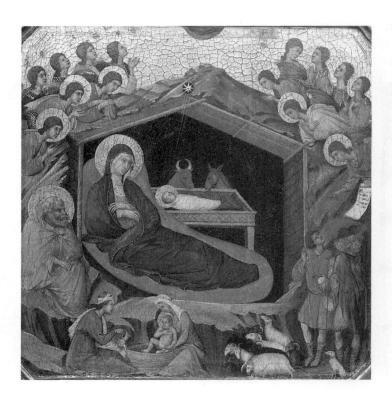

4-18
Duccio di Buoninsegna, *Nativity, c.* 1308–1311. Central panel: 17¼" × 17½". National Gallery of Art, Washington, D.C. (Andrew W. Mellon Collection.)

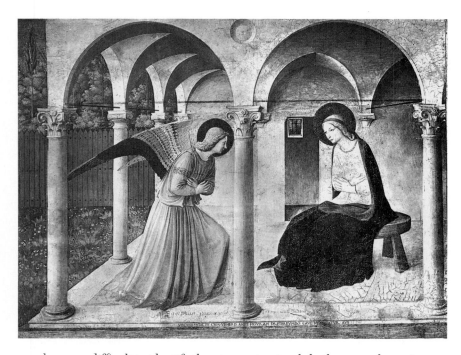

4-19
Fra Angelico, *The Annunciation*, c. 1440–1445. Fresco. San Marco, Florence.

may be more difficult to identify than in music, visual rhythms may be an important structural element in a painting.

Compare the overall rhythm of the mosaic *Justinian and Attendants* (Fig. **4-20**) with that of Pieter Brueghel's *The Wedding Dance* (Fig. **4-21**). What elements of form are used to create those rhythms? Look again at Duccio's *Nativity* (Fig. 4-18) and Fra Angelico's *The Annunciation* (Fig. 4-19). What lines

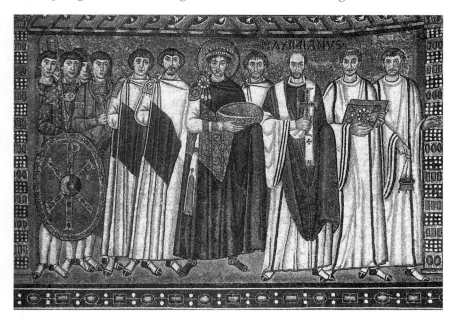

4-20
Justinian and Attendants, c. A.D. 547. Apse mosaic from San Vitale, Ravenna.

4-21
Pieter Brueghel the
Elder, *The Wedding
Dance*, 1566. Oil on
canvas, 47″ × 62″.
Courtesy of the Detroit
Institute of Arts, City
of Detroit purchase.

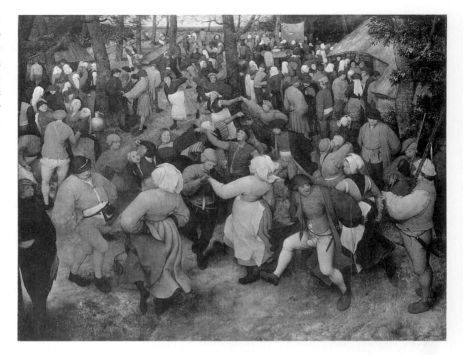

are repeated? What shapes are repeated? How do the rhythms they establish affect each painting?

Space

Now consider the space: How are you carried back into the picture? Gradually? Predictably? Or are you snapped back suddenly into the distance? Is the space orderly? Measurable? Ambiguous? Clear? Is it deep or is it shallow? Is it flat?

How does the artist achieve the illusion of depth in the picture? By means of overlapping planes? Decreasing the size? By contrasts of dark and light? Going from high contrast colors in the foreground to low contrast colors in the distance? Using bright colors in the foreground and pale colors in the distance (*atmospheric perspective*)? Does the artist construct a mathematically based perspective system (*linear perspective*)? Does the artist provide paths to lead your eye back into space? Conversely, does the artist do things to flatten space and bring the background closer?

Notice how differently space is treated in three paintings: El Greco's *The Agony in the Garden* (Fig. **4-22**), Nicolas Poussin's *Landscape with Burial of Phocion* (Fig. **4-23**), and Fairfield Porter's *Flowers by the Sea* (Fig. **4-24**). Where is the space clear, calm, and orderly? Where is it ambiguous? Where does it seem mysterious? Which paintings have the deepest space? The shallowest? How did the artist create a sense of space in each? What feeling or mood is created by the space?

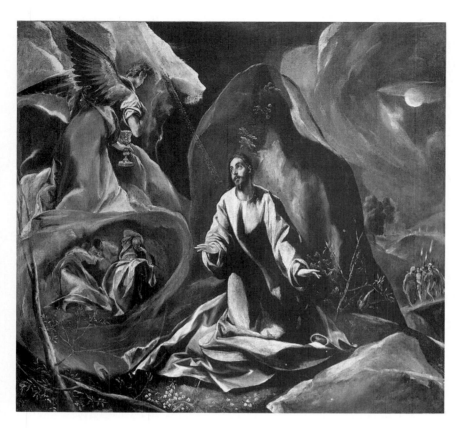

4-22
El Greco, *The Agony in the Garden*, c. 1590. Oil on canvas, 40¼″ × 44¾″. The Toledo Museum of Art. (Gift of Edward Drummond Libbey.)

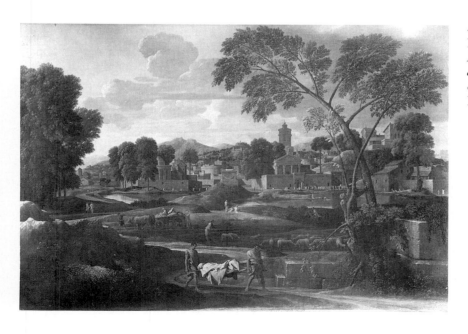

4-23
Nicolas Poussin, *Landscape with Burial of Phocion*, 1648. Oil on canvas, 47″ × 70½″. Louvre, Paris.

4-24
Fairfield Porter,
Flowers by the Sea,
1965. Oil on
composition board, 20″
× 19½″. Collection,
The Museum of
Modern Art, New York.
(Larry Aldrich
Foundation Fund.

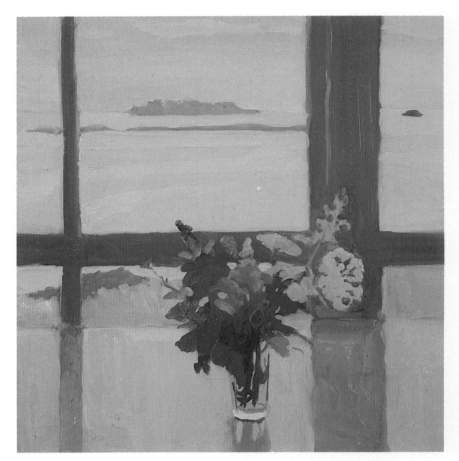

We have asked many questions, not all of which can be answered in every case. Some of these questions just won't apply to the image you might be looking at or thinking about. But others will, and you can think up more, depending on what you are analyzing. Because every painting you look at presents you with a unique situation, it's up to you to see what you can find in it. What do you notice first? Why? Which elements seem to dominate? Which are of less importance? What do they contribute? What multiple functions might they have? What effect do they have on the painting? Always keep in mind that a serious painter will try to consider every aspect of his or her painting, leaving nothing to chance.

To assess the impact of a particular element, try to imagine what the painting would look like if that element were altered or replaced with something different. Without touching the painting, block out an area with your hand to help yourself visualize the change. What would the landscape be like if a certain tree were removed from the foreground, or if it bent a different way? What would the portrait be like if you weren't looking *up* at the king? What would happen if

the background to a figure were more detailed? Less detailed? If the sky were bluer, or grayer? If the water were rougher, or smoother? If the paint were thicker, or thinner? If the colors contrasted more, or contrasted less?

Then go further in your analysis. Try to recognize the roles that these formal elements play and to discover how they function in the painting. Ultimately, you will want to see how they affect the painting and your experience of it.

The roles played by color, light, texture, volumes, shapes, lines, pattern, and space can be described best by words drawn from analogous nonvisual experiences. Colors are aptly characterized as "warm" and "cool." Color can also be sweet, sour, luscious, luminous, velvety, austere, harsh, or gentle. Color can scream, and it can whisper. Light can be warm or cool, hot or cold; it can be harsh, gentle, cheerful, or eerie. Texture can be rough or polished, heavy or light, turbulent or serene. Brushstrokes can be deft, dashing, turbulent, coarse, or refined. Volumes can be robust or delicate, heavy or light, aggressive or tranquil. Shapes can be gentle, graceful, robust, eccentric, or harsh. Lines can be graceful, nervous, gentle, violent, soft, strong, elegant, or crude. The surface arrangement can be balanced, stately, harmonious, simple, complex, or chaotic. Rhythms can be quick, graceful, regular, off-beat, solemn, or monotonous. Space can be tense, serene, constricting, ample, logical, or dreamlike.

Think of every painting as having a personality. Can you see it as happy, gentle, vigorous, ferocious, pompous, honest, polished, coarse, loud, quiet, elegant, sensuous, austere? Or can you think of it as having a certain taste or flavor or fragrance?

These ways of describing paintings and what is in them are not, of course, precise. But they may be the best way of showing how formal elements function in a painting and determine its character.

A FORMAL ANALYSIS: RUBENS'S *CROWNING OF ST. CATHERINE*

The illustrations in this chapter were chosen because they show with exceptional clarity how the various formal elements appear and function. To see how these elements are combined in one painting, we will study Peter Paul Rubens's *The Crowning of St. Catherine* (Fig. 4-25). Located in the Toledo Museum of Art, where it was recently cleaned, it is possibly the finest painting by Rubens in North America. This painting was commissioned in 1633 as an altarpiece for a church in Malines, Belgium. It depicts the vision, or dream, of an early Christian martyr, St. Catherine of Alexandria, in which she sees herself crowned by the infant Jesus. With her in the painting are two other martyred saints, Apollonia of Alexandria on the left and Margaret of Antioch on the right. The pincers held by Apollonia and the dragon held by Margaret are attributes, or symbols, of their martyrdom.

Working on a grand scale (8½' × 7'), Rubens gives this visionary event a great physical energy and presence. He almost persuades us that movement is

4-25
Peter Paul Rubens,
*The Crowning of St.
Catherine*, 1633. Oil on
canvas, approx. 8½′ ×
7′. The Toledo Museum
of Art. (Gift of Edward
Drummond Libbey.)

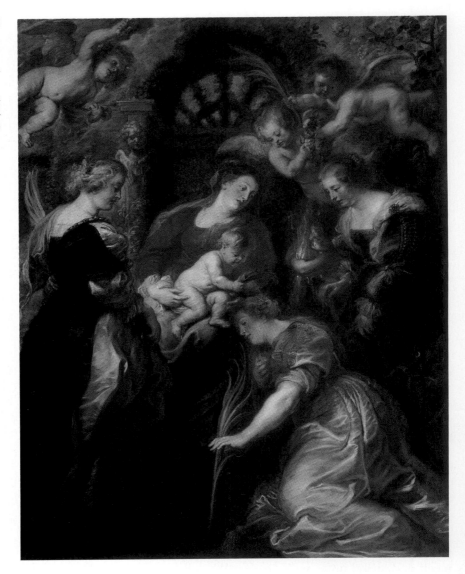

occurring as we watch. The movement, however, is not random, and the painting is not chaotic, for wherever we look our eyes inevitably come to rest in the serene center, where the primary event, the crowning of the saint, takes place. It is this event that Rubens wants us to witness and remember, and it is here that our eyes linger.

Rubens constructs this painting very deliberately. He emphasizes the importance of Mary, Jesus, and the head of St. Catherine by placing them in the center of the painting. Lines drawn diagonally from corner to corner would intersect at the hand of Jesus that holds the crown. Rubens restates these directions in the

strong diagonals that rise from the lower corners of the painting, one along the edge of Apollonia's gown and the other along the back of St. Catherine. These lines bring us to the central area. The figure of Mary is at the apex of a triangle that stabilizes the motion-filled composition. Mary's gaze, together with the oval silhouette of her shoulder and arms, carries our eyes gently downward to the area of the crown and the head of St. Catherine. There is a rough correspondence in size between figures on the left and figures on the right. This symmetry emphasizes the center and at the same time gives a sense of solemnity to the event.

Much of the action in the painting is aligned along its central vertical axis, which runs through the entire canvas from top to bottom. We can follow its descent from the vertical arm of the trellis through the heads of Mary and Jesus to Jesus's hand holding the crown, then through the head of St. Catherine downward along the palm branch to the bottom of the painting. The axis is repeated by the sides of the trellis. These sides form strong verticals that extend downward along the edge of the purple gown of St. Apollonia on one side and along the edge of the white gown of the kneeling St. Catherine on the other, and give stability to the composition. Besides restating the central axis, the sides of the trellis frame, and thereby emphasize, the central figures.

The arch of the trellis completes the frame. St. Catherine's left arm echoes in reverse the curve of the arch, and pushes our eyes in a clockwise direction that rises along the figure of Apollonia to the cherub above her, and descends along the cherubs and the figure of Margaret on the right to complete the effect of an oval shape surrounding the central figures. The radial elements of the trellis point to Mary. Below the arch of the trellis, repeated curves — the palm branch held by the cherub, the arcs of the trellis, and the cherub's wing — bring us down to Mary's inclined head and again to the head of Jesus. By both framing and echoing their heads, these curves serve to integrate the background with them.

Rubens paints these figures larger than life size and draws us into the action by omitting a foreground that would otherwise have separated us from them. Rubens nearly eliminates the background as well and in this way focuses our attention on the action. We look up at the cherubs and down at St. Catherine as if we are there at the scene. All of the figures and the action are brought close to us, so that everything we see contributes to the immediacy of the event. That sense of immediacy and robust energy also emanates from the loose and vigorous brushstrokes. Long, zig-zagging strokes, like currents of water, animate larger areas such as the gowns, while shorter, more blended brushstrokes quiet the action in the faces of the figures.

An amazingly bright light seems to radiate out of this painting. Although the scene takes place outdoors, the light does not cast harsh shadows, but is soft, rich, and warm. The entire scene has a kind of shimmering haze, giving it an appropriately dreamlike quality. This soft shimmer is achieved by gentle blending of color into color, by layering of transparent colors, and by softening the edges of all shapes.

Light is also used to impress the story upon us. By highlighting faces and gestures, Rubens makes sure we feel the absorption of the figures in the mystical event. Through our empathy with them, we ourselves become absorbed. The

many reds, pinks, oranges, and purples warm the scene. The colors are sweet, rich, and sensuous, reflecting off surfaces even in the shadows.

Rubens also uses color to organize the painting. He reserves his strongest and purest colors for the central area—the large area of Mary's red tunic and the contrasting blue of her robe. These colors attract our attention and hold it there. Rubens surrounds the bright colors with contrasting darks to make the center even stronger. Outside the center, spots of red and pink catch our eye and give movement. At the same time, the balance of purples to the left and right stabilize the composition.

Rubens's brush technique makes us aware of surfaces. Rich fabrics, glowing skin, and soft hair invite us to touch them, at least in our imagination. The sense of materiality here, of substance, is matched by few painters.

The volumes are voluptuous and rounded; the shapes are bounded by energetically flowing lines. The curves echo and re-echo one another, like harmony in music. We have already observed how repetitions of the arch of the trellis bring our eyes to Mary and then to the head of Christ. See also the way the folds of Mary's blue robe correspond to the line dividing the purple and yellow areas in the gown of the figure on the left; and the way those folds are taken into the curve of the palm branch held by St. Catherine. The curve continues along Mary's knee, and is repeated in her left shoulder. See, too, how the gesture of St. Catherine's left arm is restated by the arm of the cherub in the upper right, and in reverse by the arm of the cherub in the upper left. These and many other subtle correspondences give the painting a harmony and unity that would be impossible to attain in reality, and in that way elevate the painting above the level of natural events to a more sublime realm.

In sum, rather than a human event rendered in otherworldly terms, we see a spiritual event rendered in human terms. These figures, weighty and solid, belong to the natural world. Rubens dresses them in contemporary costume, gives them personality, and suffuses the painting with human grace and charm. Rubens thus celebrates the spiritual in palpable, earthly terms. But we can go further in understanding this painting by turning that idea around again: we can see in the painting a statement of faith in the possibility of life to be exalted—a faith that people can be good, wise, and beautiful in both image and spirit.

Rubens shows us a dream wrapped in a legend. Perhaps that mysterious blending of illusion and reality, which is the nature of dreams, inspired the painter, who blended illusion and reality in the creation of his art.

FORMAL ANALYSIS AND INTERPRETATION

By going beyond merely *describing* the subject matter to looking at *how* the subject matter is presented, you will come to a deeper understanding of the painting. Your investigation of formal elements will help you to see the painting through the eyes of the painter. By becoming

aware of the formal relationships that are subtly embedded in a painting, you will discover what was done to give it character and interest. Your questions will also reveal the attitudes and feelings of the artist toward the subject matter. Isolating and examining the formal elements will help you to learn in the clearest possible way what the painting is meant to say and will enable you to establish what is possibly the most intimate and pleasurable relationship to the painting.

Formal analysis is a point of departure in the investigation of art. It is a way of looking that can take you from sight to insight. Formal analysis opens the doors to appreciation by helping you see that a representational painting does not just mirror reality, but makes a statement about it. And it helps you to read and to interpret that statement as thoroughly and as lucidly as possible.

5

LOOKING OVER
THE ARTIST'S SHOULDER

W hat goes on in artists' minds as they scrutinize their work? Formal analysis provides some solid insights. Comparing related images by the artists can carry us even further. ¶ In this chapter, we'll look at the same images the artists looked at. We will have an opportunity to test our skills in reading paintings. We'll observe the changes the artists made when they took the next step, and we'll try to discover why they made those changes. The comparisons we make will provide an opportunity to trace the path of their thinking—as if we were looking over the artists' shoulders.

PREPARATORY STUDIES: GUERCINO'S *ESTHER BEFORE AHASUERUS*

Giovanni Francesco Barbieri, known as Guercino, worked primarily in

the North Italian region of Emilia. Like many of his contemporaries in the seventeenth century, he mined Biblical and mythological texts for subject matter, and his robust paintings often presented individuals in complex physical and psychological interactions.

¶ Three preparatory compositional studies exist for Guercino's painting *Esther before Ahasuerus* (Fig. **5-1**). To make Guercino's formal decisions comprehensible, we need to know the story behind the painting. It is found in the Old Testament Book of Esther. Ahasuerus, a pagan king, dismisses his wife and chooses another: Esther. Unbeknownst to the king, his new queen is one of the Jewish minority living in the kingdom. The king's haughty prime minister, infuriated by the refusal of the queen's cousin to bow down to him as he passes on the street, persuades the king to destroy all the Jews in his kingdom. Now is the time for Esther

47

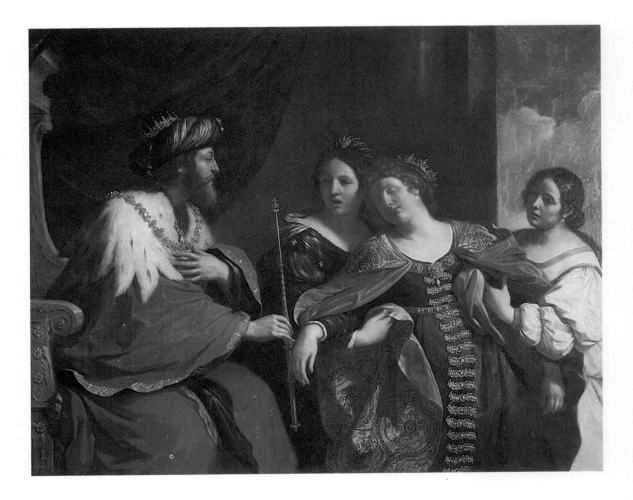

5-1
Guercino (Giovanni
Francesco Barbieri),
Esther before Ahasuerus,
1639. Oil on canvas,
62½″ × 84¾″. The
University of Michigan
Museum of Art.

to act. After three days of fasting and prayer, she dresses in her best clothes and enters the king's chamber to help save her people. Esther knows that an unannounced intrusion can mean death unless the king holds out his scepter. Physically exhausted and emotionally drawn, Queen Esther passes out in the arms of her attendants as the king, showing his love for her, extends the scepter. It is at this point that Guercino sets his scene.

Guercino's challenge is to give voice to those silent characters and to involve the viewer. He accomplishes this through a language of pose, gesture, and expression.

His first sketch (Fig. **5-2**) shows Esther slightly higher than the king. Guercino could have intended that Esther dominate the scene, but if so, he was to change his mind. By the second study (Fig. **5-3**), as in the painting, the king is placed above the other figures—an appropriate image of authority.

Guercino saw problems in the king's original pose. Leaning back as Esther approaches, his scepter on his shoulder, the king could be interpreted as recoiling from her. The gesture of his hand could be taken for fear or alarm. Guercino takes care of this in the next drawing by having the king lean forward. The king grasps Esther's

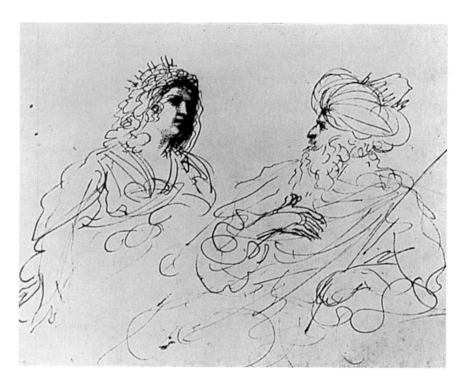

5-2
Guercino (Giovanni
Francesco Barbieri),
Esther before Ahasuerus,
1639. Drawing, pen
and ink. Private
collection.

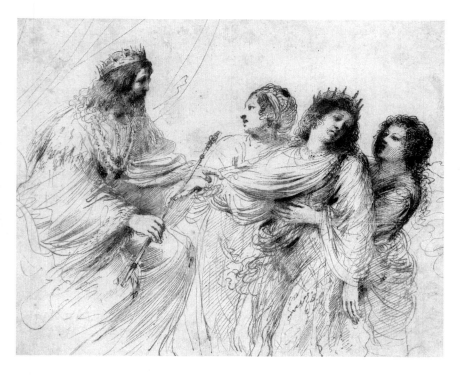

5-3
Guercino (Giovanni
Francesco Barbieri),
Esther before Ahasuerus,
1639. Drawing, pen
and ink. Windsor
Castle, Royal Library. ©
1991. Reproduced by
gracious permission of
Her Majesty Queen
Elizabeth II.

5-4
Guercino (Giovanni
Francesco Barbieri),
Study for *Esther before
Ahasuerus*, c. 1639.
Pen and brown ink
and wash, laid down,
8½″ × 10¼″. The
University of Michigan
Museum of Art.

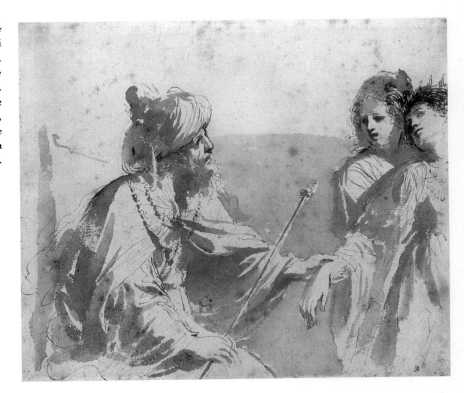

wrist. His scepter tilts toward Esther. He has let her touch it. Now it is the king who is assertive. His presence dominates the scene.

Guercino also introduces the attendants, but the three women resemble an awkward chorus line. They rear back uniformly from the king, looking contrived and unnatural. Guercino reworks the women's poses, Esther's most of all. His final arrangement for them in the painting is much more varied, rhythmic, and graceful.

In the third study (Fig. **5-4**), the right side of which appears to have been cut off, the king still holds Esther's wrist, but her hand has dropped, and is silhouetted in the space between them. The king is lower now, and he tilts his head and opens his mouth. These decisions make him less threatening, as well as less regal. He seems more like an ordinary person. Guercino is to change this in the painting.

The third study shows further reworking of the poses, and these are carried into the painting. The V shape of the arms of the king and queen is emphasized in the painting, where it is part of a graceful zigzag that moves through the center of the painting from left to right. Esther's head falls against her attendant, and she falls toward, rather than away from, the king. She and the king are now connected by a large arc, each of them forming a segment. All of these shifts in the positions of the figures are meant to create visual relationships that are at once physical and psychological.

Guercino's reworkings draw the viewer ever more securely into a drama of relationships at its emotional height. Guercino intensifies the event by bringing the viewer up close and putting a strong light on the faces and hands. Like a

good stage director, he contrasts the alarmed expression of the attendant with Esther's closed eyes. He has that attendant looking at the scepter, a dramatic device that reminds the audience of what it already knows: that the scepter is the instrument of life or death. The gleaming scepter holds our attention, too. A symbol of authority, it has balance and dignity, like the king himself. Appropriately, it separates the king from the rest. But the king thrusts it forward, and by that gesture announces authority's subjection to the power of love.

A MINIATURE PAINTING FROM INDIA AND A PREPARATORY DRAWING: *PALACE LADIES HUNTING FROM A PAVILION*

Our next subjects belong to a tradition of miniature painting that developed in the Mughal courts of India between the sixteenth and nineteenth centuries. Using bright, opaque watercolors, artists illustrated histories, mythologies, and scenes of daily life. As in much of Western art ("Western art" refers to the art that developed in Europe and later spread to North and South America), we are presented with images of a perfected world, but here the images are more highly stylized. Their small scale, flattened space, bright flat patches of color, and delicate execution give them a decorative quality. Still, the artists' love of precise details ties these images to the real world.

During the Mughal period, courts of the nobility patronized the arts. Our artist, whose name is unknown, worked in the city of Kota, in north central India. The painting, *Palace Ladies Hunting from a Pavilion* (Fig. **5-5**), is a scene familiar to the Kota court.

With botanical exactitude, the painting depicts a fertile landscape with an abundance of lively animals. Tucked into this scene is a pavilion with three ladies daintily pointing their rifles. Hunting was a favorite pastime at the Kota court, and women were participants. Hunting towers were built beside the ponds where animals came to drink twice a day. Still, the landscape is most likely derived from the artist's imagination.

In the study (Fig. **5-6**), the artist blocked out the composition with several sweeping lines: a vertical line at the right edge of the pavilion, and some long, curved lines in the upper part of the drawing to show where the hills would go. Then the artist developed the details of the landscape and added the animals. Finally, the colors were tested out with some light watercolors, mostly green and some blue in the sky.

The handling of the objects is rudimentary. The artist is just getting things located. But several details are noteworthy. The shorthand sketch of the rocks in the top left corner is different from the way a Western artist would sketch rocks. The squiggly lines seem unscientific, but lively. Notice the face in the setting

5-5
Anonymous, *Ladies
Shooting from a Pavilion*,
c. 1810. Color on paper,
13½″ × 10¾″. The
Cleveland Museum of
Art. (Purchase from the
J. H. Wade Fund,
55.48.)

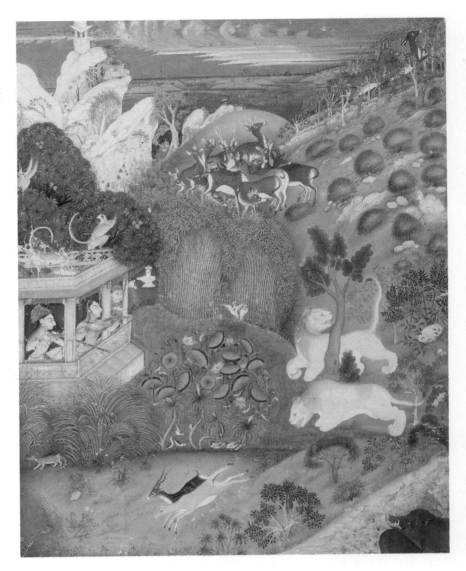

sun, literally peeking out at the scene — or is it at us? Perhaps the artist penciled this in for amusement.

Comparing the sketch and the painting, what strikes you as the biggest change overall? Is it the shift from horizontal compositional lines to the more dynamic diagonals? Much of the sketch is arranged in horizontal bands, which must have struck the artist as sluggish. The increased use of diagonals in the painting enlivens the scene considerably.

In the lower half of the sketch, the only diagonal lines are on the pavilion. These diagonals are retained in the painting, where they become steeper. The pavilion is reworked, and its smaller size fits less obtrusively into the landscape.

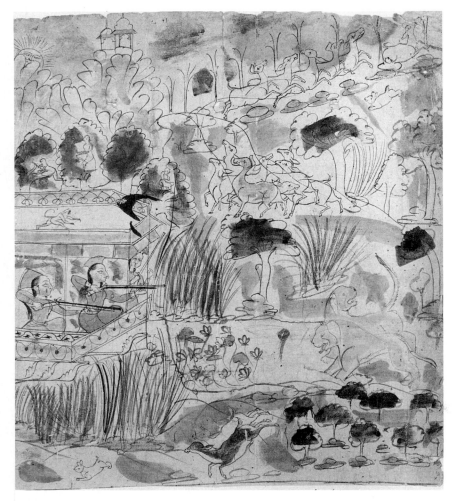

5-6
Anonymous, *Three Ladies Shooting from a Hunt Tower*, c. 1810. Sketch, pencil and watercolor on paper, 11¼″ × 10¼″. The Cleveland Museum of Art. (Anonymous gift, 78.50.)

The artist also adjusted the angle of the grassy hill at the top. The profile of that hill becomes a major compositional line in the painting, and its angle is carefully calculated. It sweeps into the picture from the upper right with energy not present in the sketch. The drop is steep now, almost precipitous, and it brings the viewer to the pavilion, whose diagonal lines match those of the hill and bring them to rest.

The diagonal is repeated elsewhere: by a farther hill and some of the mountains, by several lines in the lower right, and by the leaping gazelles. These diagonals help organize the composition and give it an internal harmony.

Strong opposing diagonals push off from the upper-left corner and bring the eye to the center. The wild profile of the mountains on the horizon and the profile of the trees below them lead to the grove of bamboo, which in turn brings

the eye to the lions. At the lions, the gray tree picks up the diagonal movement and gently brings it to rest.

Many of the shapes, like the lines, echo one another. The shapes of the mountains appear again in the trees and in the bamboo stalks near the center. The shapes of the bushes and rocks on the hill repeat each other and turn up in the shapes of the clouds as well as in the lily pads.

So far we've noted the larger developments in the move from sketch to painting. The artist reworked the smaller areas, too. Consider the changes made to the lions and the tree.

The lions in the sketch overlap; it's hard to see who's who, and their combined profile is clumsy. In the painting, they are separated, and their individual gestures are more easily distinguished. Negative shapes appear between them, and the decision to overlap a lion by the tree makes three varied shapes out of the lions instead of two similar ones.

The nearer lion's tail changes direction. In the painting the tail curves upward gracefully, echoing the tail of the other lion, as well as the tree. Tails and tree help to hold the eye in the central area. The tail of the other lion goes from a simple **C** curve in the sketch to a more graceful **S** curve in the painting, where it echoes the tree. Finally, to tighten up the scene, the artist shifts the lions and the tree closer to the center. These careful reworkings of lions, tails, and trees shows the meticulous care with which the artist integrated the many small pieces of the composition.

These changes to the composition not only integrate the parts more successfully, but bring more movement to the scene. The artist replaced the vertical bamboo stalks in the lower left of the drawing with long, gracefully curved leaves. He saw the rifles making two long horizontals and tilted them up and down. He looked at the farther bank of the pond and saw a rigid horizontal edge. In the painting, the edge ambles along in slow curves like time on a lazy afternoon.

In the shift from sketch to painting, repetitious elements were weeded out. A band of running deer at the top is reduced to two, and the trees behind them are more varied. A distant landscape of lakes and hills is introduced where the deer and trees had been. This gives us another option: we can imagine ourselves way back there by the water, or, if we prefer, inside the watchtower perched on the rocks, enjoying the view.

Proportions are altered for the painting. The study is boxier; the painting is taller and more elegant. With this change comes a subtle change of perspective as well. In the sketch, we look across at the action. In the painting we experience space more ambiguously. Higher, farther away, our point of view becomes more panoramic, fanciful, and indeterminate. These changes are significant and bear considerably on our response to the scene.

In the painting the expanded sky enriches the color by providing oranges and gold to contrast with the predominant greens. The artist uses bright greens and mustard colors to attract the eye to the ladies and then to the lions. Both the patterning and the color make these the focal points. The silver gray of the pool quiets the action in the central area.

For the painting, the artist changed the color of the rifles. They are black in the sketch, but in the painting they blend in and appear less prominent. They are less threatening, and we can also see that the ladies now appear less intent on using them. We wonder if the guns will be fired at all.

Our comparison has revealed a number of changes by the artist. Those decisions were based on a determination of what would make a vivid and entertaining image. But what was behind those decisions?

We've seen an absorbing concern for the integration of the parts. The many diagonal lines sharing the same angle bring harmony to the scene. Frequently repeated shapes also call and answer one another, like musical themes. Even the animals appear in pairs. Lions, tails, and trees relate fastidiously. Of course we'll never see anything quite like this in the real world. All of these relationships are manifestly artificial and bring to the scene a make-believe quality that removes it from reality. Tiny in size and delicate, it is as contrived and charming as a fairy tale.

What is the artist telling us? What content is here? It's a vast, natural world that we are shown, but the people are safe. The horizon stretches far away and the rocks are rugged, but one of them wears a look-out like a jaunty cap, and the sun is shining, the weather is fine, the water is peaceful, and the animals aren't very fierce. The scene becomes even calmer as you move from the distance to the center, where the ladies are amused and the lions seem untroubled. The many paired animals and the abundant foliage suggest the theme of procreation, which is alluded to by the small Hindu religious symbol, the *lingayoni*, that is set into the painting between the pavilion and the bamboo. Only a snarling boar tucked into the lower-right corner, perhaps as an afterthought, breaks the mood.

The theme here might be love, but it is balanced by death, for the ladies have rifles, and, as the boar realizes, they might use them. Thus the theme is large, for love and death touch us all. But we are the privileged observers here. We, like the artist and the original owner, hold in our hands a tiny scene, and we look down on it like a god from a great remove. The artist has ensured that our reaction will be philosophical and detached—unlike the participants, who are bound to the events and consequences of this endless moment.

CHANGING THE IMAGE

Oil paint tends to become transparent over time. As this happens, underlying images may gradually appear and show where the artist had a change of mind. Many paintings reveal buried secrets in this way.

In his painting *Hide and Seek* (Fig. 10-13), Alfred Stevens had originally included a young girl standing in the doorway. If you look carefully at the reproduction, you will see the dark form of her dress (below the wall in the farther room), and you can make out her legs. Stevens might have improved the composition by painting out the girl, but my guess is that he made this change to

5-8
Jan van Eyck, *Arnolfini and His Bride*, 1434. Detail. Infrared photograph, 8″ × 10″. National Gallery, London.

thicken the plot. Who is she hiding from? Who has the dog noticed? What about the glove on the floor? As you can see, soap opera is not strictly a modern taste.

X-rays and infrared light allow us to see beneath the surface of a painting and to discover changes that took place. Figure **5-8** is an infrared photograph showing a detail of Jan Van Eyck's *Giovanni Arnolfini and His Bride* (Fig. 17-14). It reveals that the artist altered the position of Arnolfini's hand to make it more graceful and to incline it, appropriately, in the direction of his bride.

Many painters change their minds along the way. Emerging images, x-rays, and infrared photographs, *pentimenti* (visible traces of underlying brush-strokes) point to where this happened. A recently cleaned Velázquez portrait of King Phillip IV shows that the painter removed a cap from the king's hand and popped it on his head, where it looks better. The old cap in the king's hand is showing through the overlying paint. In a painting by Vermeer, a chair is beginning to see the light of day, and *pentimenti* show where Manet changed the angle of a rope in a sailboat by painting it over and doing another.

MULTIPLE VERSIONS

Many artists return to an image and make a fresh start with another version. Figs. 11-3 and 11-4 show two of three known versions of a painting by El Greco. Many other images examined in this book are part of a pair or a series. Each version brings something new to the subject.

Two Versions of a Painting by Winslow Homer

Winslow Homer began his artistic career as an illustrator for Harper's magazine during the Civil War. He remained interested in depicting the experiences of ordinary people and often placed them in challenging situations. The excitement and the peril of a life on the sea was a favorite theme.

Homer occasionally returned to an image he liked to make a second version. His *Sailing the Catboat* (Fig. **5-9**) and *Breezing Up* (Fig. **5-10**) are both so appealing that it's hard to guess which one came later. See if you can tell without looking at the dates in the captions. Don't go by the brushstrokes as one was painted in watercolor and the other in oils, and Homer excelled in both tech-

5-9
Winslow Homer,
Sailing the Catboat,
1873. Watercolor,
7½″ × 13½″. Private
collection.

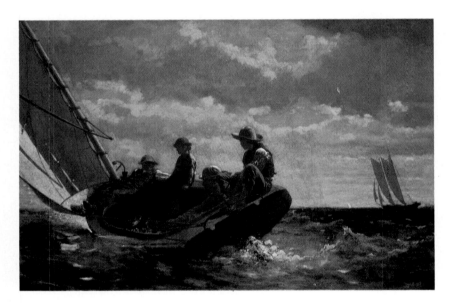

5-10
Winslow Homer,
Breezing Up, 1876.
Oil on canvas,
24⅛″ × 38⅛″.
National Gallery of
Art, Washington, D.C.
(Gift of the W. L.
and May T. Mellon
Foundation.)

niques. Concentrate on the composition. You'll notice that one boat includes an extra figure. What difference do you think that makes? Does it help to have the figure here? Homer also made changes to the background. A lighthouse and a spit of land in *Catboat* are replaced in *Breezing Up* by a distant boat. On the extreme left in *Breezing Up* is a tiny lighthouse on the horizon. Barely visible on the horizon to the right is a white sail, and a white seagull appears in the sky. How do the presence or absence of these elements affect the picture's overall composition? What associations do they set off? What feelings do they give you?

The paintings were made three years apart. In moving from the earlier to the later version, Homer removed all extraneous detail. He believed that whatever is not strictly necessary to a composition hurts it. He sensed that the silhouetted figure sitting on the end of the boat in *Catboat* was unnecessary. In *Breezing Up*,

the rhythm in the figures is simpler and more emphatic, and the energetic diagonals make a stronger contrast where the reclining boy crosses the mast. Homer may have felt that this contrast would more effectively convey the excitement of zipping along in that precariously tilted boat.

Homer's changes to the background also shift the meaning of the image. The land that appears in the earlier painting tells you they're not too far offshore. The lighthouse symbolizes protection. Homer wanted something that spoke to the isolation of the boys, that put them out farther, somewhere more dangerous. To that end, he removed the lighthouse in the second version, replacing it with a boat that is dark, distant, and lonely. The sails of that boat repeat the shape of the sail of the nearer boat, pulling the composition together and hinting at a connection between boyish enthusiasm for the sea and the lonely life of the sailor. The tiny lighthouse on the left tells you they're a long way from the shore; the sail in the distance and the seagull give a sense of the vastness of the space. You see more of the sky now. Grayer, colder, the weather more threatening, it brings an ominous edge to this robust scene.

Rembrandt's Print
Christ Presented to the People

The etching technique allows us to watch the creative process at work on one single image. Etchings are made using metal plates coated with an acid-resistant film, or ground. Using a sharp, needle-like tool, the artist draws the image through the ground and onto the plate, which is then submerged in acid. Where the plate has been exposed by the lines, the acid bites in, reproducing those lines in the metal. Then the plate is removed from the acid, the surface is cleaned, and ink is pressed into the etched lines. The plate is placed under a sheet of dampened paper and run through a press under tremendous pressure, which transfers the inked lines from the plate to the paper.

The drypoint technique is a variation. Using a stronger tool, the artist draws directly onto the metal plate, bypassing the ground. Lines made in this way have a burr on the edge, which gives them a soft, rich character. Rembrandt frequently combined drypoint with etching. However, the print we shall look at is unusual in that it was done entirely in drypoint, perhaps as a technical experiment.

Generally, lines in an etching or drypoint must be built up gradually to produce a rich dark tone. Because of this, artists do these prints in stages. They print an image to see what it looks like and then recoat the plate and etch in more lines where they want it darker. Artists can also erase areas by scraping them down with a sharp-edged tool, though this is difficult to do. Scraping restores the flat surface of the plate, which may then be reworked and re-etched. Each separate stage of an etching or drypoint is called a *state*.

Rembrandt van Rijn lived in Amsterdam in the seventeenth century. He frequently illustrated Biblical stories, and he told those stories in human terms. Compare these two states of Rembrandt's etching, *Christ Presented to the People* (Figs. **5-11** and **5-12**). What changes did Rembrandt make?

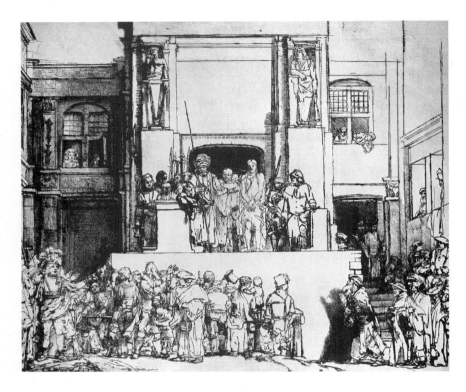

5-11
Rembrandt van Rijn,
*Christ Presented
to the People*, 1655.
Drypoint, third
state of eight,
15″ × 17¾″.
Rijksmuseum,
Amsterdam.

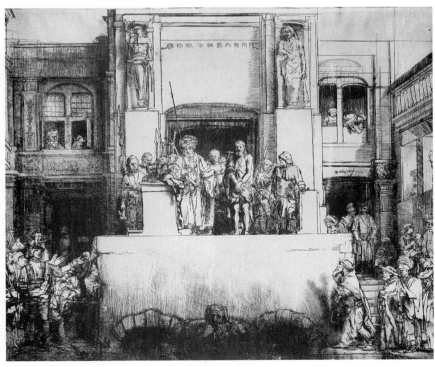

5-12
Rembrandt van Rijn,
*Christ Presented
to the People*, 1655.
Drypoint, seventh
state of eight,
14″ × 17¾″.
Rijksmuseum,
Amsterdam.

First and most important, Rembrandt removed the crowd that mills around the base of the platform in Figure 5-11. He must have thought the people were too distracting from the central subject, the presentation of Christ. In the later state, Christ is farther from the crowd, more poignant in his isolation. By clearing away the crowd, Rembrandt also created a large, relatively bare space as a kind of frame around the central figures. Darkening several areas around the edge of the print, Rembrandt dramatizes the central scene even more. The action takes place on a grander stage. The architecture, more monumental, makes Christ seem more pitiful.

Rembrandt introduces two vaults with rounded arches where the crowd had been. These of course relieve the emptiness of that area, but they also echo the shapes of the windows higher up on the sides, with their rounded tops, as well as the now rounded arch of the massive doorway above the heads of the central figures. These repetitions help tie the composition together harmoniously. The result is a simpler, more powerful image — one that lets you see the story more clearly. The later print has been trimmed at the top (Rembrandt did this in the fourth state). Unnecessary space is thus deleted. The image, consequently, becomes even more concentrated.

We've looked at what Rembrandt removed from the earlier image. It's also interesting to see what he left unchanged. Two figures in the crowd are now more prominent. On the left, a young, elegantly dressed man plants himself in a swaggering pose. His gesture conveys amusement, if not derision. Across from him, on the right, an old man in plain robes strides forward energetically. His arms, clasped hands, and their shadow point, like his enraptured gaze, to Christ. These two men clarify for the viewer the ideological poles of the crowd, just as they are literally placed on opposite sides. They represent two possibilities. The center now empty, these figures implicitly raise a question in the mind of the viewer: on which side will you stand?

TWO PAINTERS PAINT THE SAME SUBJECT: *ESTHER BEFORE AHASUERUS* BY GUERCINO AND BY GENTILESCHI

We shall close this chapter with a comparison of two artists, contemporaries, each of whom did a version of the same subject. We have already taken a close look at Guercino's *Esther before Ahasuerus* (Fig. **5-1**). The popularity of the Esther theme probably had to do with its use as a Christian symbol: Esther appealing to the king was interpreted as representing Mary's role as intercessor with Christ. However, the subject must have held special meaning for the painter we shall look at next: Artemisia Gentileschi.

While still a teenager, Gentileschi was involved in a famous trial in which she charged her teacher, an assistant in her father's painting workshop, with rape.

During the trial she was required to submit to thumb-screw torture to deter-mine the truthfulness of her statements. Her work as an artist, and in particular her representations of women, could have been influenced, at least in part, by this experience.

Gentileschi worked in Rome, Florence, and later Naples, at a time when women painters were a rarity. Her letters convey the personality of an indepen-dent woman making her way in a world dominated by men. She was aware of her talents and proud of them. Many of Gentileschi's paintings are of female hero-ines of the Bible whose interactions with men were especially intense: Esther; Bathsheba, who was commanded to be unfaithful by King David; Susannah, who resisted the sexual advances of men who tried to blackmail her; Judith, the heroine who used her beauty to trap and kill Holofernes. Her frequent choice of subject suggests a very different way of thinking about women than we find in most European paintings of that, or any, time.

Most of the women who appear in Western art have been portrayed as beauti-ful but passive and compliant (at least, until recently). Their beauty was pre-sented for the pleasure of men, whether those men are placed in the painting with the women or were viewers of the painting (see, for example, Figs. 6-22 and 10-7). Gentileschi's women are beautiful too, but their beauty, like their charac-ter, is their own possession and not an adornment for others to admire. At least until the last decade of her career, when her women conformed more to prevail-ing tastes, Gentileschi's women defied being categorized as sex objects.

Gentileschi, whose *Esther* was completed about a decade or more before Guercino's, chooses the same dramatic moment in the story: Esther fainting as Ahasuerus reacts to her unexpected appearance (Fig. **5-13**). Gentileschi's

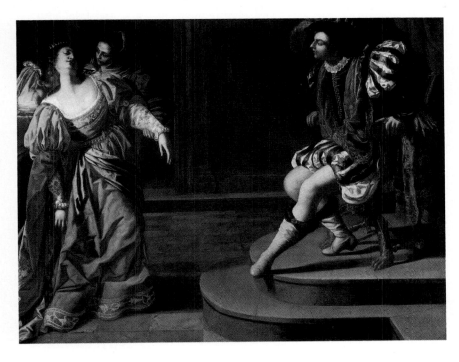

5-13
Artemisia Gentileschi, *Esther before Ahasuerus*, 1630s. Oil on canvas, 82½″ × 108″. The Metropolitan Museum of Art, New York. (Gift of Elinor Dortance Ingersoll, 69.281.)

version is much larger than Guercino's. In both paintings the figures are life size, but Gentileschi's figures are shown full length.

Guercino's drawings show his concern to establish the right relationship between Esther and Ahasuerus. You will recall that he had thought of positioning Esther higher than the king but later changed his mind. A recent x-ray examination of Gentileschi's painting, at the Metropolitan Museum of Art in New York, hints that Gentileschi had considered that possibility as well. The x-rays show that the platform of the throne has been overpainted. Depending on your reading of the original, the platform could have been smaller or lower. If lower, Esther would have been as high as the king or even higher, thus making Esther the dominant figure in the painting. Art historian Mary Garrard[1] suggests that a change may have been made at the request of the person who commissioned the painting.

The relationship between Esther and the king would certainly have been of major interest to Gentileschi. A recent study by Ward Bissell[2] suggests that this is the reason why Gentileschi based her painting on the apocryphal Book of Esther rather than on the Biblical account. The apocryphal version highlights the emotional states of the figures in the drama. The king's gesture with the scepter — characterized by Bissell as "an act and a symbol of authority" — is not mentioned in the Apocrypha, and it drops out of Gentileschi's version.

The psychological intensity of the personal relationship is unmitigated. It is Esther on one side, the king on the other. A dog that once sat at the base of the steps, attended by a page, has been painted out by Gentileschi. The void between the two figures becomes absolute. It speaks eloquently of the personal gaps between the two: gaps of gender, of roles, of intentions and needs, and of backgrounds.

We look now at Esther, then at the king. But even with the king higher in the picture than Esther, it is Esther who gets the most attention. She's a larger figure than the king — the reverse of Guercino. Guercino has a servant look at the scepter, but Gentileschi has all eyes turning to Esther, strengthening her position as a focal point.

In the Guercino, Esther is integrated with the servants, but Gentileschi submerges the servants in the shadows, so Esther dominates the group. The light around Esther's face and chest is brighter, and there is more of it, than falls on the king. Warmer colors gather around Esther. Her gown is a tawny yellow, set off by a bright, fresh blue. The king's colors, rose and green, are equally rich, but more subdued.

As he rises from his throne, the king's pose is elegant, but conventional; as she swoons, Esther's collapse is startling. Her gown is shown just beginning to crinkle.

We know, of course, how the story ends. Esther faints, but her personal strength in the end is greater than the king's. Guercino, painting at a time when conventional wisdom saw men as the authority, had to show his king wise and in control. Gentileschi had to show this too. But following her own instincts, Gentileschi found a way to show a woman who, even while passing out, was on her way to a triumph.

6
IMAGES AND ILLUSIONS

From the time of the Renaissance, Western painters achieved a breathtaking realism. They could conjure up space and fill it with solid objects; they could get light to shine out of faces and pour through windows, or reflect off goblets and globes; and they could create warm skin, cold armor, or the texture of a peach. We wonder: how did they do it? What are the secrets behind those dazzling sleights of hand? ¶ This chapter will investigate the traditional painting techniques that created that magic. We will also explore some of the schemes and devices artists have used to heighten the drama of those magical flights.

OIL PAINTING TECHNIQUES

The development of distinctive individual painting styles owes much to the rich possibilities inherent in the oil medium, which has been used in Western painting since the fifteenth century. Functioning essentially to bind the pigment, or color, to the canvas, oil is extremely versatile, permitting the artist a wide variety of painting techniques. Oil paint can be applied in thick strokes or thin, and accordingly can be made opaque or transparent. A transparent film of paint will tint whatever color lies beneath it. A paint film that is darker than the color below it is called a "glaze." Glazes create the effect of luminosity, as light reflecting from the underlying color literally shines through the darker film. Alternatively, a thick layer of paint will cover the underlying color completely, but the painter can let some of the underlying color show through by dragging the brush lightly over the surface and allowing the strokes to break in places. Because oil takes a while to dry, colors can be blended easily

right on the canvas, thus making it possible to achieve infinite gradations of color and shading. Paintings take on character from the techniques of brush and paint. Some painters prefer one approach exclusively, though many paintings are built up of combinations of paint application: thick, thin, opaque, transparent, direct, and blended.

Along with the paint, the brush itself has an effect on the image. Jan van Eyck used fine round brushes that were extremely soft in order to blend his colors smoothly. Like many painters, he took pains that the strokes not interfere with the illusion. El Greco, on the other hand, used broad, stiff brushes, whose bristles left visible marks (see Fig. **6-1**). El Greco's dashing, nervous strokes help energize his paintings by bringing the movement of the whole into the smallest detail.

The range of techniques inherent in the oil medium is still being explored. The paintings of Jackson Pollock (see Fig. 17-8) and Willem de Kooning (see Fig. 17-9) have carried the medium beyond anything seen before, and have revealed some of its surprising accidental effects. Artists like Anselm Kiefer (see Fig. 12-12) and Jennifer Bartlett (see Fig. 15-8) continue to experiment with paint application.

Until the nineteenth century, however, all paintings were developed by a fairly standard procedure, one calculated to best produce illusionistic effects. First the raw canvas was covered with a coating of glue to protect it from rotting.

6-1
El Greco,
Purification of the Temple, c. 1600–05.
Detail of Fig. 11-4.
Reproduced by courtesy of the Trustees, The National Gallery, London.

Then the drawing was applied. Drawings, when used, were transferred to the canvas by blocking out a grid of squares or rectangles on the drawing and again on the canvas. By drawing the corresponding lines in each space, the drawing was easily and accurately enlarged on the canvas (this method is called "squaring up"). Next, a thin layer of paint, the "ground," was applied, sometimes rubbed into the canvas with a cloth. Often, the ground was tinted a warm color, such as gray, brown, or clay-red. Care was taken that the drawing show through the toned ground. The artist would then block out the basic forms in monochrome, usually a brown color. The lightest areas would be picked out with a pure white. The colored ground served as a middle tone. Sometimes the middle tones, or half-tones, were developed in mosaic-like patches that were later blended together. Over this monochrome underpainting the artist would apply the colors. Opaque strokes were reserved for highlights and details, while glazes were applied where soft, luminous effects were desired. A final protective coat of varnish gave a uniform glossiness to the painting.

This procedure, while standard, was modified in various ways by painters interested in particular effects. Some, like Jan van Eyck (see Figs. 17-14 and cover), Raphael (see Fig. 4-7), and Leonardo da Vinci (see Fig. **6-2**) painted on white or very light grounds that lent themselves to bright, clear effects. Much later, in the seventeenth century, Rubens, in contrast to the general practice of his time, used a light ground in order to heighten the luster of his colors. Like Van Eyck, Raphael, and Leonardo, he applied his paints in extremely thin layers, like transparent veils. His *Crowning of St. Catherine* (Fig. 4-25) is filled with light because the white ground shines through those transparent colors.

6-2
Leonardo da Vinci, *Mona Lisa*, detail, c. 1503–05. Oil on canvas, approx. 30" × 21". Louvre, Paris.

These painters used glazes to produce the remarkable effects of soft, interior light and warm, glowing flesh. Frequently, many layers of glazes were used. Because the painter had to be sure the paint on the surface was dry before applying the glaze, the glazing process could take weeks and even months. The translucent shadows that give so much life to the face and hands of the *Mona Lisa* (Fig. 6-2) could only have been achieved by repeated applications of glazes.

In the sixteenth century, Venetian painters like Titian

and Tintoretto (see Fig. 18-9) used loose, visible strokes of paint, which tended to energize their images while softening the edges of forms. In the seventeenth century, Rubens, Rembrandt, Hals, and Velázquez furthered the development of vigorous brush techniques.

Like other painters of his day, Rembrandt prepared a ground toned with a warm, medium brown. Then he blocked out his underpainting using shades of gray, working without a drawing. Rembrandt frequently applied the paint in thick, opaque layers, called "impastos." At times, broad strokes simplified the form by rendering it in simple, solid planes, as in the hand of *Hendrickje Bathing in a Stream* (Fig. 17-2). Rembrandt also used glazes for the deep, lustrous pupil of an eye, or to create the effect of radiant skin. For the illusion of lace or jewelry, he built up mounds of pure white paint, and then glazed over them with a warm tone so they would seem to glow. Occasionally, Rembrandt also scraped into the thick paint with the handle of his brush to produce the texture of jewelry.

Because a "toned ground" supplies the middle value to the underpainting, it enables the painter to achieve a solid effect quickly and easily. In addition, it helps unify the painting and gives warmth to the color. Frans Hals (see Fig. **6-3**)

6-3
Frans Hals, *The Gypsy Girl*, c. 1628. Oil on canvas, 23″ × 20½″. Louvre, Paris.

and Diego Velázquez (see Figs. 6-12 and 6-13) used toned grounds, and, instead of glazing, built up their paintings using impastos. Like Rembrandt, they explored the effect of letting distinct strokes and colors of paint coalesce in the eye of the viewer to produce the illusion of the object. This technique departs from the more literal representations of earlier artists like Van Eyck, Raphael, and Leonardo (see Figs. 17-14, 4-7 and 6-2) and prefigures Impressionism (see Fig. 17-5). Up close, Hals's and Velázquez's loose, dashing brushstrokes create lively surfaces. Velázquez gives us a masterful display of illusionism, as opaque blobs and strokes, applied in almost abstract touches and rhythms over thin, blended washes of paint merge in the eye to create the object when viewed from a distance. Hals's direct and vivacious strokes give you the feeling that a moving figure has been caught in an instant of time. Compare Hals's *Gypsy Girl* (Fig. 6-3) with the more poised, stable figures of Van Eyck (see Fig. 17-14) or Leonardo (see Fig. 6-2).

Fragonard's *Blind Man's Buff* (see Fig. 13-2) was built up of thin layers on a brown ground. Toward the end, Fragonard applied heavier paint in deft, self-contained touches to objects in the foreground. These strokes enrich the surface, and invite the eye to linger on such details as flowers, folds of cloth, the old, worn, wooden gate, and the copper pot. At the same time, the thick dabs help to bring the foreground objects closer by distinguishing them from the more thinly painted background. The heavy paint makes these objects seem more touch-

6-4
Jan Vermeer,
A Painter in His Studio,
c. 1666. Detail.
Kunsthistorisches
Museum, Vienna.

able, and thus increases the illusion of their solidity. The blue ribbon around the woman's neck, for example, is thickly painted, and stands out slightly. Thick, white paint dabbed along the nearer rim of the copper pot pulls it forward in space and gives the illusion of light reflecting off the surface. Seventeenth-century Dutch still-life painters were similarly fond of using spots of opaque white to show light reflecting off shiny objects such as glass, jewelry, and metal. Vermeer refined this technique for his interiors by applying opaque white in minute dots to give an iridescence to objects that catch the light (Fig. **6-4**).

In the nineteenth century, artists revived the use of the white ground. One of the first was the English painter J.M.W. Turner (Fig. **6-5**). Turner was

6-5
Joseph Mallord William
Turner, *The Campo
Santo, Venice*, 1842.
Oil on canvas, 24½″ ×
36½″. The Toledo
Museum of Art. (Gift
of Edward Drummond
Libbey.)

trained in the watercolor technique, where the transparent strokes automatically depend on the white paper for luminosity. His landscapes are amazingly bright, thanks to the white ground that comes through the thin, overlying layers of paint to create an illusion of natural light radiating out of the canvas. Instead of the monochrome underpainting, Turner used colors from the start, and this, too, contributed to the richness of his paintings.

Monet was particularly interested in depicting the changing sensations of light and atmosphere (see Fig. 17-5). Nevertheless, he built up his images by underpainting. He used a pale, tinted ground over which he laid thin washes of color in broad areas. Then he proceeded to apply small dabs of opaque paint, keeping the strokes distinct, so that when viewed from a distance the colors would mix together in the eye to create a sparkling effect. At times the color of the first washes would show through between the thicker strokes and help tie the area together (a technique used later by Matisse). While Monet painted directly into wet paint, he also exploited the effect of dragging fairly stiff paint over a rough, dry surface and letting the color break (see Fig. 18-16). This too produced a sparkling effect. Monet worked out of doors with the subject before him, setting the canvas aside for another time when the light effects had changed. Though he often completed his paintings in the comfort and steady light of the studio, he was able to achieve what he called "instantaneity"—a fleeting moment captured on the canvas.

While Monet devoted himself to painting reality as he saw it, his paintings moved, paradoxically, toward abstraction. As solid forms dissolved in the light, details disappeared and space flattened. Colors brightened and, perhaps most dramatic of all, the brushstrokes called attention to themselves and seemed almost to take over the image. This new independence of paint from the subject

inspired later painters who, carrying these formal interests even further, developed the abstract art that has dominated the twentieth century.

Of course, realist painting never disappeared; in fact it is currently thriving. Figurative painters today are highly conscious of the formal investigations of abstract artists. Some share abstraction's interest in form, but explore it in terms of the image. Fascinated by the phenomenon of illusion itself, many build their paintings in a way that makes the viewer keenly aware of the magic of illusion. Some work on a large scale. The image, when seen up close may dissolve into abstract shapes and colors.

Richard Estes uses photographs as a basis for his paintings but rearranges the parts to suit the composition. He underpaints in monochrome tones, which gives a dusky quality to his colors when seen up close. Careful adjustments of the values of the colors — how light or dark they are — create the effect of a clear outdoor light in the painting when viewed from a distance.

In Estes's paintings, the discrepancy between near and distant views is striking. Approaching *Helene's Florist* (Fig. **6-6**) we can see the almost photographic image breaking down into a mosaic of flat patches of opaque color. Up close (Fig. **6-7**), we see less blending of colors than you would expect; details have a crisp, abstract quality, and we discover in them a surprisingly wide range of color.

Neil Welliver works on a small scale with the subject before him, and then uses those paintings as a basis for large-scale paintings done in his studio. He makes a large drawing on paper, transfers it to the white canvas, and paints in sections from the top down. The scale of the paintings and the amazing details draw us into the scene. You can't miss the brushstrokes in Welliver's landscapes: they are thick and juicy, multilayered, springing with energy, and seem to be as

6-6
Richard Estes, *Helene's Florist*, 1971. Oil on canvas, 48″ × 72″. The Toledo Museum of Art.

6-7
Richard Estes, detail of
Helene's Florist, 1971.
The Toledo Museum of
Art. (Gift of Edward
Drummond Libbey.)

6-8
Neil Welliver, *Late
Light*, 1978. Oil on
canvas, 96″ × 96″.
Detail. Extended loan
to the Rose Art
Museum, Brandeis
University, Waltham,
Massachusetts. (The
Herbert W. Plimpton
Foundation.)

full of life as the trees, rocks, waters, and skies of Maine that they depict (Fig. **6-8**). Welliver makes us aware not only of the life that is out there, but of the life that is in the paint as well.

VISUAL DEVICES AND OPTICAL EFFECTS

These are some of the painting techniques used to create the illusions we see in oil paintings. Along with these techniques, painters developed a number of visual devices to heighten the impact of these illusions. Fifteenth-century Flemish painters, for whom extremely fine detail was a tradition, occasionally reached for *trompe l'oeil* ("fool the eye") effects. In Jan van Eyck's *Angel of the Annunciation* (Fig. **6-9**), the wings of an imagined statue appear to overlap the painted frame and to cast a shadow on it.

The background, painted to look like dark marble, appears to reflect the back of the statue. Thus the statue appears to exist in real space. In a painting by Hans Memling, a man sits with a book before him. His elbow and the clasp of the book, painted onto the real frame, appear to extend out of the confines of the painting and into our world. Petrus Christus completed his portrait of a Carthusian monk by adding a painted wooden frame with a life-size fly walking on it. These and similar effects were repeated by other artists.

Foreshortening is an optical effect intended to overcome the flatness of the picture surface. When an arm reaches toward the viewer from the canvas (as in Caravaggio's *Supper at Emmaus*, Fig. **6-10**), it is more exciting than it would be if the arm went sideways, or parallel to the plane of the canvas. This is because the foreshortened arm seems to penetrate space more explicitly. It makes you really

6-9
Jan van Eyck, *Angel of the Annunciation*, c. 1416–20. Oil on panel, 15⅗" × 9⅗". Thyssen-Bornemisza Collection, Lugano, Switzerland.

6-10
Caravaggio, *Supper at Emmaus*, *c.* 1600. Oil on canvas, 55" × 77". Reproduced by courtesy of the Trustees, The National Gallery, London.

feel the space. In a similar way, three-dimensional movies of the 1950s would occasionally have some object (such as a spider) zoom right out at you from the screen. These were, needless to say, the moments that everybody waited for.

A frequent device of still-life painters is to project an elongated object toward the viewer. Sometimes, like the scallion in Chardin's tiny *Still Life* (Fig. **6-11**), it extends forward from the nearest edge of the table. The foreshortened object

6-11
Jean Simeon Chardin, *Still Life*, *c.* 1732. Oil on canvas, 6⅝" × 8¼". Courtesy of Detroit Institute of Arts. (Bequest of Robert H. Tannahill.)

tends to mitigate the barrier between the painted world and our own. Similarly, in Rembrandt's *Night Watch* (Fig. 2-1), the extended left hand of the central figure connects the painted world to our own. Standing in front of the life-size figure, you feel as if you could shake hands with him.

In another visual effect the barrier is emphasized rather than minimized. A large object, called a *repoussoir*, is placed in the foreground, usually to one side, and the viewer looks past it into the scene. The *repoussoir* acts as a frame within the picture. This effect intensifies our awareness of the recession of space. In Church's *Parthenon* (Fig. 4-2), the column on the right acts as a *repoussoir*. In Vermeer's *A Painter in His Studio* (Fig. 11-31), the *repoussoir* is the curtain.

When the *repoussoir* is placed nearer the center of a painting, the effect can be dramatic. In *The Surrender of Breda* (Figs. **6-12** and **6-13**), Velázquez has you look at a large part of the landscape through screens of pikes and lances. Even more striking is the very center of the painting, where the extended arm, the hand, and the keys frame a view of soldiers in the distance. A similar situation appears in Delacroix's *Massacre at Chios* (Figs. 17-3 and 18-14) where the horse's leg and the rifle barrel frame a view of the landscape. These areas take on a dreamlike, irrational quality, as space both shrinks and expands, bringing together near and far, large and small, distinct and hazy.

Velázquez and Delacroix create optically correct effects by focusing on foreground figures and blurring what's in the distance. Likewise, in Velázquez's *Las Meninas* (Fig. 1-1), the dog in the foreground and the figures reflected in the

6-12 (above)
Diego Velázquez, *The Surrender of Breda*, detail.

6-13 (left)
Diego Velázquez, *The Surrender of Breda*, 1634–35. Oil on canvas, 10′1″ × 12′. Museo del Prado, Madrid.

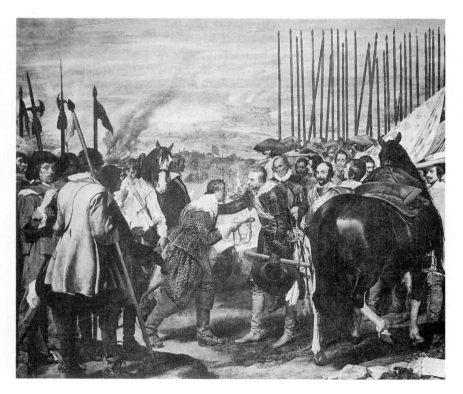

6-14
Jan van Eyck,
*Madonna with
Chancellor Nicolas
Rolin, c.* 1433.
Panel, 26″ × 24⅜″.
Louvre, Paris.

distant mirror are slightly blurred—just as they would be if we were standing in the room looking at the little princess. Much earlier, Jan van Eyck produced a magical realism through a precise rendering of every detail, whether near or far. This effect can be seen in *The Madonna and Chancellor Rolin* (Fig. **6-14**), an imagined religious scene. Here, foreground and extreme distance, brought together in the center, are painted in equal detail—an effect possible only in a painting.

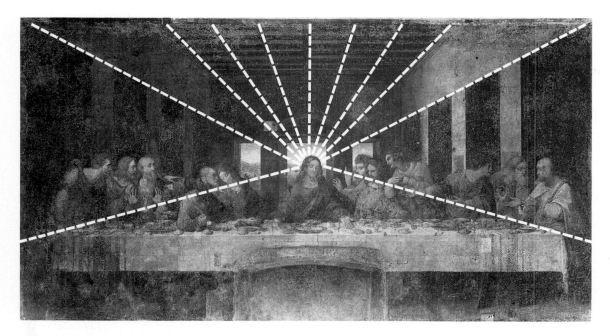

6-15
Leonardo da Vinci, *The Last Supper*, 1495–98. Fresco, 15¼' × 29¼'. Santa Maria delle Grazie, Milan.

Van Eyck is aware that painted images can make us see what is not truly there; indeed, they make us see more than the eye can see. He underscores this phenomenon by placing two chums on the bridge, the taller of whom might well be the artist himself. These fellows peer over the wall, and quietly encourage the viewer to share in multiple pleasures: the delightful view, and the power of illusion.

In *Night Watch* (Fig. 2-1), Rembrandt uses the silhouettes of a gun stock and a leg to heighten the drama while making us experience the recession of space. Placing darks over lights and also lights over darks in the same picture was a favorite device of Dutch artists in the seventeenth century. These overlaps helped them achieve rich visual effects while also producing a strong illusion of receding space. Rembrandt used it frequently (see also his etching *St. Jerome Reading in an Italian Landscape*, Fig. 15-3).

A fascination with space and the determination to represent it convincingly is a persistent feature of Western art. The foreshortening of the figure in painting began in ancient Greece. Greek and Roman artists developed systems of perspective so that space would appear in a believable way. In the Renaissance, the formulation of linear perspective gave artists a tool to create spaces that were overwhelmingly convincing to the eye. In this mathematically-based system, parallel lines that recede into the distance are made to converge, eventually meeting at a single point on the horizon. (see Fig. **6-15**). Every part of the painting is thus organized into a unified, consistent, even measurable, space; a space that seems to extend naturally from our own space, much like a stage or a window.

Piero della Francesca's *The Flagellation* (Fig. **6-16**) takes some risks to create a particular experience. The startling contrast in the sizes of the figures catches us by surprise and at first seems wrong. But the carefully delineated patterns of

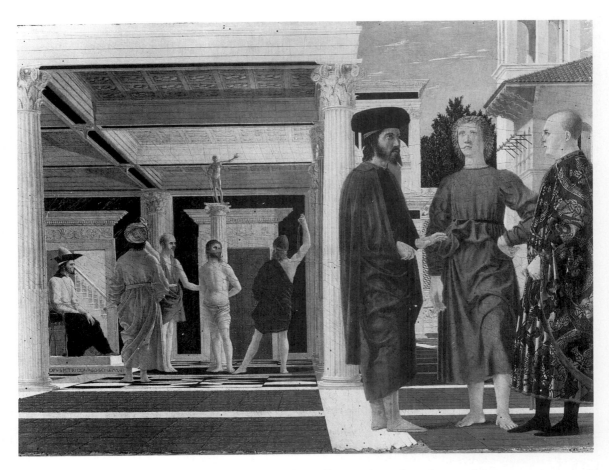

6-16
Piero della Francesca,
The Flagellation, c.
1459. Panel, 23¼″ ×
32″. Palazzo Ducale,
Urbino.

the floor tiles as well as the coffers on the ceiling show us that we are in a rational space. Piero creates a disquieting feeling because the unexpected occurs in the context of an orderly space. The apparent disruption of space, which distances the three foreground figures from the impending torture of Christ, conveys to the viewer a tragic disconnection of feeling.

Renaissance artists competed with one another to demonstrate their mastery of perspective. While many of them multiplied details such as complicated tile patterns or architectural fantasies, Leonardo kept his mural of *The Last Supper* (Fig. 6-15) restrained. Perspective dissolves the wall, connects the space of the scene with our own, and places the viewer directly before Christ.

A number of Renaissance artists, like Leonardo, created murals that aimed at tricking the eye into seeing spaces that were not really there. By adjusting their paintings to existing architectural features, and sometimes even incorporating those features into their paintings, artists created a painted architecture that magically extended the room.

In Mantegna's ceiling of the Camera degli Sposi (Fig. **6-17**); the first painted dome in the Renaissance, cupids and smiling women, perhaps portraits of servants, peer over a painted balustrade into the space of an actual bridal chamber.

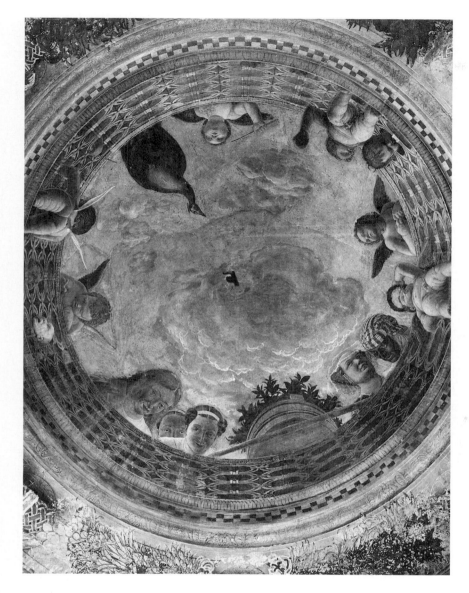

6-17
Andrea Mantegna,
ceiling of the Camera
degli Sposi, 1474.
Fresco. Ducal Palace,
Mantua.

The newly married couple is teased by one cupid who threatens to drop an apple onto their bed and by a tub of flowers precariously supported by a pole.

In a room in the Villa Farnesina (Fig. **6-18**), a mural surrounds the viewer. Painted columns and terraces create a floor to ceiling illusion that opens onto a painted landscape that corresponds to the actual landscape outside. Included in the painted landscape is a distant view of Rome exactly as the city would appear from the balcony.

In seventeenth-century Europe a number of churches were populated by companies of heavenly figures that appear to burst through the ceiling and descend into the space of the church itself (Fig. **6-19**). Painting, sculpture,

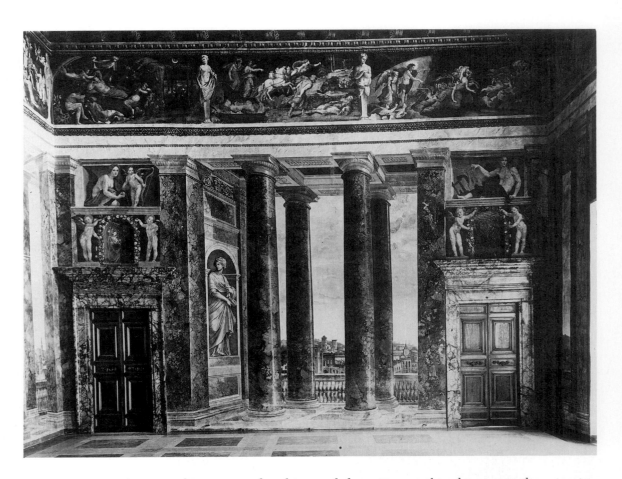

6-18
Baldassare Peruzzi,
Sala della Prospettive,
c. 1515. Wall fresco,
Villa Farnese, Rome.

architecture, and architectural decoration combined to create these inspirational visions. Painted angels and sculptured angels and illusionistic as well as real architecture are integrated so carefully that it is impossible to tell where the one stops and the other begins. The usual clues delimiting works of art are absent: no frames, no pedestals, no signatures. The boundaries between object and viewer have evaporated. In these Baroque spaces, we experience the power of illusionism at its most grandiose.

The interplay of reality and illusion is consumately realized in Velázquez's masterpiece, *Las Meninas* (Fig. 1-1). In this charmed space, Velázquez brings together free-standing figures, a figure framed in a doorway as if in a painting, figures in paintings hanging on a wall, and figures reflected in a mirror. The painting hints that all these levels of reality might themselves be a reflection in a mirror into which the painter gazes — and spies the subjects of this painting. To pique our curiosity further, the painter has included the back of a gigantic canvas on which he is at work. But who is the subject? Is it the king and queen, whose reflections we see in the mirror? Is it the princess? Or is the painter at work on the painting that we see?

Is this tantalizing play of illusions merely a subplot to the domestic scene, or is it the other way round? Whatever your answer, it is clear that Velázquez cre-

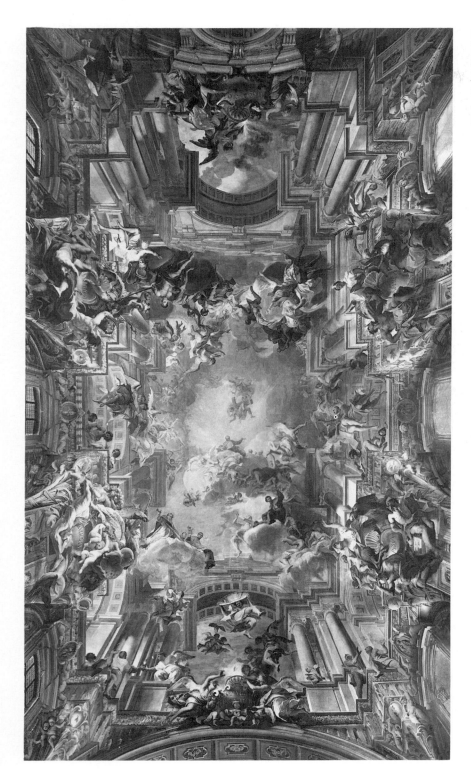

6-19
Fra Andrea Pozzo, *The Glorification of St. Ignatius*, 1691–94. Ceiling fresco in the nave of Sant'Ignazio, Rome.

6-20
John Peto, *Office Board*, 1885. Oil on canvas, 24⅜″ × 19⅞″. The Metropolitan Museum of Art. (George A. Hearn Fund, 1955.)

ates meaning by fusing reality and illusion. These sundry individuals — royalty, servants, painter, and pet — have been caught like a snapshot, seemingly unposed, in a moment scooped out of the flow of time. The king and queen are there; the little princess, heiress to the throne, stands calmly at the center. But it is the painter, shadowy and forceful, who presides over this scene, fully aware that it is through the power of his brush alone that their images are forever preserved.

Trompe l'oeil paintings were popular in seventeenth-century Holland and in the United States in the late nineteenth century. They were painted for the pleasure of illusion. *Trompe l'oeil* paintings were basically still lifes painted life size in painstaking detail with no trace of the brushstrokes. In a format popular in the United States in the late nineteenth century, bits and pieces of paper and other odds and ends were painted as though tacked to a board or placed just in front of it (see Fig. **6-20**). Because of the flatness of the objects, you have to stand close to the painting to see that they are painted and not real.

6-21
M. C. Escher, *Relativity*,
1953. Lithograph,
10¾″ × 11½″.
National Gallery of
Art, Washington, D.C.

Closer to today, the lithographs of M. C. Escher create illusions of impossible spaces (see Fig. **6-21**). Escher's scrupulously realistic style fools the mind into believing those spaces could exist in reality. In showing us that things are not always as they seem, Escher's prints make us aware of our tendency to confuse illusion with reality. Thus in their own delightful way they remind us gently of our human fallibility. It is just this fallibility, of course, that allows us to get involved in what we see. But it is our willingness to laugh at ourselves that allows us to enjoy it.

SENSATIONALISM

A number of artists exploited their subject matter to beckon the viewer through the magic window of realistic painting. They realized that a good story with interesting characters could help get you involved and keep you there. Before the existence of movies and television, billboard-size paintings, loaded with detail and often with casts of thousands, provided wide-screen entertainment to the public. The entertainment value of paintings was often enhanced by subject matter that was violent or erotic. Religious paintings were often pretexts for gory scenes depicted in meticulous detail, while paintings set in ancient Greece or Rome showed gorgeous women in various degrees of undress, with more than historical appeal for the viewer (see, for example, Fig. **6-22**). Many artists played up the sensational aspects of their art, just as many movies do today, to make them more appealing. Thrills, danger, sex, and suspense weren't invented in Hollywood.

Years ago, huge paintings were hauled across the United States and exhibited at fairs to crowds eager to absorb their complex dramas and scenes of foreign lands. Films today provide similar public entertainment. Early filmmakers quickiy learned to exploit the heightened realism of moving pictures. In 1896, the Lumière brothers in France placed their camera on the platform alongside a railroad track and filmed a train approaching. When their film was projected for the first time, on a tablecloth strung up in a cafe, people reportedly ducked under their tables or rushed to the exit at the sight of the oncoming train. Years later, three-dimensional films had a similar effect on audiences. Like many of those traveling paintings, many films we see are not, by themselves, the stuff of great art. They carry no serious messages. But however trivial they may be when compared to films with serious content, they serve a useful purpose. They give us a means of escape, and relieve the tedious inevitability of things as they are.

IMAGE AND MATERIAL

Images are shaped and affected by the material that gives them life. At the same time, the material is brought to life and given significance by the images. In a painting, the images come out of paint and are thus subject to whatever paint itself can say and do. Likewise, a figure carved in wood will carry in it something that speaks of wood. Old-time Hollywood glamour was bound up with sparkling images on the silver screen.

We may distinguish image from material for convenience in discussion and for the sake of formal analysis or historical research. But our awareness that material and image in works of art are, indeed, inseparable keeps us open to the appreciation of what we see. The techniques and devices that we have discussed in this chapter demonstrate the unique reciprocity of material and image that is at the heart of every work of art and the source of the spell it casts upon us.

6-22
William Bouguereau,
Nymphs and Satyr,
1873. Oil on canvas,
102⅜″ × 70⅞″.
Sterling and Francine
Clark Art Institute,
Williamstown,
Massachusetts.

7

FEELING OUR WAY INTO ARCHITECTURE AND SCULPTURE

The drama of a building or sculpture is played out in solid forms that share our space. Consequently, buildings and sculptures awaken reactions often far less contemplative and detached than reactions to a painting. Because we are linked physically to buildings and sculptures, our reactions become participatory. ¶ Certain buildings and sculptures seem to possess a power that transcends their form and materials. The Lincoln Memorial with its statue of Lincoln; the Capitol Building in Washington, D.C.; St. Peter's in Rome; the cathedral of Notre Dame in Paris; Michelangelo's *David*; or the Statue of Liberty are more than just works of art we admire esthetically: they are foci of shared histories, themes, and ideas. Buildings and statues like these act as magnets, becoming gathering places where the history of a people continues to unfold. They become identified with a place, and symbolize it. Great buildings and sculptures shape and enlarge human experience. ¶ But plain old buildings and sculptures do that, too. The local baseball stadium, a Civil War monument, a favorite hangout, or the place you call home are also places that shape and enlarge experience. A good way to feel your way into our subject, then, is simply to look around you and notice what you see. ¶ On the way to work I drive along a block on the edge of town that has some unusual buildings. Six are in a style reminiscent of American Colonial architecture, with white columns and an occasional cupola; one is a Victorian mansion with a mansard roof and shingle siding; one looks like a saloon from the days of the Wild West. Just beyond them in the next block is a building whose stucco walls, tile roof, and round arches marked out in bricks give it a Medieval

Spanish look. Five of these buildings are restaurants, three are office buildings, and one is a funeral home. Most were built within the last ten years. You've probably seen buildings like these where you live. Probably none of them are examples of great architecture, but they do illustrate something that architecture is supposed to do, and that is make us feel good. Why we feel good in being reminded of the past as we eat, drink, work, or go about our other daily activities is a good question. What do you think?

Whatever the reasons, it seems to me that apart from their references to the past, the architecture of these buildings is bland and uninteresting. If you compare these buildings to the originals—to the public and domestic architecture from which they were more or less freely copied—you will likely find that the originals were more handsome, better proportioned, and more ingeniously designed.

THE CHARACTER OF BUILDINGS AND CITIES

A building can have an *intrinsic* quality that makes it appealing, whether or not it reminds us of other buildings. That quality has to do with its overall appearance and presence, which is something we feel, or sense, as well as take in with our eyes. Buildings have personality or character, much as do people. It's easy to sense that character when we look at, say, an old barn, a Gothic cathedral (Fig. **7-1**), or the Capitol Building in Washington, D.C. (see Fig. 10-17).

Even the buildings on my way to work have character, though it is, I believe, thin and contrived. Less distinctive buildings are more difficult for us to respond to. We may feel that they lack something. But they may be worth thinking about anyway, particularly because so much of what surrounds us and what we live in seems dull and nondescript. Dull it may be, but just how nondescript it is may depend on how carefully we look at it.

About a thousand years ago Chinese artists were fond of describing mountains as proud, humble, serene, majestic, austere, and so on, and it seems to me that we can think of the character of buildings in similar terms. Buildings are made for people, and they can act like people. A friendly house reaches out to you with a porch or a path. A house with small windows and a heavy door, set back from the sidewalk, remains aloof. A house can seem formal, especially if it's symmetrical, or suggest informality and fun by parts and pieces stuck here and there. Think of the kind of house you would like to live in. Its character will reflect your character.

Buildings inevitably express some idea or concept. A barn is protective, earthy, mothering. A Gothic cathedral lifts our thoughts. The Capitol Building evokes with dignity the tradition of democracy and its origins in classical antiquity. Consider the public buildings where you live: the libraries, restaurants, houses of worship, schools, museums, stores, and banks. How do they show you

7-1
Robert de Luzarches,
Amiens Cathedral, west
facade, c. 1220–1288.

what they are used for? What impression do they try to make on you? What associations do you make when you look at them?

What is the feel of your neighborhood? What does it reflect about the values of the community? What does it reflect about *your* values?

Buildings and architectural environments reflect more than technical necessity and practical considerations. Historically, architectural forms have been rooted in the human need to belong and to feel connected. In various places

around the world, dwelling places were invested with religious meanings that linked the inhabitants to the cosmos. Religious structures and ceremonial sites were oriented to sacred places in the landscape, to heavenly bodies, or to cardinal points on the compass. Town plans conformed to diagrams of the universe. In the Renaissance, plans formulated for the Ideal City attempted to connect human experience to a higher, more rational order of being.

[Living in a square house] is a bad way

to live, for there can be no power in a square. You have noticed that

everything an Indian does is in a circle, and that is because the Power of the

Word always works in circles, and everything tries to be round. . . . The life

of a man is a circle from childhood to childhood and so it is in everything

where power moves. Our tepees were round like the nests of birds, and these

were always set in a circle, the nation's hoop, a nest of many nests, where

the Great Spirit meant for us to hatch our children.

—Black Elk, from his autobiography, *Black Elk Speaks*,[1] dictated 1930–31

The small size and compact arrangement of towns and villages fostered a sense of community. Central spaces were devoted to public use. To this day, town and city centers around the world—open spaces known variously as the plaza, the piazza, the center, the Great Market, the campus, the common, the square, or the village green—draw people together for shared experiences, religious, secular, or social. These centers give the place coherence and identity, and nourish and celebrate community and continuity.

What is the character of the modern city? Cities have always been theaters of competing aims. Cities today make visible the stresses of social change and conflict. Not always committed to the common good, at best uncertain as to how to achieve it, cities have become fragmented and fatigued. Once-vital civic centers are replaced by shopping strips and "centers" at the fringes, incapable of generating the rich mix of people and activities familiar within the old centers. Alienation is a modern term (perhaps it is a modern experience), and it is reflected in modern urban environments. It is also fostered by those environments. Human impulses remain, and the need to belong and to feel connected is with us still—but will cities regain their capacity to brighten and civilize human experience?

COMPONENTS OF ARCHITECTURE

To get an idea of how individual buildings "work" on us—affect how we feel—we need to look at them closely. To do this, we can separate a building into its essential characteristics, or components,

7-2
Ictinos and Callicrates,
the Parthenon, view
from the west,
Acropolis, Athens,
448–432 B.C.

much as we divided paintings into their formal elements. Investigating these components is the best way to strengthen our grasp of what the building is saying to us.

Site

Notice the site — where and how a building is placed and what's around it. Does the building blend in with its surrounding or does it want to stand apart? Is the building close to the street or set back? Does it have much space around it? How is it landscaped? Does the building seem to integrate with nature or contrast with it? How important is the site? What does it contribute to your sense of the building?

The Parthenon, dedicated to the goddess Athena, was placed on a site crowning the city named for her (Fig. 7-2). The geometrical forms of the building contrast with the flowing contours of landscape and clouds, presenting the

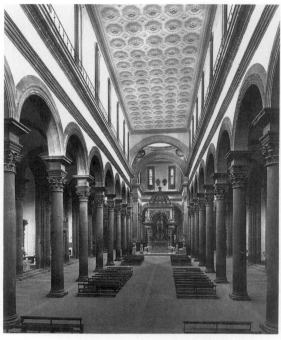

7-3 (left) Notre Dame Cathedral, east end and part of the nave, Paris, begun *c.* 1180; modified 1225–1250.

7-4 (right) Filippo Brunelleschi, Santo Spirito, interior, nave, Florence, begun 1436.

image of an entity that is separate, self-contained, and distinct. Yet it is always seen with reference to the natural world that surrounds it, and a kind of balance between the two is reached. The Gothic cathedrals, on the other hand (for example, Amiens Cathedral, Fig. 7-1), were built among the densely packed houses in the centers of Medieval towns. Immense in size, they dwarfed their surroundings. The Medieval cathedrals were images of the Church itself, which was both authority and protector, a dominating presence in every aspect of social and private life.

Space

A building is fundamentally a space to be in, so it makes sense to be aware of those spaces and how they affect us. Space has a push and pull to it, more felt than seen. A large indoor space can make us feel small at first, but when we adjust it will give a sense of grandeur and importance to us and to what we do in it. Human activity is magnified in the vast spaces created for the pageants of the Church or Court. By contrast, the nooks and crannies of a house can be just the place to withdraw into for a quiet talk or for reflection. In the Cathedral of Notre Dame the space, while unified, is complex and infinitely subdivided (Fig. **7-3**). In Brunelleschi's Santo Spirito the space is simpler and more precisely defined, and our orientation to the other parts of the building is more explicit (Fig. **7-4**). In Notre Dame, space seems immeasurable and tends to draw us upward, while the space in Santo Spirito seems more finite and contained, and makes us feel part of a clear and orderly world.

Space is defined by wall and ceiling. Walls give us an idea of the massiveness of the building—how thick, solid, and heavy it feels. Is the wall a smooth, closed plane, or is it perforated by windows, arches, or other openings? How much of the wall is open? How much is closed? How does the wall join the ceiling?

Light

Almost inseparable from our experience of space in architecture is our experience of light. In a Gothic cathedral, light is diffused, softened, and warmed in places by windows of stained glass. Around the building and high up, under the vaults, the light dims into shadow. Brunelleschi's light is bright, even, and clear throughout. What mood is created by the light in Notre Dame? In Santo Spirito? Think of places you know where the light promotes certain feelings. Is that light bright? Soft? Warm? Is it even throughout, or varied?

Decoration

How is a building decorated? Is it ornate? Sparingly decorated? Or is there no ornament at all? Is the decoration integrated into the design of the building or does it seem stuck on? Does it make you more aware of the structure of the building or does it disguise it? Why was that decoration chosen?

I've noticed that in those buildings on the way to work the exterior ornament is important. It gives the buildings identity, as do their signs; and it gives them personality. However, in visual terms the decoration seems contrived and forced. By contrast, in the Parthenon (Fig. 7-2), or on the facade of Amiens Cathedral (Fig. 7-1), the decoration integrates with the building, and seems inevitable.

Materials

The character of materials—the warmth of wood, the roughness of poured concrete, the elegance of marble, the earthiness of mud or adobe—also affect our response. A good building puts good materials to work and lets you feel and enjoy them. See how glass works on you in the rose window at Notre Dame (Fig. 7-5), or in the East Wing of the National Gallery (Fig. 7-6). Compare the rich, dense texture of the stone facade of Amiens Cathedral with the more simple marble forms of the Parthenon, or with the spare surfaces inside the National Gallery's East Wing.

You say to brick, "What do you want,

brick?" Brick says to you, "I like an arch."

—Louis Kahn, architect, 1973

7-5
North rose window,
c. 1250, Notre Dame,
Paris.

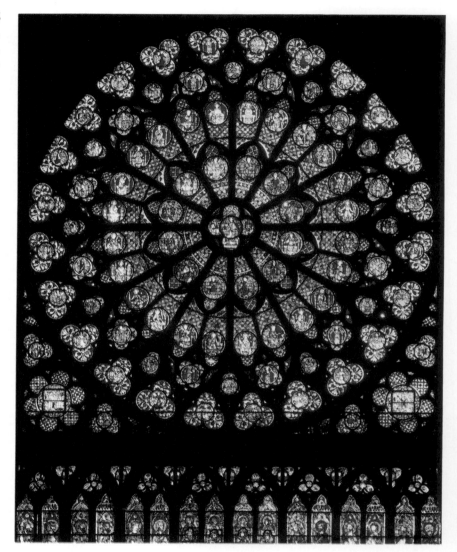

Color

Have you ever changed the color of a room and noticed how different it felt? Color affects the feel of a place. The interiors of certain mosques, shimmering with the rich and varied colors of tiles, transport the worshipper into another world. By contrast, the interiors of early Puritan churches in New England were painted gray. Rooms painted entirely in pink are used to calm prisoners in police stations. The sculptural decoration of ancient Greek temples asserted themselves through bright colors which contrasted with the gleaming, white marble.

Look at the houses in your neighborhood. Are they painted alike? Is color used to differentiate between them? Is color used to make a building stand out

7-6
I. M. Pei, East Wing of
the National Gallery
of Art, Washington,
D.C., 1978. Mobile by
Alexander Calder.

or blend in with the surroundings? What accounts for the popularity of certain
colors? What messages can colors carry? As an example, why does McDonald's
have yellow arches? Why are they called "golden"?

Rhythm

Look down a street in your neighborhood or downtown and see if you can sense
a rhythm to the buildings. A rhythm can be created by the repetition of windows,
driveways, fences, porches or stoops, street lights, or even garbage cans. Where
the rhythms are monotonous — where all the houses look alike — you may find
yourself wishing there were some variety. Notice, too, how rhythm is established

in a single house or a large building. Generally, the more regular the beat, the more formal the building will appear. As in music, rhythms can be felt as fast or slow, spritely or stately, complex or simple. How does rhythm affect the character of the Parthenon? The Capitol Building? The interior of Santo Spirito? Or the interior of Notre Dame Cathedral?

Distinctive Features

7-7
Ictinos and Callicrates,
the Parthenon,
Acropolis, Athens,
448–432 B.C.

These are some of the usual components of architecture. Along with them, innumerable distinctive and individual details also may contribute to its character. Look around your home, or your room. What do you notice? What combinations of things look appealing? What room seems to be the center of your home? What seems to be at the heart of the room? A fireplace? A chair? A table? A television set? A window? How does that room, its details and its focal point, reflect your interests and values or those of your family?

In this detail of the Parthenon (Fig. 7-7) showing the columns thrusting against the entablature, you will see forms that are spare, clean-cut, and orderly. The intersection is an image of energy, where opposing forces are engaged and resolved. A lighter, more sprightly effect is created by the columns and their arches in Santo Spirito (Fig. 7-4), as if surges of energy springing upward triumphed over the force of gravity. When I visited Santo Spirito, I felt that its forms expressed a sense of optimism (this is not a precise term, but I am talking about my reaction, and not about a measurable architectural element).

Both the Parthenon and Santo Spirito are based on an esthetic idea that calls for the clear separation of the parts. Something altogether different occurs in a Gothic cathedral, where parts blend organically in the way that a tree branches or flowing water divides. The rose window from Notre Dame Cathedral (Fig. 7-5) incorporates this esthetic idea. In the rose window we do not experience opposing forces, but rather we feel a sense of reconciliation, as the myriad elements are brought into a total scheme. The circle floats on the dark wall, as if unbounded in space or time. Without base or sides or top, it refers inward toward its own center, its circles within circles symbolically moving toward infinity. Its character, like the light it emits, is immaterial and

spiritual, in contrast to the more physical forces articulated by the Parthenon and by Santo Spirito.

Buildings act on us for the time we experience them. As we move into and through them, they can change us, change how we feel and how we behave. Of course, we affect architecture as well. Buildings reflect who and what we are. Architecture is an art form that is necessary to human survival. It is the place where human dreams and physical realities come to terms.

THE CHARACTER OF SCULPTURE

Sculpture, like architecture, takes up space, and therefore exists in a very real sense. Like other objects it can be touched, moved, walked around, and dusted off. Its essential character lies in this special presence. A sculpture can depict something such as a figure, but unlike a painting it is not an illusion. If you walk behind a painting the illusion disappears. But unless the sculpture is a relief (flat or nearly so), it will retain its identity, and remain assertive.

Frontal or Nonfrontal?

Sculptors have not always based their work on the idea that a sculpture was something meant to be walked around. Statues in ancient Egypt, in preclassical Greece, in India, and the religious statues of the Middle Ages, were frontal; that is, they faced forward. You knew that they were solid, of course, and their solidity gave them presence, but if they were to work on you, and impress you, they had to face you, sometimes look at you, and through that direct confrontation assert themselves upon you (see Figs. 10-3 and 11-21).

The carving shown in **Figure 7-8**, a ceremonial headdress, was made by the master sculptor Bamgboye for the Epa society of the Yoruba people in what is now Nigeria. Produced at a time of prolonged warfare, when societies were organized for protection around warrior-chiefs, Epa headpieces like this celebrated the power of a mythic warrior-king, Orangun.

Though this sculpture is carved in the round, the principal view is frontal. The king, sitting with calm reserve on his mount, facing foward, presents an image of confidence. His size and frontality dominate the composition. The symmetry of the carving, when viewed from the ideal position, further enhances his dignity. Accompanying the king are soldiers and musicians. They are smaller, less important in the scheme of things. Facing in every direction, their slightly modified frontal poses accommodate the intended movement of the headpiece within a crowd of onlookers.

Michelangelo planned all his figures to be seen from the front (see Fig. 15-2). However, their vigorous, twisting poses invite us to shift our orientation. One of the first European sculptors to experiment with sculpture in the round was Giovanni da Bologna. Taking Michelangelo's twisting poses one step further, he

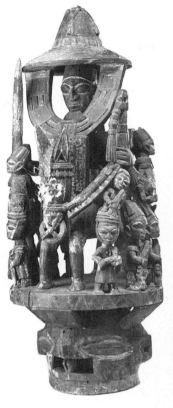

7-8
Bamgboye, *Epa Cult Mask,* c. 1920s–1930s. Wood, 48″ high. (Founders Society Purchase, Friends of African Art Fund.) Courtesy of the Detroit Institute of Arts.

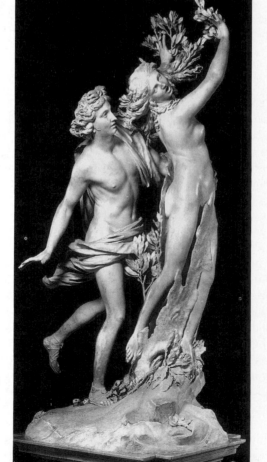

This is what the sculptor must do.

He must strive continually to think of, and use form in its full spatial completeness. He gets the solid shape, as it were, inside his head—he thinks of it, whatever its size, as if he were holding it completely enclosed in the hollow of his hand. He mentally visualizes a complex form "from all round itself": he knows while he looks at one side what the other side is like; he identifies himself with its center of gravity, its mass, its weight; he realizes its volume, as the space that the shape displaces in the air.

— Henry Moore, 1937

≈≈≈ ≈≈≈

7-9
Giovanni da Bologna,
*Rape of the Sabine
Women*, completed
1583. Marble, approx.
13½′ high. Loggia dei
Lanzi, Florence.

7-10
Gianlorenzo Bernini,
Apollo and Daphne,
1622–1625. Marble,
approx. 8′ high.
Galleria Borghese,
Rome.

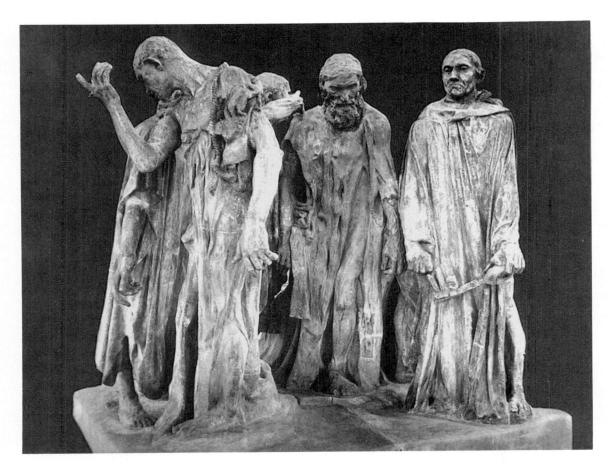

grouped figures together that would spiral in various directions so that the group could be viewed from all sides (Fig. **7-9**). The great sculptor Bernini explored the potential of sculpture to assert itself psychologically. Thus, he favored a more frontally oriented sculpture for its dramatic effects. Bernini was able to convey intense and transient emotional states by means of an extraordinary technique that seemed to transform the stone into life (Fig. **7-10**). Rodin was less exactingly realistic, but more attuned to the movement of masses (Fig. **7-11**). He consistently sculpted figures, both in groups and singly, that could be seen from every point of view. Henry Moore likewise encourages the viewer to move around his abstract pieces (Fig. **7-12**). It's hard to appreciate the difficulty of getting an object or a grouping to look good from more than one or two points of view. Where it applies, ask yourself how the sculptor took on this challenge. Like the sculptor, you will also begin to see and think in three-dimensional terms.

Clearly, it's important for our understanding of a sculpture to know whether we are meant to see it from a fixed point of view or to walk around it and see it change. Frontal sculpture has a controlling effect on us; it wants us to stand there opposite it, to tell us something. Sculpture designed to draw us around it is more informal; it invites us to explore it esthetically.

7-11
Auguste Rodin. *The Burghers of Calais*, 1886–1887. Bronze, 82″ × 94″ × 75″. Hirshhorn Museum and Sculpture Garden, Smithsonian Institution, Gift of Joseph H. Hirshhorn, 1966.

7-12
Henry Moore,
Reclining Figure, 1939.
Elmwood, 37″ × 6′7″
× 30″. (Gift of the
Dexter M. Ferry Jr.
Trustee Corporation.)
Courtesy of The Detroit
Institute of Arts.

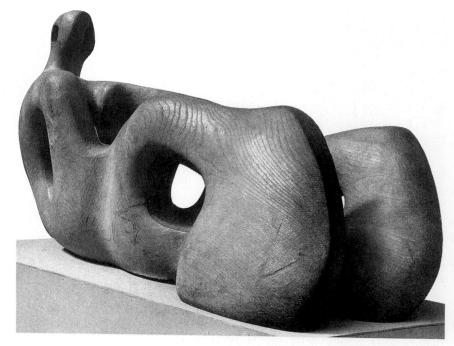

COMPONENTS OF SCULPTURE

Mass

Regardless of the angle from which we view a sculpture, we can best feel our way
into it when we are aware of its materiality, or substance. Unfortunately, we can't
always touch a sculpture to experience this. But we can use our eyes. To begin,
we might find it useful to ask ourselves to notice all the things that are there in a
sculpture that aren't there in a painting or photograph. Mass, or the solidity of
the piece, because it is central to our experience of sculpture, provides us with a
good point of departure.

Imagine yourself at Chartres Cathedral, looking up at the statues of the Old
Testament figures that flank the main entrance (Fig. **7-13**). You can readily feel
the mass of these statues because they retain the form of the block of stone as it
was quarried. Their mass extends vertically, columnlike, wedding them to the
architecture. In Hiram Power's *The Greek Slave* (Fig. **7-14**), the mass is more
difficult to perceive because the figure is further removed from the original solid
block of stone, and perhaps because the realism of the statue catches our eye
first. But the mass is there, shaped into gentle contours that flow softly into one
another. In *The Greek Slave*, flat planes give way to more rounded surfaces, and
frontality yields to a quiet turn. The figure is free-standing; we can walk around
it and feel its graceful and tranquil movement in space. Now look a the *Burghers
of Calais* (Fig. 7-11). Here we see greater movement and assertiveness where
restless forms tilt and strain against each other. Between the figures space opens

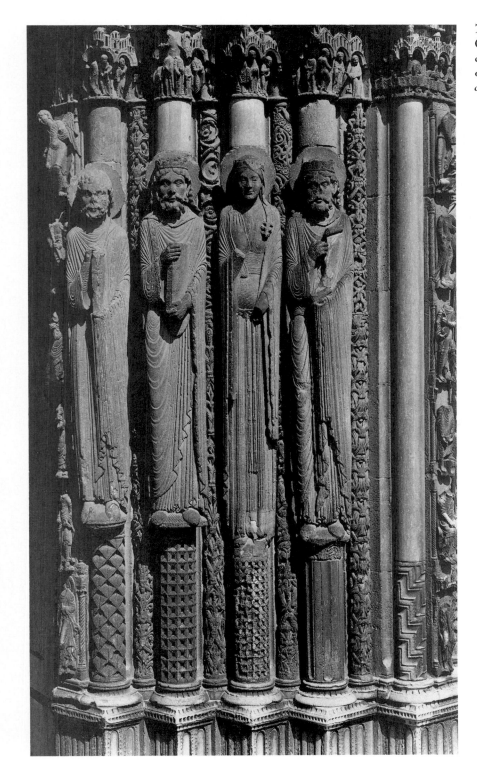

7-13
Chartres Cathedral,
central portal, detail
of jamb figures.
c. 1145–1170.

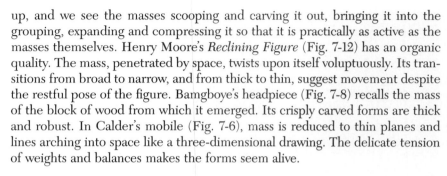

up, and we see the masses scooping and carving it out, bringing it into the grouping, expanding and compressing it so that it is practically as active as the masses themselves. Henry Moore's *Reclining Figure* (Fig. 7-12) has an organic quality. The mass, penetrated by space, twists upon itself voluptuously. Its transitions from broad to narrow, and from thick to thin, suggest movement despite the restful pose of the figure. Bamgboye's headpiece (Fig. 7-8) recalls the mass of the block of wood from which it emerged. Its crisply carved forms are thick and robust. In Calder's mobile (Fig. 7-6), mass is reduced to thin planes and lines arching into space like a three-dimensional drawing. The delicate tension of weights and balances makes the forms seem alive.

Closed Forms and Open Forms

As you can see, we also experience the hollows and spaces between, within, around, and beyond the solids. At Chartres Cathedral the sculpture is closed upon itself, blocklike; space is simply what's left over. *The Greek Slave* is more open, and we can sense the soft movement of air around her body. Rodin's grouping, even more open, incorporates space dramatically. The space feels energized here, and it changes as you walk around the piece. In Moore's *Figure*, the distinction between inside and outside is ambiguous; space flows into solid and solid thins out until you're looking at space again. Space participates in this piece, takes on the movement of the solids, and gives the piece its mystery. Space penetrates Bamgboye's carving. The free-standing figures create powerful contrasts of solid and void, as well as contrasts of light and dark. The Calder mobile is an entirely open form. The design makes us clearly aware of space as a void through which the sculptured forms move. More than the other sculptures, this piece requires space that extends well beyond itself.

Placement

Because sculptures exist in real space, their location will affect our reaction to them. Do we look up at them? Across at them? Are they part of an architectural structure? Or can we walk around them? The statues at Chartres Cathedral are a part of the building. With their elongated forms and vertical movements, they echo the overall design and character of the architecture. Looming over us, abstract, remote, they seem beyond reach, as though partially in another world. Our lovely Greek slave girl, about whom you will read more in Chapter 17, stands independent, in our world. However, she is also placed on a pedestal, which lifts her above us, and by implication, beyond everyday experience. Rodin wished to avoid the rarified quality induced by the pedestal, and intended, in violation of tradition, that the *Burghers* be placed on the ground where they could mingle naturally with the people of the town. The placement of Moore's *Figure* on a low platform locates it in our world, where its hard, weighty presence contrasts with the more ephemeral human one. In contrast, the mobile floats in airy tranquility, seemingly weightless and free. The Yoruba carving was made to be seen in movement. Brought out for festivals, it was worn by young

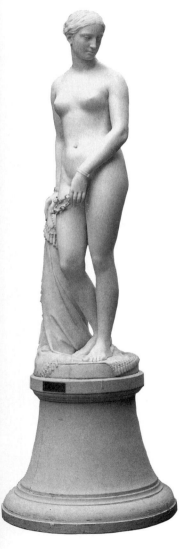

7-14
Hiram Powers, *The Greek Slave*, c. 1846. Marble, life-sized. In the collection of The Corcoran Gallery of Art, Washington, D.C.

men, who placed their head in the lower part and performed dances that included vigorous leaps.

Technique

African sculpture is most often carved, though some is constructed out of separate parts. Bamgboye carved the headpiece from a single block of wood. The deep cutting and crisp planes assure visibility when the mask is in motion. In Western art, sculpture was traditionally either carved or modeled. The sculpture at Chartres and *The Greek Slave* were carved out of stone. To Michelangelo, carving was the only proper method of making sculpture. He conceived it as releasing the figure from the confines of the stone. In modeling, the sculptor builds up the piece with a soft material such as clay, wax, or plaster, and later has it cast in a harder, more permanent material, typically bronze. *The Burghers of Calais*, for example, was modeled in plaster and cast in bronze.

Like many sculptors today, Calder constructed his pieces (Fig. 7-6). For the National Gallery piece, his largest, he called in experts to help him gauge the weight and the tensile strength of the material. Because of its size and weight (it extends 70 feet and weighs 900 pounds), it was doubtful for a time that it could be done at all.

A carved sculpture is limited by the shape of the block and tends to be self-contained; a modeled piece tends to be more expansive, while a piece that is constructed or otherwise fabricated can be even more free. In carved and in modeled sculpture the material yields directly to the will of the artist, and we can see, sometimes literally, his or her touch. Constructed pieces, on the other hand, can be made by technicians following the instructions of the artist.

Material

Feeling our way into sculpture also means getting a feel for its material. The material gives character to the piece and the piece can make us aware of the character of the material. How heavy is it? How hard is it? Is its surface rough? Smooth? Sleek? Dull? Grainy? Shiny? How does it reflect light? What is its color? Is the color natural or was it applied? How light or dark is it? The durability and graininess of the stone at Chartres, the soft glow of the marble in *The Greek Slave*, the chunky vitality of Bamgboye's wood, the rippling energy of Rodin's bronze, the organic flow of Moore's elmwood with its visible grain, and the crispness and springiness of the aluminum and steel in Calder's mobile are a part of what there is to enjoy in the sculpture we have seen.

Sculptural materials are not as yielding as paint but assert themselves in the piece. When you look at a sculpture, ask yourself: What did the sculptor do to bring out the character of the material? Do you experience that character? Or did the sculptor suppress it in order to make you see something else? What, finally, is the interplay between the material and the image? To help you answer these questions, imagine the sculpture made out of something else. What difference would there be? How would the character of the piece be affected?

We live for the most part in a visual world, but much of what we love comes to us through touch — a cool breeze or mist on your cheek, dewy grass, the warm touch of skin, smooth pebbles in your hand. Sculptors work with a particular material because they love its properties and they love what it can do. They think and feel in terms of the material — its hardness, its resistance, its weight, density, moisture, coolness, and so on. Perhaps sculpture originated when someone noticed that a rock resembled a figure, and worked it a bit just to make it more realistic. But sculpture, like pottery or weaving, would not have become an art unless people loved the feel of materials in their hands, loved their touch and texture, and loved the way they could be shaped to give form to ideas.

8
DESIGNED FOR USE

Wherever people have established communities, handcrafted objects were woven into the fabric of their lives. Most societies drew no distinction between arts and crafts. Many had no word for "art" or "artist" in the language. Art was not separate enough from other activities to be recognized as something unique. It was simply a matter of making things well (see Fig. **8-1**). ¶ Our word *art* derives from the Latins *ars*, which means *skill*, especially in a craft. When the word *art* entered the English language in the Middle Ages, it likewise meant skill, particularly as related to knowing and doing. It was only during the Renaissance that art was distinguished from crafts. In part to elevate their status in society, Renaissance artists emphasized the individual and imaginative aspects of painting and sculpture and disparaged crafts as mere manual labor. Western culture has accepted this attitude ever since. ¶ This chapter will show that skilled and creative individuals everywhere have been drawn to the making and decorating of useful objects. Craft traditions, serving the needs of the community, ensured a supply of objects that sustained and beautified life. An improved way of making things, a lovelier form, was recognized, shared, and handed on to the next generation. The high quality of handcrafted objects points to pride of accomplishment and suggests that the love of making, the instinct toward beauty, and an innate sense of design are universal (see Fig. **8-2**). ¶ Outside Western civilization, craftspeople were generally esteemed; their important work, their knowledge of complex and mystifying techniques, their skills, and their deep involvement with natural processes inspired respect. In many traditional African societies, where the craft of carving was seen as a calling, outstanding carvers were believed to be

8-1
Fan, Marquesas Islands.
Fiber, ivory, human
teeth, traces of white
pigment, 18¼″ high.
Raymond and Laura
Wielgus Collection, on
extended loan to the
Indiana University Art
Museum.

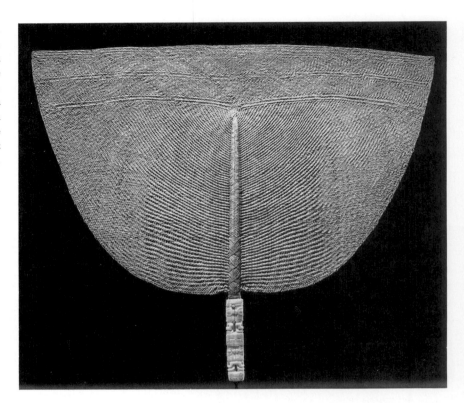

8-2
Pomo Indian Woman
Weaving Basket (Nellie
Burke of Ukiah, 1898).
Twined basket, approx.
4′ high. HBJ Picture
Library.

under the special protection of a god. In modern societies, one-of-a-kind, hand-made objects are cherished. Reverence for crafts, and for those who perpetuate the old ways of making them, may be seen in present-day Japan, where seventy craftspeople are officially designated by the government as "National Living Treasures."

Handcrafted objects manifest individual creativity, ingenuity, and the will to excel that comprise our cultural heritage. They take us out of our mechanized world and connect us to natural materials and processes. Their ancient forms evoke simpler, less hurried patterns of life. They are living connections with cultures for whom "art" and "life" were not set apart.

FUNCTIONAL OBJECTS

Most craft objects have not been intended to be works of art (see, for example, Fig. **8-3**). Pared down, unembellished, and functional, they remind us that the first role of the arts was to help people survive. Craftspeople everywhere, recognizing the possibilities inherent in raw materials, converted them into baskets, pots, looped and twined nets, woven fabrics to use and wear, and dwellings. The objects they made were simple and efficient because, above all, they had to work.

Nevertheless, the objects are often beautiful. Like the fan or the snowshoes, nothing in their design is excessive, arbitrary, or out of place. The parts engage one another perfectly, and the proportions are harmonious. We find this pure, graceful beauty in nature; for example, in the structure of a shell or a snowflake, or in the skeleton of a fish. It's also the beauty of logic and mathematical order. But here, in these simple tools, esthetic form enters the everyday world, storing and transporting, catching fish, or keeping you cool on a hot day.

Pottery vessels are designed with an eye for function. They are remarkably efficient entities, whose parts answer to the specifics of the situation. One vessel has a flat base and a long neck so it can hold a flower. Another has a lid to keep out flies. In our culture, one kind of mug has a wide bottom so the coffee won't spill in the car; another comes with a plastic lid to keep the coffee hot.

The Nazca jar (Fig. **8-4**) was made almost 2,000 years ago in the hot, dry climate of a Peruvian coastal desert. Its round shape maximizes the amount of liquid it can hold, and the rounded bottom sits easily in sand. The narrow spouts prevent spilling and evaporation, and the bridge linking them permits carrying or hanging. While its actual

8-3
Eastern Plains Indians snowshoes, nineteenth century, 55" long. The Brooklyn Museum. Acc. No. 50.67.159. (Museum purchase.)

8-4
Double spout bottle depicting a masked warrior with trophy heads. Peru, Nazca culture, *c.* 180 B.C.— 500 A.D., ceramic. Buckingham Fund, 1955.2128. The Art Institute of Chicago.

8-5
Wickerwork Basket, Thailand, twentieth century.

purpose is a matter of speculation, its design suggests an efficient response to the specifics of its use and its environment.

Consider next a simple contemporary basket from Thailand (Fig. **8-5**). The basket is attached to a wooden base that secures it, lifts it, makes it easy to handle, and keeps its contents from the ants. Here too, we see concern for practicality. The object is easy to use, and the material is used efficiently.

Efficiency and practicality also determined the type of materials used. The clay used for the Nazca jar was plentiful and accessible. The jar was made easily by placing the clay in a mold. The clay provided an excellent surface on which to paint. When fired in a kiln, the clay hardened and became watertight. A slight porousness kept the liquid cool. The colors, applied to the surface before firing, baked in and became permanent.

The materials used in the basket are easy to obtain and practical to work with. The wicker interlaces are the minimum needed for the job of contain-

ing. While lightweight, the wicker is durable, and can withstand knocks or falls. The wooden base, heavier than the wicker, is no larger or smaller than what's necessary to support the basket.

The Japanese cooking pot shown in Figure **8-6** was made about 4,000 years ago. It was set into a stove or hole at the center of a circular pit-dwelling. It was built up by stacking coils of a fairly crude clay, without the use of a turntable or wheel, and was fired in a simple open pit. The decoration is actually practical. Its upper sections form lugs, or handles, so it could be suspended by rope. The rough, nonslip sides make it easier and therefore safer to handle. The palm leaf fan and the snowshoes made beauty of necessity. The designer of this pot converted necessity into beauty.

8-6
Storage vessel, Japan, Middle Jomon Period, *c.* 2000 B.C. Earthenware, 24″ × 22″. The Cleveland Museum of Art, John L. Severance Fund, 84.68.

Unity of structure and design characterizes many functional objects. In our culture, scissors, a mug, or a paper clip are among many artifacts reduced to bare and elegant lines. In these objects, materials perform efficiently.

But what about the rim of the pot? It's not just functional, and not just part of the structure. The design seems to express the potter's impulse. It's lively; it feels exuberant, even joyous. This pot also suggests something else: that material itself can be expressive — that the clay has a kind of personality that the potter lets you see and feel. And you wonder: Did the potter make the clay dance around that way, or was the potter an agent through whom the potential of the clay was given life?

MATERIAL

Material speaks to the senses, and nowhere can one hear its voice more profoundly than in craft objects. Crafts are intimate. They invite you to feel and handle them, use them, see them, and know them up close.

We can't handle the basket from Thailand (Fig. 8-5), but we can look. Though its materials are cheap and unexceptional, they take on a certain zip because of their contrast. The wickerwork interlaces are loose, rough, and open. The wood base is cut in smooth, closed planes. You see what each part has to do and how it does it. But even more, the materials tell you about themselves. Wicker, slender and supple, embraces and contains. Wood, strong and reliable, elevates and supports.

The craftsperson determined that we would see those materials clearly. Nothing is embellished. Perhaps the reason rests on a need for economy or restrictions on time. But simplicity is also what makes this basket attractive. You can see how it all works, and even its form opens up to you: the mouth of the basket opens as it rises, and the legs extend foursquare from the center. This basket has a job to do, and it's an honest, straightforward, uncomplicated worker.

An esthetic developed in early sixteenth century Japan that called for an object to be true to the material from which it was made. This esthetic is nicely exemplified by the teabowl shown in Figure **8-7**. You can see and feel the character of the clay in the ripple of its rim and in its pitted surface. The bowl is earth-colored and thick. The impression of the tongs that lifted the bowl out of the kiln was left in the rough clay, reminding us of the process by which the bowl was created.

The Japanese have traditionally admired the look of weathered materials in utensils and buildings. The particular beauty achieved as material yields naturally to time and weathering is called *wabi*. *Wabi* might be seen in a humble tea bowl, like that in Figure 8-7; in a broom; or in the gnarled, worn wood of a bridge or hut.

Japanese craftsmen evoked the beauty of things well-used by a lacquer technique called *negoro*, which priests of the Negoroji Temple developed at the end of the thirteenth century. In this technique, a red lacquer is painted over a black

8-7
Tea Bowl, Raku ware, Japan, Edo Period, eighteenth century. Courtesy of the Royal Ontario Museum, Toronto, Canada, Acc. No. 920.26.1B.

lacquer undercoating. *Negoro* wares are common objects of simple design, such as cups, bowls, and kettles (see Fig. **8-8**). After years of handling, the red rubs away irregularly, revealing the black underneath. Only then is the piece considered to have attained its full beauty.

The *Negoro* technique makes us aware of the aging process. *Negoro* wares express the acceptance of time and change as facts of life, and they make time and change visible and beautiful in the midst of everyday experience.

Even in our throwaway society, some things grow precious over the years. To some people, blue jeans seem best when they are old and worn, or at least look that way. Of course, an esthetic of clothes that are worn and torn makes sense only in the context of the availability of new clothes. Likewise, in Japan, the esthetic of *wabi* existed against a complementary taste for objects and materials that were highly refined, polished, and decorative. This taste was imported into Japan from China.

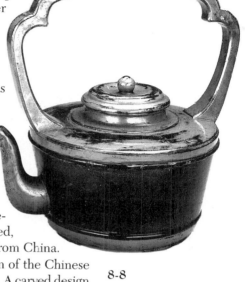

8-8
Kettle (*yuto*), Japan, late fifteenth or early sixteenth century. Red and black lacquer, 9⁹⁄₁₆″ × 12¹⁹⁄₃₂″. Detroit Institute of Arts. (Founders Society Purchase, Acquisitions Fund 1983.1.)

The smooth, graceful, curved sides and carefully turned rim of the Chinese bowl pictured in Figure **8-9** contrast with the Japanese teabowl. A carved design of lotus petals evokes the tranquility of a pond, and the transparent, silvery green glaze evokes the color of water. Known today as *celadon*, the glaze inspired poets as well as potters. This poem was written in the ninth or tenth century in honor of celadon-glazed pottery from the Yue kilns, of which this bowl is an example:

> *Bright moons skillfully carved and dyed with spring waters —*
> *Thin sheets of ice lightly turned and filled with green clouds —*
> *Ancient mirrors eaten by moss lying on a mat —*
> *Tender lotus pads filled with dew by a river bank.*[1]

8-9
Yue bowl with carved and incised decoration, China, late ninth or early tenth century. Celedon ware, diameter approx. 7″. Percival David Foundation of Chinese Art (PDF 262), University of London.

The forms of the Yue bowl are rooted in ideas of balance, order, and symmetry. The soothing colors allude to the purity of sky and water, and launch peaceful thoughts that carry us far from the cares of the material world. The Japanese teabowl (Fig. 8-7) is no less refined or ideal in its own way, but its rough, heavy form never lets us forget that we are rooted in the earth.

Ingenuity, imagination, a sense of play, and the love of beauty have compelled people to invent. But surely materials themselves made some people's fingers itch, freshened their senses, inspired them to imagine, and to create.

TECHNIQUE

The joys of creating call upon manual skills, sometimes perfected over a lifetime, and knowledge of techniques refined over generations. Craftspeople prided themselves on the wonders they could perform with materials. A skilled African carver could make a complex carving from a single block of wood (see Fig. 7-8). Gold filigree work in India and Europe tested the skills of the craftsperson, but extended the material. Inca masons constructed massive walls using enormous stones carved so precisely that a fingernail can't fit in the grooves.

Sensitivity to materials, hand–eye coordination, muscular control, timing, judgment, discipline, and patience are qualities associated with craftspeople. While a discussion of the hundreds of craft skills and techniques practiced around the world over the centuries is impossible here, I will describe several of the more unusual.

Native American cultures placed a high value on such domestic skills as weaving, basket making, pottery, and decorative work in beads and paint. Possibly the finest basket makers in the world were women of the Pomo Indian culture of what is now northern California (see again Fig. 8-2). Twined Pomo baskets were so tightly woven that they could hold water for days; some were used for cooking.

Basket making involves selecting the grasses in season, preparing them over a period of time, and finally, the construction itself. Some grasses required a year's drying time, and a fine basket could take up to two months to construct. Pomo baskets typically had thirty-five stitches to the inch. In contests of skill, women incorporated as many as sixty stitches per inch and could make perfectly stitched baskets smaller than a pea. Storage baskets, as in the illustration, were quite large; this, too, posed a technical challenge to the basketmaker.

Some Pomo baskets incorporated the feathers of birds, which were painstakingly inserted one by one around the outside of the basket. The varying angles of the feathers revealed their natural iridescence. These gorgeous feather baskets were presented as gifts to newborn girls and brides, who treasured them throughout their lives.

Native Americans developed a method of steaming wood so it could be bent and shaped. Bent wood frames were used for snowshoes, and inch-thick slabs of wood were folded to form storage containers. In many places, boats were made from a single tree by burning and scraping out the trunk, then filling the interior

with water heated by hot rocks. The sides, softened by the hot water, were spread and held apart by planks. On Canada's northwest coast, boats holding as many as thirty people were used for warfare and for hunting whales.

People in tropical regions around the world made a clothlike material from the bark of certain mulberry trees (see Fig. **8-10**). This material is called in English by its Polynesian name, *tapa*. To make tapa required removing the inner bark of the tree, scraping it, soaking it in running water for as long as a month, and pounding it to break down the fibers and thin out the sheet. The result was a soft, smooth, attractive substance, which could then be decorated. Tapa cloths can be as thick as a blanket or as thin as silk.

Wooden tapa beaters, or mallets, were incised with designs in order to spread the force of the pounding over the whole area (much like our meat tenderizers). Here too, necessity was converted to beauty, as mallets carved with squares, diamonds, herringbones, and the like left distinctive imprints in the cloth.

In many places tapa beating was a communal activity for women, and became an occasion for socializing. Villages often developed distinctive rhythms as the mallets struck the anvils. Women who left their villages have spoken of missing the pleasure of the music they made beating the tapa.

FORM

Along with technical skills, conscious esthetic judgments also go into the making of objects. Here the craftsperson is simply asking: What looks good? These judgments become apparent when we look at the form, or design, of the object, as well as its decoration. We will first consider the form.

8-10
Tapa cloth, Samoan Islands, nineteenth century. Field Museum of Natural History, Chicago (Neg. No. 106703).

8-11
Fan (*uchiwa*), Japan,
twentieth century.
Private collection.

Made of paper and bamboo, the fan in Figure **8-11** is a simple object with an uncomplicated, efficient structure. The bamboo handle, sliced and splayed like rays, becomes the skeleton. The paper applied to it plays dual roles of fanning the air and stabilizing the skeleton. A thin wooden rim supports and defines the edge. The design, tied intimately to the structure, has the simple beauty that we saw earlier in the palm leaf fan and the snowshoes.

But efficiency was not the only concern in making the fan. The craftsperson found the place where the design is most interesting—where the stalk begins to fan out—and drew the eye to it by framing it with the bottom edge of the paper. To emphasize this area further, the paper was painted black, for contrast. But the black stops part of the way up. Why? To answer that, we must look at the overall shape. The craftsperson saw that the fan was round, while the handle was straight. This seemed jarring. How could the two forms be reconciled? Creating a straight edge part way up brings the straightness of the handle into the round shape of the fan. The lower edge of the black shape echoes the upper rim of the fan, bringing it toward the handle. But in straightening slightly, it becomes more consistent with the handle. In that way, the opposites were brought into harmony.

The location of the upper black edge was determined by eye. Within the round fan area, three areas are defined. While each has a function in organizing the overall design, each is also individually formed into a pleasing shape.

Our discussion of the Thai basket (Fig. 8-5) already hinted at the integrity of its simple design. Let's look at it again. The object is divided cleanly, with the wicker on top and the wood below. The top of the basket is round, while the wooden legs make a star shape that is straight at the base. As we look toward the base, the basket becomes squared, while as the legs rise, they curve. This integrates top and bottom into a satisfying whole. Since both the basket and the base expand from the center out, the left and right profiles of the object are curves, made up of both basket and base. The sturdy legs extend just a little beyond the edges of the basket, assuring us that they can support their load securely.

The Thai craftsperson combined practicality and attractiveness in the same form. It's a neat trick if you can do it. The maker of the drinking cup in Figure **8-12** accomplished it, too. Made by the Etruscans in ancient Italy, it's a type known as a *kantharos*. The handle on my travelling coffee mug is just stuck on. It does its job, but it doesn't look like much. But see the way the handles fit the Etruscan *kantharos*. They take up the edge of the rim and send it into space, smoothly narrowing it until it's not the rim any more, it has become handles. Then the handles sweep back to encircle the bottom of the bowl and become one again. These transitions occur in a fluid, unbroken movement.

Here again, the proportions are pleasing. The base is properly modest. It lifts and pulls inward where it wraps around, like a little squeeze where the handles

8-12 (left)
Drinking cup,
(*kantharos*), Etruscan,
c. 625–540 B.C.
Bucchero pottery,
approx. 4¼″ × 7″.
DeCriscio Collection
(KM 2821), The
University of Michigan.

8-13 (below)
German clock,
Mergentheim, c. 1750.
Carved and gilded wood
with group of faience
figures. 38½″ × 23½″
× 14⅝″. The Cleveland
Museum of Art, John L.
Severance Fund,
66.362.

spring outward. The sides lift and angle out just where they should. The potter let the handles soar beyond the strictly functional, suggesting flair and humor. The cup seems a good companion to happy occasions.

We have looked at several objects whose organization harmonizes their parts. Of course, not all objects are as simple as these. Sometimes technical skill, and a social class that could patronize it, promoted an esthetic of elaboration. From the late Middle Ages, through the Renaissance and beyond, Western craftspeople often embellished objects with the enthusiasm of pastry chefs lavishing their talents on a wedding cake. The rational integration of the parts seemed of less interest than a celebration of the craftsperson's virtuosity, and a love of ornamentation for its own sake.

The architectural fantasy in Figure **8-13**, complete with fake ruins, mythological animals, dripping moss, and porcelain lovers set in classical antiquity, provides an amazing setting for a clock. While the clockworks are visible through glass windows on the sides, the design disguises rather than reveals the function of the object. The esthetic of elaboration found beauty in the longest journey between two points, and hid the machinery away.

In traditional cultures generally, ornament seems not to overwhelm but to cooperate with the object on which it is placed. A prime reason for this has to do with the importance placed on utility. Other reasons will become clear in the next discussions, in which we will investigate traditional designs.

DESIGNS IN TRADITIONAL CULTURES

In our culture, pictorial designs identify corporations, direct traffic, and tell you that your computer program bombed. Tablecloths and china are usually decorated with pretty but meaningless colors and patterns. In traditional cultures, too, designs were made for various reasons. Designs frequently had symbolic meanings. Designs could refer to the gods, myths, or histories of the society. They might contain precise messages, encoded in images realistic or abstract. In nonliterate societies, the designs and images often functioned as pictorial languages.

The clarity of the images on the Nazca jar (Fig. 8-4) suggests the importance placed on the reading of the figure and its paraphernalia. A recent study investigated the meanings of Nazca pottery images.[2] It suggests that the images are pictograms with each picture representing a concept that has a corresponding word (as in Egyptian hieroglyphics). Many of the images on Nazca ceramics of this period show a concern for rites associated with the cultivation of crops and with war. The image on our jar shows an elaborately costumed warrior wearing a cat-like mask with prominent whiskers. (Gold mouth masks like this have been excavated in Peru). The figure is grasping two severed heads, called "trophy heads." Trailing behind the figure is a headdress containing representations of trophy heads. The subordination of the individual and the emphasis on the mask and details of the costume point to a focus on ritual and ceremony in the culture.

Sometimes images or designs were intended to ensure the involvement of gods or spirits. Designs could heal and protect, or give special powers in love and

8-14
Maori canoe, New Zealand, eighteenth century. Courtesy Department Library Services, American Museum of Natural History (Neg. No. 334100).

8-15
Kuba cloth, Zaire,
late nineteenth or
early twentieth
century. Detail. Raffia,
pigmentation, original
approx. 28″ long.
Courtesy of the Royal
Ontario Museum,
Toronto, Canada
(939.2.49).

war. To this day, the Maori of New Zealand apply intricate spiral carvings to houses, tools, weapons, and boats (Fig. **8-14**). Maori tradition holds that these designs draw supernatural forces into the objects, protect the objects, and increase their power. The more beautiful and intricate the workmanship, the more powerful the designs are thought to be.

The traditional designs, patterns, and styles of figures on handcrafted objects were sometimes carefully copied. At other times each artist was expected to work out an individual statement using the group's shared design vocabulary. Inevitably, local pride and the important meanings imparted by traditional designs ensured their perpetuation.

In the present day Kuba culture in Zaire, women produce magnificent embroideries on plain cloth woven by their husbands. The women use traditional designs in endless variations (see Fig. **8-15**). The complex designs, with their intentional shifts of patterns, have been likened to Kuba music, with its complex syncopations. But although many of the design motifs have names and can be identified as abstractions of objects in nature, there is no one left who can interpret their original meanings. Pride of accomplishment and the pleasure of making foster the art today.

Design Challenges

Many objects, like the Kuba cloth, are enjoyable primarily because of the designs that adorn them. Consider the Japanese cooking pot (Fig. 8-6), whose design is organized around a plain core. It's so richly embellished that we can almost forget it's a functional object. The strips of clay, applied in rows on the sides, become animated as they approach the top. There they flow into waves of increasing energy. Finally, breakers carve out the space beyond the rim. It's as if the potter had wanted to bring the dynamic spirit of the sea into an inland dwelling, and made a clay cooking pot into a work of art.

The creative juices of artists and craftsmen are often challenged and stimulated by having to arrange designs on difficult forms. The cooking pot, for example, tapers toward the bottom, and the potter had to take that into account. The potter had to organize the design seamlessly, on all sides. The resulting design succeeds in fitting the form comfortably all the way around.

Good designs often echo the overall form of the piece. Lines and shapes that make up the designs will correspond to the profile you see at the edge of a basket or pot. Look again at the cooking pot, or at the mosque lamp from Cairo (Fig. **8-16**) which was made in the fourteenth century. Their designs are organized in horizontal bands that relate to the overall shape of the objects. The elements that make up those designs seem in touch with what's happening on the edges of

8-16
Islamic enamelled mosque lamp, with Nashki inscription around neck, after 1331. Glass, 10¾", high, greatest diameter 9". The Toledo Museum of Art, Edward Drummond Libbey, Acc. No. 40.118.

the forms they adorn. The lines in the pot are restrained at the bottom, and grow exuberant as the pot swells outward at the top. In the lamp, the shapes of the Arabic letters splay outward, and restate the angles of the edge. Small rosettes in the narrower bands echo the curved handles, as well as curved elements of the letters. The careful organization that we see in these objects is characteristic of the best in utilitarian design.

While certain design elements may harmonize with the overall form, some may also contrast with it. Such contrasts will enliven the piece. The Nazca jar (Fig. 8-4) is a good example. Let's begin with the harmonies. First, see how well the painter arranged the shapes to fit the difficult volume of the jar. The image fills the area assertively. Respecting the flatness of the surface, the images are flat and are painted with flat colors, and there is no background. The lines around the images are crisp, sharp, and clear, like the profile of the pot itself. The clarity of the images is emphasized by strong outlines. The curved lines echo the curved surface and also the shape of the vessel. Straight lines, because

they are applied to a convex surface, bend around and appear curved. But sharp angles and jagged lines are a part of this design too, and their contrast to the other elements jazzes up the rhythm.

These thoughtful relationships unify the entire form of the cooking pot, the lamp, and the jar. The well-considered designs give each a visual integrity that turns object into art. ◆ ◆ ◆

The objects we have examined in this chapter reveal how traditional craftspeople responded with ingenuity and intelligence to the requirements of function, the restrictions of material, the demands of efficiency, the challenges of designing and decorating, and the mandates of tradition. Despite these constraints and demands, the work they produced was vital and beautiful.

Would their art have been so beautiful without those restraints? Working within restraints limited the artists' choices, but directed their minds to solutions. By applying their creative powers to specific situations, the artists found ways of turning problems into possibilities.

CONTEMPORARY CRAFTSPEOPLE

Craftspeople today may work outside the constraints of tradition if they choose, and the objects they produce need not be functional to be admired. A wide range of materials has opened up new possibilities. Restraints today are largely self-imposed. Some craftspeople choose to create objects in traditional forms; others create new versions of the old forms, while still others create new forms entirely. New materials and experimental techniques expand the options.

A pioneer of modern fiber arts, Ed Rossbach (see Fig. **8-17**) has carried weaving far beyond traditional forms. Rossbach was trained in a narrow range of commercial techniques. But commercial textiles have interested him less than experimentation. He has used his mastery of traditional methods of interlacing to make new forms. He has also combined those techniques with modern materials, such as corrugated cardboard, newspapers, plastic tubes, camouflage netting, decals from cereal boxes, and plastic shopping bags. He has combined traditional materials with contemporary imagery: Mickey Mouse, John Travolta, Rossbach's wife, and Spot the dog have been incorporated into brocaded silks, silk organza, damask linen, plaited construction paper, and sea grass. He has built pieces around commercial postcards and has transfered images taken from *Sports Illustrated* onto commercial cotton cloth.

Rossbach's work combines the rational aspects of traditional craft techniques—the efficient use of material and the sensible relationship of the parts to the whole—with a whimsy that leads

8-17
Ed Rossbach, *John Travolta*, 1978. Construction with heat transfer. Collection of the artist.

to unexpected outcomes. The objects he makes are seldom functional, and thus they blur the line traditionally drawn between crafts and fine art.

While mass production has displaced crafts, it has ensured their perpetuation in the hands of individuals for whom craft work is an act of love. Many crafts-people today produce functional objects, though these too, like Rossbach's creations, move into the area of fine arts. Craft fairs, which provide a place to meet the artists as well as view the crafts, have become immensely popular in recent years. The revival of crafts in our culture today may reflect a desire and a need to humanize our environment and our lives.

INDUSTRIAL DESIGN

Reactions against excessive ornamentation have occured periodically in the West. The Arts and Crafts Movement, which originated in England in the late nineteenth century, championed simplicity and "truth" in design by promoting handicrafts at a time when machines were putting craftspeople out of work. The movement regarded industrialization as dehumanizing. Mass production threatened to drive out what they saw as honest, simple, traditional design by multiplying soulless reproductions that were at best merely fashionable and at worst, tasteless.

Artists associated with the Arts and Crafts Movement studied and produced traditional crafts of all kinds. They established workshops in England and in the United States, and even a utopian community (at Aurora, in upstate New York). The movement's recognition of the dignity of handicrafts remains in our culture to this day. But its efforts to resist the machine age were, of course, doomed.

A more successful approach to design was adopted at the Bauhaus, an art school that flourished in Germany in the years between 1919 and 1933. The Bauhaus embraced the machine as the emblem of the modern age. Bauhaus ideologists believed that machine technologies promised a better future for all. They aimed to train artists and designers in every field who could work with, not against, machines and use them to design products that would improve life.

The stripped-down economy of the machine, with its unembellished forms, suggested to Bauhaus artists an esthetic of purity. Consider the chair that Marcel Breuer designed at the Bauhaus (Fig. 15-4). It is the first chair to use tubular steel, an industrial material. Like a machine, its lines are clean-cut and its forms are interpenetrating. The forms seem to be working, and they are all exposed to view. There is no applied ornament. The design carves through space like an abstract sculpture.

The Bauhaus artists recognized that the machine—functional, efficient, often beautiful—embodied design principles seen in the simple handcrafted objects of premodern cultures. Many of the Bauhaus artists studied and collected the crafts of those cultures. But rather than copy the objects and their designs, they attempted to incorporate lessons learned from these objects into modern designing. Sensible structure, simple design, and the use of materials according

8-18
Raymond Loewy,
designer (with Virgil
Exner), 1947
Studebaker

to their nature were principles applied to the design of housing, fabrics, coffee pots, lamps, and furniture.

Functionalism became a guiding principle for modern designers. In his landmark book, *Toward a New Architecture* (1923), the Swiss architect Le Corbusier illustrated grain elevators, airplanes, and steamships and held them out as examples of the century's finest architecture. In the 1930s and '40s, industrial designer Raymond Loewy streamlined trains, buses, and automobiles to make them more efficient as well as to make them look faster (see Fig. **8-18**). His automobile designs integrated parts, lightened the weight, improved aerodynamics, and at the same time improved safety and comfort. The fact that Loewy's Avanti, designed for Studebaker in 1961, is still being custom made demonstrates the staying power of fine design.

Today "user friendly" applies not just to computers, but to many objects designed for comfort and reassurance as well as efficiency. The machine-like, hard-edged look associated with modern design has given way in recent years to softer, gentler lines. Finnish designer Olof Bäckström's 1960 design for Fiskars scissors introduced molded plastic handles to fit thumb and fingers; orange for right-handed people, red for lefties. Bäckström's scissors design was ergonomic — that is, the scissors were designed to fit the hand and complement its

8-19
Allen Samuels,
industrial designer,
Libbey glasses.
Manufactured by
Libbey Glass Company,
Toledo, Ohio.

movements. The correct anatomical design improves control, and its asymmetrical, soft look reassures the user and makes cutting seem fun. Fiskars scissors are in the Design Collection of the Museum of Modern Art.

Allen Samuels's drinking glasses were mass-produced by the Libbey Glass Company in the 1970s (Fig. **8-19**). Samuels designed these glasses to accommodate the needs of children and people suffering from arthritis. The bubblelike swelling at the center catches light and makes us aware of the lovely, fluid properties of glass. At the same time it keeps the glass from slipping out of the hand and enables the glasses to stack easily. Sensitively integrating form and function, these glasses are wonderful to look at and reassuring to use.

Humor and decoration, both banished from orthodox modern design during much of the twentieth century, have made a comeback in recent years. In the 1980s the Memphis Group in Milan, Italy, led by industrial designer Ettore Sottsass, began producing colorful and zany commercial furniture, objects. and patterns that resembled free-form design extravaganzas. As Memphis sees it,

functionalism and ergonomics are beside the point. Memphis kicks out the jams, exploring and incorporating the bright colors and patterns of African art, the elegant surfaces of Japanese art, the monumentality of ancient and exotic architectural forms, and quotations from earlier Western styles such as Arts and Crafts, 1920s Art Deco, 1950s suburban "moderne," and Pop Art. These incongruous styles are combined in individual pieces along with incongruous materials such as marble and plastic (Fig. **8-20**). Memphis invites outstanding designers from around the world to design pieces. Many architects, too, have designed objects for Memphis, as well as for other design

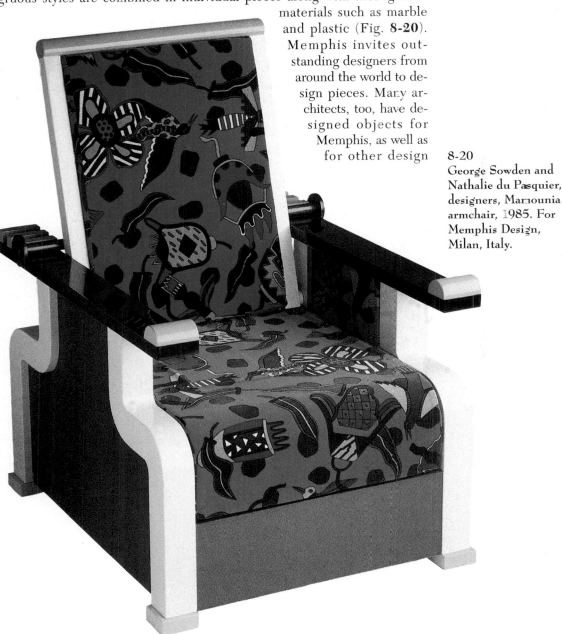

8-20
George Sowden and Nathalie du Pasquier, designers, Mamounia armchair, 1985. For Memphis Design, Milan, Italy.

firms. In 1985, American architect Michael Graves designed a teakettle for Alessi with a small, red, plastic bird perched on the spout, to whistle when the water boils.

Memphis broke new ground by rejecting functionalism and promoting decoration for its own sake. The influence of Memphis designs continues still.

Conclusion

Handcrafted objects invite us to observe the intimate reciprocity of materials and human skill. A sensitivity to materials and the development of techniques produced a wealth of objects compelling in their beauty and attesting to the human capacity for converting necessity to joy.

Traditional designs usually communicated specific ideas. Integrating harmoniously with the forms on which they were placed, they also communicated an unspoken need for wholeness and order.

In the modern world, technologies of mass production have almost entirely replaced the old traditions of handcrafts. Even so, creative individuals in industrial societies are still drawn to designing useful objects. Simple, functional designs suggest that the same principles of designing apply universally. But Mickey Mouse watches and birds perched on teakettles suggest that functional objects can also be a place for fantasy and fun.

Modern manufacturing conditions have brought new criteria for products, and have placed new stresses on designs and designers. Manufacturers balance efficiency, safety, durability, comfort, and pleasure against cost effectiveness and the perceived demands of mass markets. Bad designs find their way into the marketplace. Toys are unsafe for children, cars burn too much fuel, and packaging is inefficient and wasteful. We could look for guidance to traditional cultures, for whom making things well was not just art, but a way of life.

The objects we have examined in this chapter are just a few of many. I have chosen an eclectic approach to demonstrate that all artists address the concerns of designing for use, and to emphasize the availability of objects for your own examination. Even a coffee mug can be a starting point.

9
PHOTOGRAPHY

Since the Renaissance, the impulse to explore and record the material world has intoxicated the West. In 1839, a French painter, Louis Daguerre, and an English scientist, William Henry Fox Talbot, patented methods to make permanent images without pencil or brush. Sunlight itself produced the small miracles. Talbot referred to them as "fairy images," and later, "sun pictures" (see Fig. **9-1**). Eventually they would be called photographs (from the Greek, meaning "light writing"). ¶ Daguerre's images—Daguerrotypes—were marvelously lifelike. The image, appearing on a silver-coated copper plate, seemed to hover magically just beneath the glimmering surface. But these images could not be duplicated. Talbot's method was different. It produced a negative from which many copies could be made, and it soon became photography's predominant technique. ¶ Over the next several decades the new invention was rapidly refined. Bulky apparatus grew lighter, and developing techniques became more efficient. Negative materials became "faster," that is, more sensitive to light. This meant that studio poses could be less stiff in appearance, and that moving figures would appear less blurred. Portable cameras made photography available to all. George Eastman's compact, hand-held Kodak was introduced in 1888. Photofinishing was provided by the Kodak company, which advertised, "You Press the Button, We Do the Rest." ¶ In a process remaining to this day, people used photographs to catalog the world. Everything and anything became a subject. Fast, cheap, and easy, photography had many advantages over painting. People simply "took" pictures of whatever caught their fancy—they didn't have to create them.

9-1
William Henry Fox
Talbot, *Leaf of a Plant*,
c. 1839. Plant VI,
from The Pencil of
Nature, The Royal
Photographic Society.

Early on, photography's path forked into two distinct branches. One explored photography's potential as art; the other used photography as a means to document or record. As an art form, photography could borrow a history from painting and build on its pictorial traditions. As document, photography had exactitude, detail, and objectivity. Of course, overlaps were inevitable. Art photographs are powered by their ties to reality, while "straight" photographs also invite esthetic considerations.

Consider the photographs shown in Figures **9-2** and **9-3**. Are they records? Or beautiful images? Or both? The photograph of Saint-Cloud (Fig. 9-2) begs to be compared to a painting because of its evocative subject and careful composition. The image makes this corner of a formal garden look magical and hallucinatory. And the bleak, massive forms of the ruined mill (Fig. 9-3), black and sickly against the pale sky, convey the pathos of war much as a painting might. Yet both are records of a time and a place.

9-2
Eugene Atget, *Saint-Cloud*, 1915–1919. Albumen silver print on paper, approx. 7" × 8½". National Gallery of Canada, Ottawa.

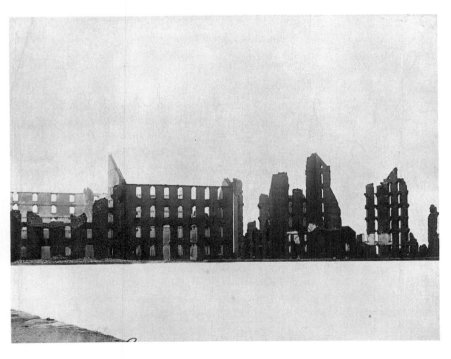

9-3
Studio of Matthew B. Brady, *Ruins of the Gallego Flour Mills, Richmond*, 1863–1865. Albumen silver print from a glass negative, 6" × 8³⁄₁₆". Collection, the Museum of Modern Art, New York. (Purchase.)

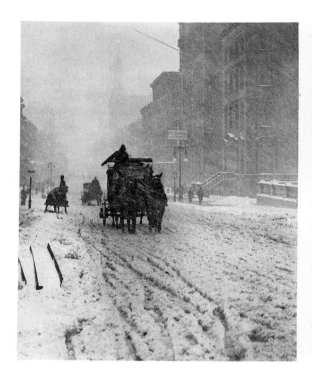

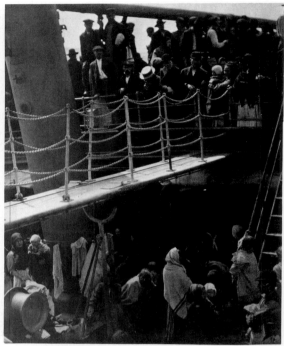

9-4 (left)
Alfred Stieglitz, *Winter, Fifth Avenue*, 1893. Plate 2 from *Camera Work*, No. 12, 1905. Photogravure, 8⅝″ × 6¹⁄₁₆″. Collection, The Museum of Modern Art, New York.

9-5 (right)
Alfred Stieglitz, *The Steerage*, 1907, from *Camera Work*, No. 36, 1911. Photogravure (artist's proof), 7¾″ × 6½″. Collection, The Museum of Modern Art, New York. (Gift of Alfred Stieglitz.)

The work of the great photographer Alfred Stieglitz, who began taking pictures in the late nineteenth century, demonstrated that the two directions could indeed be reconciled. Stieglitz turned his camera on the real, everyday world. In *Winter, Fifth Avenue* (Fig. **9-4**) you can almost hear the horses snorting and the driver swearing at them. But there is also something comfortably picturesque about the scene. The falling snow softens the textures of the buildings, almost as if they were in an Impressionist painting. The carriage approaches the center, while the snow that obliterates the background brings it into greater focus.

Now look at *The Steerage* (Fig. **9-5**), which Stieglitz made fourteen years later. Here we have a collection of people and objects that seem arranged by chance rather than by conscious selection. The unconventional composition seems to put things out of whack. There is no clear focal point, the people are jumbled, and the picture splits in two at the center. Yet those apparent aberrations bring a sense of reality to the picture. You look around it as if you were there.

Though Stieglitz had abandoned the obvious compositional devices of traditional painting, this photo was in fact carefully composed. Massive mechanical forms frame and structure the scene. The disguised composition, because it is not obviously artistic, allows for a more natural reading of the subject. Stieglitz's work opened the door to investigation of the camera's ability to give expressive power to what was accidental or momentary. The question for many twentieth-century photographers became: How could the camera reach into the real

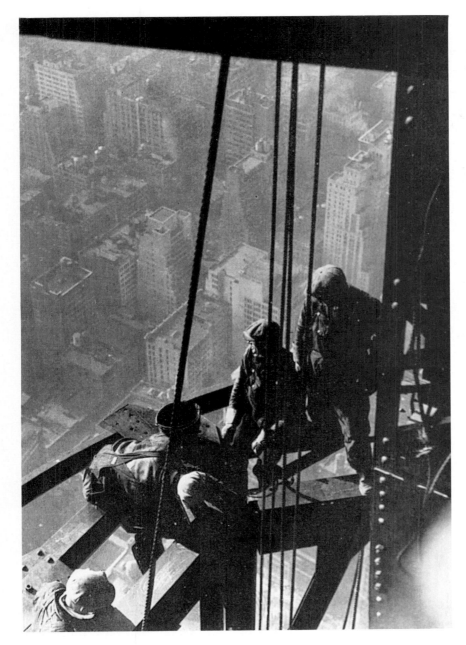

9-6
Lewis Hine, *Riveting the Last Beam on the Empire State Building*, 1931. George Eastman House, Rochester.

world, make one aware of objects and situations as they passed by, and make them evocative (Fig. **9-6**)?

Stieglitz's photographs veered from painting's ways of seeing and depicting to a mode that was more purely photographic. What constitutes photography's way of seeing, its distinctive character?

LOOKING AT PHOTOGRAPHS

Photographs present us with a peculiar tangle of subject matter, machinery, chemistry, and artistry. Typically, the mechanics are forgotten, the artistry is neglected, and the photo and its subject matter are confused. We slip right through the photo into the image, like Alice through the looking glass. We wander in Atget's garden, and perch on the girders with the ironworkers. To appreciate the photographs themselves, however, we need to detach the image from its subject matter, much as we did with paintings in Chapter 4.

Photographs can be read like paintings. Formal elements—line, shape, light and shadow, composition, space, texture, and perhaps color—are organized to create particular effects. Examining these elements helps us distinguish the subject matter from its image.

But formal analysis doesn't get us far enough, because it neglects a crucial distinction between photographs and paintings. A painting is made up. A photograph is an imprint, like a shadow cast on a wall. Photographs "capture" reality. A painting can persuade you that nature is impressive. But a photograph carries the weight of proof (see Fig. **9-7**). Photography's central character resides in its automatic ties to reality.

Photographers, however inventive, deal with a hefty number of givens. The realization of that "given" aspect of a photograph is basic to an appreciation of its

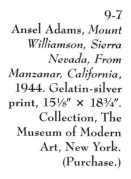

9-7
Ansel Adams, *Mount Williamson, Sierra Nevada, From Manzanar, California,* 1944. Gelatin-silver print, 15⅛″ × 18¾″. Collection, The Museum of Modern Art, New York. (Purchase.)

9-8
Arthur Fellig (Weegee),
The Critic, 1943.
Gelatin-silver print,
10⁷⁄₁₆" × 13"
Collection, The
Museum of Modern
Art, New York.
(Anonymous gift.)

unique character. Photos are a record of the encounter between photographers and what was given them to see. Because of this, we examine photographs differently from paintings. We find ourselves asking different kinds of questions — questions that let us see deeper into those photographic images. What do I notice? What details catch my attention? What has been left out? What people or things are brought together? Are they there on purpose? Or by chance? What is recognizable and familiar? What is unusual or unexpected? What associations do I make with what I see?

If there are people in the picture, what do we know about them? How do we know? By their expressions? Gestures? Clothes? Photographs invite us to examine these characteristics (see Fig. **9-8**). Much as we do when people-watching, we wonder what photos reveal about character.

A photograph can show us more about a place than we might see if we were there. Because it always shows us less than the whole, it may stand for more than what it shows. What clues are we given about the place? What does the photographer want us to know and feel? Always selective, photographs can create a mood or feeling that becomes indelibly associated with a place and time. Consider, for example, Atget's *St. Cloud*, or Stieglitz's *Fifth Avenue*.

9-9
Frederick H. Evans,
*Westminster Abbey,
South Nave Aisle,*
c. 1911. George
Eastman House,
Rochester.

Photographs of objects invite the question: Why these? Does the photo provide information? Do the objects awaken associations? Are we asked to enjoy shapes and forms? Frederick H. Evans's image of Westminster Abbey (Fig. **9-9**), evokes the stately, timeless Gothic world. In Paul Strand's photograph, *Wire Wheel, New York* (Fig. **9-10**), subject and image speak of a new esthetic of abstract forms hidden in the real world.

Whatever photograph we look at, we should keep alert to the decisions made by the photographer. Certain decisions must be made on the spot. Where is the camera lens pointed? What is the main subject? How is the action framed? How close are we brought to it? What do we see around it? Some decisions are made before the picture is taken. What kind of camera was used? What lens was attached? Did the photographer use low or high contrast film? Was it black-and-white or color? Did it yield an image that is fine or grainy?

Setting the *f-stop* — the opening, or aperture, of the camera — affects the amount of light admitted into the camera. The shutter speed, which determines how long

9-10
Paul Strand,
Wire Wheel, New York,
1918. The Metropolitan
Museum of Art, The
Alfred Stieglitz
Collection, 1949
(49.55.318).

the aperture remains open, also affects the light intake. The adjustment of these two features on the camera affects the sharpness of motionless objects at varying distances. A small opening and a long exposure yields sharpness throughout the image, while a large opening and a short exposure yields sharpness at one particular point, and softness nearer and farther away.

Adams's photograph of rocks, mountains, and clouds (Fig. 9-7) is sharp and clear throughout. He wants you to see the relationship of every element to each other element. Lewis Hine softens the city (Fig. 9-6) so that the focus is on the ironworkers.

Light plays important roles in these images. In Adams's photograph, silhouettes on the rocks bring the distant light into the foreground and reveal the correspondence of rock to mountain. Light helps to create the rhythm that unifies this scene. In Hine's photograph, light contrasts the men and the skeletal foreground structure with the city far below. The city appears gauzy, like a dream. The steel girders are dark, almost macabre. The shadows wed the men to the building, and the lack of detail gives them a certain monumentality.

In Weegee's photograph, *The Critic* (Fig. 9-8), the glare of the flashbulb isolates the main characters from the background. In the harsh light, details stand out, and the already mask-like faces of the opera-goers become even more garish.

A simple portrait can also require decisions. For the portrait in Figure **9-11**, Julia Margaret Cameron placed the girl indoors, softened the focus, and created a gentle light. In contrast, Walker Evans used a sharply focused lens in harsh, direct sunlight (see Fig. **9-12**). In Cameron's image, the girl seems poised in another world, detached from time and reality. Evans gives us specifics of clothing and background, and makes sure we notice the relation between the woman's wrinkled brow and the grain in the weathered boards of her house.

Photographers can also make decisions after the shutter is snapped. In the darkness the negative can be manipulated in various ways. The size of the print, its sharpness, its tone, its color, and its texture can all be affected in the darkroom. The composition of a photo can be changed by cropping, that is, trimming the edges. Photos can be printed lighter or darker, and the contrasts can be altered. Darkroom techniques can also darken or lighten specific elements. These practices are commonplace in most photographers' studios.

9-11
Julia Margaret Cameron, *The Angel at the Tomb*, 1870. George Eastman House, Rochester, Acc. No. 81:1124:09.

9-12
Walker Evans, *Allie Mae Burroughs, Alabama Cotton Tenant Farmer Wife*, 1936. Gelatin-silver print. Collection John T. Hill.

Because photographs record things as they happen to be, we rarely find the consummate organization that we come across in painting. Many photographs seem incomplete. The action has stopped, and the story is suspended. We peer into someone else's world, inspect everything, and perhaps see even more than the people in the picture do. We fill in the blanks and complete their stories in our minds.

The incompleteness of a photograph is, in the end, its special virtue. You may react to what the photographer wanted you to see, or you may discover something in the photo that interests only you. Whatever the case, a good photograph gives you the feeling that your encounter with the subject is important, and plants a seed about it in your mind.

A PHOTOGRAPH
BY BRUCE DAVIDSON

9-13
Bruce Davidson,
*Untitled, (New York
City East 100th Street)*,
#6, 1970. Silver print.

Consider the photograph by Bruce Davidson (Fig. **9-13**). I projected it on the screen in my art appreciation class one afternoon. My intention was to present an image that was casual and per-

haps even ordinary—like a snapshot. And indeed, at first there was little reac-tion. Then someone noticed that we were looking outside, and that the photo was asking us to compare what we saw in the room to what was outside the window. The neighborhood seemed overgrown and hostile. It was then that people noticed that the girls looked small and fragile. Their pose—how they leaned together, and how their arms hung limply at their sides—made them seem vulnerable, and their perch at the far end of the sofa made them seem isolated and alone. The panes on the window appeared like barriers, and evoked a feeling of alienation. The wide-angle lens gave a slightly queasy feeling to the perspective of the room. The students then began to notice what was not there. The room seemed bare, and suggested poverty, though tempered by the pretty dresses. The starkness of the scene was emphasized by the use of black-and-white, rather than color, film. The crisp, emphatic black-and-white print helped contrast the black skin of the girls with the white surroundings. The discussion then turned to race. People agreed that the image evoked feelings of sympathy for the plight of black children born into poverty. But could the image speak for poor white children as well? Had white children been substituted, would the meanings have changed? And finally, did the appearance of black children con-firm a stereotype in American culture that characterized all blacks as poor?

As you can guess, some people found the image sympathetic and life-affirm-ing; others found it troubling. Many different meanings were extracted from this image on that afternoon. One thing was certain: the photograph, which at first seemed almost negligible, was remarkably important to everyone in the room forty-five minutes later.

Afterward I learned that the photographer, Bruce Davidson, had visited East 100th Street, in New York's Spanish Harlem, for two years, taking and also hand-ing out photographs, and getting to know the people and earn their trust. The street was one of the poorest in the city. Davidson aimed to reveal his subjects sympathetically. When the photographs were exhibited at the Museum of Mod-ern Art in 1970, many people from the neighborhood came to see themselves.

Critics who published reviews of the exhibition echoed my students' reac-tions. Some found the photographs warm and empathetic, and some feared that Davidson's work would inadvertently stigmatize his subjects. One felt that the beauty of the photographs made them incapable of conveying the horror of the street. Underlying the intensity of these convictions is the understanding that a photograph documents, and hence confirms, a reality.

PHOTOGRAPHIC VISION

Photographic images have changed ways of seeing. Within decades of the invention of the camera, certain cityscapes by Impressionist painters reflected the new mode. Photography's helter-skelter arrangements, blurred images of people and horses in movement, strange juxta-positions, and objects moving out of the frame appealed to the Impressionists as a fresher, truer vision of the world around them.

9-14
Camille Pissarro, *Place
du Theatre Francais*,
1895. Oil on canvas,
28½″ × 36½″.
Los Angeles County
Museum of Art
(M.46. 3.2). Mr. and
Mrs. George Gard De
Sylva Collection.

9-15 (below)
A. Robert Birmelin,
*The Moment I Saw
the Man with the Rifle*,
1985. Acrylic on
canvas, 48″ × 78″.
Private Collection.

In Pissarro's painting (see Fig. **9-14**), the view is from high up, as if photographed from a window by a curious observer. From this vantage point we see the patterns on the ground, and people are tangled in the trees. As in photographs of the time, carriages drive out of the picture, and moving figures blur at the edges.

If you turn again to Ben Shahn's painting, *Handball* (Fig. 4-3), you will see that it adheres to the looseness of the snapshot on which it is based (Fig. 4-4). The partially hidden figure on the left is retained to heighten the sense of reality.

Since the 1970s, many painters have projected photographic slides onto their canvas and traced the outlines of the images in the dim light. Some of their paintings reflect the camera's way of seeing. Details erode, and edges are softened or may recombine in the glare of light.

Today, the camera's eye instructs and inspires painters. Robert Birmelin's paintings (Fig. **9-15**) evoke the chaos of the busy urban scene as one might experience it on the spot — or in a photograph. Blurred arms; tilted buildings; sudden recession of space; and loose, slightly awkward compositions suggest snapshot images of life caught on the fly.

The realistic but often fragmented character of photographs was exploited further by the collage technique. Developed around World War I, this technique involves cutting up photographs and reassembling them in unexpected juxtapositions to create new images. Strange figures and fantastic objects inhabit disrupted spaces. Ironic and often humorous, collages are moored uneasily to reality because of the veracity of the photographic details (see Fig. **9-16**).

Darkroom techniques also produced abstract pictures. In the 1920s, László Moholy-Nagy, Man Ray, and others explored a number of techniques including *photomontage* (combining negatives to

9-16
Hannah Hoch, *Schnitt mit dem Küchenmesser Dada durch die erste Weimarer Bierbauchkulturepoche Deutschlands* (Cut With the Kitchen Knife Through the Last Weimar Beer Belly Cultural Epoch), 1919. Staatliche Museen Preussischer Kulturbesitz, Nationalgalerie, Berlin.

9-17
Man Ray, *Faces
(Solarisation, Portrait
reflète)*, 1932. Solarized
silver print, 11¾″ ×
9¼″. Courtesy The
Menil Collection,
Houston, Acc. No.
F075-03.

create new images), *photograms* (images created without the use of a camera), and *solarizing* (reversing dark and light around the edges of a form; see Fig. **9-17**). Solarizing was widely used later for psychedelic posters of the 1960s. These explorations of the medium of photography expanded its possibilities and suggested photography's capacity to reach beyond the world of appearances.

Functioning as a tool for scientific investigation, photographs have made visible what the eye cannot see: the graceful coronet created by a splash of milk, the delicate pattern of the eye of a housefly, the mysterious landscapes of microscopic worlds. Photographs taken by astronauts in 1968 showed a beautiful, blue earth rising above the moon. In 1990 satellite-mounted cameras revealed the

surface of Venus, and speeded-up still photos showed for the first time the movement of our planet revolving on its axis. Transmitted by television newscasts to homes everywhere, images such as these are a part of our culture — the way we look at our world and find our place in it — and by expanding our awareness, they have altered our culture in turn.

PHOTOGRAPHY TODAY

In the last several decades, photography has been combined with painting and printmaking to produce blends of fantasy and reality. Robert Rauschenberg has incorporated silkscreened photographs into paintings and prints. He has also coated magazine photos with lighter fluid and rubbed the other side of the page to transfer the image onto a drawing of his own. Andy Warhol likewise used photosensitized silkscreens for his paintings.

Within the art world, photography itself has been long overshadowed by painting. From the beginning, many people regarded the camera as little more than a toy, and photography as a kind of hobby. But some argued early for the acceptance of photography as an art form. Alfred Stieglitz pioneered the exhibition of photographs as art in his New York gallery in 1907. Photography was taught at the Bauhaus, in Germany, in the 1920s. The influential Museum of Modern Art in New York established the first Department of Photography in the country in 1940.

9-18
Doug and Mike Starn,
Mater Dolorosa, 1987.
Toned silver print, tape,
wood, pastel, 48″ × 42″.
Courtesy Stux Gallery,
New York.

Photography today is moving into the mainstream of the art world. Many photographers are bringing to their work a kind of open-ended creativity associated with painting and sculpture. A large number are questioning conventions long identified with photography: its clean-cut appearance, its implicit veracity, its ties to the real world, its flatness, and its small size.

Since the mid-1980s, two young artists working as one have attracted considerable attention. The Starn twins, Doug and Mike, combine blowups on photographic paper to create images on a colossal scale (see Fig. **9-18**). Rejecting the traditionally pristine character of photography, they tape, tack, and staple together individual photographic prints, often intentionally misaligning them in the process. With details magnified, every accidental speck, splotch, and nuance of tone is made visible. The papers may be dipped in chemicals to tone them variously, and

9-19
Doug and Mike Starn,
*Horse + Rider of
Artemision*, 1989–
1990. Teflon on film,
silicon, wood, pipe
clamp, 92″ × 192″.
Courtesy Stux Gallery,
New York.

surfaces may be affected further by glue, tape, and chemical spills. Cracks, tears, and the natural curling of the photographic paper add to the overwhelming feeling of fragility. Even parts of the frames may be missing.

The Starns often present romantic or religious imagery: a rose, a dead Christ with gaping wounds, a weeping Madonna—the latter images photographed from Old Master paintings. The images appear to be affected by time. Many seem in a state of ruin or dissolution, as if unearthed in an excavation, or afflicted by chemical pollution. Sharp edges become ragged as they are enlarged, and the patchwork shifts of color, tone, and focus further obscure the images. The pale tones feel melancholy, like the petals of a flower pressed in a book. The misaligned prints give a feeling of slippage, as if a wholeness has been lost. These techniques distance the image and create a feeling of pathos.

More recently the Starns have been printing images on transparent film that is then mounted on thin strips of wood and metal clamped to a metal frame to hold them taut. The strips, under tension, arc forward to create a kind of transparent sculpture. Sometimes the transparencies are layered, as in this piece, where two prints of the horse's head join at the muzzle.

Horse + Rider of Artemision (Fig. **9-19**) is based on a photograph of an ancient Greek statue. Horse and rider, dynamic and full of life, appear as if caught in fragments of an ancient snapshot. The code letters and numbers and

the name "Kodak" on the margins are left visible to make us aware of the photographic process. We can't help but notice that the rider looks like a contemporary person gazing directly at us. The arm, which once held reins, now seems to beckon us. The image, delicate, transparent, shadowy, suggests that time is ephemeral. But clamped firmly together, the piece also suggests the potential of the photograph to win a reprieve from time.

The reproduction will indicate the shadows cast on the wall, which multiply the effect of transparent planes. In an exhibition in the Akron (Ohio) Art Museum, where the Starn brothers installed the show themselves, one could see the rider twice: once on the print and again in the pale shadow on the wall. It looked as though the image had emerged from the wall, like an apparition.

The Starns's pieces subvert what we expect photographs to be. We do not see through the surface of the photograph to a believable reality. The pieces both question and extend the power of the camera to embrace reality. Freewheeling and one-of-a-kind, they occupy ground once claimed only by painting and sculpture.

In the work of Cindy Sherman, Sandy Skoglund, and a number of others, photography crosses over into the area of theater, where it dissolves the border between fact and fiction, reality and appearance. In their work the camera regains some of art's function as illustration, but it is up to the viewer to invent the story. Sherman uses herself as a model to create fictionalized single-image biographies of female cultural stereotypes: the haggard housewife, the victim of abuse, the glamour girl, the runaway, the lovelorn teenager (see Fig. **9-20**). Her innocuous-looking, snapshot-like images take on something of the presence of

9-20
Cindy Sherman,
Untitled, #90, 1981.
Color photograph, 24"
× 48". Metro Fictures
Gallery, New York.

9-21
Sandy Skoglund,
Radioactive Cats,
© 1980. Cibachrome,
30″ × 40″. P.P.O.W.
Gallery, New York.

9-22 (below)
Barbara Kruger,
Untitled (Your Body
is a Battleground),
1989. Photographic
silkscreen/vinyl, 112″
× 112″. Mary Boone
Gallery, New York.

icons in their large-scale formats, and hint at a dark side to the characters portrayed.

Skoglund arranges props and actors to construct tableaus, and then photographs and prints them on a colossal scale. Skoglund also presents the actual tableaus as installations in the gallery. The images, realistic but curiously tangential to real-world situations, suggest stories, or parables. Skoglund shows ordinary places altered by strange arrivals. Lime-green cats invade a kitchen, 140 goldfish swim through the space of an all-blue bedroom, and bare tree limbs invade a rust-colored office, while bright blue leaves float everywhere. The inhabitants seem barely conscious of these extraordinary events, as though they happened every day. (Fig. **9-21**).

9-23
Video image of student stopping a line of tanks in Tiananmen Square, Beijing, China, in June 1989.

Barbara Kruger's photographs (see Fig. **9-22**) incorporate photographs borrowed from quasi-familiar advertising images. Together with accompanying texts that themselves look and sound like advertising slogans, these appropriated images are given ironic meanings that uncover their psychological and cultural ramifications. Kruger shows the ways that popular culture conditions and enforces conformity to prescribed female gender and social roles.

Apart from photographs made for galleries as works of art, many photographers today work in the tradition of photojournalism. Photographs appearing in magazines and newspapers involve us with people and events almost as they happen. Television, of course, transmits news instantaneously. But it is the still image pulled from the film or videotape that remains in the mind and serves as the key that reawakens the event in our thoughts (see Fig. **9-23**).

PHOTOGRAPHS AND AUTHENTICITY

Photography launched a revolution in seeing that extends to this day. The photographs of Matthew Brady, Alexander Gardner, and others, showing the battlegrounds of the Civil War (see Fig. **9-24**), spelled out the implications of that revolution. Their photographs of corpse-strewn battlefields brought the war home, and brought authenticity to the telling. An editorial in the *New York Times* on October 20, 1862 stated:

Mr. Brady has done something to bring home to us the terrible reality and earnestness of war. If he has not brought bodies and laid them in our door-yards and along

9-24
A. Gardner, *Home of a Rebel Sharp Shooter, Gettysburg*, 1863. Glass negative. Library of Congress.

the streets, he has done something very like it. . . . These pictures have a terrible distinctness. By the aid of the magnifying glass, the very features of the slain may be distinguished. We would scarce choose to be in the gallery, when one of the women bending over them should recognize a husband, son, or a brother in the still, lifeless lines of bodies, that lie ready for the gaping trenches.[1]

The Civil War photographs staked out new ground for photographic images by asserting that the camera eye could look anywhere. These photographs claimed attention as witnesses rather than as beautiful or comforting works of art. The images seemed objective and dispassionate in a way that paintings could seldom claim to be.

Photography transformed our understanding of the world quite suddenly by making much of it available. Today, the availability of photographic images—including electronically generated images such as video—allows a virtually instantaneous grasp of events. It means a breadth of knowledge previously unattainable. Images, extending our eyes everywhere, give us the power to observe, gather data, and reflect on it at leisure.

But if photographic images give us the world, they also filter it. As we have seen, the camera is no objective observer. It looks where someone points it, selecting and ordering as directed. No less than paintings, photographs are creations. They not only capture reality, they create reality. Responding to intentions, they shape our attitudes.

Much of what we see of the world today is on television. Our understanding of current events is skewed by television's need to entertain and amuse, as well as

inform. Images of whatever is colorful, violent, or odd serve those needs. Political discourse is reduced to "sound bites." News is squeezed into half-hour time slots. What is shown? How long does it last? Which images are most telling? And what do they tell? These questions suggest that to a considerable extent television news is a manufactured event that denies its manufacture.

Because they seem objective, photographs lend themselves to abuses. Gardner's photographs purported to be living records of the Civil War. Yet Gardner is known to have photographed the body of the soldier in Fig. 9-24 on the battlefield, identified it as a Union soldier, then hauled it to this spot, changed his identity to Confederate, and photographed him as though he had fallen at his post.

For years, touchups to photographs have removed wrinkles from faces and grease stains from shirts. These are small alterations. In Stalinist Russia, the practice of airbrushing politicians out of photographs when they had fallen out of favor constituted an abuse of the truth, as well as an affront to the public. In our time, computers alter images. In 1982, *National Geographic* shifted the position of an Egyptian pyramid to better fit the cover. A *TV Guide* cover in August 1989 showed Oprah Winfrey's face on Ann-Margret's body. Today, computer-doctored photographs can not only rearrange figures, but also add them, delete them, or change their color (Fig. **9-25**). And the technology is ever simpler, more accessible, and more precise.

What are the consequences? For one, consider our present use of photographs as illustrations in newspapers or magazines, or as evidence in court. We assume that they are trustworthy records. Soon we may need to rely on the word

9-25
This computer-altered image of the Yalta Conference places Groucho Marx and Sylvester Stallone with Winston Churchill and Franklin Roosevelt.

of an editor or photographer that the images are untouched. Yet last minute "computer enhancing" can be done without the knowledge of either the editor or the photographer.

Our increasing reliance on electronically recorded images—video—for information raises similar problems. Video images can be altered with no means of detection. No negative exists to document what the camera actually saw. Can television news editors resist the temptation to "improve" the images they show? What are the legal and ethical ramifications of altering images? We can be sure that electronic technology will carry these questions into the future, and perhaps keep a step ahead of the solutions.

CONCLUSION

Photography is a form of art in which the artistic component often seems of little importance. At the same time, the artistic aspects of photography are inescapable, as anyone knows who has ever pointed a camera at somebody and said "hold still" or "move over." Photography is fascinating, in part because of these ironies.

For years photography was the domain of hobbyists, adventurers, and commercial hacks. Photography was not generally considered an art form. If today photographs are exhibited in museums of art, it is because we recognize that they speak to us in a language of images that is distinct and compelling.

The invention of photography made it possible for anyone to preserve an indelible image of what he or she saw. For the first time in history non-artists had the means to make significant statements through pictures. Today, practically everyone can take pictures. Photography is a democratic art.

Of course, not all photos are intended as major statements. Most people take pictures for fun—for the pleasure of recalling people and places and good times. Photos preserve those people, those places, and those times. They celebrate the private and personal experiences that would otherwise have passed from memory. Time moves on; things change and slip into the past. But the images we take forever prove that we went somewhere, or saw someone, or did something, and, for as long as we can hold on to them, suggest that these things counted.

Photography has challenged old ideas about art, about art's purposes, about what art looks like and says. It has proposed new ways of mediating between people and the world around them. Photography has secured its own territory as an art form at the point where art and life merge, but it has altered the terrain forever.

10

STUDYING ART AND ITS HISTORY

The special kind of looking we do in a formal analysis helps us to recognize the decisions that an artist makes. These decisions, determined by the artist's attitudes and feelings, translate those attitudes and feelings into tangible forms. Because of this it is reasonable to see a painting, or any work of art, as an expression of the personality of its creator. ¶ But there is more to it than that. Consider Rubens's painting, the *Crowning of St. Catherine* (Fig. 4-25). The subject of the painting, and the characters in it, were almost certainly decided by the Augustinian priests who ordered it. The size of the painting was most likely determined by the space behind the altar where it was to be placed. The attributes of the saints, the color of Mary's clothes, and the presence of cherubs were all in accordance with traditional iconography. The subject matter and the form—an altarpiece depicting a scene from a saint's life—were common

in Western art from the Middle Ages on, though the type was restricted to Catholic countries after the Reformation. Finally, although the style of the painting is Rubens's own, it shares characteristics with the work of his contemporaries. ¶ Clearly a work of art is more than the product of an individual artist. It is also a product of its place and time. The role art plays in the society; the political, economic, and social situation; the religious or philosophical outlook; and the availability of materials will all have an impact on the art. ¶ While the actual weight of each of these factors is always open to speculation, no one will question their influence. Who uses the art? Who pays for it? These factors too will determine the subject matter and affect the way that subject matter is presented. ¶ Think of the art produced by any society. What does it look like? What materials are used? Is the art meant to be

seen at rest or in motion? Is it meant to be touched or not? Is the art a source of reverence, information, or enjoyment? Is the artist an aristocrat, a craftsperson, a shaman, or a nonconformist? Is the artist a man or a woman? A professional or an amateur? For the most part, the answers to these questions are culturally determined. At some point, then, an investigation of art must move beyond formal analysis to include the study of the art in its context.

CONVENTIONS IN ART

The study of art and its history makes us aware of the extent to which a work of art is subject to traditional forms, procedures, and modes of presentation. Consider, for example, in painting or sculpture:

- the size of a figure
- how time is presented
- the subject matter

How these are determined is not altogether in the hands of the artist — at least, not so much as one might think. In considerable measure they are a matter of convention, that is, a way of seeing and doing things established by tradition.

Incorporated in the art of any time or place is an accumulation of conventions. Within each culture its own conventions seem perfectly natural. Consequently, they are invisible to an extent — invisible, that is, until comparisons with works from other cultures and other periods bring them to light.

Let us examine these three examples — size, time, and subject matter — to see how they are treated in various cultures. We shall also try to find out *why* they appear that way.

Perspective

What determines the size of a figure in a painting? Is it entirely up to the artist? Most readers will guess that the size of a figure is determined by its location in space, the largest figures being nearest us. This accords with the rules of linear perspective, the mathematically-based system devised in the Renaissance. Because we're used to this system, and because it corresponds to the way we observe things — it's like what we see in a photograph — it seems natural, perhaps inevitable, to us.

But linear perspective isn't really natural at all. As any art student can tell you, perspective has to be learned. Nor is linear perspective the only sensible way to spell out reality. In Western art before the Renaissance, and in non-Western traditions, other perspective systems have been in use, and these also make sense.

In many cultures, size has been given symbolic meaning. In the Yoruba headpiece (Fig. 7-8) the legendary warrior-king, who was believed to possess spiritual powers, is the largest figure. In Christian art of the Middle Ages, figures repre-

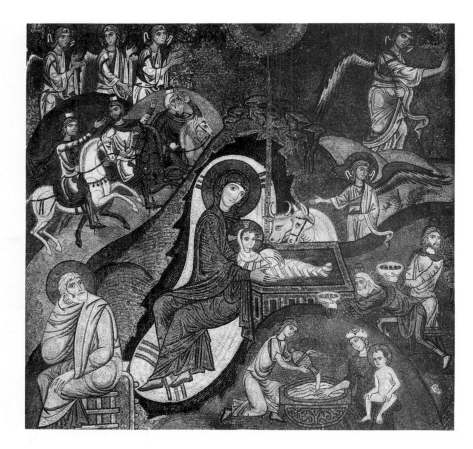

10-1
The Nativity, twelfth century. Mosaic. Palatine Chapel, Palermo.

senting God, Christ, Mary, and the saints appeared larger than ordinary mortals to convey their divinity. You can observe this in the twelfth-century *Nativity* (Fig. **10-1**) or Duccio's *Nativity* (Fig. 4-18). In medieval art, important people were also made larger so they could be easily seen. Similarly, in Buddhist art, narrative scenes usually depict Buddha as larger than everyone else. In Egyptian art, the size of figures was determined by social rank. The king, who was believed to be partly divine, was the largest of all (see Fig. 3-4). To an Egyptian, a Buddhist, a Yoruba individual, or someone living in medieval Europe, *our* system, in which figures diminish in size as they recede in space, would seem to violate the natural order of things.

Some Chinese or Japanese art, where near and distant figures are the same size, offers yet another way of ordering reality. Asian artists might insist that their vision is more truthful than ours: after all, do people really shrink when they walk away from you?

Asian art points up the difficulties inherent in the Western perspective system. Western artists find it a problem to show figures combined with large-scale architecture, or to show groups in which distant figures remain clear. In these situations, figures can become tiny, indistinct, or irrelevant. In Eastern traditions (in Turkey, Persia, and India, as well as China and Japan) artists solve these

10-2
Firdowsi, Shahnameh
(Book of Kings), folio
638r, *Nushirvan
Receives an Embassy
from the Ray of Hind, c.*
1527–1528. The
Metropolitan Museum
of Art, New York,
Collection of Arthur H.
Houghton, Jr.

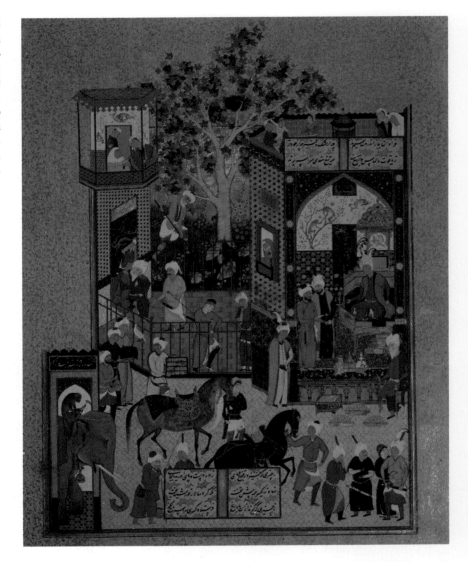

problems by flattening out the space in order to bring distant figures forward, where they can be clearly seen (see Fig. **10-2**). Figures in the background are shown higher up in the picture. The architecture, also unconstrained by the rules of linear perspective, is subordinated to compositional demands. Unconfined by the Renaissance perspective system, but working within their own conventions, Eastern artists could concentrate on weaving richly decorative arrangements of line and pattern.

The appearance of a figure in a painting thus depends in part on the particular convention in which the artist is working. The Renaissance perspective system is but one of a number of conventions — traditional or customary practices — for the depiction of space, any and all of which may lay claim to a basis in truth.

Time

Next we'll consider how time is presented in a work of art. Based on the art most familiar to us, we might think it only natural that a work of art show us a single moment in time. Think of Rembrandt's *Night Watch* (see Fig. 2-1), or of Impressionist painting (Fig. 17-5) or of photographs. All of these capture a single moment in time. But not every artistic tradition aims at this as a matter of course.

The art of ancient civilizations such as Egypt and Assyria presented figures and events existing *beyond* the reach of time. Solid, blocklike forms in sculpture (Fig. **10-3**) and crisp, factual delineations in painting (see Fig. 3-4) were meant to guarantee immunity from change and decay. Whether propaganda or magic, or both, the art had no interest in time-bound phenomena, but rather in the eternal order of things. The quality of timelessness is found as well in the religious art of medieval Europe (Fig. 7-13) and in the sculpture of Africa (Fig. 7-8), which is also spiritual.

10-3
Pair Statue of Mycerinus and His Queen Kha-Merer-Nebty II, 54" high. Museum of Fine Arts, Boston.

In medieval art a painting or carving may show more than one episode of a story, thus depicting *various* moments of time in a single frame. Consequently, the same figure may appear in more than one place. In the mosaic of the nativity shown in Figure 10-1, you can see the infant Christ held by Mary, and again, in the lower right, being washed by the two midwives. The Magi appear on the left, riding toward the star over the manger, and on the right, presenting their gifts. Of course, no one would have construed that these people were in two places at the same time, any more than you or I would be confused by the conventional layout of a comic strip. The medieval mode of pictorial presentation makes sense, in its way, for it is able to present an entire story efficiently in a limited space.

The idea that a scene should highlight a precise moment in time had occurred in some Greek and Roman art, but was of little concern in the Middle Ages. It reappears on the eve of the Renaissance, in Italy, in the work of a few artists of the early

10-4
Masaccio, *Expulsion from the Garden, c.* 1425. Fresco. Brancacci Chapel, Santa Maria del Carmine, Florence.

fourteenth century. Their art expresses the intuition of a more rational world than that conceived in a pre-Classical antiquity or in the Middle Ages. In Renaissance art, linear perspective, with its ordered space, was joined with the complementary notion of the depiction of a precise moment in time (Fig. **10-4**). Thus fixed in space and time, human events could be given an immediacy beyond the scope of the more abstract art of Egypt, Assyria, or medieval Europe (Fig. **10-5**), with their meditations on timeless events and eternal truths.

Scenes presenting a single moment in time involve us with specific individuals who have character and feeling. Just as we are drawn up close in time and space, we are also drawn up close psychologically. By replacing the old convention with a new way of seeing (which itself eventually became a convention), artists of the Renaissance presented a new reality.

10-5
The Story of Adam and Eve, from the Carrow Psalter, *c.* 1250. The Walters Art Gallery, Baltimore.

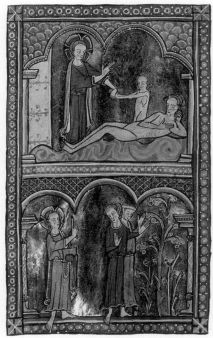

Subject Matter

Subject matter — what is chosen and how it appears — is affected by artistic and cultural conventions. Why have there been so many female nudes in Western art since the Renaissance? Why is their sexuality so often made overt? One reason is that men did these paintings for men. The paintings answered to the fantasies of men, not of women, and reflect time-honored social conventions.

Accordingly, women have typically been represented as dominated by men. Men stand and hold the reins or the rifles, while women sit to their left and hold teacups or flowers. Nude or bare-breasted women were frequently cast as goddesses or allegorical figures. Safely distanced, often imparting a moral lesson, these could be viewed by men without guilt (think of Hiram Powers's *The Greek Slave*, Fig. 7-14).

The tradition of the female nude in the West begins with Greek goddesses. Revived in the Renaissance, the female nude became an embodiment of ideal beauty. Often sensuous, but always idealized, the nudes were affirmations of the sublime, transformative powers of love (see Fig. **10-6**).

But as culture changes, so do conventions. In the eighteenth century, the female nude became vulgarized. She is more often found in the bedroom than the landscape, and is usually more provocative than profound.

The sexuality of many nineteenth-century female nudes is overt, even fetishized. Consider this harem girl by the celebrated French painter, Ingres

10-6
Giorgione, *The Pastoral Concert*, c. 1508. Oil on canvas, approx 43" × 54". Louvre, Paris.

10-7
Jean-Auguste-
Dominique Ingres,
Odalisque with Slave,
1836–1840. Oil on
canvas mounted on
panel, approx. 28⅓″ ×
39⅓″. Courtesy of the
Fogg Art Museum,
Harvard University,
Cambridge,
Massachusetts.
(Bequest of Grenville L.
Winthrop, Acc. No.
1943.251.)

(Fig. **10-7**). Her sexuality is so blatant that one wonders whether she was painted "tongue-in-cheek." Passive, inviting, this woman is a sex object. She exists for pleasure twice-over — once for the Sultan who owns her, and again for her audience of real-life men, who get to imagine themselves as sultans.

In nineteenth-century Western Europe, this sort of depiction was taken for granted. It is commonplace in ads today. But this convention is not universally shared. An African sculptor would likely have regarded Ingres's painting as vulgar. In traditional African art, only minimal distinctions are made between the sexes. Convention determines that both appear with equal dignity.

The continent of Africa is far from the monolith of popular Western imagination. A multitude of artistic styles and conventions reflect Africa's extraordinary cultural diversity. In sub-Saharan Africa, however, certain conventions appear frequently. The primary vehicle for depicting human beings is the free-standing statue (see Fig. **10-8**). Most are abstract, but still recognizable. Typically, the figures are frontal, nude, and symmetrically balanced, and show the entire figure. The aim is to represent a general, unindividualized human type.

The head is enlarged to indicate its importance as the seat of intellect and wisdom. Standing figures are often represented with knees slightly bent. This is

visually effective, providing a lively contrast to the straightness of the torso. But in conveying potential for action, it also expresses life-force, an important and widespread concept in Africa. In this view, what counts in a person is not outward appearance, but the energy and potential within.

This emphasis contrasts with the Western concern for natural appearances, and the realistic, often sensuous art that has ensued from it. But it should not be altogether unfamiliar. The art of African cultures is akin to medieval religious art in Europe (which was also governed by strict conventions). Both traditions emerge in the context of an intense apprehension of the spiritual world. Like the sculptor at Chartres (Fig. 7-13), or the painter of the Byzantine icon (Fig. 3-5), the African artist's concern is not for the exactitude of the image, but, through abstract forms, to evoke that which is invisible to the eye.

Ingres's painting reflects the Western concept of art-for-art's-sake. Images of women, like images in general, were viewed for pleasure. Art in Africa, on the other hand, remained an integral part of the cultural environment—the religious, political, and social life of the people. Where art in the West became increasingly sensuous, art in Africa remained what it had been: a means of contact with the spiritual world.

The perceptive reader will also have noticed other conventions of subject matter in Ingres's painting: the depiction of the Islamic world as sensuous but decadent, and the equating of social rank with skin color. In Ingres's time these conventions were perfectly natural (see also Fig. 18-14). Are these conventions alive today? The answers are to be found in popular art, such as ads, films, and television shows.

Our discussion has demonstrated that *how* a painting or sculpture looks depends not just on the artist but on the culture that produces it. We can go even further and say that *what is depicted* in a painting also depends on the culture.

Landscape art provides a striking example of this. Nearly everyone enjoys looking at views of landscapes. We find them in calendars, Christmas cards, cigarette advertisements, and films. Some European painters of the fifteenth and sixteenth centuries created imaginative landscape settings. But these were exceptions. The regular use of the landscape as an independent subject appeared in European painting only as late as the seventeenth century, primarily in Holland. Of the landscapes that were produced before this, most were intended as settings for human dramas; even the Dutch were reluctant to omit the human presence in their landscapes. Despite the beauty of these paintings, many art critics outside of Holland in the seventeenth and eighteenth centuries ridiculed the Dutch landscape painters and considered their paintings meaningless. It was not until the nineteenth century that landscape painting came to be widely accepted.

Landscapes of course appeared in the backgrounds of portraits and figure paintings beginning in the late Middle Ages. Many of them are quite detailed. Sometimes actual locations were introduced and can be identified. But evidence that an artist painted on the spot is extremely rare (with the exception of an occasional ink wash or watercolor study). All landscapes were painted in the studio right up until the nineteenth century, when at last a few artists, anxious to

10-8
Female Figure, Tabwa culture, Zaire. Wood, 19¼″ × 5¼″. Courtesy of the Menil Collection, Houston, Texas.

10-9
Wen Cheng-Ming,
Landscape, c. 1517. Ink
on paper, 36¾" × 8³⁄₁₆".
The University of
Michigan Museum
of Art.

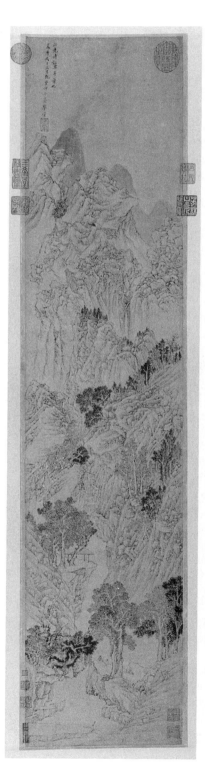

capture more precisely the light and atmosphere of a particular site, dared to paint out of doors.

While landscape painting was a relatively late development in the West, another culture had long focused on it with great intensity: the Chinese. For over one thousand years landscape was for Chinese artists the highest expression of their art (Fig. **10-9**).

What accounts for this disparity? The answer lies within the cultures themselves. The contrasting attitudes toward landscape as subject matter reflect contrasting philosophical attitudes toward the natural world. During the Middle Ages, Christians were bidden to look away from this world to the next. The natural world was of little concern. Then, in the Renaissance, the natural world became a stage for human actions. The Chinese tradition, on the other hand, held that humanity was small within the natural order. For the Chinese, nature was pervaded by a living, cosmic spirit. Chinese tradition therefore encouraged people to contemplate nature, either directly or through paintings, as a means of attaining harmony with that spirit.

Clearly, for Western culture at least, nature as subject matter just wasn't as natural as we might think. Not everyone found it as interesting as we do today, or thought of it as beautiful or precious. The status of landscape as subject matter has always been determined by cultural predispositions, not individual tastes. Even the way a landscape is painted is not just based on the whim of the painter, but on tradition.

Western painting from the fifteenth century onward is characterized by the use of oil paint, which, as we have seen, lends itself to illusionistic depictions of the subject. Chinese landscapes are painted in ink and are made up of distinct

10-10
Anthony van Dyck,
Charles I at the Hunt,
1635. Oil on canvas,
approx. 9' × 7'.
Louvre, Paris.

brush strokes and washes (Fig. 10-9). These marks retain their identities; they do not wholly transform themselves into realistic images by Western criteria. However, they *evoke* natural forms, and because of their innate expressiveness, they manage to convey the essence or character of whatever they depict. Thus where Western art aims at an optically correct representation of the outward appearance of a mountain or tree (see, for example, Poussin's *Landscape with Burial of Phocion*, Fig. 4-23), Chinese art aims to transmit the inner nature, the "spirit resonance" of the mountain or tree.[1]

What is the relation of the figure to the landscape? The figure in a Western painting will often seem to stand apart from and to dominate its world (Fig. **10-10**). The figure in a Chinese landscape will be small. It will appear to be

10-11
Wen Cheng-Ming,
Landscape, c. 1517.
Detail. Ink on paper,
36¾″ × 8³⁄₁₆″. The
University of Michigan
Museum of Art.

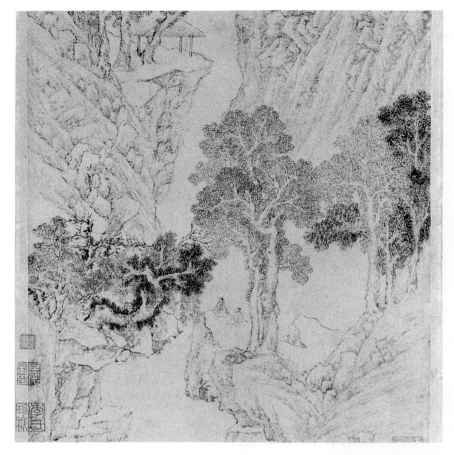

enveloped by the world around it, and integrated into that world (Fig. **10-11**). The decision as to where the figure is placed in relation to the landscape reflects a cultural attitude regarding the relationship between humans and nature.

The kind of perspective used is also determined by tradition. Typically in Western painting the point of view is low, as though the viewer were standing on the ground on the edge of the landscape, looking across at it. As the landscape recedes into the distance, objects diminish in size. In Chinese landscapes the observer is given an aerial view. Objects do not diminish in a regular way. You may find yourself looking down and up and even around the side of a mountain or rock. In this way you are drawn *into* the space of the scene and invited to walk around in it. Western paintings, based on linear perspective, suggest a rational, logical order, whatever their subject matter. By contrast, the more intuitive perspective of Chinese paintings inevitably lends them an imagined quality.

We have seen very different roles for landscape in these two cultures. In the West, landscape was for centuries of little or no interest. In the East it was of consummate importance. When landscape appears in Western art, its character contrasts strongly with that of Chinese landscape. Even the relationship between the viewer and the subject matter is different: Western landscapes we observe from the outside; Chinese landscapes we contemplate from within.

REALISM

IMPRESSIONISM

POST-IMPRESSIONISM

1870

MANET,
*Luncheon on
the Grass*
1863

RODIN,
*The Burghers
of Calais*
1886–1887

VAN GOGH,
Starry Night
1889

FRANÇOIS
MILLET,
Gleaners
1857

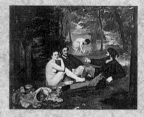

MONET,
Poplars
1891

CEZANNE,
*Still Life with
Basket of Apples*
1895

MUNCH,
The Scream
1895

DARWIN,
Origin of Species
1859

American
Civil War
1861–1865

1960 1970 1980 1990

POSTMODERN

NEW FIGURATIVE PAINTING

ISM POP ART

KIEFER,
Interior
1981

KRUGER,
*Your Body is
a Battleground*
1989

Assemblage
Environments
Happenings

Earth and Site Art
Conceptual Art
Performance Art

WARHOL,
100 Cans
1962

CHRISTO,
Running Fence
1972–1976

STARN TWINS,
*Horse + Rider
of Artemision*
1989-1990

CHICAGO,
The Dinner Party
1973–1979

Vietnam War
ends
1975

Opening of the
Berlin Wall
1989

Persian
Gulf War
1991

GREECE ROME BY

CLASSICAL PERIOD (EASTERN

Poseidon Column of Trajan
(or Zeus) A.D. 113
c. 450 B.C.
 Justinian a
Parthenon Attendan
448–432 B.C. c. A.D. 54

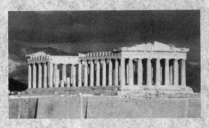

Pericles Constantine
c. 495–429 B.C. recognizes
 Christianity
Socrates A.D. 325
c. 469–399 B.C.
 Augustus
Plato c. 27 B.C.–A.D. 14
429–347 B.C.

Aristotle
384–322 B.C.

EARLY RENAISSANCE HIGH MANNERISM
 RENAISSANCE

MASSACIO, TINTORETTO, CAR
Expulsion from Miracle of S
the Garden JAN VAN EYCK, RAPHAEL, the Slave at F
1425 Giovanni School of Athens 1548 c.
 Arnolfini 1509–1511
 and His Bride
 1434
 MICHELANGELO,
BRUNELLESCHI, Day
Santo Spirito 1520–1534
1436 LEONARDO
 DA VINCI,
 The Last Supper
 1495–1498

Columbus sails Protestant
to New World Reformation
1492 begins
 1517

NEO-CLASSICISM

1800 1820 1850

ROMANTICISM

R[

DAVID,
*Oath of
the Horatii*
1784

DELACROIX,
Massacre at Chios
1822–1824

COURBET,
The Stone Breakers
1849

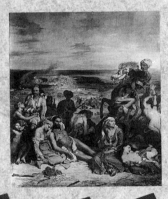

The Capitol
Building,
Washington, D.C.
1792

J.M.W. TURNER
*The Campo Santo
Venice*
1842

JEAN
M
The

French
Revolution
1789

Photography
patented
1839

MARX,
*Communist
Manifesto*
1848

1900 1910 1950

CUBISM DADA SURREALISM ABSTRAC
EXPRESSION

PICASSO,
Ma Jolie
1911–1912

BREUER,
Armchair
1925

POLLOCK,
Number 1, 1948
1948

DALI,
The Phantom Cart
1933

DUCHAMP,
Bottle Rack
1914

FREUD,
*Interpretation of
Dreams*
1900

World War I
1914–1918

The Bauhaus
1919–1933

World War II
1939–1945

1000

MIDDLE AGES

ROMANESQUE

ZANTINE
ROMAN EMPIRE)

nd
ts
7

ST. PIERRE,
Moissac
c. 1115–1135

First Crusade
1095–1099

Charlemagne
establishes
Holy Roman Empire
800

GOTHIC

Chartres
Cathedral
jamb figures
c. 1145-1170

Carrow
Psalter
c. 1250

GIOTTO,
Meeting of
Joachim and
Anna
c. 1305

Ottoman
Turks
conquer
Constantinople
1453

1600 **1650** **1700** **1750**

BAROQUE

AVAGGIO,
upper
mmaus
1600

REMBRANDT,
Hendrickje
Bathing in a
Stream
1654

RUBENS,
he Crowning of
St. Catherine
1633

POUSSIN,
Et in
Arcadia Ego
c. 1655

Founding of the
French Royal
Academy
1648

ROCOCO

POZZO,
Glorification of
St. Ignatius
1691–1694

WATTEAU,
Embarkation
from the Isle of
Cythera
1717–1719

J.H. FRAGONARD,
Blind Man's Buff
1750–1752

American
Revolution
1776

CONVENTIONS AND STYLE

Artistic conventions represent a particular way of seeing and doing prescribed by the culture. Every society thinks of its own traditions, if it considers them at all, as sensible and self-evident. But as we have seen, what is obvious or natural in one place may not be so obvious or natural in another.

Artistic conventions that are unfamiliar to us may look strange. We are tempted to think that there was something wrong with the way the artist saw the subject. It may be that the artist was clumsy. Yet it is also possible that the artist was working successfully within a framework of conventions different from the ones to which we are accustomed. Conventions that vary from our own are not mistakes or wrong ways of looking at things, but *different* ways of looking at things.

The art produced in any culture reveals the preoccupations of the society. We can discover those preoccupations by asking: What is included? What is omitted? How is it shown? The art of every culture articulates, in concrete terms, the assumptions the society has made about the nature of life and experience. Who are we? What is our place? How does the universe work? What counts? The study of art history reminds us that these questions have been answered in strikingly different ways, and contributes to our understanding of those answers.

Works of art do not necessarily address themselves *consciously* to these questions. Some do, of course. But all works of art, *in their very appearance*, tell us these things. The forms themselves speak to us both of the artists, and of the cultures of which they were a part. The visual statements that works of art make about their society can reveal as much as written statements, and even more.

In order to interpret these statements art historians frequently compare various representations of specific subject matter, as we have done here with landscape and the female nude. As a part of their efforts to interpret works of art, art historians focus on style. When we look at the art of any one period we find a consistency of appearance. That consistency of appearance — the ways things look — is called a style. A style is formed by the whole range of conventions that are in use at a particular time. It also reflects the creative achievements of individual personalities. For these reasons, style is central to the study of art and its history. If the study of art and art history is in part the comparison of changing styles, it is because these styles speak for the times in which they were produced. The replacement of one style by another suggests a new way of looking at things. What is dropped? What is retained? And why? Art history raises these questions, and tries to provide answers to them.

GOING BEYOND FACE VALUE

The study of art and its history sharpens our eyes and trains us to read works of art for the statements they contain. We now know that there are a number of ways one can read a painting (or any work of art). We'll consider some of them now.

One way, of course, is just to look at what is being presented. Paintings show us what things mattered to the society. They can show us jewels and fine clothes, globes and telescopes, ships and cannon, castles and villages, violence and beauty, piety, and pomp. What is omitted is important too.

Paintings have long been enjoyed simply as illustrations of stories, so it is also important to be acquainted with the theme of the painting. What is the story? Who are the players? Is the subject historical? Allegorical — that is, do the characters represent specific ideas? Is the subject a combination of the two? What changes, if any, has the painter made in telling the tale?

This surface reading of paintings must sometimes be supplemented by another approach: the recognition and interpretation of symbols. A symbol is a pictorial element that stands for something else. For example, a dollar sign, a halo, and Elsie the Borden cow are all familiar symbols. Like all symbols, they function because their meanings are acknowledged by all members of the society. Ignorance of symbols and their meanings can leave us open to misinterpretations of what we see in a painting or sculpture. Did the early Christians wear plates on their heads? Do we worship cows? In societies having minimal literacy, or no written language at all, the meanings of symbols are quite specific. In literate societies symbols are more challenging to recognize. They have not been codified, and their meanings are looser, more open to interpretation. For example, a landscape, however realistic and natural it may appear, may contain symbolic meaning, as when it represents a storm, a rainbow, or a sunset. Symbolic meaning might be imparted by details such as a tree broken at the trunk, or a ruined building. What do you think of when you see a shadow on the wall? A skull? A dog sleeping by the hearth?

Some of the symbols I have mentioned can be seen in Jacob van Ruisdael's painting of the *Jewish Cemetery* (Fig. **10-12**). The cemetery is a real place, but the ruined building is an invention of the painter. What other symbols can you find in the painting?

Of course, we can enjoy the images we see purely as naturalistic representations. But to close our eyes to the secondary meanings they evoke, or once evoked to their audiences, would be to miss out on a complete understanding of them.

People often use gestures to communicate without words. Gestures frequently appear in paintings, where they may also have specific meanings. In Persian art, a finger placed before the mouth indicates surprise. In early Christian art, hands open and raised to the level of the shoulders represents an attitude of prayer. The English art historian Michael Baxandall, who investigated the sign language developed in the Middle Ages by Benedictine monks, suggests that the gestures of Adam and Eve in Masaccio's *Expulsion from the Garden* (Fig. 10-4) have precise meanings: Adam displays shame, while Eve displays grief.[2]

Colors frequently carry symbolic meanings. In some cultures, colors are prescribed for certain figures or objects. The ancient Egyptians used red to represent evil. In China red traditionally symbolizes happiness. In paintings of the Renaissance, the color of Mary's robe was always blue, to symbolize her role as Queen of Heaven. In the Hindu art of India, blue is the color of Krishna. Persian

10-12
Jacob van Ruisdael,
The Jewish Cemetery, c.
1655. Oil on canvas,
56" × 74½". Courtesy
of The Detroit Institute
of Arts. (Gift of Julius
H. Haass in memory of
his brother, Dr. E. W.
Haass.)

miniatures used black to represent India. Since these colors were used in part for identification, any arbitrariness in their use was out of the question.

There are, of course, a number of possible reasons why a color is selected. The color of a tree, for example, may be chosen because it was matched with nature, insofar as the artist was able to do this. It may be a matter of convention, such as the gravy-colored trees that flourished in paintings between the sixteenth and the nineteenth centuries. Or the color may come out of the artist's imagination. Clearly then, it is important for our understanding of a painting to distinguish the mode in which color is used.

Certainly, if we want to open to *all* the meanings that are contained in a painting, we can't restrict our attention to subject matter alone. Some meanings lie beneath the surface of the subject matter, and we need to know about them to make sense of what we see.

Finally, meaning is communicated through *form.* As I pointed out in Chapter 4, looking carefully at the form of painting, that is, the way the subject matter is presented, strengthens our understanding of its content. We achieve insight into

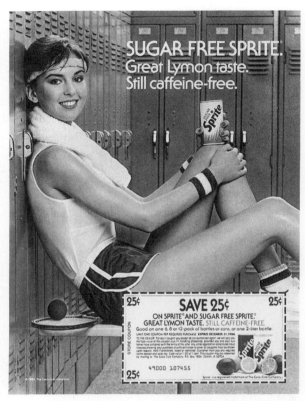

10-13 (left) Alfred Stevens, *Hide and Seek (Cache-Cache)*, c. 1876–1880. Oil on panel, 29¼″ × 20⅜″. University of Michigan Museum of Art. (Bequest of Margaret Watson Parker, Acc. No. 1955/1.85.)

10-14 (right) Courtesy of The Archives: The Coca-Cola Company.

a painting, or for that matter any work of art, when we consider *why* the subject was handled in a particular way. Our analysis becomes a kind of decoding of the piece we are looking at, or a reading between the lines in order to discover its implicit meanings.

Our comparisons of Western and African nudes, and Eastern and Western landscapes, were examples of this kind of inquiry. Essentially, we are asking ourselves what values, ideas, and attitudes are embodied in art. These may have been so much a part of their time and place that the artist, taking them for granted, may have been only marginally aware of them, if at all. But time and change can make them clear to us. So much so, in fact, that sometimes the first reaction we have to a painting or sculpture — or for that matter, to an advertisement — is a response to just these meanings. For example, look at Figures **10-13** and **10-14**. How is each woman dressed? How is she posed? Where is she placed? What is she doing? Where is she looking? What else is included in the scene? What do these images tell you about changing social attitudes toward women?

These, then, are some of the ways that we may study works of art for the meanings they contain. The trick is: never take what you see at face value. Keep in mind that any work of art is a highly selective, highly refined, and inevitably highly fictive version of reality. Its appearance will be determined not simply by

the subject and the personality of the artist, but also by the styles and conventions of the time.

We can think of culture as a lens through which we view reality. However clear-eyed, however rational we may think it is, culture colors whatever we look at, and modifies it in some way. Thus culture determines to a great extent what we see in a work of art, what ideas will find expression, and what the artist's attitudes will be.

We can learn from all works of art — even the ones we don't particularly enjoy. By learning to read them for the statements they make, we can form an idea about the attitudes, values, and beliefs of people and cultures unlike our own. There is a history to art because there is a history to human experience. The advancement of our understanding of that experience is one of the goals of art historians.

WESTERN ART

Now let's turn our attention to the art of Western civilization. Western art is only one of a number of artistic traditions, but it is the one that has been given to us. Any discussion of Western art and civilization must take into account the major changes in outlook that occurred at various times — changes that made themselves felt in the art. In Chapter 17, we will consider some of the particular ideas and interests that Western art has incorporated over the years. In Chapter 18, we will survey the artistic styles that characterize the major art historical periods. If, however, we were to look at Western art in the most general terms, emphasizing the constants rather than the variables, what would we find? In the remainder of this chapter, we will look at the art from the High Renaissance to the beginning of the modern period — from about A.D. 1500 to 1900. This art provides the background to our own epoch; it has shaped our environment, and constitutes most of what we see in museums today. What is its character? What preoccupations do we find?

To begin with, the art focused on human activities. We find this at the roots of Western art, in Greece, where freestanding statues of handsome youths were dedicated to the gods and where crisp, lively images of men and women decorated the pottery (Fig. **10-15**). Unlike the art of other cultures, where figures were abstract or symbolic, Greek painting showed people engaged in activities — running, sailing, fighting, conversing, and so on — and gave them the vigor, self-awareness, and individuality that remains a part of Western art to this day.

10-15
Exekias, Group E, *Quadriga Wheeling Right*. Amphora and lid, Attic Greece, c. 550–530 B.C. Wheel-thrown, slip-decorated earthenware, approx. 18" high. The Toledo Museum of Art. (Gift of Edward Drummond Libbey.)

Furthermore, Western art is, strikingly, an art of realism; it is an art that corresponds as far as possible to visual perception. Artists working in this tradition have asked not only "What is it?" and "What do I see?" but "How does it look?" and "How can I make a convincing illusion of what I see?" We find the beginnings of this interest in Greece and Rome. Following the Middle Ages, with its other-worldly focus, Renaissance art revived the idea of art as imitation.

We must keep in mind, however, that while art since the Renaissance has presented convincing depictions of the external world, it rarely aimed to show life just as it is. Much more often than not it sought to *idealize* life: the most perfect examples from nature would be chosen as models and then presented in even more beautiful form. The teachings of the Greek philosopher Plato (*c.* 427–347 B.C.), rediscovered during the Renaissance, were the basis for the belief that such "improvements"—essentially, images of perfection—would furnish a better idea of truth or reality than the depiction of things as they are.

Always take from nature that which

you wish to paint, and always choose the most beautiful.

—Leon Battista Alberti (from *On Painting*, 1435)

In addition to the idealized forms, the *themes* that were selected frequently conveyed a picture of life on a loftier plane. Illustrations of Biblical stories and of Greek and Roman history and mythology were especially popular, appearing again and again. Imaginative and philosophical images such as Giorgione's *Pastoral Concert* (Fig. 10-6) were also admired because of their refined evocation of a supposed Golden Age of antiquity. Only subjects such as these seemed sufficiently worthy for art.

Western idealism was linked to an educational or moralizing end. The function of art to instruct and to improve, as well as to delight the senses, was continually asserted from the Renaissance on. That this principle had been articulated in ancient Rome only gave it greater authority. In 1649, the Spanish painter and theoretician, Francisco Pacheco, wrote that religious paintings "perfect our understanding, move our will, refresh our memory of divine things. They heighten our spirits . . . and show to our eyes and hearts the heroic and magnanimous acts of patience, of justice, chastity, meekness, charity and contempt for worldly things in such a way that they instantly cause us to seek virtue, and to shun vice and thus put us on the roads that lead to blessedness."[3] On October 16, 1780, Sir Joshua Reynolds, in a lecture to students at the Royal Academy in Somerset, England, asserted that the artist's task is "to raise the thoughts, and extend the views of the spectator" to the ultimate purpose of leading the public to virtue. The Official Catalogue of the Salon exhibition of 1793 in Paris declared in its introduction: "The arts should never limit themselves to the single aim of pleasing by faithful imitation. The artist must remember that the goal which he has

set before him is, like that of all work of genius, to instruct men, inspire in them the love of goodness and to encourage them to honorable living."[4] And in 1869 William Cullen Bryant concluded his argument for the establishment of a public art museum in New York (later to become the Metropolitan Museum of Art) by pointing out that by providing "attractive entertainments of an innocent and improving character," the museum would combat the temptations of vice bred by a large and overpopulated city.

In accordance with this attitude much of the art, whether religious or secular, aimed to inspire people by providing them with images of piety, nobility, dignity, grandeur, and courage. Not all art responded to the call for moral uplift, however. A great deal of Western art remained happily and resolutely decorative. People looked to art simply for pleasure, much as we do today. Artists such as Titian, Rubens, and Velázquez, who painted intensely moving religious and historical dramas, also gave us paintings to please the senses. Much of the Rococo art of the eighteenth century shunned all that was serious. (See, for example, Fragonard's *Blind Man's Buff*, Fig. 13-2.) The landscapes of Claude Lorrain in the seventeenth century and the cityscapes of Canaletto and Guardi in the eighteenth were more picturesque than profound. Yet these artists, in their own ways, elevated whatever they painted to a higher, more poetic, more visionary plane.

In sum, art focused primarily on human activity, which was depicted in lucid but imaginative statements. Aspiring to truth through images of a perfected world, and providing inspiration through depictions of exemplary action, art often served high-minded moral and instructional purposes. At the same time, the function of art to give pleasure remained a constant.

Unhappily, the idealization of life occurred on a somewhat less exalted level. Paintings tended to flatter their subjects. (Even Joshua Reynolds, who was quite successful as a portrait painter, flattered his sitters; this may be the reason why he had so many commissions.) It's easy to recognize this kind of flattery in the idealized but, to our eyes, pretentious way that the subjects in a portrait were presented (Fig **10-16**).

It is also important to recognize the accommodation that art made to the version of reality that patrons wished to project. Painting, sculpture, and architecture put into tangible forms the outlook of a particular class. The art would not necessarily have spoken for the whole of society, especially when the

10-16
Drawing by Donald Reilly, © 1966 The New Yorker Magazine, Inc.

"Give me more angels and make them gladder to see me."

disparity between classes within the society was wider than it is today. Scenes depicting idyllic life in the country or poor-but-happy beggar children in the city were part of the fantasy life of the rich. Only rarely did a work of art record the grimmer reality experienced by the poor, or give expression to their hopes and dreams.

Western art tended to prefer the wings of fantasy to the mirror of reality. Most often these wings carried it directly to antiquity; to the persons and events of the Bible, of Greece, and of Rome. This orientation to ancient history, noticeable in any trip to a museum, and evident even in the illustrations of this book, puzzles many people today. What magic did the ancient past possess that charmed successive generations?

The answer lies in an idealistic attitude toward antiquity which has only recently, in our own century, been questioned. As far back as late Roman antiquity the belief prevailed that the greatest wisdom resided in the past. Since that time, the West has looked upon two ancient civilizations as perpetual examplars for humanity: one, the civilization of Greece and Rome, and the other, the Hebrew civilization of the Near East. This reverence for the past conditioned Western intellectual life and its art.

In the Middle Ages, the Church preserved classical texts along with the teachings of the early Church fathers. The writings of certain classical philosophers continued to be considered authoritative. In the Renaissance, people believed that the study of classical antiquity would bring about a renewal of Western civilization. That renewal would produce the kind of person who, at that time, was associated with classical civilization: proud, capable, serious, virtuous, and free.

While Renaissance humanists were absorbed in classical antiquity, the Protestant Reformation of the sixteenth century focused on the Bible and early Christianity. Protestant theorists, like the classicists, looked for a regeneration of society based on events and teachings of the ancient past. Thus Renaissance and Reformation alike were haunted by the assumption that civilization had declined since that more perfect time.

Modern culture reverses that sequence. With faith in the inevitability of progress, it has tended to trust in the eventual perfection of society through social and technological advances. It is therefore not easy for us to appreciate the degree to which people gave authority to the teachings of antiquity. As late as the seventeenth century, and even beyond that time, the Bible, as the word of God, and the teachings of certain Greco-Roman scholars, such as Aristotle, Hippocrates, and Galen, were thought to be the final word on the physical nature of the universe, on humanity, and on humanity's place in the universe. The evidence of scientific investigation, such as it was, carried less weight. The dispassionate scientific outlook with which we are familar today was unknown until the seventeenth century: before then, people sought and found in the world around them proofs for what had already been revealed in ancient texts. (Except for Leonardo da Vinci, who wrote in his notebook: "To me it seems that those sciences are vain and full of error which are not born of experience, mother of all certainty, firsthand experience which in its origins, or means, or end has passed through one of the five senses.")

10-17
William Thornton,
E. S. Hallet, Benjamin
H. Latrobe, Charles
Bulfinch, architects.
*The United States
Capitol*, Washington,
D.C., 1793–1867.
Dome designed by
Thomas Ustick Walter,
1804–1888. Internal
diameter 98', total
height 222'.

While the idea of material progress eventually took hold, Western civilization never resolved its doubts as to whether society had improved in a moral sense, or in terms of its ideals. Hence the demand for an art that would inspire, by helping to recover the image and the spirit of antiquity.

Beginning with the Renaissance, and continuing virtually to our own time, classical art became a foundation for painters, sculptors, and architects. Because ancient statues were thought to provide examples of form brought to perfection, they were used as models by painters and sculptors. Roman buildings provided a basis for architecture. Architects journeyed to Rome so they could observe the remaining monuments firsthand. Their studies included measurements of proportions as well as sketches of architectural details. These found their way into buildings. The "grandeur that was Rome" was to live on in courthouses, banks, and public buildings throughout Europe and the United States (Fig. **10-17**).

In the nineteenth century, art began to look back on the Middle Ages. Romanticism, with its sense of the questing soul, and its celebration of intense states of emotion and exaltation, found its Golden Age in the medieval period, glorified as a time of faith, passion, and spirituality. Because Gothic architecture in particular seemed the perfect expression of its age, it was revived in countless examples in Europe and the United States.

But for the most part in Western art we find a tendency to "classicize" — to adjust the forms and themes of the painting or sculpture to agree with the forms and the principles of Greco-Roman art. The aim was for an art that would not only be beautiful, but that would edify and inspire as well. Art and architecture based on Greco-Roman forms seemed expressive of lofty ideals, and allowed both artist and patron to feel themselves linked to the classical tradition.

When we look at Western art from the Renaissance to the modern period, then, this is generally what we find:

- an interest in human activity
- realism
- idealism, based on a fascination with antiquity

As a caution, keep in mind that not all art shared these characteristics. For some artists, imitation was not an aim. Much of the art spurned idealism, and aimed instead at realism, information, or amusement. Not all artists have been fascinated by antiquity. But even if these characteristics were not prominent, they were there in the background, providing something to react against.

Though much of what was traditional in art has been rejected in modern times, our culture is still suffused with survivals and reminders of antiquity. Modern architecture reacted against classical decorative forms, but many contemporary architects and designers no longer feel compelled to define what is modern in terms of that reaction (see, for example, Fig. 13-9). For that matter, we may sense in the clear forms of a modern skyscraper a spirit akin to that of Greece and Rome. To this day, Western art, whether abstract or representational, remains an art of strongly individualized statements of human experience.

CONCLUSION

There is more to a work of art than its esthetic quality. Works of art of every kind are statements of human experience. Formal analysis develops our ability to read and discern those statements, while an investigation of the cultural context provides information we need to verify our conclusions. Together, these approaches carry us beyond face value and allow us to tap into the tacit, often unconsciously placed meanings that are found in every work of art.

By providing information about the past and about other cultures, the study of art helps us to see ourselves in relation to those who came before us, as well as those with whom we share the planet. Ultimately it can provide illumination for our own lives. Studies in art raise questions such as: How were those people different from us? How were they like us? What values have changed? What things persist? What can we learn from them? Are we any wiser? and What makes us unique?

11
ABSTRACT ART

Up to now we have been talking mostly about representational art, whose meaning is imparted through images closely tied to the real world. Representational works of art instruct us in knowing, seeing, and feeling about the subject. But what about abstract art? What's left to a painting or a sculpture when you take away recognizable subject matter? Will it still have something to say to us? Why would an artist want to distort an object in a painting? How are we expected to understand that painting? Are we all expected to understand it in the same way? ¶ Abstract art raises some serious questions. It presents its audience with certain challenges that aren't there in representational painting. One of the early abstract artists, Wassily Kandinsky, said that abstract art "speaks of mystery in terms of mystery." While it may be that mystery is at the heart of abstract art (perhaps some mystery is at the heart of every work of art), I think that it's possible to clear away some of the confusion surrounding it. To that end this chapter will trace the development and discuss, in general terms, the nature of abstract art. By the end of this chapter, we will have some answers to these questions.

FORM AS A VISUAL LANGUAGE

To begin, let me ask you to set aside for now the obvious differences between abstract and representational art. I'd like to suggest that there really is no fundamental division between abstract and representational art. In a sense, *all* art is abstract. Every painting, however realistic it may appear, departs in some ways from the subject. The artists extract from the subject what they feel to be significant, and present it in forms that express their ideas most effectively.

11-1
Giotto, *The Meeting of Joachim and Anna at the Golden Gate*, c. 1305. Fresco. Arena Chapel, Padua.

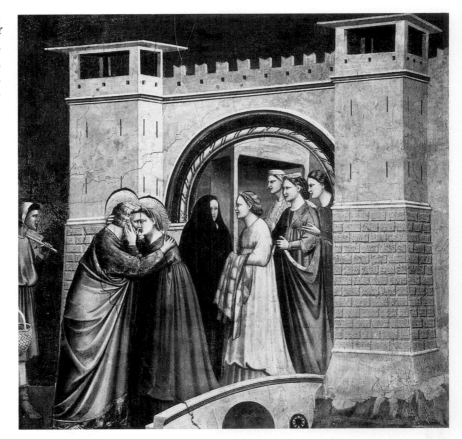

Thus *all* artists have an interest in form. Form is the language through which meaning is communicated. Artists use elements of form, such as color, light, shapes, and lines, as writers use words, or as composers use sound. Artists who have learned to use this language skillfully are able to express themselves clearly and powerfully.

To theoreticians of the past, form sometimes seemed less important than the subject matter of a work of art. Until this century, paintings were frequently ranked according to their subject matter or theme. People felt that paintings should show noble things. Accordingly, paintings showing historical events were considered superior to landscapes and still lifes. Paintings that affirmed human dignity took precedence over those that depicted what was merely anecdotal or amusing. This emphasis on content was based on the realization that art exerts an influence on human life. Nevertheless most critics today consider this kind of evaluation to be naive and restrictive.

Artists of the past were perfectly aware that a painting's worth depends on more than its subject matter. As we saw in chapter 4, *Reading Paintings*, representational painters were highly attuned to the effects of form—as attuned as are contemporary artists whose work has no recognizable images.

11-2
Jacques Louis David,
The Death of Marat,
1793. Oil on canvas,
approx. 63″ × 49″.
Musées Royaux des
Beaux-Arts, Brussels.

Consider, for example, Giotto's *Meeting of Joachim and Anna at the Golden Gate* (Fig. **11-1**). In depicting Joachim and Anna's joyful reunion, Giotto merges their bodies into a single arched shape. We can feel the appropriateness of that shape to the theme of reunion. Above them, the arch connecting the twin towers echoes the curve they make. Similar curves appear in the bridge and in its arches. In this way Giotto causes the central action to reverberate throughout the picture. The repetition of curves restates the central theme, while it both unifies and enriches the image.

The Death of Marat (Fig. **11-2**) provides another example of the ingenious use of form. In this painting, David creates a heroic image out of a sordid subject—a man assassinated in his bathtub. How was David able to accomplish

11-3
El Greco, *Christ Driving the Money Changers from the Temple*, c. 1570–1575. Oil on canvas, approx. 46⅝″ × 59⅜″. The Minneapolis Institute of Arts, The William Hood Dunwoody Fund.

this? He selected a low point of view, which gives stature to Marat. By eliminating background details, he ensures that our eyes stay fixed on the figure. Verticals and horizontals predominate, and produce a feeling of monumental calm. But more than anything, it is that vast, empty space above the figure that makes this painting distinctive. By covering it with a piece of paper you will see how much it contributes to the painting.

Representational artists, of course, had to subordinate their interest in form to the demands of realism. To put colors wherever they pleased or to disrupt the logical flow of space was likely to encourage criticism. But at the same time, all artists tried to present their subject as memorably as possible. They realized that the imaginative handling of form would achieve this aim.

Representational painters often explored form as keenly and as persistently as abstract artists today. The handling of color, light, space, and composition, as well as the development of painting techniques, was seen as providing worthy challenges. At times subject matter may have been no more than a pretext for the artist's investigation of form.

Comparing the early and the late work of an artist can be revealing. As artists mature, their work may move beyond the conventional imagery of the time to reveal something much more individual. Superfluous details drop away, and the compositions become more unified. Brushstrokes loosen up and become more expressive. Some representational artists developed a more personal use of color or light. Some even distorted faces, figures, and space to intensify the emotional effect, to emphasize a point, or simply to make the painting more exciting (Figs.

11-3 and 11-4). Strong, mature personalities in the history of art felt the constraints of literal representation — and left it behind.

Merely to copy what you saw seemed unworthy. Inventiveness and imagination — in composition, gesture, and expression, or the ability to conceive of a memorable scene — were regarded as no less essential to a great painting than the accuracy of the drawing. Nevertheless, most painters were satisfied to explore formal relationships within the limitations of representation. Those artists who intentionally distorted natural forms generally did so in ways that still preserved obvious ties to the visible world. The forms could be altered, but they were still respected.

BEYOND REPRESENTATION

Not until the latter decades of the nineteenth century did some artists push form until it truly broke free of limitations imposed by representationalism. At that time most artists, as well as the public, found acceptable only those paintings that presented subject matter with a high degree of realism and detail. They admired the immaculate brush techniques that could accomplish this. But avant-garde artists rejected technical skill as a goal for art, and questioned the idea that detailed representation is of primary importance. They felt that the art of precise representational images was confining.

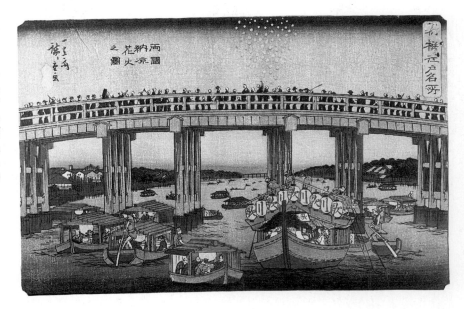

Leading the avant-garde was a group of painters who came to be known as Impressionists. In the 1870s and 1880s these painters moved away from narrative, or informational concerns, to concentrate on form, especially effects of light and color. Their free-style brush techniques released figures and objects from the confines of edges. Details became softer, more evocative than telling (see Monet's *Poplars on the Bank of the Epte River*, Fig. 17-5). Although the Impressionists adhered to the tradition of looking closely at the subject, the results they achieved suggested new and exciting pictorial possibilities, and encouraged further experimentation with form.

The discovery of Japanese prints provided a shot in the arm. These prints arrived in Parisian import shops unceremoniously wrapped around imported china. Their bright flat colors, strong patterns, radical perspectives, and daring asymmetrical compositions opened the eyes of artists like Whistler, Van Gogh, Degas, and Toulouse-Lautrec, who at times incorporated these new visual ideas into their work (Figs. **11-5** and **11-6**). The prints inspired them to reach for greater freedom in their interpretation of the subject.

Some advice: do not paint too much after nature. Art is an abstraction; derive this abstraction from nature while dreaming before it, and think more of the creation which will result than of nature. Creating like our Divine Master is the only way of rising toward God.

— Paul Gauguin, 1888

11-6
James McNeill Whistler, *Old Battersea Bridge*, c. 1878. Etching, Kennedy 177 iv/v, approx. 8″ × 11½″. The University of Michigan Museum of Art. (Margaret Watson Parker Bequest, Acc. No. 1954/1.371.)

11-7
Paul Gauguin, *The White Horse*, 1898. Oil on canvas, 55½″ × 35″. Musée d'Orsay, Paris.

By the end of the century, many artists were thinking of the subject as a point of departure. Artists like Van Gogh, Gauguin (Fig. **11-7**), and Munch (see Fig. 13-4) had moved away from exact representation by altering aspects of the subject they painted. Colors became stronger, more independent. Space was bent or flattened. Shapes, lines, and even brushstrokes began to assert themselves. By handling form in this less restricted way, artists discovered that they were able to present images that were fresh, exciting, intense. At the same time, they were making their art more expressive of their feelings and ideas.

In addition, these artists sensed that an abstract handling of form could more effectively disclose the true nature of the subject. By depicting people, objects, landscapes, as they had never been seen before, artists felt that they were revealing things that no one had realized were there. They regarded their paintings not as *representations* but as *interpretations* of what they saw (see Fig. 4-5).

Experimentation with abstraction brought about an increasing discrepancy between the appearance of objects and how they were represented. Cézanne (Fig. **11-8**) discovered that by making minute adjustments of lines and planes, which distorted natural appearances, he could create energies more intense than a photograph or a literal representation could achieve, and, at the same time, disclose relationships that would otherwise remain unseen. He worked with both landscape and commonplace

11-8
Paul Cezanne, *Still Life with Basket of Apples*, 1895. Oil on canvas, 24¾″ × 32″. Courtesy of The Art Institute of Chicago, Helen Birch Bartlett Memorial Collection.

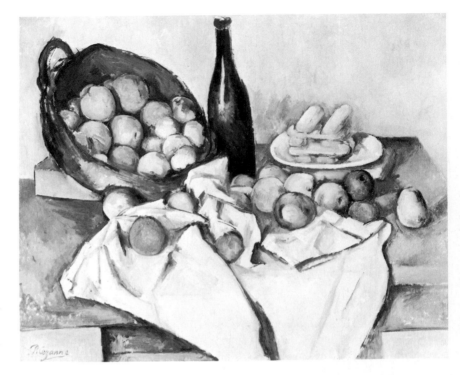

11-9 (below)
Pablo Picasso, *Les Demoiselles d'Avignon*, 1907. Oil on canvas, 8′ × 7′8″. Collection, The Museum of Modern Art, New York. (Acquired through the Lillie P. Bliss Bequest.)

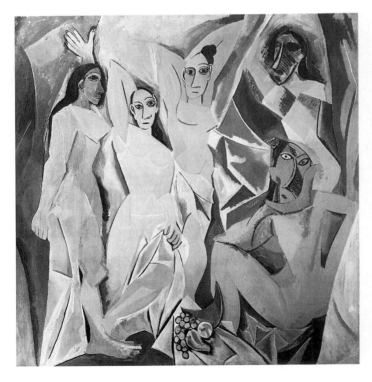

objects—apples, bottles, pottery—stretching and compressing both objects and the space, thus giving to the subject an unusual gravity and intensity. Basing their work on Cézanne's investigations, Picasso and Braque fragmented and disguised objects almost beyond recognition (Figs. **11-9** and **11-10**). Form and space crumpled and became ambiguous; solid planes became transparent. At the same time, painters like Matisse and Vlaminck (see Fig. **11-11**) continued Gauguin's investigation of the painting as a patterned surface of rich colors.

In the early 1900s, the wooden figures and masks created by artists of the Ivory Coast of Africa were discovered by European artists. As a result, Picasso, Modigliani, Matisse, Brancusi (Fig. 11-25), Lipchitz (Fig. **11-12**), Moore (Fig. 7-12), and many other

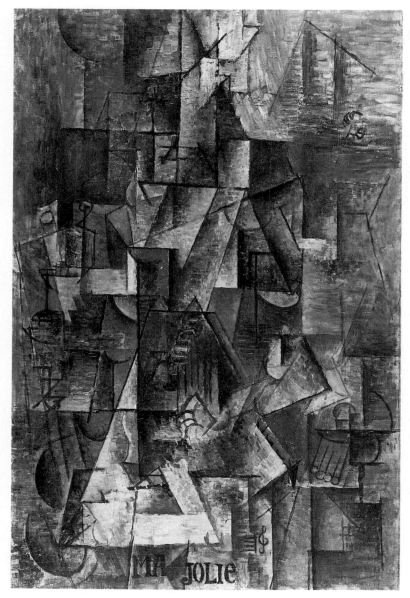

11-10
Pablo Picasso, *Ma Jolie*, winter, 1911–1912. Oil on canvas, 39⅜" × 25¾". Collection, The Museum of Modern Art, New York. (Acquired through the Lillie P. Bliss Bequest.)

M any think that Cubism is an art of transition, an experiment which is to bring ulterior results. Those who think that way have not understood it. Cubism is not either a seed or fetus, but an art dealing primarily with forms, and when a form is realized it is there to live its own life.

— Pablo Picasso (from Albert H. Barr, Jr., *Picasso: Fifty Years of His Art*)

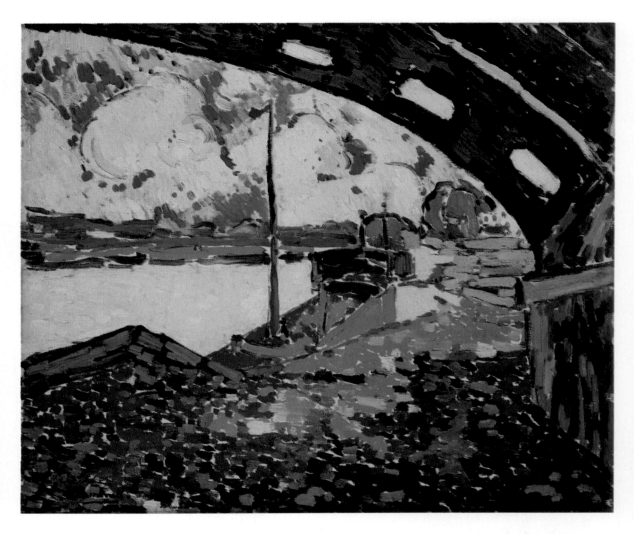

11-11
Maurice de Vlaminck,
*Under the Bridge at
Chatou*, 1906. Oil on
canvas, 21½″ × 27⅝″,
signed lower left:
Vlaminck. The Evelyn
Sharp Collection.

painters and sculptors experienced a dramatic breakthrough in the concep-
tualizing of the human figure, and in their understanding of form. Distortions
and unexpected formal relationships gave African carvings a striking, evocative
character (Fig. 11-13). They seemed to reach beyond outward appearances and
put the viewer in touch with another, more elemental realm. Inspired by this art,
European artists explored the idea that form could have an independent reality,
or in Picasso's words, could "live its own life."

Picasso and Braque were absorbed with the life of forms when, between 1910
and 1912, they developed what was to become a major influence on modern
art—Cubism (Fig. 11-10). In recreating both the object and the space around it,
they broke decisively with Renaissance concepts of representation, and pre-
sented a new reality—one that exists only in the painting.

To heighten the play between "real" reality and painted reality, they some-
times copied words from the typeface of newspapers and magazines into their

paintings. These acted as clues along the trail of a guessing game that the viewer could play in deciphering the image. Carrying this idea further, they also glued or "collaged" actual objects—pieces of newspaper, corrugated cardboard, sheet music, and so on—into paintings and drawings (see Fig. 11-33). Picasso also combined found objects to construct small sculptures. These discoveries amounted to inventions of new art forms, and were taken up later by many artists in many different forms and materials.

Abstract art implicitly raised questions about the nature of perception. Can we trust our senses? What can we know for certain? How do we assimilate what we see? What sort of reality is contained in a painting? Abstraction raised questions about the nature of art and the role of the artist. Should paintings merely do what photographs could do better? Is the artist no more than a showman, presenting familiar objects arranged in attractive ways for our amusement? What can a painting show us that nothing else can? How can it accomplish this?

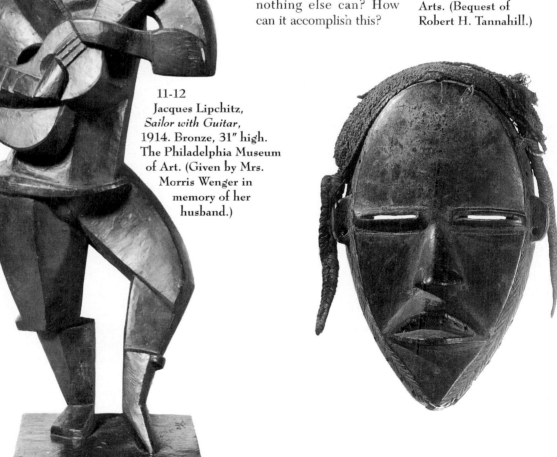

11-12
Jacques Lipchitz,
Sailor with Guitar,
1914. Bronze, 31″ high.
The Philadelphia Museum
of Art. (Given by Mrs.
Morris Wenger in
memory of her
husband.)

11-13
Dan culture, Poro
Society mask, Gold
Coast, Africa, nineteenth
or twentieth century.
Wood, 9″ × 5¾″ ×
2⅝″. Courtesy of The
Detroit Institute of
Arts. (Bequest of
Robert H. Tannahill.)

11-14
Paul Klee, *A Walk with the Child (Ein gang mit dem kind)*, 1940. Black crayon on off-white paper, mounted on heavier paper, 19⅜″ × 13¾″. The University of Michigan Museum of Art, Acc. No. 1951/2.38.

It is not my task to reproduce appearances. A photographic plate can do that. I want to penetrate within. I want to reach the heart.

—Paul Klee

≈≈≈ ≈≈≈

The distortion of objects and space that we experience in abstract paintings is intended to catch us by surprise, push us off balance. We are forced to resolve a dilemma—to put together in our minds a whole, complete, and consistent world where there is none before us. In these paintings the artist asserts the power of imagination to reorder experience, and invites the viewer to participate in that reordering. Mystery, ambiguity, irony, fantasy, and humor, as well as the creative and imaginative presence of the artist, become a part of what modern art is about (see Figs. **11-14** and **11-15**).

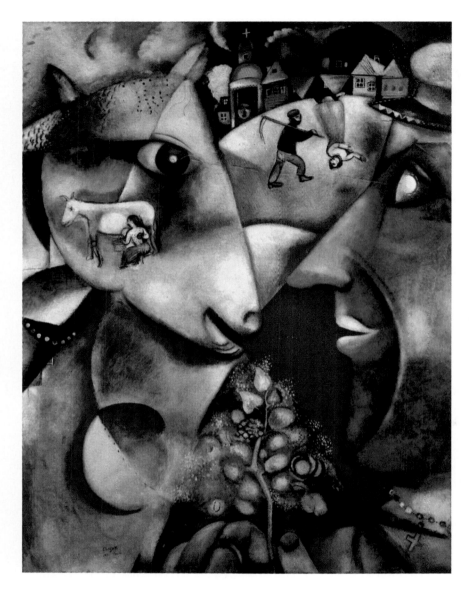

11-15
Marc Chagall, *I and My Village*, 1911. Oil on canvas, 21¾″ × 18¼″. The Philadelphia Museum of Art. (Gift of Mr. and Mrs. Rodolphe M. de Schauensee.)

I always seek very consciously to construct a world where a tree can be quite different, where I myself may well discover suddenly that my right hand has seven fingers whereas my left hands has only five. I mean a world where everything and anything is possible and where there is no longer any reason to be at all surprised, or rather *not* to be surprised by all that one discovers there.

— Marc Chagall (from Edouard Roditi, *Dialogues on Art*, 1960)

It was becoming increasingly clear in the early part of the century that pure form—colors, shapes, lines, volumes, and their arrangement—was not only beautiful, but was capable of producing considerable psychological impact on the viewer. The exploration of form led a number of painters and sculptors to purge their work of recognizable subject matter altogether. They felt that so-called nonobjective form—form that does not represent something else—could provide sufficient content for a painting or sculpture.

Painters such as Kandinsky and Mondrian came to regard the representation of objects as an impediment to the strongest experiences that art is capable of producing. The representation of objects seemed too tied to the specific, the particular, the familiar. They believed that through the contemplation of pure form and the logic of formal relationships, the viewer would be led beyond the world of appearances to another, more profound reality.

I wish to approach truth as closely

as possible, and therefore I abstract everything until I arrive at the

fundamental quality

—Piet Mondrian, 1914

In nonobjective paintings and sculptures (paintings and sculptures having no recognizable subject matter) the subject matter of the piece is not something *outside* of the piece. Instead, the colors, shapes, textures, masses, and spaces, and their weights, balances, and movements become the subject matter. The ideas that these never-before-seen worlds call up to us provide the central meaning of these pieces (Fig. **11-16**).

The development of abstract art was an intensely serious business, and not, as has often been thought, a matter of whimsy, or of indifference to content or meaning. Many of the artists who developed abstract art regarded it in spiritual terms. They saw their art as evoking something universal, fundamental, and profound. Some of the later abstract artists saw their art in these terms also, while others would regard their work as a reflection of their own minds or state of being. Still others would claim that there is no reference in the content of their work to anything outside the work itself. However dissimilar, these points of view are all based on the idea that a work of art is an independent entity whose forms are intrinsically capable of providing meaning.

The beauty of pure form was not the discovery of abstract artists. Neither was the awareness of the emotional power of form, nor the desire to evoke the inner essence of things. Nor was the notion that subject matter exists to fire the imagination of the artist rather than to be copied. All of these ideas, as we have seen, were shared with traditional artists. What was new was the willingness of abstract artists to carry their work further from objective reality than traditional artists. For many artists abstraction seemed the only possible way to realize their ideas.

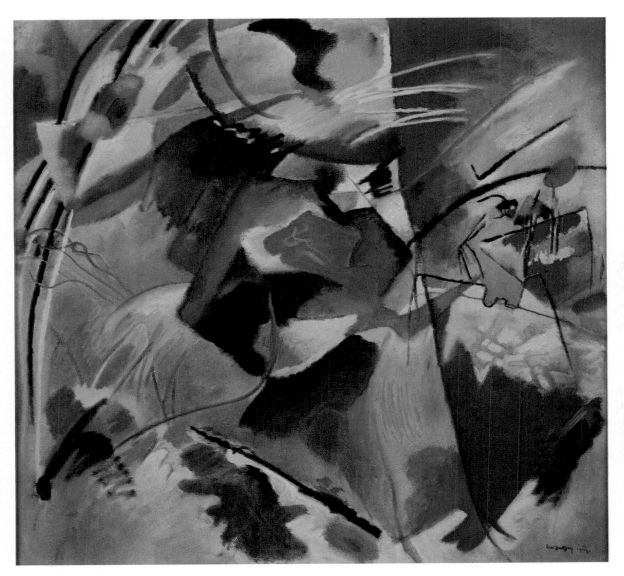

11-16
Wassily Kandinsky,
*Improvisation with Green
Center, c.* 1913. Oil on
canvas, 43¼″ × 47½″.
Courtesy of the Art Institute
of Chicago, Arthur Jerome
Eddy Memorial Collection.
Collection, the Museum of
Modern Art, New York.
(Mrs. Simon Guggenheim
Fund.)

In the course of time it will be
proved clearly and infallibly that abstract art, far from being divorced from
nature, is rather more closely and intimately linked with it than
art ever was in the past.

—Wassily Kandinsky, 1931

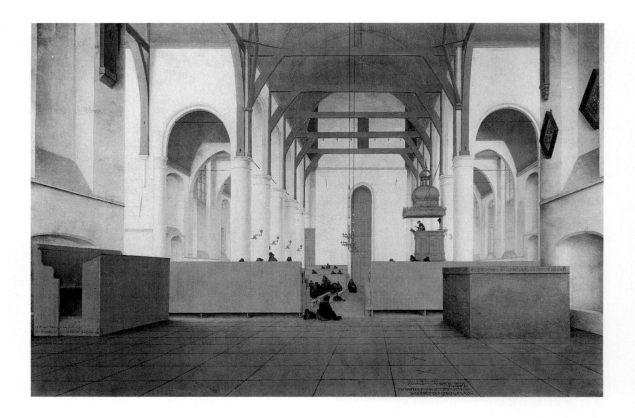

11-17
Pieter J. Saenredam,
*Interior of the Church of
St. Odulphus in
Assendelft*, 1649. Oil
on panel, 19¾" × 30".
Rijksmuseum,
Amsterdam.

The breakthroughs that created abstract art were brought about by painters educated in the representational tradition. These painters frequented museums and collected reproductions of the works of representational painters they admired. Paul Cézanne (1839-1906) referred to the Louvre museum as "the book in which we learn to read." Paul Gauguin (1848-1903) brought with him to Tahiti photographic reproductions of the work of Raphael, Michelangelo, and Rembrandt. Henri Matisse (1869-1954), widely known for his abstractions of the human body, insisted that his students draw and sculpt from the model in the traditional way. During his long career, Picasso reinvestigated through his own paintings, at various times, the art of ancient Greece, and of Rembrandt, Poussin, Velázquez, Goya, Ingres, Delacroix, Manet, and Cézanne.

Clearly these artists respected painters of the past, particularly those whose formal interests coincided with their own. But the modern painters were rebels for whom realism itself held no particular value. They had shaken off the constraints that realism imposed on those earlier artists. Now they could explore and develop more thoroughly the ideas and formal concerns they found in earlier paintings. In a sense, they could carry those ideas to their logical conclusions (Figs. **11-17** and **11-18**).

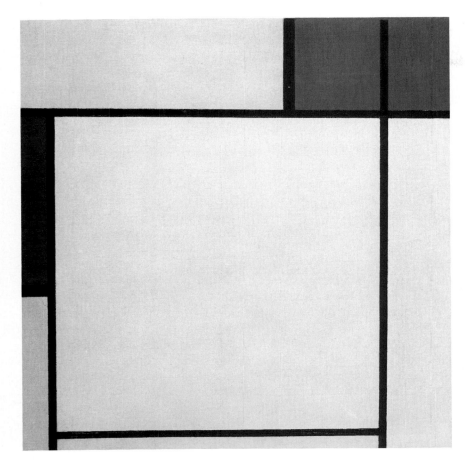

11-18
Piet Mondrian,
*Composition with
Red, Yellow, and Blue*,
1927. Oil on canvas,
20⅛″ × 20⅛″.
Contemporary
Collection of the
Cleveland Museum of
Art.

BACKGROUND OF ABSTRACT ART

All artists build on what they have received, of course, and often base their investigations on the work of an artist whom they admire. Unlike earlier artists, however, abstract artists made revolutionary changes, probably among the most revolutionary and sudden in the history of art. Why did those changes occur then? Why were the changes so swift? Probably no one can answer these questions fully. Still, events in the art world itself foreshadowed abstract art.

In the nineteenth century, a number of artists had become interested in exploring form and subordinating subject matter. In part, they were reacting against the official art schools, which were emphasizing subject matter and technique, and discouraging formal experimentation. At the same time, they were asserting their individuality, an idea encouraged by Romantic artists, poets,

musicians, and writers earlier in the century. Manet had been exploring un-
usual compositions in the 1860s, 1870s, and 1880s. The Impressionists intro-
duced bright colors and thick, juicy paint, and made the viewer keenly aware of
the surface of the painting. The use of the camera, with its automatic fidelity to
life, suggested that abstraction was a more viable direction for a painter. At the
same time, photographic images expanded ideas about composition. Japanese
and, in the twentieth century, African art also pointed to new ways of handling
form. European academic art continued to hold sway in the art schools and with
the public, but to many young artists its meticulous realism and glorified subject
matter seemed phoney and devoid of spirit.

Radical experimentation with form was also stimulated by events beyond the
world of art. The discovery of X-rays, radio waves, and radioactivity, and the
development of electrical technology, brought to everyone the realization that
invisible forces shape and govern the natural world. Advances in psychology
revealed the existence of an invisible, inner realm—the unconscious—that
shapes and governs the human personality. All of these developments suggested
a discrepancy between appearance and reality—a theme taken up in modern
literature and theatre as well as in painting.

The old notion of the universe as a vast, but logical machine was called into
question. Einstein's discoveries altered our understanding of time and space;
the automobile and airplane altered our experience of them. Microscopes, high-
power telescopes, and experimental photography presented new images of the
world. The telephone, the electric light, the radio, and the automobile dras-
tically transformed patterns of life. Hope and apprehension mingled at what was
felt to be the threshold of a new age, as social, economic, and political turmoil
culminated in the cataclysm of World War I. Clearly the old art, with its accep-
tance of surface appearances, its orderliness, its technical refinement, and its
affection for the past was no longer adequate. Only an art that was abstract
seemed in keeping with modern times.

THE NATURE OF ABSTRACT ART

Abstract art isn't just another way to
say the same thing. Its very nature implies something different. In "going fur-
ther," abstract art conveys the idea that reality lies *beyond* what we see through
our eyes. Reality is not equivalent to the world we take in through our senses,
and it can't be conveyed or understood by depictions of what we see around us.
Representational painting, whatever its particular style, expresses a fundamen-
tally rational, common-sense outlook. Its space is orderly, even measurable. The
objects depicted are solid, touchable things whose surfaces may be so meticu-
lously painted that we are tempted to think of them as real.

Abstract art abandons the depiction of tangible objects in a measurable
space, as though it were no longer valid to make objective and confident state-

ments about reality. Hints, nuances, fleeting glimpses, ambiguity, or empty spaces replace the solid, the tangible, the recognizable, the understandable. Abstract art suggests that unseen forces affect all things. One cannot speak with confidence of the material world: one can only speak of one's own perceptions.

Certainly, abstract paintings and sculptures are, like representational pieces, as varied as the artists who produce them. It is possible, however, to discern a number of distinct aims that compelled artists to involve themselves with abstraction. Four of these aims are mentioned earlier in this chapter:

- to reorder and intensify what we see
- to heighten the expressive quality of the piece
- to emphasize some aspect or quality that would otherwise go unrecognized
- to create something beautiful and profound out of pure form

To these we may add:

- to create ambiguity or mystery
- to reveal what is felt but not seen
- to create something absolutely unique
- to explore form out of curiosity
- to reveal the private visions of the artist

These aims are not necessarily at variance with the aims of representational art. But abstract artists would assert that abstraction provides a stronger means of achieving them.

HOW DOES ABSTRACT ART WORK?

Despite the more tenuous relationship of abstraction to the world of objects, abstract artists can't proceed haphazardly or arbitrarily any more than can representational artists. Since formal elements are prominent, the artist must handle them with exceptional consideration. There are no illusions of reality to divert attention from what the artist does. Each calculation is crucial, and any lapse of judgment can mean the failure of the piece. Tossing together a few shapes at random, making a texture, or just squeezing pretty colors out of the tube can't make art.

The illustrations in this chapter are, of course, outstanding examples of abstract art. What you or I see when we visit a gallery may be dull and boring. Remember that abstract art is all fairly recent, and the process of time that distinguishes quality has scarcely begun to occur. Certainly representational art has its share of mediocre work too. No style of art is automatically better than any other, and no style can ensure quality.

Abstract art is successful when its forms become visually exciting; when they begin to add up, to make sense together, to "work." Furthermore, a good abstract painting or sculpture, like a good representational painting or sculpture, will have a strong conception behind it. It will have something to say. No art simply goes through the motions—certainly, no art of quality. Abstract art can make you more aware, more conscious, just as a representational painting can.

11-20
Solidarity logo,
Gdansk, Poland, 1980.
Designed by J. and K.
Janiszewski.

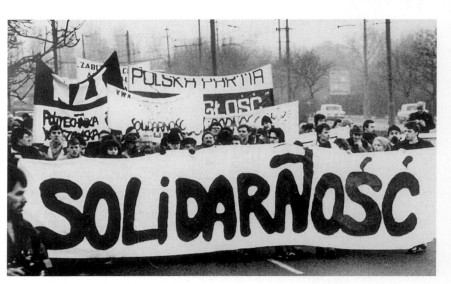

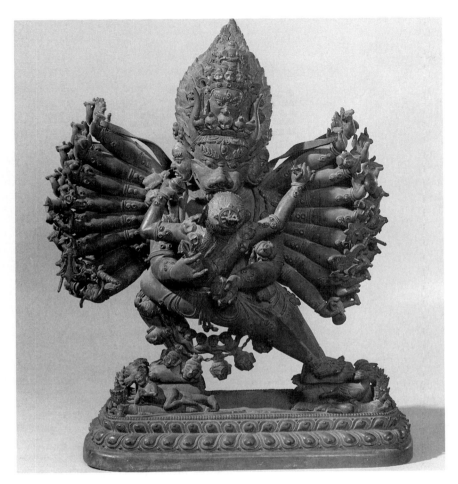

11-21
Vajrabhairava and His Sakti, sixteenth or seventeenth century, Tibet. Gilt copper, approx. 15" × 27". Courtesy of the Museum of Fine Arts, Boston. (Bigelow Collection.)

This is because form itself is expressive, and has the potential to communicate ideas. In Saul Steinberg's drawing, for example, you can almost *hear* the raspy growl of the dog and the chirpy sing-song of the woman (Fig. **11-19**).

Popular culture supplies many examples of expressive abstract forms. Corporate logos use lines and shapes to communicate power, high-tech competence, or friendliness. Typefaces are similarly designed to communicate through their forms. The famous "SOLIDARNOSC" ("Solidarity") logo (Fig. **11-20**), created for the shipbuilders' strike in Gdansk, Poland, in 1980, conveys a restless, excited forward movement.

Artists working in non-Western traditions were highly conscious of the expressive power of abstract form. Consider the ferocity of the figure of *Vajrabhairava*, the Lamaist (Buddhist) deity (Fig. **11-21**), whose multiple arms and legs are not only symbols of power, but make us feel that power in drumlike rhythms. Like much of non-Western art, the sculpture combines both abstract and naturalistic forms, each intensifying the other. The great Japanese artist

11-22
Katsushika Hokusai,
The Great Wave, from
*Thirty-Six Views of Mt.
Fuji, c.* 1822.
Woodblock print, 10″
× 14¾″, 21.6765,
Spaulding Collection.
Courtesy of the
Museum of Fine
Arts, Boston.

Hokusai also worked in an abstract tradition. His extraordinary image of *The Great Wave* (Fig. **11-22**) impresses upon us the awesome power and beauty of the wave.

If we compare abstract images to snapshots, or for that matter, to our recollections of the real thing, we are again reminded of the capacity of abstract form to convey meaning. In Picasso's *Weeping Woman* (Fig. **11-23**), everything — the knife-edged shapes, the crazed lines, the sour colors, the coarse brush strokes, the violence done to the face — expresses the anguish of the woman. The whole of the painting speaks of her pain. The haunted spaces of Giorgio de Chirico's *Mystery and Melancholy of a Street* (Fig. **11-24**), would not likely be realized in a photograph of the subject. We are affected by the serene, gracefulness of Brancusi's *Fish* (Fig. **11-25**), the brooding mystery of Georgia O'Keeffe's *Black Cross, New Mexico* (Fig. **11-26**), and Hokusai's *Great Wave* because they reach beyond natural appearances to reveal what is profoundly essential to the subject.

Twentieth-century photographers have shared the interest in abstract form. A number of photographers have used the camera to reveal a world of abstract forms — forms that are all the more striking because they reside in the real world (see Fig. 9-10).

11-23
Pablo Picasso, *Weeping Woman*, 1937. Oil on canvas, approx. 21″ × 17½″. Private collection, London.

11-24
Giorgio de Chirico, *Mystery and Melancholy of a Street*, 1914. Oil on canvas, 34¼″ × 28⅛″. Private collection.

11-25 (below)
Constantin Brancusi, *Fish*, 1930. Gray marble, 21″ × 71″; on three-part pedestal of one marble and two limestone cylinders, 29⅛″ high. Collection, The Museum of Modern Art, New York. (Acquired through the Lillie P. Bliss Bequest.)

11-26
Georgia O'Keeffe,
*Black Cross, New
Mexico*, 1929. Oil on
canvas, 36″ × 30″.
The Art Institute of
Chicago Special Picture
Fund, © Georgia
O'Keeffe.

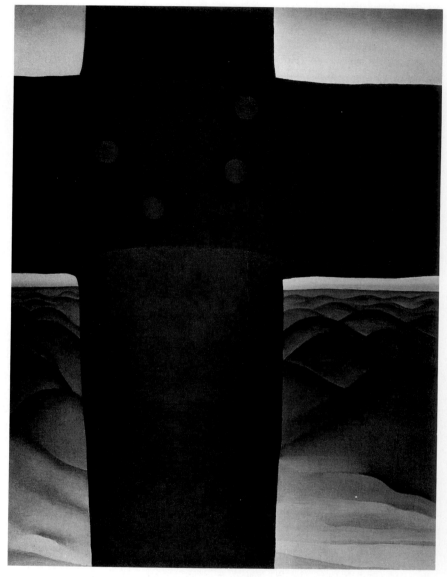

A hill or tree cannot make a good
painting just because it is a hill or a tree. It is lines and colors put together so
that they say something. For me that is the very basis of painting. The
abstraction is often the most definite form for the intangible thing in myself
that I can only clarify in paint.

— Georgia O'Keefe, 1976

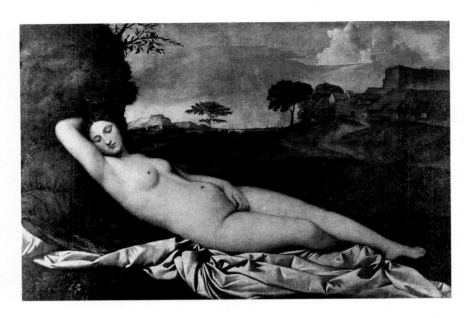

11-27
Giorgione, *Sleeping Venus*, c. 1505. Oil on canvas, 42½″ × 69″. Staatliche Kunstsammlungen Dresden, Gemäldegalerie Alte Meister.

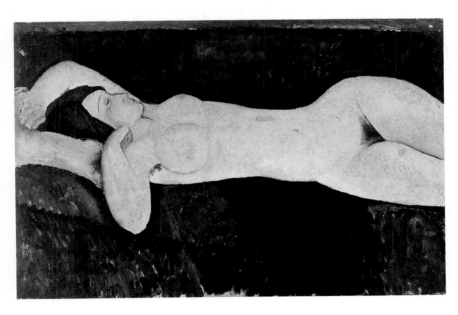

11-28
Amedeo Modigliani, *Reclining Nude*, c. 1919. Oil on canvas, 28½″ × 45⅞″. Collection, The Museum of Modern Art, New York. (Mrs. Simon Guggenheim Fund.)

It is the expressiveness of form that makes possible the parallels we sometimes find between representational and abstract images. Look at the sensuous line that flows along the contour of Giorgione's *Sleeping Venus* (Fig. **11-27**). You also see it in Modigliani's *Reclining Nude* (Fig. **11-28**), and again in Henry Moore's sculpture, *Reclining Figure* (see Fig. 7-12). The angularity of the contour in Grunewald's drawing *Christ on the Cross* (Fig. **11-29**) conveys anguish

11-29
Matthias Grunewald,
Christ on the Cross,
early sixteenth century.
Drawing, finely
brushed chalk.
Staatliche Kunsthalle,
Karlsruhe, Germany.

and pain. Max Beckmann uses angularity to create a similar effect in his print, *The Descent from the Cross* (Fig. **11-30**). Both Vermeer and Vuillard create a serene orderliness by resolving the disparate elements of their interiors into simple shapes bathed in a soft light (Figs. **11-31** and **11-32**).

PICASSO'S *SHEET OF MUSIC AND GUITAR*

Now let's consider some of the things a person can think about when looking at a particular abstract image. Look at Picasso's *Sheet of Music and Guitar* (Fig. **11-33**), a collage of pasted paper and

11-30
Max Beckmann,
*The Descent
from the Cross*,
1918. Drypoint,
12¹⁄₁₆″ × 10³⁄₁₆″.
Collection, The
Museum of
Modern Art,
New York. (Gift
of Bertha M.
Slattery.)

What I want to show in my work is
the idea that hides itself behind so-called reality. I am seeking for the
bridge that leads from the visible to the invisible.

—Max Beckmann, 1938

11-31
Jan Vermeer, *A Painter in His Studio*, c. 1666. Oil on canvas, 51¼″ × 43¼″. Kunsthistorisches Museum, Vienna.

pastel that was done in the winter of 1912–1913. It measures 16½″ × 18½″. What are some of the ways we can respond to it?

1. To begin with, we can see it as an interplay of abstract forms, and involve ourselves with its shapes and their relationships.

 We might ask: How varied are the shapes? What shapes seem related to each other? Why? What shapes seem to be in front, and which are farther back? Does this ever reverse? What kind of lines are used? Which lines seem related? What rhythms can you feel? Why are so few colors used? Why did Picasso use these particular colors? What kind of space has Picasso created? Is it flat? Is there depth?

 We might also ask: What makes a shape interesting? Are certain shapes inherently more interesting than others? More pleasing? Are abstract

11-32
Edouard Vuillard,
Interior (L'Aiguillée),
1893. Oil on canvas,
15⅞" × 12¼". Yale
University Art Gallery.
(Gift of Mr. and Mrs.
Paul Mellon, B.A.
1929.)

forms more interesting than those that resemble recognizable objects, or the other way around? Is a shape or a color lovely in itself, or does it become lovely in the context in which it is placed?

2. We can think about what difference it makes that the piece is made of glued paper. How many different textures do we see? Would it be more or less interesting to us if it were all in paint, rather than paper and pastel? How is paper being used in a new way, and why?

Another line of thought: How does collage affect our sense of the "realness" of the piece? Does the use of the actual sheet music make the picture seem more "real" despite the obvious abstraction of the guitar? Or

11-33
Pablo Picasso, *Sheet of Music and Guitar*, 1912–1913. Collage, 16½″ × 18½″. Musée National d'Art Moderne, Paris.

does it suggest something fanciful and capricious on the part of the artist? Does collage make the space seem more real, because of the overlapping of papers, or does it force its flatness to our attention?

3. Why did Picasso put a guitar in the piece? Why the actual sheet music? Is it only coincidental that music is a theme in this abstract picture? Is Picasso using the theme of music to tell us something about abstract art? Does this image in some ways resemble music? What associations might a guitar have had for Picasso?

4. Is the collage orderly, or casual? Clear, or ambiguous? Is there humor in it? A sense of play?

5. What does the collage tell us about music? About art? About Picasso? About life and experience in the early twentieth century? About ourselves?

6. We can look upon the collage historically. We can see it as an important breakthrough in the history of art: an artist having made an image, not out of paint or precious materials, but by cutting out pieces of ordinary paper and arranging them. Why did this happen at that particular time in art history? In the wider context of social history? To what extent was what Picasso did in consonance with his time? What influence did it have on later art?

7. We can think of the picture as a milestone in the career of the artist. We might investigate what was going on in the other work of Picasso at that time or even what events were taking place in his life.

These are my musings — very likely, you've thought of some things yourself. Clearly, every picture we look at can open up many lines of thinking.

MEANING IN ABSTRACT FORMS

There was a time in the United States when abstract artists were thought of as demented, antisocial, and unpatriotic. Today most people accept and enjoy at least some art in which familiar things appear exaggerated or distorted. Consider the popularity of Van Gogh, or the cartoons of Walt Disney. Nonobjective paintings and sculptures are placed in banks, hotels, and public squares, and abstract shapes and patterns find their way into popular art. Linoleum designs, formica table tops, logos, typefaces, package designs, fabrics, popular illustration, movies, and television advertisements have all been affected by abstract art. Nevertheless abstract art still presents us with special problems. Paintings and sculptures that present nothing but their own forms may seem to have nothing to say, and thus create confusion for the viewer accustomed to recognizable images. Distortions of objects may seem to rob a picture of its beauty and meaning.

Abstract art thus raises the question of meaning in a work of art. How specific or literal in meaning must a work of art be? Based on paintings of the past, in which specific meanings were imparted through precise images, we may come to abstract art expecting the same access to meaning. This approach causes us trouble. Abstract art tends to be evocative, or suggestive, rather than literal or descriptive. To a degree not found in traditional art it is open-ended, and dependent on the willing imagination of the viewer to complete its meaning.

Since the late nineteenth century a number of artists have encouraged a nondirected contemplation of their work by avoiding titles that give specific information about the subject. Whistler suggested an analogy with music by calling his paintings "serenades" and "nocturnes." Later, Kandinsky, Mondrian, and other nonobjective painters used the words "improvisation" and "composition" as titles for their paintings. Sometimes an artist chooses a title that simply

identifies the predominating forms within the painting. Other titles may refer to the person who inspired them, to the place where they were painted, or to the order of a piece in a sequence of works.

While the lack of specificity in abstract art may seem perplexing, it presents no problem in other areas. Music, for example, doesn't transmit distinct bits of information. (Can you describe the message of a Beethoven symphony, or a jazz piece?) Nor does it, typically, reproduce sounds of the real world or tell stories. It has no words. Yet we sense that music contains ideas. It directs our thoughts, creates moods and affects our feelings. We react to it and we enjoy it. Its rhythms, sounds, and melodies are beautiful in themselves.

Dance and architecture are generally indifferent to the communication of literal messages. Nevertheless, they too create moods and influence the way we think and feel. Through the expressiveness of their forms alone, they direct our thoughts to some aspect of experience and engage us in it.

It might be useful to borrow a leaf from our experience with music, architecture, and dance, when we contemplate an abstract painting or sculpture. We may discover that precise messages are not required for our enjoyment of it. The absence of literal meaning can be a liberating experience. Because it is not tied to the familiar and the literal, abstract art can give you experiences that representational painting can't. You can see things that you won't see anywhere else. You can muse over them in a way you can't do with art whose meaning is spelled out for you by its title and limited by its subject matter.

Helen Frankenthaler's large-scale painting *The Bay* (Fig. **11-34**) was in fact painted in her bayside studio in Provincetown, Massachusetts. The title was given when the newly painted tints of blue and the raw canvas reminded the artist of the bay and its weather. But the title is just a hint. Although it withholds specifics—perhaps *because* it withholds specifics—Frankenthaler's image releases the viewer's own imaginative powers.

When you look at an abstract painting or sculpture, don't try to puzzle out a message or read it like a script. Try to experience it. Keep your mind and senses open. Try not to impose your own preconceptions on what you see. Let it lead you where it wants to go. If it works for you, it can open your eyes and reveal something new, fresh, or unforeseen.

Perhaps we have to set aside the idea, central to Western thought since the Greeks, that knowing must be based on logic and reason to have validity. Orderly systems of knowledge have brought about a magnificent science and technology in the West. But art experiences are of a different kind. What we apprehend is taken in, not through logic and rational thinking, but "through the skin," so to speak. Art experiences bypass the logical, systematic modes of thinking that we use in order to understand, say, how a car works, or to learn why water freezes. Art experiences may have more to do with our subconscious than our conscious minds, which may be why art of all kinds—theater, music, poetry, and films, for example—can affect us so strongly.

From time to time each of us experiences what we call "intuition," "gut feelings," or "sixth sense." Perhaps you have experienced spiritual feelings, exaltation, empathy, or love. You may have felt a sense of awe in the presence of

11-34
Helen Frankenthaler,
The Bay, 1953.
Acrylic on canvas,
6'8¾" × 6'9¾". © The
Detroit Institute of
Arts. (Gift of Dr. and
Mrs. Hilbert H.
DeLawter, Acc. No.
65.60.)

mountains, the ocean, or stars on a clear night. You may have experienced a state
of total awareness or involvement through meditation, or through participation
in a religious ritual. All of these are ways of knowing—nonrational ways of know-
ing, but no less real. It is this kind of knowing that art, and abstract art partic-
ularly, draws upon.

Responses to art of any kind are often difficult to pin down. They are subjec-
tive. They vary in intensity. One person will feel an affinity for a work of art that
leaves another cold. One person can find humor in a piece while another finds it

serious. One can find passion while another finds order. Perhaps all of them are right. Often you don't really feel the piece, or grasp its meaning, until much later.

What you actually experience when you experience art may be very hard to say, and harder yet to explain. But that does not mean that the experiences are not genuine. It's best to look — and look long enough — at what is there. Just as you would with representational art, see what the artist is doing with form. In abstract art the elements of form, unconstrained by the limitations imposed by representation, can be handled as the artist feels they are needed. Color, light, space, lines, patterns, and textures can all speak to us. The task of the artist is to make these eloquent.

You can get an idea of the way this happens through some remarks made by the artist Josef Albers in an interview he gave in 1970.[1] As he showed the interviewer around his studio, he pointed out the many tubes of paint he was using:

> On this shelf alone I have eighty different kinds of yellow and forty greys. I have them sent from all over the place . . . to put two colors side by side really excites me. They *breathe* together. It's like a pulse beat. And there is one color that dominates, just as a child takes over one parent. Greens are very jealous of each other, for instance. I like to take a very weak color and make it rich and beautiful by working on its neighbors. What's gloomier than raw sienna? Now look at what I've done to it there: It's gold. It's shining and alive, like an actor on the stage. Turning sand into gold, that's my work and aim.

Albers was fascinated by the interaction of colors. He saw them as actors on a stage, having roles to play, and influencing one another just as people do. He makes us aware that the identity of a color is affected by what surrounds it. Raw sienna in the tube is a tan color, but when placed beside certain colors it can shine like gold. It is as if Albers could make two colors out of one.

What might the color have been that turned sand into gold? Raw sienna looks muddy (artists call it an "earth color"), but next to a darker color it would appear lighter. Next to a bluer or a more purple color, or even a muddier one, the yellow in it would assert itself. In small amounts it would shine more.

In any painting, a sensitive handling of the elements of form awakens and transforms them into something more than they are by themselves. Interacting with each other, they combine to make a whole that is greater than the sum of its parts — like musical notes.

Alber's own paintings provide an example. Consider his small painting, *Memento* (Fig. **11-35**). Albers limits the number of colors and applies them pure and unmixed so you can't miss what they're doing. In the simple, modest format individual colors quietly appear to structure themselves, and to bring out one another's character and flavor. Light appears to radiate from within the painting. *Memento* shows us the mysterious ways that colors behave when they interact: how they advance and recede, how they give off light, how they establish, lose, and recapture their identities.

Every painting or sculpture, whether abstract or representational, is a context in which formal elements play off of each other. Through this interaction a presence is created that transcends those individual elements. The painting be-

comes more than dabs of color on canvas; the sculpture more than masses and spaces. A personality emerges, and the piece takes on a life of its own. Of this, Albers had written:

> The aim of life
> is living creatures
> The aim of art
> is living creations

— Poems and Drawings

11-35
Joseph Albers, *Memento*, 1943. Oil on masonite, 18½″ × 20⅝″. Collection, Solomon R. Guggenheim Museum, New York.

CONCLUSION

Modern history has seen cataclysmic changes in age-old patterns of life. Since the early part of the nineteenth century, urban population increases, industrialization, political and ideological totalitarianism, the assimilation of diverse communities into a mass culture, and the effects of technology have resulted in the increasing regimentation and isolation of the individual. During this time we have seen the emergence of an art that clings stubbornly to the belief that people must be free to explore on their own terms who they are and what they experience. It has not been an art of glory, of certainties, of formality, or of sentimentality. It has not often been refined, well-mannered, gentle, or sweet. It has not often looked backwards to the past. It has been honest, intensely personal, and direct. It has sought to penetrate to the heart of things.

Abstract art conveys the idea that another reality lies beyond the world of appearances. Through images of a world imagined, rather than a world observed, it points to the discrepancy between reality and appearance, a discrepancy also perceived by the natural sciences and in psychology. The abstract arts of other cultures were similarly based on the presumed existence of another reality, that of the spiritual world, and were intended to transport the mind of the viewer to that world through the power of abstract forms. The meanings, of course, were precise. In modern abstract art, however, we are free to discover and carry away our own meanings.

In contrast with the art of the past, which supplied us with visions confirming our certainties, abstract art supplies us with visions through which we may address mystery. It corresponds in spirit with Albert Einstein's statement that "the most beautiful thing we can experience is the mysterious." If the worlds within worlds of abstract art indeed penetrate to the heart of things, it is because, like all art, they distill within themselves some aspect of experience, some fragment of truth as it is given us at any time to know.

12
POSTMODERN ART

SUBJECTIVE VISION

Now as never before, artists have the opportunity to explore individual interests. In the past, art articulated the beliefs and values of society (or, more specifically, of the patrons of art) through traditional subjects and themes. These of course were subject to interpretation by the artists. But by present-day standards artists were held on a short tether in terms of how far they could depart from either customary subject matter or the way in which subject matter could be depicted. Within these restrictions, some artists managed to be remarkably independent. But originality was never as highly regarded as it is today, and those who ventured too far from tradition into private visions were usually dismissed as eccentrics. ¶ The current value placed on originality reflects the tendency to affirm that subjective experience — yours and mine — takes precedence over tradition

 as a means of knowing the world and our place in it. This attitude is characteristic of our time and has itself become a convention of modernism. This attitude is not characteristic of the past, and it may not be true in the future. Its spirit is democratic, liberal, romantic. It is a response to a time characterized by rapid change; by the falling away of old certainties, institutionalized truths, and a common core of social, political, and religious beliefs and practices. Authoritarianism of any kind is suspect. We tend to accept nothing without the test of our own experience, and believe that we must find things out for ourselves. ¶ This way of thinking is reflected in an art that has more than ever before taken on the aspect of continuous experimentation. Art appears to us today as a continuing search for the new. Most artists working today place a great value on originality. They are

attracted by the unknown. Many see their art primarily as a vehicle of exploration into their own personal world. In this chapter we will investigate some of the recent work that exemplifies this movement toward subjective vision.

Since the 1960s, it has become apparent that a number of artists have been moving in directions that are distinct from abstract art. Because of the variety of directions they have taken, and the absence of any uniform program, they have been called, simply and tentatively, postmodern artists, based on the idea that they are exploring beyond the frontiers of modern art. (It is possible, of course, that in time this art will be considered simply another manifestation of modern art.)

What they share is an eagerness to push out the boundaries of art; to remove what they see as arbitrary, conventional limitations to what art is, what it looks like, and what an artist does. They have opened up a number of issues about art that had heretofore been considered settled: What constitutes a work of art? Is it always and only a product? Can it be an event, a place, or a person? Where is its proper place — always in the gallery? Can it be located outside? What materials can be used in a work of art? Must it remain the same over time, or look the same each time it is presented? Must art be beautiful, unique, and totally original? Must art have substance at all? Can chance or accident play a part in it? How long must it last?

In the background was a situation in the art world in which painting had suddenly become "safe." By the mid-sixties, abstract art was being collected avidly, and Pop Art, with its recognizable images based on commercial art and mass-produced objects, had attained respectability. Art had become an investment, a status symbol, an all too predictable esthetic experience. To a number of young artists it seemed time for something new. They felt a need to break away from the heady concerns of Abstract Expressionist painting, which celebrated the life of forms and the passionate involvement of the artist in their creation. They wanted to go beyond the esthetic limits of Pop Art as well. Their aim was to draw art even closer to life, and to a broader range of experience.

Any incentive to paint is as good as any other. There is no poor subject.

Painting relates to both art and life. Neither can be made. (I try to act in that gap between the two.)

A pair of socks is no less suitable to make a painting with than wood, nails, turpentine, oil and fabric.

A canvas is never empty.

— Robert Rauschenberg, 1959

BLURRING THE LINE BETWEEN ART AND LIFE

Already in the 1950s Robert Rauschenberg and Jasper Johns had begun extending the boundaries of art by incorporating into their work ordinary manufactured objects from the real world, or replicas of them (Figs. **12-1** and **12-2**). Their work awakens us to the idea that anything becomes art if the artist places it in an art context.

In the early 1960s, "assemblages," "environments," and "Happenings" pushed the boundaries of art further by taking it out of the gallery or museum

12-1
Robert Rauschenberg, *Untitled (Parachute)*, 1955. Collage—mixed media, 57″ × 56½″. Yale University Art Gallery, New Haven, Connecticut.

12-2
Jasper Johns, *Painted Bronze*, 1964. Painted bronze, approx. 5½″ × 8″ × 4¾″. Kunstmuseum Basel, Ludwig Collection.

and into the world of immediate, tangible experience. Assemblages consisted of everyday objects removed from their usual context and stacked, heaped, or otherwise combined so as to be looked at apart from their function. Environments were essentially assemblages that you could walk around in (Fig. **12-3**). People were encouraged to interact with the objects they found in assemblages and environments. From that interaction evolved the idea of a participatory event, or a "Happening" (Fig. **12-4**).

The common function of these alternatives is to release an artist from conventional notions of a detached, closed arrangement of time-space. A picture, a piece of music, a poem, a drama, each confined within its respective frame, fixed number of measures, stanzas, and stages, however great they may be in their own right, simply will not allow for breaking the barrier between art and life.

And this is what the objective is.

—Allan Kaprow (from *Assemblages, Environments, and Happenings*, 1966)

Assemblages, environments, and Happenings broke down the old distinctions between art and non-art, between art and the real world, and between artist and spectator. They demonstrated that esthetic purity and refinement is not necessary to art, and pointed instead to the central importance of idea and attitude. Art was no longer something "special." Postmodern artists in the 1970s, '80s, and '90s would explore the implications of these ideas by further blurring the line between art and life, but in ways that were highly personal and idiosyncratic.

12-3
Allan Kaprow, *Yard*, 1961.

12-4 (below)
Jim Dine, *Car Crash*, 1960.

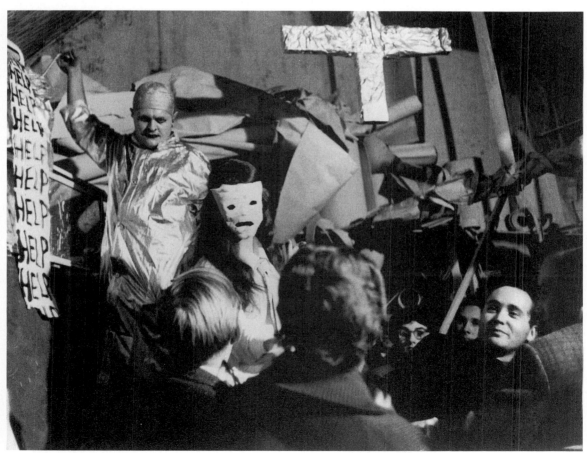

UNIQUE PIECES

Postmodern art is not a style, but a collection of individuals doing different things. Some artists present us with objects, constructions, and environments that exist somewhere between painting, sculpture, and architecture. These pieces are unique, not abstractions of other objects. Their forms reflect the imaginative world of their creator. The pieces of Eva Hesse (Fig. **12-5**), at once delicate and mysterious, may not strike us as beautiful, but many people find them so haunting that beauty seems irrelevant, or, rather, it emerges in a different guise.

Frequently we are expected to interact with postmodern pieces. We may touch them, move them, walk on or through them, be inside them, read them, or listen to their sounds. As in Douglas Huebler's *Variable Piece 4/Secrets* (see Fig. 2-3), they may require the participation of the spectator to bring them into being or to complete them. They show us that the hushed, reverential, nontouching atmosphere of the museum is not the only way to experience art. These pieces are meant to give us experiences that are more intense and accessible because of our physical involvement with them. To experience Lucas Samaras's *Mirrored*

12-5
Eva Hesse, *Untitled*, 1970. Fiberglass over polyethylene over aluminum wire. Seven units, each 7'2" to 7'3" × 10" to 16". Private collection.

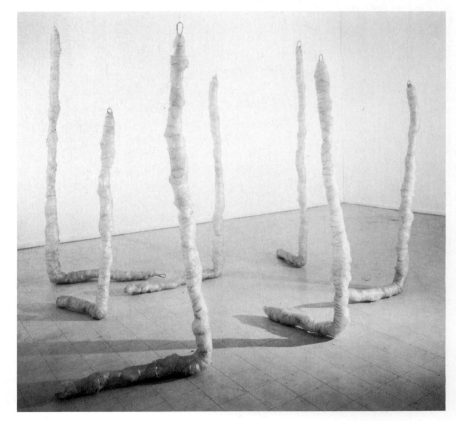

12-6
Lucas Samaras,
Mirrored Room, 1966.
Mirrors, 8′ × 8′ ×
10′. Albright-Knox Art
Gallery, Buffalo, New
York. (Gift of Seymour
H. Knox, 1966.)

Room (Fig. **12-6**), for example, you must go inside, where you feel as though you are floating in an infinite, sparkling space.

Natural environments altered in some way that is neither conventionally esthetic nor practical can provoke reactions different from our reactions to parks, gardens, or paintings of landscapes. These "site pieces" encourage us to ponder the nature of our relationship to the earth. They remind us of traces left by civilizations whose attitudes toward the earth were less utilitarian than ours. Site pieces carry us away from points of reference to society or to culture. Robert Smithson's *Spiral Jetty*, for instance, brings us into a world where we experience ourselves in relation to vast reaches of space and time (Fig. **12-7**). Recently a number of artists have created site pieces that focus on environmental concerns.

12-7
Robert Smithson,
Spiral Jetty, 1969–
1970. Black rock, salt
crystal, and earth, 160'
diameter. Rozel
Point, Utah.

Sometimes we are presented with a thought, a proposition, information, the demonstration of a concept, or simply a word. The artist encourages us to explore what these mean to us in terms of our own experiences. These presentations — examples of Conceptual Art — suggest that an idea implanted in our minds can exist as a work of art. They imply that the essence of a work of art is not its form or appearance but the idea or ideas that it elicits. Douglas Huebler's *Variable Piece 4/Secrets* (Fig. 2-3) is a witty example.

Sol LeWitt is a Conceptual artist. His wall drawing, *Location of a Rectangle* (Fig. **12-8**), provides an example of this direction. Its appeal lies more in the playful elegance of its conception than in the visual result.

The words "system," "establishment," and "power structure" came into colloquial use in the 1960s to denote complex sociopolitical institutions and their reciprocal interactions. In the 1970s, computer systems, electronic circuitry, and an awareness of ecological systems also affected the public consciousness.

Process, systems, and structures, as well as chance and randomness, turned up in various ways in the work of a number of artists in recent years. Hans Haacke has explored political, economic, social, and physical systems through photographs, documents, maps, and even self-contained environments demonstrating natural phenomena. He has been particularly interested in the political and social processes that operate in the art world within contemporary Western society, and in the ways that these processes, and the systems they form, affect

The Location of a Rectangle

Instructions from the artist:
A rectangle whose left and
right sides are two thirds as
long as its top and bottom
sides and whose left side is
located where a line drawn
from a point halfway between
the midpoint of the top side
of the square and the upper
left corner to a point half-
way between a point halfway
between the center of the
square and the lower left
corner and the midpoint of
the bottom side is crossed
by two lines, the first of
which is drawn from a point
halfway between the midpoint
of the left side and the
upper left corner to a point
halfway between the point
halfway between the center of
the square and the upper right
corner and the midpoint of the
right side, the second line
from a point halfway between
the point where the first line
ends and a point halfway be-
tween the midpoint of the
bottom side and the lower
right corner to a point half-
way between a point halfway
between the center of the
square and the lower left corn-
er and the midpoint of the left
side.

12-8
Sol LeWitt, *Location of
a Rectangle*, 1975.
Wall-drawing,
11" × 15½", with
artist's instructions.
Wadsworth Atheneum,
Hartford, The Ella
Gallup Sumner and
Mary Catlin Sumner
Collection.

the public's understanding of art. Haacke's *News* (Fig. **12-9**) was an installation of working ticker-tape machines that brought the news of five news services into the museum. At the end of each day, the news was collected and stored in cannisters. For Haacke, the museum context was essential to the piece, for only there could the piece jar the observer into a consideration of the elitism and the unreality that Haacke regards as a part of the art world today.

Haacke packaged a process we don't usually pay attention to — news gathering. In contrast to other works of art usually found in museums, his piece was obviously linked to everyday life. It was informative, up-to-date, and available to all free of charge. What parallels with art might be found in the process of news gathering? How important are these parallels to our understanding of and reliance on news?

12-9
Hans Haacke, *News*,
1969–1970. Five
teletype machines
printing out wire
service news.
Installation in the
Software Show at the
Jewish Museum,
New York.

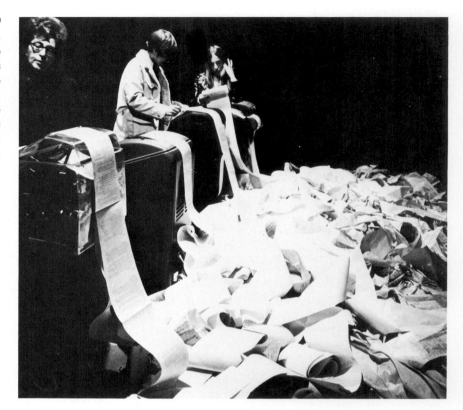

The artist's business requires his

involvement in practically everything. . . . An artist is not an isolated system.

In order to survive, he has to continuously interact with the world around

him. Theoretically, there are no limits to his involvement.

— Hans Haacke, 1968

Performance art has its roots in the wild, often impromptu events staged in
auditoriums, cabarets, and streets by Futurist groups in Italy and Russia before
World War I. As Happenings again merged art with theater in the 1960s, they
revived the idea of the artist as performer, and artists created an art around
themselves.

Laurie Anderson is a creative dynamo whose performances mesh visual arts
with music and narrative (Fig. **12-10**). Anderson's stories and observations,
which she frequently delivers in an electronically altered voice, are accom-
panied by high-tech electronic equipment that generates rapid-fire image and
sound environments. Like several contemporary rock stars, Anderson moved
into performance from the visual arts, and her appeal has spread beyond the "art

world" into popular culture. In performances and records, Anderson constructs the persona of a gentle, sensitive person of either sex, sometimes naive, sometimes savvy, moving cautiously through today's social and political realities. Anderson suggests that irony, sympathy, and humor can help the modern individual to survive.

Today's art scene is eclectic, reflecting an energetic individuality and a no-holds-barred attitude toward art. Many artists are creating gallery "installations," environments populated with objects and perhaps accompanying narrative materials. New technology, such as duplicating machines and computers, has enriched our visual world with new art forms and new imagery. Video is another burgeoning art form. In the hands of artists, a video can be a meditation, images of ice skaters gliding across a wall of television monitors, or a talk about racial prejudice.

Art as well as life is examined in the contemporary interest in "image appropriation." Appropriated images are images borrowed from earlier art forms or from popular media, and incorporated into a new work of art. The Starn twins and Barbara Kruger, who are discussed in Chapter 9, are well-known examples of this interest. Appropriation raises questions such as: What value should we place on a one-of-a-kind image? Aren't reproductions just as good? What is meant by originality in a work of an artist? How valuable is it? Can artistic styles and their meanings be renewed? Is art ever in the past? And what can we learn from the commercial art that is all around us?

Many artists working in traditional categories today shun esthetic polish in order to let the viewer become involved with the process of creation, and re-experience with the artist the transformation of material into idea.

12-10
Laurie Anderson,
United States Part II.
Performance Art.
Presented by the
Kitchen at the
Orpheum Theater,
New York, 1980.

12-11
Nancy Graves, *Colubra*,
1982. Bronze with
polychrome patina,
35¾″ × 28″ × 22½″.

Since the 1960s, Nancy Graves has made highly individual paintings, draw-
ings, films, assemblages, and sculptures, typically based on scientific data.
Graves uses the word "whimsical" to describe her work. Recently she has been
exploring bronze casting techniques that permit her to transform leaves, seed
pods, corn husks, palm fronds, and other natural forms into imaginative, brightly
painted sculptures (Fig. **12-11**).

12-12
Anselm Kiefer,
Interior (Innenraum),
1981. Oil, acrylic,
emulsion, straw, and
shellac on canvas
with woodcut, 113″
× 127⁷/₁₆″. Stedelijk
Museum, Amsterdam.

A dramatic resurgence of figurative painting captured attention in the art world in the past decade, reflecting a postmodernist concern for expressive, psychological, or narrative content. Images once again are primary vehicles of communication, but in keeping with the postmodern abhorrence of esthetic "finish," they are frequently unkempt, abrasive, and direct.

Anselm Kiefer was born in Germany in 1945, the year that ended World War II and Hitler's Reich. Keifer's mammoth, brooding paintings take on epic religious, mythic, and historical themes relating to his native land. His *Interior* (Fig. **12-12**) shows a formal room that existed in Hitler's Chancellery in Berlin. The room bears the burden of its history. Actual wooden panels attached to the canvas emphatically darken the windows, and the muddy, mottled, caked-up paint and straw (which occasionally comes loose and litters the floor) speak of decay. A fire burns, blackening the room. Is it a fire from Hell? Is it spiritual? Or both at once? Can it purge? Can it redeem and renew? Kiefer's raw paintings pull art into the center of life. For Kiefer, art is nothing less than an activity through which society can be saved.

Contemporary science fiction films provide an arena for postmodernist ideas and interests. Here the imagination is exercised in the context of the real, tangible world. The fantastic special effects and sets of such films as *Star Wars* (George Lucas, 1977), *Star Trek II: The Wrath of Khan* (Nicholas Meyer, 1982),

12-13
Two "light cycles" race across the video game grid in *Tron*. © 1982 Walt Disney Productions.

Blade Runner (Ridley Scott, 1982), *Tron* (Steven Lisberger, 1982), and *Terminator 2: Judgment Day* (James Cameron, 1991), fulfill the yearnings of artists for situations that integrate art with life (Fig. **12-13**).

In short, postmodern art shuns what is familiar, or undermines our assumptions about it. Like abstract art, and modern art in general, postmodern art aims to lift us out of our usual channels and take us from certainty to uncertainty, if only for a while. It may be later, on reflection, that the significance of our experience becomes clear, and we return once more to certainty. If so, we return not as we left, but enlightened, perhaps changed, in some way.

CHRISTO'S *RUNNING FENCE*

The above discussion provided some ideas about recent developments in the art world. In each case I suggested a few general ideas about the works of art. Now let's spend some time with one work.

Christo's *Running Fence* (Fig. **12-14**) is an extraordinarily imaginative piece, rich in meaning. The project took four years, during which time Christo was involved with property owners, lawyers, engineers, surveyors, environmentalists, politicians, boards, courts, and commissioners. There were meetings with the 59 ranchers and landowners on whose property the fence was to be located, eighteen public hearings, a 450-page Environmental Impact Report, and sessions in the Superior Courts of California before contracts were signed and permission was finally granted. To understand *Running Fence*, we must realize that for Christo, all this preparation was not preliminary, but as much a part of the art as the structure itself.

More than 300 workers helped to construct the fence. Made of white nylon, 18 feet high and 24½ miles long, it was constructed in California where it was on display, as planned, for two weeks in September, 1976. After that it was removed. The project, which cost about $3 million, was funded by the prior sale of drawings, prints, and collages that Christo made in connection with *Running Fence* (Christo finances all his projects by himself, and refuses grant money). With that as introduction, let's consider what lines of thinking the project can generate.

12-14
Christo, *Running Fence*, 1972–1976. Steel posts and nylon sheeting, 18' high, 24 miles long, Sonoma and Marin Counties, California. Photo courtesy of Jeanne-Claude, © Christo 1976.

1. Works of art as we usually think of them are made to last. The transience of *Running Fence*, like other projects of Christo, moves it toward real-life experiences. Can we see it as a poignant commentary on life? On history? On personal experience? Is it a message of faith? Or simply a message about our throwaway culture?

2. Most art today is done by one individual in private. Because Christo's pieces are group efforts, and quite public, they recall traditional projects such as the building of churches and cathedrals in the Middle Ages, old-time barn raisings, and the decoration of Christmas trees. Can you think of any other group projects in art?

Christo's project involved democratic governmental and legal processes, and it tested the exercise of private property rights. What sociopolitical meanings might Christo's four-year struggle contain? Consider the statement of Christo's wife, Jeanne-Claude, that "the real dimensions of *Running Fence* are political, social, and economical."[1]

The participation of many individuals in the project is central to Christo's ideas. Christo believes that the experiences and interpretations of people involved in his pieces enrich the work. Do you agree that these interpretations can also be considered contributions? If so, would you consider all those drawn into the work as creators too?

3. Consider *Running Fence* esthetically. Its photographs show a graceful, sensuous form whose colors changed with the light. At night it glowed under the full moon. People who saw it said its movement made it seem alive. The *Fence* was not straight, but wound over the hills like a river. Occasionally, part of it would dip out of view. It grew out of the ocean; we view it against the sky and against the earth. Do you enjoy its contrast with the landscape? Its harmony with the landscape? Both? Does it intrude, or does it complement the landscape?

Why would Christo want to move out of the gallery, and out of the city, to create this shape on the landscape?

Its scale is awesome. Or, if we like, it may be no more than a fine, curving line. How important is its scale? Can we isolate it from its surroundings?

What could you have experienced up close? Far away? Walking along it? What might you have discovered along the way?

4. *Running Fence* is also a screen that hides things. Hiding something can make us more aware of it. We look at packages and wonder what's inside, or look at curtains and wonder what is behind them. Out on the landscape, *Running Fence* acts as a baffle but also as a frame; it obscures and reveals at the same time.

We wonder: What might hiding, screening, obscuring mean to Christo, who has used this theme repeatedly in his work? What might it mean to us? What might it mean in sexual or psychological terms? In social or philosophical terms?

Running Fence is also, of course, a fence. It marks a place and it makes a boundary of some kind. Yet it opened at places to allow for passage of automobiles, cattle, and wildlife. What might a boundary or a border suggest to you? Can we see this aspect of *Running Fence* as a political statement?

5. Most of the viewers of *Running Fence* will know it secondhand, through photographs, films, and books. Thus the project raises the questions: How necessary is it to have experienced this, or any work of art, firsthand? What advantages might there be to viewing a work in reproduction? Which experience tends to encourage exploration of the ideas contained in the piece? Which yields more information? Which would be more exciting? More memorable? More esthetic? To what extent is the real existence of any work of art in the mind?

Most art is known to its audience today through photographic reproductions, films, and television. How does this affect our understanding of works of art? How might it affect the future history of art? How is our understanding of news events shaped by our watching them on television?

Photographs of site pieces by Christo, Smithson, and others are remarkably beautiful, and films such as the Maysles brothers's *Christo's Valley Curtain* (1972) and *Running Fence* (1972-76), and Robert Smithson's *Spiral Jetty* (1970) are also fascinating and informative. Photographs and films do much more than provide a record: they shape our experience of the pieces as well. Thus we might ask: To what extent might the photographs and the films be considered the end products? To what extent might they be considered as art, rather than as the report of the art? Consider that the Maysles brothers made their films with the cooperation and patronage of Christo, while the *Spiral Jetty* film is Smithson's own work, and that these films, photographs, and books are a source of revenue.

6. What works of art might be considered predecessors of the physical aspect of *Running Fence*? Might Christo have been influenced by the Great Wall of China or Hadrian's wall in England? The Iron Curtain? Picasso's collages? Dada pieces (see Fig. 17-6)? Old movies about buccaneers and sailing ships?

The answers to some of these questions may be found in Christo's own background. At a meeting of the College Art Association in New York in 1982, Christo suggested that an experience in Bulgaria, where he was born, might explain his fascination with concealment. Bulgaria lay behind the Iron Curtain, and Christo pointed out that when he was growing up the only thing that entered Bulgaria from the West was the railroad train known as the Orient Express, which ran between London and Istanbul. While in art school he and his fellow students were required by the government to tidy up the countryside where the train passed through to present a pleasing image of Communist Bulgaria to the West. Even the haystacks were to be formed in a certain way. These weekend activities made him aware of the interplay of appearance and concealment as a theme in art.

At the same time, the experience of altering a site could have provided a basis for thinking about the landscape as material (not just subject) for art. We too might want to consider whether the reshaping of a site constitutes an art form. We recognize parks and landscape architecture as forms of art. But what about a field of neatly packed haystacks? Furrows ploughed up in rows? Quarries? Excavation sites? A final thought: Was the Bulgarian government an unwitting patron of avant-garde art?

Christo also spoke of his immigration to the West from behind the Iron Curtain. His fascination with the Iron Curtain, both as image and idea, is more than implicit in his work. In 1962 in Paris, Christo piled oil drums on one another to create a wall that blocked off a narrow street. He called this piece *Iron Curtain*. In time, the oil drums were removed; the *Iron Curtain* dissolved easily, leaving its audience to ponder walls, what they are and why they are.

INDIVIDUALISM AND CONSERVATISM

All artists look into their own thoughts, feelings, and imagination for direction. What the public sees as individualistic is often the cutting edge of new artistic ideas, attitudes, proposals, forms, projects, and images that will eventually pass into the public domain. By the time the art appears in college art history courses, it is seen in terms that are broader, more universal. It is seen as embodying certain cultural values, as carrying symbolic meanings, political meanings, sociological meanings; or as an example of the prevailing style. Those are, of course, valid ways to look at it. Nevertheless, a work of art as we understand it today remains in essence a personal statement, the expression of one individual, irreducibly subjective.

The study of art in Western civilization reveals a tendency toward artistic freedom. It asserted itself in the Renaissance, received impetus during the Romantic period, and attained full consciousness with modern art. During those years the boundaries of art, its imagery and its content, were in a state of expansion. It would be well to remember that even before modern times artists such as Bosch, El Greco, or Rembrandt might, by virtue of their originality, puzzle their audience to the point of despair.

But there were conservative tendencies as well. A fundamental commonality of form and intention maintained itself among Western artists, even including the independent geniuses. Even Rembrandt (see Figs. 2-1, 15-3, and 17-2), whom we think of as a great individualist, collected statues from Roman antiquity, as well as paintings by and engraved reproductions of the work of Raphael, Leonardo, Durer, and other artists of the Renaissance. Occasionally Rembrandt even borrowed the poses of figures for his own compositions from Raphael and from engravings of ancient statuary, and his subject matter—landscapes, portraits, and illustrations of Bible stories—was typical of his time.

However diverse the styles and attitudes of Western artists have been since the Renaissance, until recently there was a general agreement that art—at least serious works of art—should be beautiful, meaningful in some religious or humanistic way, and lasting. Late nineteenth-century artists such as Monet, Van Gogh, Renoir, and Cézanne still adhered to these principles, and they are implicit in the art and writings of the pioneers of abstract art. It was the Dada group, formed during World War I, that first held them up for question. Postmodern artists regard them as untenable for the most part, because it is just these values that keep art pure, precious, and apart from life.

ART AND NON-ART

If much recent art has attempted to shun associations with the forms and ideas of the art of the past—with what we know as "fine arts"—it has, with the same motion, moved into closer proximity to all that is extraneous to it: to the prosaic and unexceptional aspects of everyday

experience, to materials that are drab and commercial, to investigations that traditionally fall within the domains of natural and social sciences, mathematics, and philosophy, to what is subject to chance, accident, or natural processes. In using new subject matter, it also may speak in the language of that subject matter. At times the methods and the procedures of those "non-art" activities are of greater interest to the artist than methods and procedures traditionally associated with art.

Artists in the past revealed the beauty of things, but always tried to persuade their audiences that their art was more beautiful than what it depicted. People who view postmodern art may be disturbed because they can't see the art in it. Of course, it's really not the art that has been relinquished, but the esthetic aspects. The beauty, the idealism, the sentiment—those things we typically associate with art—are absent. But if art as we have come to know it is not there, then, according to Allan Kaprow, "the rest of the world has become endlessly available."[2] Kaprow developed this idea further in an essay published in *ArtNews* magazine in 1971. There he contended that "non-art" objects were more exciting than objects intended as art. He asserted that the Lunar Module mooncraft was superior to contemporary sculptural efforts, that the broadcast exchanges between the Apollo II astronauts and the Manned Spacecraft Center in Houston were better than poetry. He praised bright, plastic and stainless steel gasoline stations, mechanical clothes conveyors used in dry cleaners' shops, and vapor trails in the sky. Kaprow suggested that the impact these have on us derives from their being unintended as art.

ROOTS OF POSTMODERNISM

If Kaprow, Rauschenberg, Johns, and postmodern artists in general have a spiritual father in art, that figure is Marcel Duchamp. In 1914, Duchamp began to exhibit what he called his "ready-mades": commercial objects that he bought in a store and presented, unchanged but for his signature, in an art gallery (Fig. **12-15**). Later, in 1917, Duchamp attempted to exhibit a urinal, which he entitled *Fountain* and signed with the name of the manufacturer, Mr. R. Mutt. The work was rejected on the grounds that it was obscene, and unoriginal as well. In defense of the latter charge, Duchamp replied: "Whether Mr. Mutt with his own hands made the fountain or not has no importance. He CHOSE it. He took an ordinary article of life, placed it so that its useful significance disappeared under the new title and point of view—created a new thought for that object." To the charge of obscenity he replied that similar objects are commonly found displayed in plumbers' shops, and added his opinion that "the only works of art America has given [produced] are her plumbing and her bridges."

Ready-mades blurred the line between art and the real world. More important than the particular objects themselves, however, was Duchamp's intention. In effect, he thumbed his nose at the idea that art was something precious and apart from everyday realities. Duchamp's humble objects were chosen precisely for their lack of character.

12-15
Marcel Duchamp,
Bottle Rack, 1914.
Ready-made, replica
1961. Metal. Courtesy
of Mrs. Marcel
Duchamp.

Duchamp was associated with the Dada movement. The name "Dada," a nonsense word, was picked by the artists and writers who formed the group. Created out of the disillusionment of World War I, the Dadaists scorned what they regarded as the hypocritical self-satisfaction of contemporary Western civilization. They rejected the art that accommodated its complacent middle classes — an art they perceived as primarily concerned with esthetics. They felt that esthetic concerns had deadened art. Hence they purged their work, whether art, music, dance, theater, or poetry, of both esthetic considerations and rational coherence. Through creative activity that was utterly nonesthetic, and even anti-esthetic, they hoped to force people to reinspect old assumptions. What is art? What is reality? What might be the relation between the two? Their use of everyday objects broke the tyranny of beauty, and suggested that life was as interesting as art.

Duchamp and the Dadaists insisted that art must challenge the mind. What was beautiful, historic, or permanent held no interest. They rejected art that was out of touch with present realities — social, political, or cultural. Their hard-headed manifestos and public events (some of which ended in riots) conveyed a belief in the possibility of an art that, although overtly nihilistic, would be genuinely redemptive to society.

Dada is a state of mind . . .

Like everything in life, Dada is useless.

Dada is without pretension, as life should be.

Perhaps you will understand me better when I tell you that Dada is a virgin

microbe that penetrates with the insistence of air into all the spaces that

reason has not been able to fill with words or conventions.

—Tristan Tzara, poet and founder of Dada, 1924

The Dada movement as such was short-lived. By the 1920s its members were directing their energies elsewhere. But its influence on later artists was profound. Dada's interest in everyday, ostensibly non-art objects was revived in the fifties and sixties, and postmodern artists have continued to work, as Rauschenberg indicated, in the gap between art and life. Perhaps above all, Duchamp revealed to artists the freedom that was open to them.

Another root of postmodern art can be found in the Bauhaus (which you will recall from Chapter 8). Unlike the Dadaists, for whom esthetics was a nasty idea, Bauhaus artists were intensely involved with formal concerns. Their interests, though, extended beyond the fine arts. From the beginning, the Bauhaus took a matter-of-fact attitude toward the fine arts, integrating painting and sculpture with architecture, industrial design, and crafts, on the basis of a common search for principles of basic design. Classes at the Bauhaus were called "workshops," and the same preliminary courses were required of all students, regardless of their intended area of concentration.

Those Preliminary or Foundation Courses were taught by Josef Albers and László Moholy-Nagy, who used them to initiate and to develop ideas that were to have considerable impact in later years. Albers and Moholy eventually brought their ideas to the United States. Albers, after teaching at the experimental Black Mountain College in North Carolina, became the chairman of the Department of Art at Yale. Moholy became the director of The New Bauhaus in Chicago, and eventually established the School of Design, later to be called the Institute of Design, in that city.

At these schools, art was regarded as a way of seeing, of operating. Experimentation and investigation were encouraged. Attitude seemed to be as important as talent. While at the Bauhaus, Moholy wrote a statement that became widely known (and disparaged by artistic conservatives): "Everyone is talented."

Albers and Moholy taught with an enthusiasm that stemmed from the belief that art itself is a form of learning—a means of furthering insight and awareness. Their focus in teaching was less on the product than on the process by which it is realized. Albers repeatedly told his students, "I'm not training you to be professionals, I'm training you to ask questions."

Albers taught no style; in fact he often expressed satisfaction that his students' work was so different from his own, as well as from each other's. In a 1958

12-16
László Moholy-Nagy,
Light Display Machine,
1922–1930. Kinetic
sculpture of steel,
plastic, wood, and other
materials with electric
motor, approx. 60"
high. Courtesy of the
Busch-Reisinger
Museum, Harvard
University. (Gift, Sibyl
Moholy-Nagy.)

interview in the *Yale Literary Magazine* he advised his students to "keep off the band wagon," and reminded them that "true individuality—personality—is not a result of forced individualness or stylization, but of truthfulness to one's self—of honesty and modesty." He would often tell his students at Yale: "In all of your other classes, you must come up with one answer. Here you can come up with many answers—all of them right."

Robert Rauschenberg (see Fig. 12-1) studied with Albers at Black Mountain. While Albers was seeking general principles of color and design, Rauschenberg was interested in breaking the rules. Nevertheless, years later he described Albers as "a beautiful teacher," and added: "He didn't teach you how to 'do art.' The focus was always on your personal sense of looking. . . . I consider Albers the most important teacher I've ever had."[3]

Moholy's artistic life anticipated attitudes prevailing in art today. During his career, Moholy painted on canvas, aluminum, and plexiglas; he developed a kind of three-dimensional painting that he called a "Space Modulator"; he designed merchandise exhibitions and the interiors of stores; he produced innovative layouts for books and posters; he developed typefaces; and he constructed sculptures, both stable and kinetic, using new materials including various kinds of plastics, glass, nickel, and chrome (his sculptures using transparent materials were also called Space Modulators). He developed photography and "photograms" (Moholy's term) as art forms; he created sets and special effects for the theater and made documentary films; and he designed sets and special effects for the 1936 science fiction film *The Shape of Things to Come* (most were not used, perhaps because they were too rich). From 1922 to 1930 he designed a

12-16
László Moholy-Nagy, *Light Display Machine*, 1922–1930. Kinetic sculpture of steel, plastic, wood, and other materials with electric motor, approx. 60" high. Courtesy of the Busch-Reisinger Museum, Harvard University. (Gift, Sibyl Moholy-Nagy.)

machine in chrome and glass that would throw moving patterns of light and shadow on the walls and ceiling of a room (Fig. **12-16**), and he made a film of the light effects. He designed the interior of a vista dome passenger car for the Baltimore and Ohio Railroad (never realized), pens and inkstands for the Parker Pen Company, and a six-in-one hand tool for a mail-order catalogue. His book, *The New Vision* (1938), had photographs showing the electric transformers of a railway system, street traffic at night, a gyroscope spinning, a lighted merry-go-round revolving, umbrellas crowded together, drops of petroleum on water, and the skeleton of a dirigible under construction.

Moholy's art encompassed whatever he seized on. The possibilities seemed endless to him, for he thought of art as a way of addressing life rather than as a precious gem to be sequestered. Through his life and his work, Moholy demonstrated that the world is indeed "endlessly available." The following is an account by his wife from his biography.[4]

One night we stood on the top platform of the Berlin Radio tower. Below was an intricate pattern of light and darkness, the flashing bands of trains and automobile headlights; above were the airfield beacons in the sky. Moholy must have seen it a hundred times. He lived only a few blocks away, and he had done some fine photographs from the platform on which we stood. But his enthusiasm was that of a surprised child.

"This is it—almost—this is almost painting with light."

The engine of a train puffed thick, white clouds into the night; the billowy denseness was rifted by streaks of glowing sparks.

"I've always wanted to do just this—to project light and color on clouds or on curtains of falling water. People would respond to it with a new excitement which is not aroused by two-dimensional paintings. Color would be plastic—."

THE ARTIST AS AMATEUR

M any people still think of art as a painting hanging in a museum they never visit. Along with this go ideas about beauty and esthetics that fall short of including much of what we see and experience in our daily lives. Recent art has suggested that light coming through fiberglass can affect us as much as Titian's red; that there is an esthetic character to scientific data; that photographs taken at random can intrigue us; and that demonstrations of Euclid's theorems will reveal the serene beauty and symmetry of geometry. To the mind that is open and aware, the possibilities for excitement and discovery have no limit.

If art today has to some extent lost the "master" as the prototype of the artist, it has gained the "amateur," in the sense of a person who is involved with an activity for the interest and the pleasure of the involvement itself. The artist as master who dazzles with virtuosity has given way in this art to the artist as amateur who, more quietly, invites you to share enthusiasms, interests, investigations, ideas, hunches, musings, and curiosity. This is not, of course, to say that these artists are without skill, but rather that skill is not flaunted as an end in itself.

Perhaps all artists are at heart amateurs ("lovers" in French), and all amateurs, artists; for amateurs contemplate their subject esthetically. They do not use it; they relish it. They bring to it something of themselves. Ideas, information, data, and solid forms are, in everyday experience, the domain of scientists, mathematicians, statisticians, logicians, semanticists, geographers, ecologists, sociologists, broadcasters, architects, engineers, industrial designers, salesmen, politicians, farmers, bricklayers, carpenters, mechanics, electricians. Their work interests us only insofar as it is useful to us. Were they to step out of their roles and show us the beauty and the logic, the system and symmetry of their material; were they to share their insights and say, "Look at this. This excites me. What do you think?", they would be, at least for the moment, artists. Perhaps someday this will happen—everyone has talent.

CONCLUSION

Postmodern art reflects a culture marked by change, flux, and fragmentation. It has incorporated, often in bits and pieces, the materials, artifacts, systems, and images found in that culture, subverting our expectations as a way of bringing new insights to bear on them. Thus it has concentrated attention on the nature and meanings of art and the connections between art and everything else. Investigating in particular the roles that art plays today, postmodern pieces are variously self-conscious, witty, deadpan, humorous, or deadly serious—or a combination.

Postmodernism celebrates complexity and diversity, irony and incongruity, juxtaposition and ad hoc spontaneity. Everything—high and low, new and old—can mix. Today, postmodernist attitudes find expression not only in galleries, but on the streets in punk and funky clothes, in popular music, and in music videos.

In the past, no matter how unusual a painting or sculpture might be, it could be resolved into a relatively simple bit of meaning by its subject matter or its title. A great deal might have remained beyond the awareness of the viewer, but this simplistic reading of paintings and sculpture accounted for much of the enjoyment they provided. Their meanings were precise and clearly stated.

This is of course not true of the art we have been looking at. Much of the art of the twentieth century has been intentionally unconventional, ambiguous, speculative, and open ended. It has probed rather than proclaimed; it has questioned everything including itself. The communication of some particular message or objective truth—a prerequisite in traditional art—appears to be of less consequence than its function as a catalyst for the uncovering of experience.

Postmodern art suggests that experience counts more than art itself—or invites us to extend our ideas about what art looks like to incorporate a wider range of possibilities. In a world of uncertainty postmodern art expresses trust in subjective experience. It affirms that experience—yours and mine—is valid, however personal, conditional, chancy, or open to change. It suggests further that experience may be valid precisely because of these conditions.

13
ART AND THE REAL WORLD

In Europe of the Middle Ages, art was integrated into every sphere of life. The roles of artists were clearly defined. Artists were considered on the same level as bakers, shoemakers, weavers, or dyers. No distinction was made between art and crafts. ¶ At the center of medieval society was the Church, which exercised political, social, and economic power, as well as spiritual. Art made tangible both the presence of the Church and its teachings. ¶ The Gothic cathedrals of northern Europe (see Fig. 7-1) were the supreme artistic achievements of the later Middle Ages. They drew upon the imagination and skill of architects, stone cutters, stone masons, stone carvers, carpenters, wood carvers, glassworkers, painters, and gilders. In addition, many unskilled people volunteered their labor as an act of faith. Immense, complex, gloriously endowed with art, the cathedrals conveyed the authority and splendor of the Church. They were also a source of local pride, for although specialists were imported to work on them, much of the labor and cost was assumed by citizens of the town. However, people were shrewd enough to realize that the cathedral would attract pilgrims, whose presence would benefit the economy of the town for years to come. ¶ What is the role of art today? What place does it have in our culture? How does it relate to our daily lives? To answer these questions we need to agree on the art we are going to discuss. As we have seen, art has many different purposes in our society. Many different kinds of art answer to those purposes. Some art is well integrated with everyday life. The advertisements we read in magazines or watch on television, the movies and television shows we see, our cars, comics, clothes, and furniture are all forms of art. What do they reflect about us, our attitudes

and values? What messages do they communicate? How do films and advertisements shape the way we think? What is the impact of those messages? Each of us would answer these questions in our own way. But each of those responses would help us to understand the role of art and its relation to our daily lives.

We will investigate some of these issues in Chapter 20. For now, however, let's set aside popular art and consider art that is created more or less for its own sake — the art of galleries and museums. This art is certainly less integrated into everyday life than commercial art. It seems remote and self-involved. Many people find it irrelevant.

We have seen in Chapter 8 that in most cultures, art was integrated with life. Why is there a gap between art and life in the Western world? What efforts have been made to bridge that gap? How successful have they been?

ART AND SOCIETY IN THE PAST

To begin at the beginning we must start with ancient Greece. The Greeks developed an art that was representational. Yet they didn't depict things as they actually were, with the flaws and imperfections that nature and chance imposed. Such depictions would have seemed frivolous and inconsequential. Instead they created images that attempted to present things in their essence, in their most perfect and beautiful form. Their art served as a reference and a conduit to what was permanent, beautiful, and ideal. These principles, as well as the forms in which they found expression, greatly affected the character of Western art up to the present.

Written records from ancient Greece and Rome show that despite the high quality of their work, and the legendary feats of certain individuals, artists as a class were low on the social scale. Indeed, throughout classical antiquity and the Middle Ages artists, since they worked with their hands, were thought of as little different from laborers. Still, their work was used and appreciated.

Art and life began to separate in the Renaissance, when in the glow of Humanism, works of art came to be regarded primarily as esthetic objects rather than objects that were useful or necessary. Art became something to be set aside, shown off, treasured for its own sake. At the same time, the status of artists in society began to rise. Many artists now took pains to disassociate themselves from the working class by emphasizing the academic and intellectual aspects of their work. In the new climate it appeared certain that not everyone could make art, and further, not everyone could appreciate it fully. Painting and sculpture eventually were included in the Liberal Arts — pursuits that were, strictly speaking, open only to gentlemen.

Works of art inevitably reflect the aims and interests of those who pay for them. In the Middle Ages and the Renaissance, the Church was the primary patron of artists. Paintings and sculptures of the time glorified the Church and imparted its teachings. Later, artists were called upon to embellish the courts of

kings and nobility. In the seventeenth century artists associated with royal courts were granted titles. By the end of the eighteenth century painting and sculpture were called "fine arts," and generally reflected the tastes and outlook of the upper classes. The classification of the fine arts was based on the idea that art was created primarily to please the eye and elevate the spirit, rather than serve a merely utilitarian purpose. Art was thought to be for ladies and gentlemen, who alone could appreciate it. (Artists considered themselves to be gentlemen as well, and did what they could to keep women out of the profession.) Thus art became a means of identifying and confirming the lines that were drawn between levels of society.

Most of the successful artists painted an idealized world, conforming to the tastes and outlook of their wealthy patrons. But over the years a determined minority, including Caravaggio, Rembrandt, Vermeer, the Le Nain brothers, Chardin, and Hogarth, committed themselves to painting the world as they saw it. Compare the realism of Louis Le Nain's peasants in *The Cart* (Fig. **13-1**) with Fragonard's pastoral fantasy in Figure **13-2**. Le Nain's peasants are in ragged clothes; Fragonard's might well be aristocrats playing at the country life. Is it any wonder that Fragonard was popular with the French aristocracy, while Le Nain was neglected?

Mainstream Western art, as we saw in Chapter 10, was based on the belief that truth could best be grasped in visions of a "higher" reality that transcended life. Paintings that depicted ordinary people, or everyday situations, were considered to be of little value, or in poor taste.

13-1
Louis Le Nain, *The Cart*, 1641. Oil on canvas, 22″ × 28¼″. Louvre, Paris.

13-2
Jean-Honoré
Fragonard, *Blind Man's
Buff, c.* 1750–1752.
Oil on canvas, 46″ ×
36″. The Toledo
Museum of Art. (Gift
of Edward Drummond
Libbey).

A change in attitude began to occur in the mid-nineteenth century, when paintings of ordinary people and scenes of everyday life were first shown in official exhibitions. Though these subjects were typically sweetened and sentimentalized, they reflected an interest in the "common man." More revolutionary were the paintings of the Realists, so called because of their refusal to idealize or sentimentalize their subject matter. Their respectful portrayal of working class people underscored their objection to what they saw as the escapist nature of the painting of their time (see Fig. **13-3**).

The Realists enraged the art establishment but inspired later artists to dedicate themselves to the truthful depiction of experience. As a result, a more subjective art appeared. But this art was, in general, little concerned with social

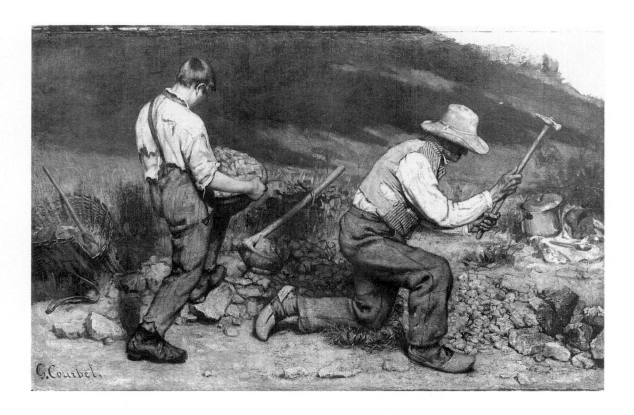

To be in a position to translate the customs, the ideas, the appearance of my epoch, according to my own estimation; to be not only a painter but a man as well; in short, to create a living art—this is my goal.

—Gustave Courbet, 1855

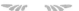

13-3
Gustave Courbet, *The Stone Breakers*, 1849. Oil on canvas, approx. 65″ × 54″. Lost during World War II. Staatliche Kunstsammlungen Dresden, Gemäldegalerie Neve Meister.

issues. The consciousness of art as an expression of the feelings and insights of the artist carried art away from social commentary toward the more introspective world of abstraction as it evolved in the twentieth century (see Fig. **13-4**).

Still, a number of efforts have been made in this century to bridge the gap between art and life. The Bauhaus in Germany aimed to connect art with the technology that was seen to be shaping the character of modern life. Walter Gropius, who organized the Bauhaus in 1919, declared that the notion of "art for art's sake" was outmoded and anachronistic. Convinced that artists had become an elitist and useless class, he asserted that they should be a part of the world of work, technology, and commercial enterprise. To this end, Bauhaus students were given practical training in trades and technology, as well as in

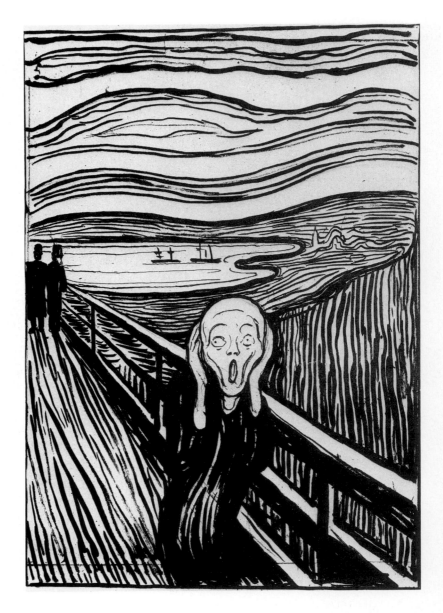

fundamental principles of design, and were expected to work in factories in order to gain firsthand information about production techniques.

In the United States a very different movement, Regionalism, aimed to bridge the gap between art and life in the 1920s and 1930s. Suspicious of European "modernism," the movement proclaimed that American art should reflect and celebrate American life (see Fig. **13-5**). Artists depicted so-called American virtues — honesty, piety, simplicity, and energy — in upbeat scenes of rural or small town life. During the Great Depression, many artists spoke of hardship and poverty through their paintings and prints (see Fig. **13-6**). They felt that

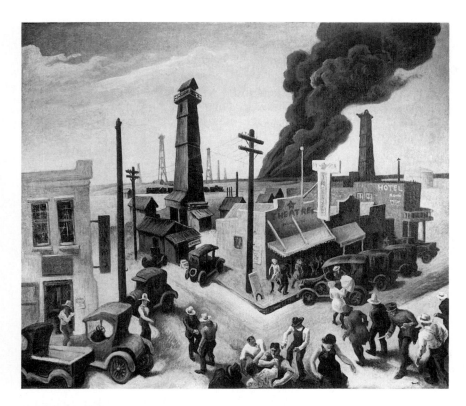

13-5
Thomas Hart Benton,
Boom Town, 1928. Oil
on canvas, 45″ × 54″.
Memorial Art Gallery
of the University of
Rochester, Marion
Stratton Gould
Fund, 51.1.

13-6
William Gropper,
Sweatshop, 1935,
Lithograph, 9⅝″ ×
12⅛″. The University
of Michigan Museum
of Art.

artists should leave their ivory towers and make a contribution to social welfare through their art. Although these artists were realists, the style of a painting or print was seen as less important than its subject and what the artist was trying to say about it. This movement is known as Social Realism.

In the early 1930s, unemployed artists were commissioned by the federal government to paint murals in public buildings. For the first time in American history, large scale art was produced that was not sequestered in museums, private homes, or institutions. Post office, courthouse, school, and library walls around the country, covered with scenes of local history and allegorical subjects, gave art an unprecedented public presence.

Social Realism faded after World War II when abstract art commanded the interest of artists and, increasingly, the public. But concern with social responsibility was to be taken up again in the 1970s, partly in reaction to the perceived self-absorption of abstract art.

ART AND SOCIETY TODAY

As we saw in chapter 12, artists in the 1950s like Robert Rauschenberg (Fig. 12-1) and Jasper Johns (Fig. 12-2) began to use commonplace objects in their work. Later, new art forms—assemblages, environments (see Fig. 12-3), and Happenings (see Fig. 12-4) took art off the walls and out of the confines of the galleries. These developments, inspired by the Dada movement of forty years earlier, renewed Dada's interest in the real world, as well as its purposive zaniness. Deploring the stuffiness that still clung to art and the art world, artists again aimed to remove the barriers between artist and audience, and between art and life.

A striking manifestation of this interest occurred in the early 1960s with the sudden appearance of Pop Art. Pop transformed the vocal, antisocial attitudes of Dada into a more easygoing social commentary that was at times humorous, and even affectionate. Pop addressed the issue of how to survive in a society inundated by mass-produced commodities, a society in which shopping and consuming had become national pastimes. Attuned to society's worship of commodities (see Fig. **13-7**) and the status they confer, Pop emphasized the glamour that consumer products attain in the media and in advertising, while hinting at darker consequences (see Fig. **13-8**).

Pop Art's unblinking reflection of contemporary life and lifestyles at first made people uneasy. Compared to abstract art, with its high seriousness, its passion, its subjectivity, and its esthetic concerns, Pop Art seemed like a put-on. But soon a new Pop sensibility made its way into American society. It brought with it a new vocabulary. Words like "camp" and "funk" reflected an attitude that found humor and ironic appeal in commonplace objects and situations. The word "Happening" came into general use and appeared in contexts other than artistic. Political events, social gatherings, and even store openings were called Happenings.

13-7
Courtesy of Buick
Motor Division.

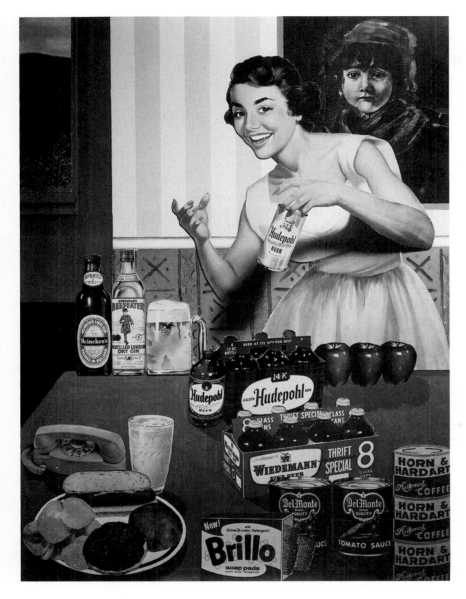

13-8
Tom Wesselmann, *Still Life No. 17*, 1962. Mixed media and collage on board, 48″ × 36″. Private collection, Chicago.

In 1968, Abbie Hoffman and the Yippies dropped dollar bills off the balcony of the New York Stock Exchange and watched the stockbrokers scramble for them. On the streets the massive and sometimes violent political demonstrations of the late 1960s were seen as living theater. Always there was the consciousness of a vast audience on the other side of the television news cameras. Political activists had learned that theater can have more impact than politics — or, perhaps, that the two were in fact the same.

It appeared for a time that there was no longer a boundary to art. Art was not just inside frames, or limited to galleries. It didn't even have to be made by

artists. Everybody was an artist. Art was wherever and whatever you wanted it to be.

The clothes worn by young people at that time signalled a heightened consciousness of life as art. There was both parody and homage, themes that were central to Pop. Clothing became living collages of historical styles. Old-fashioned clothes and discarded military uniforms were especially popular attire.

Painting literally appeared in the streets when vans and secondhand school buses were painted with colorful homemade designs. In New York City anonymous persons embellished subway cars with spray paints and magic markers. By the mid-1980s some of these "graffiti artists" were exhibiting their work in galleries in New York, Paris, and Barcelona.

Pop's informality and its celebration of commonplace, "artless" things had its counterpart in architecture. In the 1960s architects began to reject the pure, austere forms of modern architecture. Postmodern architects felt that modern architecture was too cold and impersonal, and that its formal idealism had grown out of touch with human needs. They found vitality and richness in architecture that had previously been disparaged: the architecture of a typical American Main Street, of motels and roadside restaurants, of Las Vegas, and the domestic, so-called "vernacular" architecture of the past such as one sees reconstructed at Disneyland—in short, architecture that conformed to the tastes of ordinary people. The structures these architects designed combined the formal interests of modern architecture and even sculpture with the fanciful use of traditional architectural elements for delight, surprise, and welcome associations with the past (see Fig. **13-9**).

Gradually an awareness of the beauty and value of vernacular architecture spread. Many old buildings were narrowly saved from demolition. Preservation efforts began, as individuals recognized in older structures an irreplaceable character. Many embody the history of a place; all provide links with the past. Well-constructed and frequently one-of-a-kind, their esthetic quality reaches out to us and provides a unique bridge between art and the real world.

Traditional architectural styles combined with modern forms were mandated for Seaside, an eighty-acre town built from scratch in Florida (Fig. **13-10**). Begun in 1981, Seaside is based on nineteenth-century town planning ideas, and its houses and cottages draw inspiration from the vernacular architecture of the Florida Gulf region. Developer Robert Davis hired Miami architects Andres Duany and Elizabeth Plater-Zyberk to specify the types of houses and to regulate their relation to public spaces. Other architects brought in to design private homes and public buildings had to work within those limitations. The result is a humane, comforting environment, where porches, picket fences, pitched roofs, footpaths, and gazebos recapture the charm of small-town America. But the fun lies in the game of spotting what is old and what is new, and in seeing how they are made to fit together.

Seaside exemplifies postmodern architecture's interest in grass-roots forms, which are updated and made almost elegant. Today, architect Frank Gehry cuts loose from postmodern esthetics and undercuts expectations about architectural form (Fig. **13-11**). His buildings use stark industrial materials such as plywood, sheet metal, raw concrete, and—his trademark—chain-link fencing.

13-9
Charles W. Moore,
Piazza d'Italia, 1975,
New Orleans.

Gehry's buildings are *bad* (which in current street term usage means good). They look disorganized, improvised, and unfinished. These bad guys also draw inspiration from vernacular architecture, but not the pretty stuff. Gehry finds a strength in the urban American street. His work absorbs its helter-skelter, ad hoc character, and lets us experience it in playful, robust forms.

Pop's questioning of how art should look and behave opened up other possibilities to artists. Social movements emerging in the 1960s and 1970s stimulated the desire for an art that would address itself to immediate, real-life concerns. Many women and African-Americans, committed to their respective causes, saw art as an educational tool. They were painfully aware that their particular

13-10
Dreamsicle, Seaside,
Florida. Orr and Taylor
Associates, New Haven,
Connecticut.

13-11 (below)
Frank Gehry, architect,
*Edgemar Farms
Conversion*, Santa
Monica, California.

experiences were invisible in the mainstream of contemporary art. They were distressed that art — and in particular, abstract art — seemed to be concerned only with its own ends. Rejecting the idea of art for art's sake as elitist and decadent, they advocated an art committed to raising social consciousness. For example, Judy Chicago's *Dinner Party* (Fig. **13-12**) presents a history of women's place in society through symbols included in place settings for 39 great women, and the names of hundreds of others on the tiled floor. Barbara Kruger's photographs (see, for example, Fig. 9-22) explore and expose the unhealthy roles imposed on women in contemporary life.

The capacity of representational images, as well as words and symbols, to inform and instruct attracts many of these artists. As with Social Realist art in the 1930s, the message is more important than esthetics. Some use postmodern, non-art strategies to catch their audiences by surprise. Adrian Piper is a Harvard-educated African-American woman whose pale skin leads many to assume that she is white. Her performance art and videotapes are infused with consciousness-raising issues of identity and racial prejudice. Piper described her *My Calling (Card) #1, 1986* (Fig. **13-13**) as a "reactive guerilla performance (for dinners and cocktail parties)" and added that her cards "attack and subvert institutionalized rules of etiquette that I find oppressive."[1]

Street art, in the form of outdoor murals on the walls of buildings, emerged in the 1960s and 1970s. Originating in urban ghettoes and Latino neighborhoods, it

13-12
Judy Chicago, *Dinner Party*, 1973–1979. © Judy Chicago, 1979.

Dear Friend,
I am black.
I am sure you did not realize this when you made/laughed at/agreed with that racist remark. In the past, I have attempted to alert white people to my racial identity in advance. Unfortunately, this invariably causes them to react to me as pushy, manipulative, or socially inappropriate. Therefore, my policy is to assume that white people do not make these remarks, even when they believe there are no black people present, and to distribute this card when they do.
I regret any discomfort my presence is causing you, just as I am sure you regret the discomfort your racism is causing me.
Sincerely yours,
Adrian Margaret Smith Piper

sprang out of the desire to communicate with people untouched by the establishment art of museums and galleries. It was a genuinely public art, on display in the very environments that nurtured it. It was not to be bought, owned, or hidden away. Many of these murals have a deliberately unsophisticated look that permits them to slip around the barrier that official-looking art might present. This underlies the artists' insistence that their work communicate directly with its intended audience.

The *Wall of Respect* (Fig. **13-14**), a lively amalgam of paintings, photographs, and poems, was an early and influential example of street art. Located in the heart of an African-American neighborhood in Chicago, it evolved over a period of months, drawing on the contributions of 21 African-American artists, and generating considerable interest within the community. The wall celebrated the accomplishments of outstanding African-Americans in areas of endeavor such as religion, politics, athletics, and the arts. Coinciding with the growing civil rights movement, the wall was a statement of pride. One young man reportedly gazed at it for a long time and said, "I'm gaining my strength."

Memory, pride, sorrow, and consolation are called up by the Vietnam Memorial in Washington, D.C. The memorial was created by Maya Ying Lin while she was an undergraduate in architecture at Yale. An outstanding example of public

No one asked for the Wall of Respect.

It just had to be painted. It made a direct statement to the Black community

and the statement came directly out of the community through its artists.

— Harold Haydon, Chicago artist, 1970

13-14
Twenty-one black
artists, initiated by
O.B.A.C. and William
Walker, *Wall of Respect*,
1967, destroyed 1971.
Originally at 43rd and
Langley, Chicago.

art, it survived initial controversy over its design to become the most visited monument in the capital (Fig. **13-15**). The memorial consists of a wedge-shaped wall of polished black granite panels that descends gradually into the earth to a depth of ten feet at the center. The names of each soldier who died in the war are cut into the panels, in the order of the soldier's death.

Quietly, almost imperceptibly, the monument draws us downward from the surface, into a space that is set apart. Once there, we are defined in relation to those who died, as the polished wall reveals our own reflection behind the

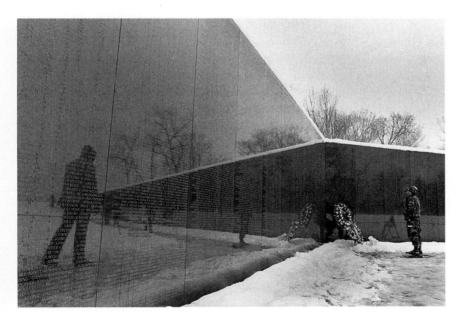

13-15
Maya Ying Lin,
Vietnam Memorial,
Washington, D.C.
1981–1983. Marble,
each wing 246' long.

columns of names. We can also see reflections of other visitors, trees, and clouds within the polished surface. Mourners make rubbings of names, and leave letters, poems, and tokens of affection — flowers, photographs, stuffed animals, bottles of champagne — beneath the names of relatives or friends.

The Vietnam Memorial, scarcely a decade old, has already become a kind of sacred place. Here the nation, so recently divided in its attitude toward the war, can unite in its homage to those whose lives were sacrificed in it. Possibly no other war memorial is as eloquent or as poignant as this.

Serious messages of timely concern are often at the intersections of art and life. Many are communicated to mass audiences through films and television. Recent arrivals in the world of art, films and television are more than mere entertainment. Like other art forms, they reflect, comment on, and shape our understanding of the real world. Some have made us aware of social problems. *The Best Years of Our Lives* (1946) deals with problems of returning veterans. *Lost Weekend* (1945) deals with alcoholism, and *The Man with the Golden Arm* (1955) deals with drug problems. Some films have attacked social institutions. *I Am a Fugitive from a Chain Gang* (1932) exposed the injustice and brutality of the chain gang system and led to its reform. *All Quiet on the Western Front* (1930) is a powerful indictment of the institution of war. *Dances With Wolves* (1990) saw America's westward expansion through the eyes of Native Americans. In November 1983, nearly 70 percent of the television-viewing audience watched *The Day After*, which depicted the horror of nuclear war. And the award-winning television series *LA Law*, which began in 1986, has scrutinized social issues such as mercy killing, child abuse, date rape, medical ethics, and age discrimination.

Art and life faced off in America at the turn of the decade, and though the match was volatile, there was no knockout. Art achieved the distinction of being denounced in the United States Senate when in 1989, Senator Jesse Helms of South Carolina blasted several photographs by Robert Mapplethorpe and Andres Serrano as pornographic and blasphemous. The Mapplethorpe photographs documented the practices of his own homosexual community; others showed children in the nude. Serrano's photograph showed a cheap plastic crucifix submerged in the artist's own urine, which the artist asserted was meant to be a protest against the commercialization of sacred imagery. Helms criticized the National Endowment for the Arts for its grant to Serrano and for its support of a travelling exhibition of Mapplethorpe's photographs (most of which were portraits and flowers), and urged the Senate to ban funds for art that was "obscene or indecent." With the Endowment under fire, the Corcoran Gallery of Art in Washington, D.C., cancelled its planned exhibit of Mapplethorpe's work.

Television newscasts followed the story, and articles and letters filled newspapers and magazines throughout the country. In the meantime, the Congress began to wrestle with the issue of whether, and how, to restrict criteria for NEA grants.

In the spring of 1990, Cincinnati's Contemporary Arts Center attempted to exhibit the Mapplethorpe photographs. Later that year, the Center and its director were brought into court on charges of breaking Cincinnati's obscenity laws.

At issue were 7 of the 175 photographs in the exhibit. As far as anyone knew, this was the first time an American museum had been charged with exhibiting obscene materials.

Prior to the trial, lawyers for both sides questioned prospective jurors about their exposure to art; their religious values, moral codes, and sexual attitudes and practices; and their feelings about censorship. Of those selected for the jury, none had been to a museum in years, and only one had ever seen Mapplethorpe's work previously (when she flipped through a book owned by a co-worker). During the ten-day trial, jurors heard testimony from a communications specialist and from museum directors and curators, and depositions from the mothers of two children who appear in the photographs. At the end, the eight jurors determined that under the law, the photographs were not obscene.

This is the opportunity for you to

decide: What is the limit? Where do you draw the line?

Frank Prouty, lead prosecutor in the Cincinnati obscenity trial, in his opening speech to the jury

Art is not always pleasing to our eyes.

Art is to tell us something about ourselves and to make us look inside

ourselves and to look at the world around us.

H. Louis Sirkin, a defense lawyer in the obscenity trial, in his opening speech to the jury

The Mapplethorpe obscenity trial generated public discussions on censorship, the definition of art, artistic aims and standards, community standards, and the role of art in the community. The trial became a point of intersection between art and the real world, vividly reminding us that the two are not necessarily worlds apart.

CONCLUSION

In Western society, from the Renaissance to the twentieth century, art was less an integral part of everyday life than a pleasurable adjunct to the good life led by the privileged classes. Among the democratizing upheavals of the twentieth century revolutionary new roles for art appeared, and art was thrust into a fresh and intense relationship with society. Artists committed themselves to following their own insights. While many

turned to abstraction as a means of conveying truth and reality as they perceived it, others worked to effect social change through representational subject matter.

The dreams behind twentieth-century art were ambitious. But the goals of these artists remained largely unfulfilled. The Bauhaus attempted to counter elitism in art by merging art with machine technology. Today the Bauhaus's goal seems utopian, and Bauhaus design may be seen as just another modern style. Some Bauhaus painters, such as Kandinsky (Fig. 11-16), Klee (Fig. 11-14), and Albers (Fig. 11-35), saw no need to connect their paintings to immediate social concerns. They continued to believe in art for the sake of the spirit. Other artists aimed to bridge the gap between art and life through the power of ideas that were politically relevant, stressing the social responsibility of the artist. Yet Social Realism, African-American art, and feminist art, despite their real-life concerns, have probably not affected many people, perhaps just because of their narrow focus. Pop artists used the visual vocabulary of advertising and the popular arts to create works that communicated to a public long intimidated by "high" art. But despite or because of its references to the everyday world, Pop art remained enigmatic to large segments of the public; indeed, Pop seemed even to scandalize people who resented its trivial subject matter and its implied denigration of art. Certain films and television shows have brought social concerns to the attention of the public, but these have been relatively few. Does the "Hollywood ending" reflect life in the real world? Entertainment may enlighten us, but its primary function is to divert us, for a time, from real-life concerns.

The detachment of art from the real world still exists today. An acquaintance with art is still often considered a badge of membership in the elite. Fine art frequently is incorporated into magazine ads for snob appeal. At the same time, public school administrators who think of the arts as an indulgence or a diversion from serious concerns drop them from the curriculum when the budget tightens, and parents frequently deprive children of the rewards of art activities by telling them to do something "useful."

Certainly there is ample evidence of a gap between art and life. However, art is available to anyone who wants to get in touch with it. Many people enjoy the sculpture in the square, or the fountain in the park, or notice the decorative details of a favorite building. Many people watch programs about art on television, hang art on their walls, buy books about art, or read reviews in national news magazines. Many people visit museums and galleries. Although the visits may be occasional, most people probably experience them as pleasant and worthwhile. Perhaps they are special just *because* they are occasional.

It is precisely that special quality that I think we seek in art. It may seem removed from everyday concerns. At times it may be difficult to understand. It may even be hard to take. But I suspect that a good number of us are delighted that art is there to encounter. We value it just *because* it is different, because it challenges us, and because it allows us to enter into the realm of the creative imagination.

14
FOLK ART

WHAT IS FOLK ART?

In its narrow definition, folk art is the work of people who enjoy making things in traditional forms or styles. It is characterized by a quality that reflects a time, a place, and an attitude. However, the limits of folk art blur at the edges. Popular art, such as hand-embellished jackets, and commercial art, such as hand-painted signs, may be considered forms of folk art. The work of some professionals, such as painters, weavers, or potters, can sometimes also qualify as folk art. "Outsider art," the strongly individual work of self-taught artists who are outside of, often isolated from, any particular tradition, is also a form of folk art. ¶ By all definitions, folk art differs from the major artistic enterprises of the culture. In Europe and the United States, folk art is distinct from the fine arts tradition, though it often contains echoes of it. Folk art, then, is the art of other, less visible groups within the main culture. The major art of a culture comes down from the top. It reflects the sophisticated training, the aims, and the attitudes of the art schools. Folk art comes up from the roots, reflecting the habits, traditions, and tastes of ordinary people. ¶ While folk and peasant cultures were long recognized in Europe, their artistic products were for the most part neglected by the dominant culture. Artists and art lovers first noticed folk art in the twentieth century, when the fanciful forms of modern, abstract art opened the way to appreciation of folk art images. The first major exhibition of folk art in the United States was held in Newark, New Jersey, in 1930. Today, art museums and galleries collect, exhibit, and promote folk art. ¶ As a consequence of mass production and the availability of goods, many traditional folk arts are disappearing. Still,

people sometimes prefer doing things for themselves. And folk painters and sculptors throughout the country now exhibit in museums and galleries, thanks to a resurgence of interest in folk art and culture.

Patterns of life, the doings and interests of ordinary people, are revealed as nowhere else in the objects they make for themselves or their circles. The intimate connection of folk art with ordinary people gives it certain qualities not found in public or professional art.

FOLK ARTS

Most often, folk artists learn by watching others, absorbing the how-to's of local skills and traditions, and perhaps adding variations of their own. Folk artists make just about everything. They make useful objects such as boxes, tables, decoys, and signs. They make paintings to look at and enjoy. They make ritual and religious statues and images. They make musical instruments, games, and toys. Someone made this wind-driven whirligig just for fun (Fig. **14-1**). Apart from making things, some folk artists concentrate on decorating and embellishing whatever comes their way.

A special occasion, or a special person, can prompt a creation. In the past, a young Cheyenne man would make and wear an elkskin robe with magical designs to cause a woman to fall in love with him. Young Jewish women in Russia and Poland embroidered prayer shawl bags for their husbands-to-be. To this day, young Zulu women send beaded necklaces to men, encoding messages in the designs and colors. If the young man wears the necklace, it's a sign he has accepted the relationship.

14-1
Artist unknown, *Uncle Sam Riding a Bicycle*, whirligig, 1880–1920. Carved and polychrome wood, metal, 37″ × 55½″ × 11″. Collection of the Museum of American Folk Art, New York. (Promised bequest of Dorothy and Lea Rabkin, P2.1981.6.)

Today in the United States, hand-made scarves and valentines serve as declarations of love, as, in their way, do lavishly decorated birthday cakes. If you have ever built a snowman, created a costume, carved a pumpkin, decorated a Fourth of July bandstand or a parade float, you too were a folk artist. For many people, no Christmas is complete without a Christmas tree and colored lights festooning the yard. Mexican-American children look forward to the piñata on Christmas and birthdays that showers them with candies and tiny gifts (Fig. **14-2**). In the southwest, small paper bags containing candles (*luminarias*) border lawns in the evenings preceding Christmas. Papier-mâché dragons, some large enough to be inhabited by eight or ten nimble dancers, bring in the Chinese New Year.

Here and there, new forms of folk art appear. In the Puerto Rican neighborhoods of New York, *casitas* ("little houses") may be found on city-owned land leased as gardens or on abandoned lots (Fig. **14-3**). These small wooden structures are characterized by their gabled roofs, shuttered windows, railed porches, and brightly colored paint. Inside are furniture and artifacts associated with Puerto Rico. Neighbors meet in the *casitas* for birthday parties, festivities, or a game of dominoes. Bringing memories of rural Puerto Rico into urban New York, the *casitas* foster community pride and solidarity in the vast, often alien environment of the city.

14-2
A youngster takes his turn at the piñata.

> We are guerrillas. We did this on our own. . . . Ten of us worked on it. A *casita* in an asphalt jungle. All around are big, tall houses, we are building back our roots.
>
> *Casita* member, 1982, translated from a statement written in Spanish

14-3
Casita, Bronx, New York. Courtesy of Bronx Council on the Arts.

In Germany, draftees approaching the end of their military service buy a tailor's measuring tape, snip off the numbers corresponding to the days left to their service, and mail them one by one to their girlfriends, who glue them around a bottle of wine. When the soldier returns home, the fully-covered bottle is opened in celebration.

Colorful designs on vans were popular among young people in the 1960s. Today that elaborately decorated van covered with decals might belong to a retired couple who wants you to know where they've been and what they've seen. Big trucks on the highway often carry a bit of decoration on the hood or door to personalize them. Retooled cars, called "low riders," are embellished with elaborate decorations. Popular primarily in Latino areas, their carefully painted decorations announce the proud individuality of their owners—who may be checking out your reaction from the driver's seat.

In the past, prow figures were attached to ships of Greeks, Romans, Vikings, and Maori (see Fig. 8-14) for power and protective magic. Nineteenth-century U.S. ships carried protective goddesses in the form of a beautiful woman carved in wood and attached to the prow. The goddess reappeared as a pin-up girl painted on fighter planes during World War II, and may be seen today zipping along the road as a hood ornament.

These restatements of tradition testify to the persistence of human impulses, despite historical change. Consider, for example, goalies' masks (Fig. **14-4**). In

14-4
Goalie's mask worn by professional hockey player Gerry Cheevers.

the United States and Canada, goalies' masks are individually decorated with designs. These are usually painted on by the goalies themselves. Imaginative and ferocious, they bring an echo of the masks of traditional cultures into the center of American life. Masks in traditional cultures were sometimes made to combat harmful forces; our goalie's aim is to terrorize the other team, and, perhaps, to give himself an edge in warding off the puck.

PRACTICAL OBJECTS

Around the world, folk artists, including professional craftspeople, have provided ingenious solutions to day-to-day problems — solutions to save time, or to make life easier. In Ireland, wooden communal vessels for drinking mead (honeyed wine), made between the fifteenth and seventeenth centuries, were provided with four handles to simplify passing from hand to hand. Watering pots made to dampen dirt floors in sixteenth-century England had holes on the bottom to receive the water when dipped into a barrel. By covering the small hole on top with their thumb, waterers could prevent the water from falling out while transporting it. Releasing their thumb caused the water to sprinkle out the bottom.

Furniture design provides many examples of space-saving ingenuity. Convertible furniture provides two functions in one. The drop-leaf table, a space-saver popular to this day, was invented in New England in the Colonial period. In a region of the Alps called the Tyrol, tables were made with tops that swung up on hinges to reveal a compartment in the base for storing table linen and flatware. In Japan, a set of cabinets can double as a portable staircase. Another example, the chair-table, dates back at least to sixteenth-century England. It begins as a chair with a large, circular back. The back holds and reflects the heat of a fireplace, and helps keep the sitter warm. The back is attached by a hinge, and when it swings down over the chair, you have a table. A further bonus is the drawer built into the seat.

In cold climates, large ovens heat rooms, and often take up needed space. Different cultures created varying solutions to this problem. In northern China, low-rising couches combined with ovens provided warmth and comfort. In Germany and Switzerland, large ceramic ovens contained built-in seats, which were usually reserved for the grandmother of the family. In European palaces, stoves standing in rooms could be loaded and stoked from inside the wall, which kept the rooms clean and the servants out of sight.

FRAKTURS AND PATCHWORK QUILTS

Many folk artists have a genius for taking ordinary things and making them extraordinary. Two traditional examples of this are *frakturs*, a type of document once used commonly among German immigrants, and patchwork quilts.

14-5
*Birth and Baptismal
Certificate for Alexander
Danner.* Attributed to
Christian Mertle and an
unidentified scrivener,
c. 1800. Watercolor,
lead pencil, ink on laid
paper, 12½″ × 15⅝″.
Probably from Lancaster,
Pennsylvania. Colonial
Williamsburg
Foundation, Abby
Aldrich Rockefeller
Folk Art Center, Acc.
No. 35.305.1.

Legal documents today are designed for files, business machines, and the
bottom of your desk drawer, but in some places they were developed into an art
form. In regions of the United States settled by German immigrants and their
descendants, hand-written certificates, called *frakturs*, recorded births, bap-
tisms, marriages, and deaths, just as in Europe. Most continued to be written in
German, sometimes using a traditional German script (*fraktur*) that originated
in the Middle Ages. *Frakturs* were usually executed by a schoolmaster or a
minister, who could be counted on for fine handwriting.

Frakturs provided opportunities for artistic embellishments. Births and bap-
tisms in particular became occasions for a decorated *fraktur*. Along with the
names and dates, pious sayings, figures, or fanciful decorations were incorpo-
rated in sprightly watercolors. A *fraktur* might show the parents of the child, a
scene of the Crucifixion, George Washington, or a view of the town.

In the *fraktur* illustrated in Figure **14-5**, lions and unicorns present a baby to
the world. The verse, in translation, says: "God bless our going out and coming

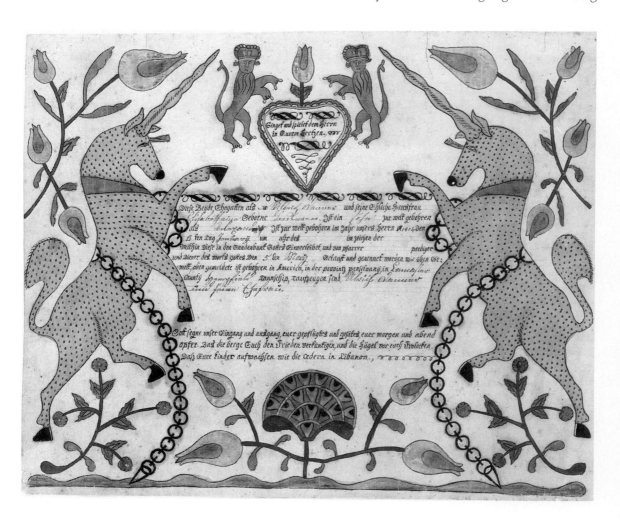

in, Your plowing and seedtime . . . That the mountains bring you tidings of peace and the hills dance before you, and may your children grow like the cedars in Lebanon."

Frakturs were made exclusively by men. Quilts, like weaving and needlework since antiquity, have traditionally been made by women.

Patchwork quilting came over from Europe, but it became a people's art on American soil (see Fig. **14-6**). In the homes of the early pioneers, materials were scarce. Housewives patched worn bedcovers with leftover cloth. Eventually cloth became more abundant, making it possible to store some away. Leftover pieces of cloth could be shaped, cut, and stitched into decorative patterns. In this way, countless women turned utilitarian objects into works of art.

A patchwork quilt has three layers. The top is the patchwork: shaped pieces stitched one to another. The bottom layer is the backing. Between these layers is the batting, the thick, insulating material. When the patchwork is completed, thread is stitched through all three layers.

14-6
Star of LeMoyne, c.
1850. New England.
America Hurrah
Antiques, N.Y.C.

Appliqué quilts are a variation. In appliqué, the patches are cut out and sewn onto a single sheet, which becomes the top layer. Appliqué makes it possible to create shapes that are more complicated, even pictorial.

Harriet Powers used the applique technique for a remarkable quilt (Fig. **14-7**), in which fifteen images combine Biblical scenes with more recent events. A former slave, Powers sold her quilt because she needed the money. At the time of the sale, she wrote out an explanation of each image. Following are excerpts from her explanation of the quilt's panels, from top, left to right:[1]

1. Job praying for his enemies.
2. The dark day of May 19, 1780. The seven stars were seen 12 N. in the day.
3. Moses and the serpent.
4. Adam and Eve in the Garden.
5. John baptising Christ.
6. Jonah cast overboard.
7. God created two of every kind, male and female.
8. The falling of the stars on Nov. 13, 1833. The people were frightened and thought the end of time had come. God's hand staid the stars. . . .
9. Two of every kind of animals
10. The angels of wrath.
11. Cold Thursday, 10. of February 1895.
12. The red light night of 1846. A man tolling the bell to notify the people of the wonder. Women, children and fowls frightened but God's merciful hand caused no harm to them.
13. Rich people were taught nothing of God. . . . The independent hog which ran 500 miles from Ga. to Va. her name was Betts.
14. The creation of animals continues.
15. The crucifixion of Christ between two thieves. The sun went into darkness.

The Bible scenes in Powers's quilt allude to God's power. The other events are drawn from accounts that she had heard, and that she likewise interpreted as compelling messages of divine power. The astronomical events she illustrated have been confirmed in recent times. The "dark day" was caused by smoke from a forest fire; the "falling of the stars" was a meteor shower. The "independent hog," which is the largest figure in the quilt, is an allusion to runaway slaves, who took the same route. The reference to slavery ties the Biblical message of deliverance to events that touched Powers personally.

Patchwork quilting was frequently done out of necessity. It was maintained because it was useful. But along the way it became a vehicle for self-expression. Many women were proud of their creations, and some stitched their names into them.

In rural and small town America, quilting bees provided an opportunity for women to get together. Quilting bees were often held to honor someone.

Women often combined efforts on a single quilt for a young woman about to be married. The women worked until dark to complete it in a single day.

A variety of patchwork quilt designs have originated around the country, reflecting cultural and regional differences. The earliest quilts were the "crazy quilt" type—quilts with no planned pattern. These were made of leftovers. Later, when material could be saved and selected, geometrical designs were introduced. The thrifty New Englanders used smaller pieces of material for patchwork, while their wealthier Southern counterparts could afford the time and material required for appliqué. African-American quilts of the Southeast United States perpetuated West African traditions in methods of construction; in the use of striking colors, especially red and black; and in the use of appliqué.

Because of the rigid rules of their religious order, the Amish did not use printed fabrics. In consequence, their quilts emphasized strong colors and bold designs. In addition, the quilting—that is, the stitches that hold top, batting, and bottom together—was often exceedingly fine, and arranged in elaborate scroll designs.

Patchwork designs are often symmetrical in four directions, and are usually based on a grid system in which the separate elements are repeated with variations. This system is similar to those found in carpets from the Near East and in pre-Columbian weaving. In modern times, Bauhaus design and weaving

14-7
Harriet Powers,
Pictorial Quilt, c. 1895–
1898. Athens, Georgia.
Pieced and appliquéd
cotton embroidered
with plain and metallic
yarns, 69″ × 105″.
Bequest of Maxim
Karolik. Courtesy,
Museum of Fine Arts,
Boston, Acc. No.
64.619.

workshops investigated design systems based on a repeating theme with variations. Perhaps coincidentally, Minimalist painting has a certain affinity to the simple, geometric designs of many quilts, such as those of the Amish (see, for example, Fig. 17-10).

A patchwork quilt provides a rich visual experience. From a distance, we see a lovely overall pattern. Looking more closely, we can see the individual units with their patterns. Closer still, we see the patches of cloth printed with their own patterns. Even closer, the fine stitches and their patterns emerge.

But the beauty of a quilt also resides in something felt more than seen. Patchwork quilts absorb the spirit and touch of their makers in every shape and stitch. The individual patches of material may also contain memories of the persons who wore them. For many quilters, those pieces of personal history are an important part of the quilt. The intimate, personal quality of quilts, as well as their beauty, prompted many families to preserve them carefully and pass them down through the generations.

It took me more than twenty years,

nearly twenty-five, I reckon, in the evenings after supper when the children

were all put to bed. My whole life is in that quilt. It scares me sometimes

when I look at it. All my joys and all my sorrows are stitched into those little

pieces. When I was proud of the boys and when I was downright provoked

and angry with them. When the girls annoyed me or when they gave me a

warm feeling around my heart. And John, too. He was stitched into that quilt

and all the thirty years we were married. Sometimes I loved him and

sometimes I sat there hating him as I pieced the patches together. So they are

all in that quilt, my hopes and fears, my joys and sorrows, my loves and hates.

I tremble sometimes when I remember what that quilt knows about me.

Marguerite Ickis, quoting her great-grandmother (from Mirra Bank, *Anonymous Was a Woman*)

Today, patchwork quilting is experiencing a revival. Quilting clubs around the country foster the art, arrange for exhibitions of the work, and link the generations. Patchwork quilting has recently been in the news, functioning as a comfort to people touched by AIDS. In 1987, the *AIDS Memorial Quilt* was begun by the Names Project in San Francisco. Made up of individual quilts done by family and friends to commemorate victims of the disease, the quilt was displayed on the mall in Washington, D.C., in 1989. The 12,000-plus panels spread over fourteen acres. At the time of this writing, individual panels are being exhibited around the United States and overseas.

In 1988 Ellen Ahlgren, a retired teacher and mental health counselor from New Hampshire, placed ads in quilting magazines and recruited quilters to make quilts for babies born with AIDS. Within a year she had organized a nationwide project called ABC Quilts. By 1991 thousands of individuals, Brownie and Girl Scout troops, and church organizations had contributed quilts through this organization.

MAKING CONNECTIONS

Works of art mediate between us and the world — that is, they help us to connect, to find our place, to reconcile, and to maintain balance. This is especially true of folk art. Folk artists draw the world into their own sphere through their art, and they may locate themselves and their experiences in that world. Patchwork patterns take names and themes from politics, places, social concerns, religion, and nature. The landing of the Pilgrims on Plymouth Rock, the landing of humans on the moon, or Johnny's landing on his head in a baseball game may all be incorporated into the same quilt by an enterprising quilter. Harriet Powers's imaginative quilt brought the world's wonders into her house.

Farmers in the Austrian Alps traditionally carved their name and their bride's name over the door inside their new house to bind themselves to the place. Religious figures painted on the outside walls of houses are still a common sight in that region. Jewish spiceboxes from Europe, used in a Sabbath ceremony, are traditionally built to resemble tiny Gothic towers. Occasionally a spicebox has been modelled after a prominent local building. A spicebox from Danzig was modelled after the City Hall; one from Hamburg even replicated the tower of a local church.

Holiday customs often accumulate meanings over time and multiply connections. Since prehistory, Europeans have lit bonfires around Midsummer Day. In the Middle Ages, this pagan custom blended with the Feast of John the Baptist. For people living in the Tyrol, lighting bonfires has also come to symbolize the unity of the Tyrolese, whose region is divided today between Austria and Italy. For some Tyrolese, the lighting of the fires is an occasion for singing patriotic songs.

The Tyrolese bonfires are particularly beautiful as an art form. The fires are placed very high in the mountains, and they are lit at dusk. From below, they appear as twinkling specks of light. Some form crosses, hearts, and crosses joined to hearts. Others thread out along the mountain ridges. As the sky darkens, the lights seem to become a necklace of stars. Delicate, open to the sky, they embrace and domesticate the vast, brooding mountains. On this night the forces of nature — remote, cold, indifferent — seem stilled. For a time at least, human beings, signifying their presence, pride, and devotion through these bonfires, may feel secure.

Many examples of the mediating role of folk art are found in religious art. Originating in remote antiquity, the making of *ex-votos* is practiced widely by devout Christians in Europe and in Central and South America to this day

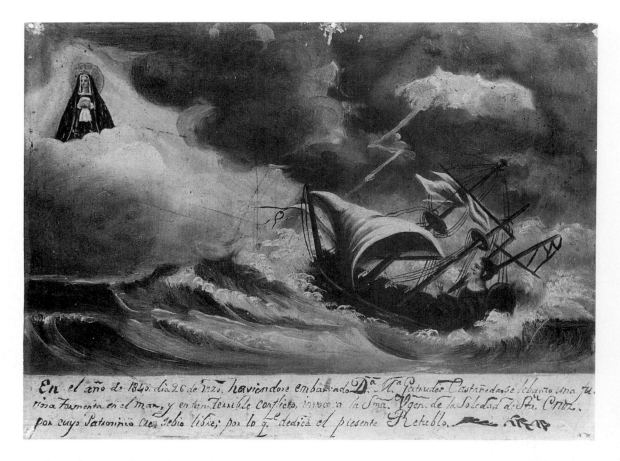

En el año de 1840, día 26 de Mzo. haviendose embarcado Dª Mª Gertrudes Castañeda, se lebanto una furiosa tormenta en el mar y en tan terrible conflicto invoco a la Sma. Virgen. de la Soledad de Sta. Cruz, por cuyo Patrocinio creo sebio libre; por lo q.ᵉ dedica el presente Retablo.

In the year 1840, the 26th day of March, Doña Maria Gertrudes Castañeda having boarded ship, there arose on the sea a furious tempest, and in such dire trouble she invoked the Most Holy Virgin of the Solitude of Santa Cruz, through whose protection I believe she was saved; for which reason the present picture is dedicated.

14-8
Ex-voto, 1840. Museo Nacional de las Intervenciones, Mexico.

(Fig. **14-8**). *Ex-voto* is Latin for *out of thanks*. An *ex-voto* is a painting or object made in gratitude to a saint or holy personage on behalf of a person who has recovered from an illness or an accident. Created by a local artist or craftsperson, paintings show the saint watching over that person, who may be falling off a horse, delivering a child, or, as in an *ex-voto* painted in Italy during World War II, running from exploding bombs. The painting usually depicts the donor or donors kneeling in prayer, giving thanks, and includes a written description of the catastrophe and the rescue.

Ex-votos have been snipped out of tin in the form of body parts, ships, and automobiles; forged in iron by blacksmiths in the form of human figures and animals; and molded in clay. In parts of Germany and Austria, molds have been used to form three-dimensional wax models of men, women, babies, and even twins. An *ex-voto* is rarely a great work of art, nor does it need to be. It's a simple and heartfelt expression of a pious faith that one is not alone in this world.

THE ART OF THE *SANTERO*

The extreme geographic isolation of the Spanish colony of New Mexico produced an indigenous art of remarkable vigor. From the eighteenth through the early twentieth century, local artists were called upon to supply the demand of churches, chapels, and homes for devotional images, called *santos*, to whom the faithful could turn in prayer. Their work reflects the distant memory of Spanish Baroque paintings and statues, such as were imported into Mexico. But isolation from the grand tradition also freed the artists to develop their own tradition of configuring the holy.

The creators of these devotional images were known as *santeros*. The *santero* was challenged to instill in each image a sense of spiritual power and to evoke the special qualities that were identified with that saint. As is true of holy images everywhere, the piety of both maker and worshiper is expressed by the wish to make the image beautiful.

Some *santeros* were monks, some were individuals who produced images when moved by impulse, and some were professionals who peddled their wares from village to village. Few *santos* were ever signed by the artist.

José Raphael Aragón was a well-known *santero* of nineteenth-century New Mexico. Like many others, he devoted himself to the production of both panel paintings (*retablos*) and carved figures (*bultos*). Aragón's statue of Spanish saint San Ramon Nonato (Fig. **14-9**) was made for the Chapel of Our Lady of Talpa in Talpa, New Mexico. In a remarkable effort, Aragón carved and painted all of the chapel's interior decorations, which are now preserved in the Taylor Museum of the Colorado Springs Fine Arts Center.

The figure of San Ramon Nonato, like other *bultos*, was carved out of soft cottonwood using a small knife. The parts of the figure were assembled and doweled together. The surface was smoothed and a coat of gesso, a chalky substance consisting of gypsum mixed with glue and water, was applied to the wood as a primer. Then the figure was painted. To complete the statue, and to enhance its sense of reality, Aragón attached real hair using a real ribbon.

Because San Ramon Nonato was born as his mother was dying of the plague, he is revered as a patron saint and protector of expectant women and midwives. Here the saint appears in his cardinal's robes, holding a monstrance in his right hand and a crowned wand in his left, symbolizing the rejection of earthly honors. Small trees appear on either side. In the tradition of the *santos*, there is no narrative — the saint stands isolated, frontal, attending to the worshiper.

14-9
José Rafael Aragón, *San Ramón Nonato*, c. 1834–1838. Native pigment, cottonwood, 18″ × 10″ × 6″. Frame dimensions 26″ × 18″. Originally found in the Chapel of Our Lady of Talpa, Duran, New Mexico. Colorado Springs Fine Arts Center, Taylor Museum Collection.

The composition is simple and straightforward, its symmetry giving it a somber dignity. The steps elevate the saint. Framed off, detached, the figure seems remote. Yet the bright colors, which clarify each element, are assertive, and keep the figure within reach. The saint's face, the focal point of the composition, is simplified, purified — a concentrated image of calm, sympathy, and understanding. In this statue, Aragón created a compelling personification of one to whom women could turn in time of need.

A Shaker "Spirit Drawing"

Intense religious feelings inspired an art form in the Shaker religious community in the nineteenth century. During a period of religious revival, a number of women in the community experienced visions believed to be divinely inspired. These visions were recorded in meticulously executed watercolor paintings, which were accompanied by written accounts of the visions.

Hannah Cohoon, a member of the Shaker community in Hancock, Massachusetts, made a number of paintings over a period of a dozen years. Her vision of the Basket of Apples (Fig. **14-10**) was painted when she was sixty-eight years

14-10
Hannah Cohoon
Basket of Apples,
1856. Shaker spirit drawing, watercolor. Hancock Shaker Village, Pittsfield, Massachusetts.

old. The painting shows a cutaway view of a basket, precisely detailed, in which a pattern of golden apples magically appears. The following verse is written above the apples:

> Come, come my beloved
> And sympathize with me
> Receive the little basket
> And the blessing so free

The inscription below the basket describes the vision:

> Sabbath. P.M. June 29th 1856. I saw Judith Collins bringing a little basket full of beautiful apples for the Ministry, from Brother Calvin Harlow and Mother Sarah Harrison. It is their blessing and the chain around the pail represents the combination of their blessing. I noticed in particular as she brought them to me the ends of the stems looked fresh as though they were just picked by the stems and set into the basket one by one.

> Seen and painted in the City of Peace.
> by Hannah Cohoon

Art historian Ruth Wolfe[2] writes that Judith Collins was a member of the Hancock community who had recently died; the others are long-dead founders of the community. The gift of the apples is intended for the Ministry, that is, the directors of the community, and is to be presented to them by the artist. This she did through the painting.

Wolfe cites a recent discovery by Daniel W. Patterson, professor of folklore at the University of North Carolina, of four songs written by "H. Cohoon" in a Shaker songbook. This raises the possibility that the verse that appears in the painting may be from a song written by the artist.

TRADITIONAL FOLK ART PAINTING IN AMERICA

The creative drive of American folk artists was channeled into paintings of all sorts: portraits, still lifes, landscapes and townscapes, religious paintings, and imagined scenes. In addition to painting pictures on canvas, painters applied images and decorative work to walls, furniture, shop and tavern signs, coaches and carriages, boxes and trunks, clock faces, toys, and more. While some worked full time, most fit art into their spare moments.

Most of them, of course, had little or no training, and worked under difficult circumstances. In the villages and farms of rural America, the work was harsh. Free time was scarce, and so were materials. In spite of this, or perhaps because of this, individuals found a kind of fulfillment in making art.

Folk art paintings tended to be conservative in subject matter and composition. Getting it right meant getting it according to traditional norms. Even so, the imagery and details of the paintings reflect points of view that are strongly individualized. After all, it took a special strength of character to do the work at all.

Because time and material were limited, folk art painters dealt only with things of consequence, and it was important to them to project their thoughts and feelings into the work. In folk art paintings one senses a strong governing idea, a person's reaction to what's there. This is, of course, also true for paintings in the fine arts tradition. But in folk painting the personal vision — insightful, idiosyncratic, often naive — is apt to assert itself more freely.

Certain formal characteristics are common to many folk art paintings. Shapes are prominent. Roundness, solidity, and volume matter less. Space flattens out. Colors tend to be bright. The result is an emphasis on pattern that may remind us of the art of children. Neither children nor the folk artists learned how to show volume, or how to draw objects in perspective. Perplexed by volume and perspective, artists concentrated on shapes and how they fit together. As objects and space flatten, color brightens, and a decorative quality emerges.

Sometimes, as in medieval or modern art, folk paintings adjust the size of persons or objects according to their importance in the scene. Key persons might be enlarged so we see them clearly and sense their importance. A large house will be reduced because it attracts too much attention, or because it would block something else. Along with this, the focus is sharp all over, like an enthusiastic description that enumerates everything. The artists leave us loving records of things they cherished.

TWO FOLK ART PAINTINGS

I'm not sure how much Alexander Boudrou liked A. Dickson, whose picture he painted (Fig. **14-11**). But he makes you feel that Dickson means business. Several compositional lines converge on Dickson, which combine with his black coat and powerful figure to make him the focal point of the painting. From what we see in the painting, he's the biggest guy in town. Indeed he's the only guy in town. He dwarfs the houses in the foreground like some apocalyptic messenger. The swirl of clouds, a device dear to the heart of filmmakers, projects dramatic emotion to underscore the auspiciousness of the event.

Folk paintings of landscapes or townscapes show life's activities, and usually feel cheerful and upbeat (Figs. **14-12** and **14-13**). They are idealized images, of course, reflecting civic, religious, and personal values. They invariably reflect a sense of pleasure in the subject, if not outright pride. Perhaps more than a little, they reflect the artist's pleasure in painting the subject.

Charles C. Hoffman, whose painting of a farm and paper mill we see in these illustrations, came to the United States from Germany in 1860, at the age of thirty-nine. The scene carefully records details of the activities that were transforming the countryside. Hoffman painted it for Henry Z. Van Reed, who owned

14-11
Alexander Boudrou,
*A. Dickson Entering
Bristol in 1819*, 1851.
Oil on canvas, 21⅛″ ×
26³⁄₁₆″. Philadelphia
County, Pennsylvania.
Colonial Williamsburg
Foundation, Abby
Aldrich Rockefeller
Folk Art Center, Acc.
No. 39.101.2.

14-12
Charles C. Hoffman,
*View of Henry Z. Van
Reed's Farm, Papermill,
and Surroundings*,
1872. Oil on canvas,
39″ × 54½″. Berks
County, Pennsylvania.
Colonial Williamsburg
Foundation, Abby
Aldrich Rockefeller
Folk Art Center, Acc.
No. 67.102.2.

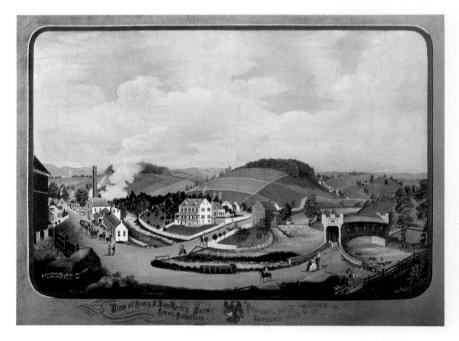

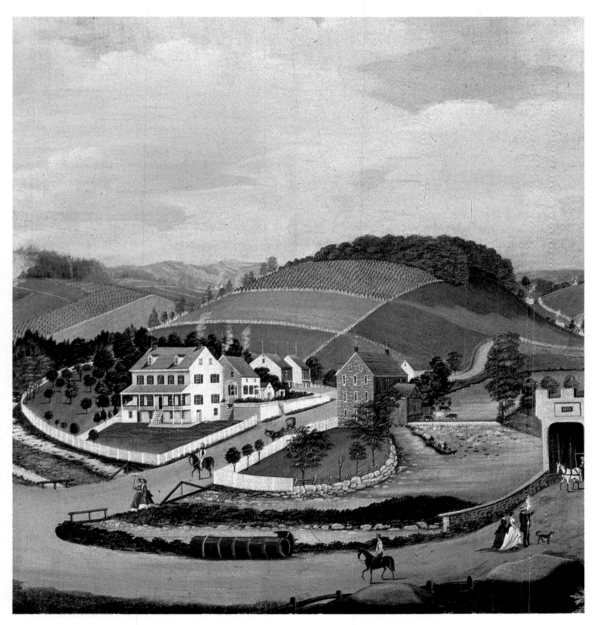

14-13
Charles C. Hoffman, *View of Henry Z. Van Reed's Farm, Papermill, and Surroundings*, 1872. Detail. Oil on canvas, 39" × 54½". Berks County, Pennsylvania. Colonial Williamsburg Foundation, Abby Aldrich Rockefeller Folk Art Center, Acc. No. 67.102.2.

the property and who appears in the dark coat in the lower left. Hoffman was reportedly paid for this painting with whiskey as well as cash. The bright optimism of the scene has no hint of the alcoholism that landed Hoffman in the almshouse. Perhaps the painter found respite in his paintings, and in the clean, industrious, well-ordered world they evoke: a world where the human community is crowned by patterned hills, with clouds floating benignly like angels in a smiling sky.

A Contemporary Folk Artist: Howard Finster

Probably the best known folk artist in America today is Howard Finster (Fig. **14-14**). Finster, whose work is sometimes categorized as outsider art, had never been to an art exhibition until he attended one of his own. His formal education ended with the sixth grade, and he became a Baptist minister at age sixteen. Along with preaching to small rural congregations, he supported himself, his wife, and five children by working in various trades.

Finster moved his family to Pennville, Georgia, in 1961, and after filling in the swamp that was his backyard, began work on an environment with "a feeling from God." Today, Paradise Garden, as it is popularly known, is a spectacular assemblage of found objects and junk that stretches over two and a half acres. One can walk through the garden on concrete paths, observe constructions and displays, and enter sheds and cave-like structures. In the summer, vines and fruit trees grow throughout the park. Hand-lettered signs bearing religious messages are placed throughout. One informs the visitor of the purpose: "I BUILT THIS PARK OF BROKEN PIECES TO TRY TO MEND A BROKEN WORLD OF PEOPLE WHO ARE TRAVELLING THEIR LAST ROAD."

In 1976, at the age of sixty, Finster began making paintings. He recounts that as he was repairing a bicycle, a vision of a tiny face in a paint smudge on his right index finger commanded him to lay down his mechanic's tools and "paint sacred art." Finster, who had been having visions since he was three, felt that this vision came from God. He considers his subsequent paintings, which number over 10,000, to be records of the visions he continues to receive. Like the sermons he still preaches and the songs he still sings, accompanied by his banjo, the paintings are intended to spread the gospel.

Finster's paintings, typically on wooden panels, are visual sermons imparted through writing as well as pictures. In neat, block-letter script, pithy messages and occasional Bible verses admonish and instruct. One is reminded that the right path will bring bliss; the wrong path will lead to sin and to the destruction of the planet by war or ecological catastrophe. These messages accompany and embellish a spectacular variety of crisply painted, straightforward images: George Washington dressed in contemporary clothes, Elvis Presley as a baby, guardian angels, spacecraft from other planets, monsters, airplanes, automobiles, Coke bottles, and smiling self-portraits. A sense of dramatic moral consequences underlies the overt charm of these paintings.

Though his popularity has grown in recent years (he has appeared on Johnny Carson's *The Tonight Show*, made an album cover for the Talking Heads, and sells his work as fast as he can produce it), he has held steadfast to his purpose. In a recent interview in *Rolling Stone*,[3] Finster said, "I'm not out trying to make money or to be a big artist. I'm trying to get the world straightened out."

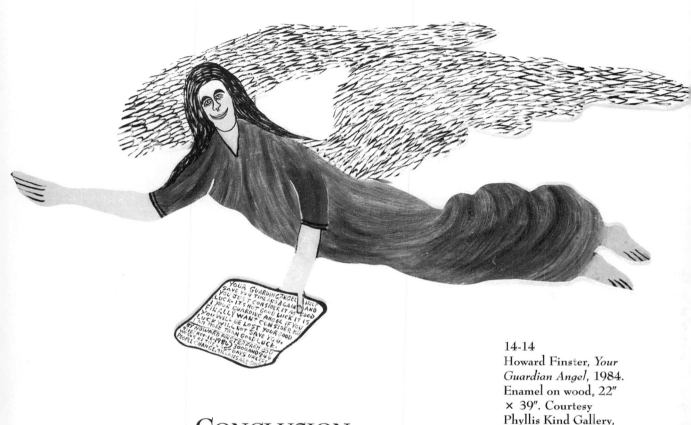

14-14
Howard Finster, *Your Guardian Angel*, 1984. Enamel on wood, 22″ × 39″. Courtesy Phyllis Kind Gallery, New York and Chicago.

CONCLUSION

Local pride, physical isolation, and the love of creating fostered a wealth of folk art traditions and styles all over the world. Though many of those traditions are waning or have already disappeared, folk art persists, often in new forms.

Folk art reveals the creativity of individuals who work for themselves or friends, rather than for an art gallery. It's an answer to the question: What can you do if you have little or no professional training? Arguably, folk art contains some of the purest examples of human creativity.

In an attempt to preserve these vanishing art forms, and to promote appreciation of the art, collections of folk art have been growing around the country. Recently, the Museum of American Folk Art, founded in 1961, moved into spacious quarters in the heart of New York City. Museums devoted to fine arts have recently begun exhibiting folk art. Books on folk art are plentiful, and many magazines are devoted to various folk art forms.

Many of the pieces in present-day collections were dearly loved, but many were devalued. Folk art today is all around us, easily accessible. What folk art treasures lie within your reach?

15
CREATIVITY

What is creativity? Are all artists creative? Are they creative in the same way everywhere? To understand creativity, we must observe it not only in individual examples, but in the context of the culture as well. We will see that creative individuals are drawn to art everywhere, but their energies are channeled, and hence expressed, in different ways. ¶ Most readers will associate artistic work with individualism and creativity. But the celebration of individualism is a relatively recent and singular event in cultural history. It was not until the Renaissance that creativity appeared as a distinct value in human experience. Creativity distinguished the individual from the masses, and arts from crafts. Artists like Michelangelo exemplified the idea that a work of art was more than a mere variation on a theme: it was a singular creation conceived in the imagination, divinely inspired, and fired by great feeling. Since the Renaissance Western art has been identified as a way of reaching into the soul, of seeing deeply into things, and of discovering truths. The examples set by Giotto, Michelangelo, Rembrandt, Van Gogh, and others have indeed shown creativity to be an activity of the highest spiritual order. ¶ Outside the post-Renaissance West, creativity was permitted in varying degrees. Individuals in centralized state workshops—for example, producing copies of statues in ancient Rome, or pottery in the Mayan empire—for the most part had little opportunity for creative work. But individuals working on their own, in smaller, decentralized societies—women in the Pomo culture, for example, *all* of whom wove baskets (see Fig. 8-2), or Kuba women, who embroidered in their spare time (see Fig. 8-15)—had fewer restrictions, and more incentive to produce original

work. Full-time professionals, such as Persian and Indian miniature painters (see Figs. 5-5 and 10-2), who were gathered into court-centered workshops, produced highly individual work in figurative traditions akin to that of the West. However creative these individuals were, they worked within traditions that were conservative by present day standards. Of course, measured by current practice, *all* other artistic traditions are conservative.

Cultures that strongly determined artistic focus produced art of remarkable quality. While in some places art was made by skilled, full-time professionals, in most places it was the product of individuals of varying skills and creative abilities who worked at it in their spare time. An artistic tradition is a great teacher. By directing creative energies, it refines and sustains ways of seeing and doing over long periods of time. Cultural traditions such as basket weaving, rug weaving, needlework, decorating clothes, or carving a design on a spear make it natural for many individuals to produce something in which they could take pride.

All artistic traditions change over time, as individual contributions alter inherited forms. A tradition may be more fixed in its forms and less prone to change where serving the state or the religion (sometimes these were the same). But while a culture may be conservative with regard to the content of the art, it may nevertheless encourage technical experimentation.

PERUVIAN WEAVING

The impressive variety of weaving techniques in pre-Columbian Peru suggests a major cultural investment in inventing new textile structures and in discovering what designs and patterns these new techniques made possible (Fig. **15-1**). Experimentation in weaving was encouraged as generations of individuals built upon what they inherited.

Techniques in weaving developed over a long period of time in many different places in the world. Weaving is based on the idea of crossing and intersecting yarns at right angles in a regular way. Weaving itself must have developed out of simpler techniques, such as knotting and looping (which we can see today in basketball nets, fishing nets, and string shopping bags). Perhaps the first fiber technology was tying knots to hold things together to make more complex objects that would prove useful as containers, as clothes, or as shelter.

The Peruvian Indians used simple looms that made it possible for parallel rows of yarns stretched between two bars (the warp) to be intersected by perpendicular yarns that were introduced one row at a time (the weft). Weft yarns were attached to a needle or short stick (shuttle) that, in the most basic weave, passes under every other warp yarn in one direction and over it on the way back. The repetition of this simple procedure produces the "plain weave," which is still the most common weave in use today.

Illustrations painted on Peruvian pottery show that weavers (always women) would place a model before them to look at while they worked. Of course, they could either copy it exactly or devise a variant of their own. That variant, if it was a new pattern or design, might necessitate some change in technique or pro-

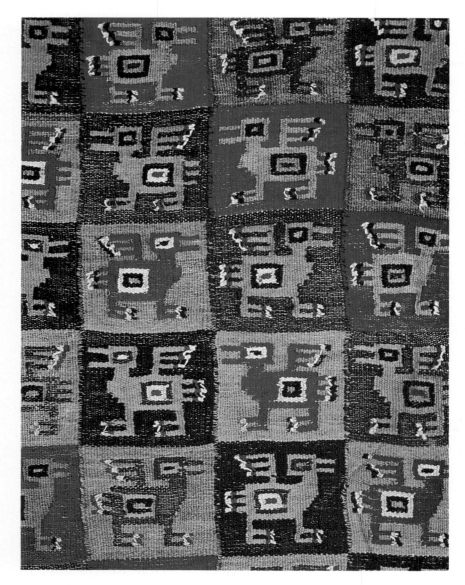

15-1
Peruvian Weaving,
Coastal Huari
(Tiahuanaco), Peru,
A.D. 600–1000. The
Michael C. Rockefeller
Memorial Collection,
The Metropolitan
Museum of Art, Acc.
No. 1978.412.257.

cedure. By exploring variations in the weaving procedure, the weavers were able to produce designs in endless varieties and combinations.

Peruvian Indian weaving demonstrates the evolution of a basic idea into more intricate forms. Creativity in Peruvian weaving can be seen as accepting the limitations of the process, while exploring every capacity of the weave. The method of exploration was to question each thread and to try out everything.

The colors and the specific images — typically of humans, animals, and plants — were limited in number and strictly organized according to the principle of variety within a restricted format. Variety was achieved by both simple and mirror-image repetitions of an image, and by placing the colors differently within each image in the sequence. The images were abstracted in a geometric

manner natural to the weaving process. The arrangement of the figures was so exacting that the space between—called the "ground"—at times became as active as the image of the figure itself. In short, every aspect was consciously considered, and nothing was extraneous to the design.

When we look at Peruvian and many other figurative weavings we should keep in mind that the patterns or images are not applied to the fabric as we might daub paint on a picture, but are integrated with the structure of the fabric. A key feature of weaving is this intimate relationship of design and technique, where the subtlest modification of the technique produces changes in the image. The Peruvian Indians produced images that were unique within the limmitations inherent in the technique.

Did this and other pre-modern artistic traditions repress creativity, or did they encourage it? Are limitations necessarily stultifying? Robert Brumbaugh, an anthropologist who observed the Telefomin people of Papua, New Guinea (see pages 287–88 and 333), points out that because of the narrow restrictions on their art, inventiveness and ingenuity are highly valued in the culture. Observations of other cultures suggest that wherever art is made, artistic criteria are developed, and fine-tuned artistic criticism is applied to the work. But unlike observers of the free-wheeling gallery art of the present day West, people of other cultures expect the art to look a certain way—according to a cultural norm or ideal. Individuality and creativity may be admired, but they are not expected to carry the work far from the norm. African carvers working within narrow restrictions carefully observe and discuss their work in terms of creativity as well as skill. Likewise, Native American women have prized creativity in their work. But all craftspeople working in traditional or pre-modern cultural milieus have had to balance their own creative needs against the expectations and requirements of the culture. That is true to some extent in the modern West, too. But nowhere is creativity, with the expectation of originality, allowed free reign as it is in modern Western societies, and at no time more than in the United States at the present.

CREATIVITY IN WESTERN CULTURE

In the years between the Renaissance and the nineteenth century, artists and public concurred in the belief that a work of art should be beautiful, appropriate, and skillfully made. Within this context individuality was recognized and admired. Competence was identified with the solution of immediate technical problems, but creativity, much more admired, was signalled by the demonstration of superior imaginative faculties.

In modern times, the declining power of tradition placed even greater value on originality. Individuality and experimentation were encouraged by the increasing rate of social change, as well as the increasingly democratic outlook of the West.

As early as the first part of the nineteenth century, observers noted a growing interest in personal exploration and experimentation. In his review of the Paris

Salon exhibition of 1827, the French artist and writer Étienne Delécluze made the following statement:

> This exposition is odd because of the diversity of the works admitted to it. Never has the diffusion of the tastes under which the artists have worked been so great as it is at present. There is not one painting whose composition, draftsmanship and coloring is not attached to a system peculiar to each originator.[1]

Four years later the Paris Salon was reviewed by the German poet Heinrich Heine. His commentary has a surprisingly modern sound:

> Every painter now works according to his own taste and on his own account Every artist strives to paint as differently as possible from all others, or, as the current phrase has it, to develop his own individuality.[2]

To account for this, we should look again at the social context. By the end of the eighteenth century, political, economic, and social factors had brought about the decline of the centuries-old system of patronage by royalty, by the aristocracy, and by the Church. With the passing of these traditional patrons, artists lost security—but at the same time, they were released from the restrictions that these conservative institutions imposed. Artists were now on their own, competing for a market composed of the burgeoning middle class, and a gradually widening range of individual tastes.

The loss of religious and royal patronage meant the end of the formal integration of art with society. With the intimate relationship with Church and Crown gone, artists had to ask themselves a new set of questions: What role did they now play in society? Whose needs would their art serve? What subjects would they be interested in? What style would be appropriate? Of one thing they could be sure: they were now more free to follow their own interests; in fact, they could work to please themselves alone if they chose.

Nineteenth-century Romanticism encouraged individualism in the arts; in the twentieth century, freedom of expression is considered a right. Unfettered creativity is highly regarded today because individualism makes sense to us. We connect it with cherished concepts of human freedom and dignity that have evolved, however haltingly, in Western civilization.

For painters, sculptors, and craftspeople today, artistic freedom presents a great challenge. The dos and don'ts once imposed by tradition channeled the artist's energies and directed the work, or for innovative artists, provided points of departure. Artists today must not only seek solutions to problems but, to a greater degree than ever, must invent the problems themselves.

GIOTTO

As far back as the early fourteenth century the Florentine painter Giotto amazed viewers of his frescoes with his ability to depict solid figures in a three-dimensional space and to give those figures a

warm, human quality (see Figs. 4-13 and 11-1). Although his figures may look naive and doll-like to our eyes, they were much more realistic than any painted by his predecessors, and made a deep impression on those who viewed them. In the same century Boccaccio, writing about Giotto's achievement, stated that "there was nothing . . . that he could not recreate with pencil, pen or brush so faithfully, that it hardly seemed a copy, but rather the thing itself. Indeed, mortal sight was often puzzled, face to face with his creations, and took the painted thing for the actual object."

Giotto gave his figures a solid appearance by subordinating their details in order to emphasize their bulk. He also painted them in light and shadow. Certainly he was not the first person to observe that light and shadow reveal the solidity of objects. Other painters he knew — Cimabue and Duccio — had tentatively explored the use of light to model form. But Giotto's volumes convince us, because he handled light in a way that is consistent and unified, and not arbitrary. While this effect may seem obvious to us, we should note that no painter in Italy had done it before Giotto. We might also note that Giotto neglected to paint the shadows that his figures cast on the ground. Could this have been an oversight? Or did he consider the shadows irrelevant?

Giotto inherited a tradition of painting, with its particular forms and conventions. But instead of working within the framework of the convention, he questioned the convention itself. Why must the figures in a religious painting look flat, stiff, other-worldly? Wouldn't it be more effective, more moving, if the viewers could identify with their humanity? Essentially, he found new ideas to investigate, which led him to break new ground.

Giotto's creative genius set a course for Western painting, as artists attempted to emulate his triumphs. But it took over a century before artists fully understood and absorbed the lessons he taught.

MICHELANGELO: *DAY*

Sculpture has a factual aspect to it: it not only *has* a presence, it *is* a presence. Since ancient times sculptors have exploited the potential of hard material to assert itself upon the viewer when transformed into a recognizable figure. Renaissance sculptors were concerned with making their sculptures lifelike. Michelangelo's idea of sculpture, though, was quite different. He conceived of sculpture primarily in its material aspect, as mass, rather than as merely an imitation of the subject. Thus he was able to bring an intense presence to the piece. Michelangelo had the capacity to visualize the sculpture in the block of stone, but also to retain the feeling of the block of stone in the sculpture.

Like other artists of the Renaissance, Michelangelo took as his ideal the antique statues that remained in his native Italy, including some that were unearthed during his lifetime. But he brought to his figures a sense of inner life, of an intense psychic or emotional energy that went beyond anything he could have known from classical antiquity or, for that matter, from the Renaissance. Mi-

chelangelo achieved this by conceiving original poses for the figure, and by exaggerating parts of the anatomy. He discovered that a twisting pose (*contrapposto*) could give a figure a sense of movement arising from within. Combined with exceptionally powerful musculature, a figure would seem to be exerting an outward thrust emanating from a life force centered inside the stone.

The magnificent allegorical figure of *Day* (Fig. **15-2**) in the Medici Chapel peers out at us uneasily, weighed down by some exterior force seemingly both physical and psychological. His muscles are extraordinarily powerful and taut, as if he were trying to pull free, and yet he appears strangely frozen, as if powerless to move. His left hand and right foot are still not free of the stone, and his pose on the curved base is unstable, as if he were being pulled downward by the counterforce of gravity. The torso is conceived in terms of simple masses twisting against one another in conflicting directions; the right arm swings one way, and the left leg crosses over in opposition. These tensions draw us back to the statue again and again as they beg for resolution; we're waiting to see which way he's going to go. Michelangelo may be telling us that life resolves itself only in God's time, not in ours. The face gives us no answers. Roughed out, unfinished, it is a man in the process of emerging from the stone. The shadow cast over his deep-set eyes leaves room for our own interpretation of his expression.

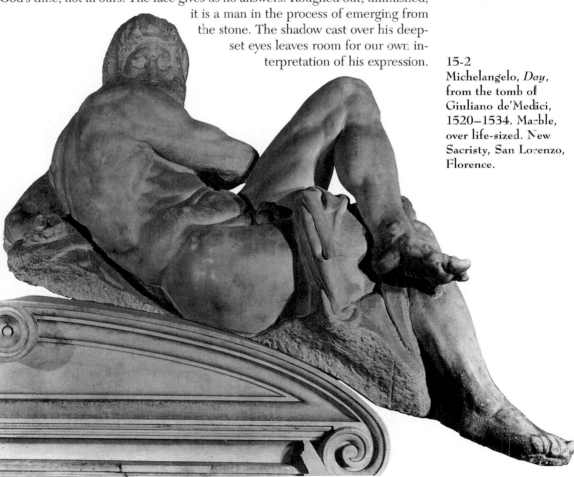

15-2
Michelangelo, *Day*, from the tomb of Giuliano de'Medici, 1520–1534. Marble, over life-sized. New Sacristy, San Lorenzo, Florence.

Michelangelo's ability to fuse the life of the figure with the life of the stone was a superior creative achievement. His revelation of the expressive capacity of the body opened up new possibilities for the human figure and the role it could play in art. Michelangelo's particular vision of the human body influenced his contemporaries, while his idea of sculpture as mass, and his ability to touch the material and bring it to life, was to influence Rodin, Henry Moore, and other sculptors of the twentieth century.

REMBRANDT: *ST. JEROME READING IN AN ITALIAN LANDSCAPE*

Now let's look at Rembrandt's etching of *St. Jerome Reading in an Italian Landscape* (Fig. **15-3**). According to legend, St. Jerome removed a thorn from the paw of a lion, for which he earned himself a furry friend for life. In this work, Rembrandt appropriately includes the lion, but breaks with convention in showing the saint out of doors; traditionally Jerome is shown in his study where he translates the Bible into Latin.

Like the setting, the composition is also unconventional. Surprisingly, Rembrandt gives the buildings in the background the greatest detail, while the figure of St. Jerome, the principal subject of the etching, is scarcely touched in. Rembrandt not only experiments with the overall composition, but with the treatment of areas within it. The figure of St. Jerome, although loosely treated, is convincingly solid. In contrast, the hindquarters of the nearby lion are flattened with parallel lines while its head receives more detail and seems fully rounded. As we look throughout the etching we find that the line handling in each section differs so that we get a surprise wherever we look. Yet the picture holds together, in part because it resolves into a few areas of dark and light.

By substituting suggestions for more finished details, and by bringing the white of the page into the solid figure, Rembrandt anticipated the drawings and paintings of modern artists, whose experiments with composition and solid forms were more explicit. The interplay of lights and darks, the push of flat against solid areas, the variation in line and tone, and the unexpected compositional decisions test out and even reverse conventional procedures and make this print an unusually rich visual experience.

With all this, the picture is still more than an impersonal formal exercise. Let's imagine ourselves there. What would catch our eye? Very likely we would notice the lion before we saw an old man peacefully reading. As we focused our gaze on it, other things would fade, or just go unnoticed. We might also enjoy looking at picturesque buildings clustered in the distance, which would throw the man and the lion out of focus. A tree overhead would scarcely be glimpsed out of the corner of our eye. Rembrandt's treatment of the scene, besides being visually inventive, is true to the way we would see it if we were on the spot. His treatment of details is not arbitrary, but corresponds with our natural perception.

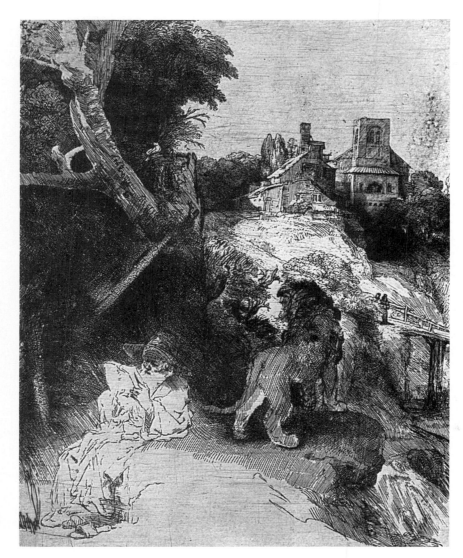

15-3
Rembrandt van Rijn,
*St. Jerome Reading in
an Italian Landscape, c.*
1654. Etching, approx.
10″ × 7″. Courtesy of
The Art Institute of
Chicago, Clarence
Buckingham
Collection. ·

At the same time, the composition makes a particular statement about the subject matter. The light pouring over St. Jerome makes him special, even though the lion is at the center. Yet, by presenting his subject in so quiet and undramatic a fashion, Rembrandt makes the scene feel natural and true to life. The lion turns away from us; the saint is almost lost to sight in the sunshine. The wondrously understated, casual depiction of St. Jerome makes him more accessible, more like someone you can relate to personally. He even seems nearsighted, judging from the way he holds his book close to his eyes. It is altogether a fantastic, dreamlike world here, where a lion contemplates a beautiful landscape and an old man, half-seen, peacefully reads in the sunlight nearby; but Rembrandt seems to be telling us, simply, quietly, this is the way things might be.

THE CREATIVE PROCESS

The sixteenth-century biographer Vasari writes that when Leonardo da Vinci was at work on *The Last Supper*, he could be seen "standing half a day lost in thought." Urged by the duke to complete the work, Leonardo pointed out that "men of genius may be working when they seem to be doing the least, working out inventions in their minds, and forming those perfect ideas which afterwards they express with their hands."[3]

Works of art do not spring full-blown from the imagination, but are part of a process. Following upon that mysterious phenomenon called insight, inspiration, or revelation, artists work things out in the conscious mind, turning around ideas, pushing them forward, testing things out—and imagining again.

A drawing or sketch can, as we have seen, catch an inspired thought on the wing, but further drawings will refine the idea. Sculptors typically make small models in preparation for large figures. Michelangelo made models of clay and wax, and used some of them for more than one painting or sculpture. Rodin's *Burghers of Calais* (Fig. 7-11) was developed over a period of about five years, during which time Rodin worked out ideas for poses and composition. Each figure was modelled in the nude as an aid to understanding the pose. Some painters made small dolls in clay or wax that they could group together as a basis for a painting.

When I came back from Paris, I painted those rowing pictures. I made a little boat out of a cigar box and rag figures, with red and white shirts, blue ribbons around the head, and I put them out in to the sunlight on the roof and tried to get the true tones.

—Thomas Eakins (see Fig. 4-11)

Artists greased the wheels of their creativity in other ways as well. Rodin occasionally composed by cutting out drawings of his nudes and collaging them together. Hokusai would paste cutout drawings of figures into his settings in preparation for his prints. Today, artists work out compositions using the instant camera, the slide projector, the duplicating machine, the light table, and tracing paper.

Returning to the same subject permits an intensive exploration of the particular problems and possibilities that subject offers. Raphael repeatedly drew and painted two-, three-, and four-figure compositions, inventing and reinventing complex interweavings of gaze and gesture. His *Madonna and Child and St. John the Baptist* (Fig. 4-7) is an especially beautiful resolution of this grouping. Cézanne repeatedly painted arrangements of apples on a table top, as in Fig. 11-8, and returned again and again to paint Mt. Sainte-Victoire.

Time and reflection . . . modify little by
little our vision, and at last comprehension comes to us.

—Paul Cézanne, about 1905

~~~  ~~~

Artists learn from each other, taking techniques, poses, and compositions as starting points. Borrowing ideas is considered normal. For example, the landscape and buildings in the background of Rembrandt's *St. Jerome Reading in an Italian Landscape* are based on a sixteenth-century Italian drawing that was in Rembrandt's possession. For *The Stone Breakers* (Fig. 13-3), Courbet borrowed a pose from Poussin's *Et in Arcadia Ego* (Fig. 18-11). Of course, the artists rework the earlier ideas to suit their own purposes. For the socialist Courbet, to take an ancient Greek youth and turn him into a modern-day, aged laborer was to make a point.

Sketches, models, tracings, repetitions of themes, and borrowings were aids to creativity. The persistent investigation and reworking of ideas, with each study the basis for another, was a means of moving from what is known to what is yet to be discovered. Ideas may spring into the mind, but it takes commitment to bring them to realization. Thomas Edison's statement, "Genius is one percent inspiration and ninety-nine percent perspiration," could apply to the arts as well as to the sciences.

# THE MIND IN MOTION

Ideas often pop into our heads out of the blue, and we can't easily say how we got them. Often the mind is elsewhere. Everyone gets creative ideas from time to time when driving, showering, or before falling asleep. Men get brainstorms while shaving in the morning. At these times our minds relax a bit. By free-floating, musing, daydreaming, the creative part of our brain is freed up to do its job.

Art today is a place for creativity to unfold. It's where you can let go and open up, peacefully, without hurting yourself or anyone else. Of course, creativity is by no means confined to the world of art, or to artists. *Everyone* has the potential to be creative. Creativity can happen in the laboratory, in the office, in the neighborhood, or in the kitchen. Creativity is vital to growth; indeed creativity *is* growth.

If you want to be more creative, allow yourself to be curious. Think about "What if . . . ?" (That's probably what Leonardo was thinking when he contemplated his partly-finished *Last Supper*). Creativity means getting out of the usual channels of thinking and doing. It happens when you let your mind take a stretch.

Creative ideas can occur to us all, but we improve our chances when our minds are prepared for them. Consider the following examples from the twentieth century.

In 1925, a young furniture designer on the Bauhaus faculty named Marcel Breuer bought a bicycle and rode it to pass the time until classes began. Noticing the handlebars and the light strong frame of tubular steel, he conceived the idea of using that material for furniture. With the aid of a local plumber he created the first tubular steel chair that very year (Fig. **15-4**). Later he refined the design, and by 1926 his chairs were being mass-produced and sold.

Up to the time of Breuer's discovery, furniture in the Bauhaus, as elsewhere, was constructed of wood. Breuer recognized that tubular steel, with its light, efficient, machinelike appearance was more compatible with streamlined, modern architecture than wood. Breuer made his breakthrough by questioning the premise that wood alone was appropriate material for furniture. While the idea apparently occurred to him in a flash, it was made possible because he had been working with furniture and thus was likely to relate it to what he experienced.

Charlie Chaplin's films contain unforgettable moments of inspired visual thinking. The paraphernalia of modern, urban life — escalators, revolving doors, assembly lines, roller skates — became springboards for Chaplin's imagination as he explored their potential for unanticipated uses. In *The Gold Rush* (1925), for example, he manages to convince his starving companion, as well as the audience, that a boot can provide a sumptuous dinner (Fig. **15-5**). In another scene he plunges two forks into dinner rolls and transforms them into dancing feet.

**15-4**
Marcel Breuer,
Armchair, 1925.
Chromeplated steel
tube, canvas, 28″ high.
Manufacturer:
Gebrüder Thonet
A. G., Germany.
Collection, The
Museum of Modern
Art, New York. (Gift of
Herbert Bayer.)

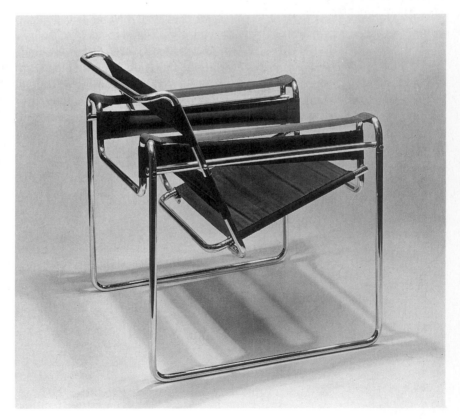

15-5
Charles Chaplin in *The Gold Rush*, 1925.

15-6 (below)
Pablo Picasso, *Head of Bull*, 1943. Handlebars and seat of a bicycle, 16⅛″ high. Musée Picasso, Paris.

In another example of visual wit, Picasso welded the handlebars of a bicycle to the seat to make the head of a bull (Fig. **15-6**). Much later Picasso was heard to say that he'd like to toss the *Bull's Head* on the ground and watch someone discover it, pick it up, dismantle it, and fit the pieces back into a bicycle.

These three examples appear to show capricious and spontaneous thinking. Breuer looked at a bicycle and saw furniture; Picasso looked at a bicycle and saw a bull; Chaplin looked at shoelaces and saw spaghetti. We ought not forget, however, that the artists were already geared into thinking along certain lines. Breuer had furniture on his mind. Picasso enjoyed bullfights, and frequently incorporated the bull into his art. Both Picasso and Chaplin were devoted to taking objects out of context and turning them into something else. Their individual mental sets enabled all three to wrest particular ideas from the situation before them. What seems capricious and spontaneous would perhaps be better understood as the product of a mind both focused and in motion.

# EVA HESSE

Contemporary artists look inward for the direction once supplied by tradition. Theoretically, at least, anything is possible. But the openness of the situation today multiplies the opportunities for disaster. Creativity is not the same as doing whatever you want.

It takes a special kind of courage to be oneself in art; to trust what's inside you and believe that your work will make sense some day. For serious artists a life in art represents a struggle toward self-realization. In our time, that struggle has been romanticized, while the reality—the risk, and the fears—generally remains hidden.

Eva Hesse (see Figs. **15-7** and 12-5) was an immensely creative artist, in part because she was willing to take risks in her art. In 1964, when she was 28, she entered into her diary:

> Making art. "painting a painting." The Art, the history, the tradition, is too much there. I want to be surprised, to find something new. I don't want to know the answer before but want an answer that can surprise.[4]

Some months afterward she wrote: "Without trying I'll never know." Five years later she had become a well-known artist. Interviewed in 1970, she reiterated the theme of risk and exploration:

> That's why I think I might be so good. I have no fear. I could take risks . . . I'm willing really to walk on the edge, and if I haven't achieved it, that's where I want to go.[5]

**15-7**
Eva Hesse, *Repetition 19, III*, 1968. Nineteen tubular fiberglass units, 19″ to 20¼″ high, 11″ to 12¾″ diameter. Collection, The Museum of Modern Art, New York. (Gift of Charles and Anita Blatt.)

Hesse developed an unconventional and highly individual art, neither painting nor sculpture as we traditionally know them. She was careful that her pieces not have obvious resemblances to other things; the associations should be subtle, private. She also managed to stay away from the looks and styles that were currently popular in the New York art world. Hesse was convinced that if the work reflected herself, it would take on individuality and strength:

> I don't know if I am completely out of the tradition. I know art history and I know what I believe in. I know where I come from and who I am related to or the work that I have looked at and that I am really personally moved by and feel close to or am connected or attached to. But I feel so strongly that the only art is the art of the artist personally and found out as much as possible for himself and by himself. So I am aware of connectiveness — it is impossible to be isolated completely — but my interest is in solely finding my own way.[6]

Her pieces were not polished or graceful, and they avoided effects that were pretty. They are never quite organized or lined up. The forms, often made of rough plastic substances, just seem to *be* there, hanging, lying, or leaning in positions natural to them, as though they had taken on some strange, awkward kind of life. Hesse's loose, chancey way with materials, and her evocative personal imagery opened new directions for artists in the late sixties and seventies. With its uncompromising reflection of self, her work demonstrated how far art could go to embody the personal world of the artist. In this respect her example remains important and instructive to this day. Hesse thought of her art in personal terms:

> First when I work it's only the abstract qualities that I'm really working with, which is to say the material, the form it's going to take, the size, the scale, the positioning or where it comes from in my room — if it hangs from the ceiling or lies on the floor. However, I don't value the totality of the image on these abstract or aesthetic points. For me it's a total image that has to do with me and life. It can't be divorced as an idea or composition or form. I don't believe art can be based on that. This is where art and life come together.[7]

Eva Hesse's mature work was produced in a span of less than five years. She died of a brain tumor in 1970, at age 34.

These eloquent statements from Hesse's interviews and writings convey some sense of that hidden experience — the perilous "walk on the edge" — that constitutes, for contemporary artists, a life in art.

I have learned anything is possible.

I know that. That vision or concept will come through total risk,

freedom, discipline. I will do it.

— Eva Hesse, 1969

# JENNIFER BARTLETT

For the past two decades Jennifer Bartlett has pushed beyond conventions. Bartlett's work in the 1970s was closely tied to Conceptual Art. Resisting the idea of making paintings on canvas, she used foot-square steel plates, each coated with baked enamel and then silk-screened with gridded pale gray lines, as surfaces for painting. Applying commercial enamel paints to the plates, she arranged the plates in gridded systems, each one inch apart, that filled entire walls. This vast matrix allowed her to devise finely calculated systems that subjected geometrical shapes and simple objects—a house, a tree, a mountain, and the ocean—to gradual changes of color and drawing styles. *Rhapsody* (1975–76), a major work, included nearly a thousand plates. Exhaustive transformations of the elemental images entirely filled the gallery walls, combining the individual units with one another and making it impossible to take in the whole at one time.

Bartlett's multiple images invited comparisons with one another. Changes of scale, color, and painting style altered each image and connected it visually to a neighbor or neighbors. No one plate or series of plates became a focal point, and nothing was repeated. Ideas were taken up, worked around, and let go, and the viewer could begin anywhere and follow the painting like an opened scroll.

I never had the kind of natural talent

that lets you draw portraits of horses or things like that. I'd do very large

drawings on brown paper that showed, for example, everything I could think

of underwater. Or scenes with people dropping from cliffs into boats, and

Indians in the background. Art teachers always liked me, but I never

understood why what I did was good.[8]

— Jennifer Bartlett

～⁄⁄⁄   ⁄⁄⁄～

In its scope, the piece was groundbreaking. *Rhapsody* combined color and black and white; dots, lines, geometric shapes, and figurative images; flat surfaces and brush strokes. The figurative images ranged in style from extreme realism to extreme abstraction. *Rhapsody* is not so much a picture as it is *about* pictures, and how they show us things.

Through the 1970s and 80s Bartlett continued to present multiple images of the subject, retaining the format of gridded plates, and later combining the plates with painted canvas. Eventually the plates give way to canvas alone.

In 1980, because of a house swap, Bartlett lived for a year in a disappointingly dreary villa in the south of France. Making the best of a bad situation, she produced close to two hundred drawings in ten different media of "the awful little garden with its leaky swimming pool and five dying cypress trees." The

drawings showed the garden from different angles and at different times of day. Bartlett also tried different kinds of drawing styles, from abstract to realistic. The drawings were exhibited as a group, sometimes with paired abstract and realistic drawings. The paintings that ensued from the pool drawings and photographs are lushly painted three-, four-, and five-panel pieces (Fig. **15-8**). Each panel shows the pool and garden at a slightly different angle, from a slightly different viewpoint. Changes to both the subject and the light dramatize the passage of time.

In shifting from plates to canvas, Bartlett's brushstrokes open up and become loose, almost nonchalant. The paint is juicy; the imagery is painterly. Yet the analytic mind is present, controlling the shifts of view. Within the sequential grouping, each separate image seems incomplete. One can never dwell for long in any one panel, for its neighbor crowds it. The pieces speak of the uncertainty of perception. Bartlett's work points to the accommodation we make to the idea that seeing equals knowing.

From the mid-1980s to the present, Bartlett's curiosity about the dichotomy between illusion and reality has led her to construct three-dimensional structures modelled on objects she has painted, and to place those constructed objects in front of the painting (Fig. **15-9**). The solid objects mimic precisely the painted, two-dimensional images, even to matching the distortions brought about by perspective. Hence the painted objects may look more "right" than their three-dimensional mates, which from certain viewpoints are curiously distorted. In basing solid objects on two-dimensional images, she reverses the usual practice of making two-dimensional images of the three-dimensional world.

While the environments in Bartlett's work are strange, the objects are familiar, almost universal. Boats and houses—adventure and security? movement and rest?—remain constants. Neat, white fences, perhaps emblems of human rationality, neatness, and order, are juxtaposed with dark, dreamy, sensuous

15-8
Jennifer Bartlett, *Shadow*, 1983 Oil on four canvases, 84″ × 240″. Collection of The Chase Manhattan Bank, N.A.

15-9
Jennifer Bartlett, *Small Boats, Houses*, 1987. Painting: oil on canvas, 9′10″ × 14′. Sculpture: painted wood, steel supports. Paula Cooper Gallery, New York.

trees, images of nature. With these as launching points, the viewer may complete the environment in terms of his or her own associations with these objects.

From the start Bartlett was uninterested in just making nice pictures. Her willingness to take risks has led her to aim high. Her work is philosophically detached and vividly sensuous, calculating and spontaneous, serious and whimsical, objective and, in its choice of subject matter, autobiographical. Bartlett's willingness to pull together opposites is a challenge, but accommodates to no convention. Her interest has always been in trying something out to see where it goes.

# CONCLUSION

Creativity manifests itself in different ways. Outside of modern Western art, creativity is generally seen in variations on inherited traditions, while in the West today it is often evidenced in departures from the tradition. Generally, creativity for its own sake has been more encouraged in the post-Renaissance West, and at no time more than now.

In the West, works of art give form to individual experience. Because they investigate and reinterpret, they change how we see things. Outside of the West, works of art speak more of collective experience. The art tends to confirm, rather than change, traditional wisdom. Creativity may be seen in the way an artist applies his or her personal touch to an inherited form.

Although Western artists today are as free as artists can be, their work is often hidden away from their potential audience. That reflects in part the gulf between art and life. But it may also suggest that some of the art, at least, is irrelevant. The art of traditional cultures, by contrast, addressed itself to central concerns of the society, or was embedded in objects designed for use. That art was made with confidence and conviction, and, as we have seen, with tradition as the great teacher.

In our investigation of creativity, we have seen cultures as the great organizers, channelling creative energies according to purposes established for the art. The value placed on originality reflects a cultural attitude about individual expression.

This chapter has emphasized the problem-solving nature of creative thinking. Although clear enough to artists, this aspect is often overlooked by their audience. Knowing what problem to address is as important as the answer given. It is possible that Michelangelo left much of his sculpture unfinished because he felt that his solutions were insufficient. His reach may have extended beyond his grasp—but that reach carried him beyond conventional solutions to the intensely personal and visionary work that he finally achieved.

Creative solutions, particularly when they are of a high order, can strike us as having been obvious. Such may be the case with Giotto's conception of perspective. But we should keep in mind how long it took artists to understand and repeat his performance. Even today perspective must be learned. It is useful to remember that the wheel, the zero, and the paper bag once existed only in someone's imagination.

All artists need a starting point. No one can just plunge in and start creating; there has to be a narrowing of focus. Generally, this was provided by tradition. In art schools today there is a wide range of starting points, reflecting the current diversity of interests in the art world and in the culture as a whole. In the next chapter, we will look at some of those starting points.

Art can't be nourished in a vacuum. For art to happen, it has to make sense in the life of a community, whether that community is a village, a city, a nation, or a family. Creativity is a natural impulse, but it can be encouraged or suppressed.

For most artists, being creative is hard work, requiring diligence and self discipline. Many surrender some of the usual satisfactions of life to devote themselves to it. But being on the edge of an idea and discovering something new is incomparably exciting. As my artist friend Nancy Hansen put it, it is "being so involved you don't even know you're happy."

The capacity to be creative distinguishes what is most human in us. In every area of human endeavor creative individuals enrich our lives by changing the way we see and experience things. By aspiring to understanding, and by their devotion to that goal, they offer illumination and growth to us all.

# 16
## ARTISTS' EDUCATION

I f you wanted to be an artist, what would you need to know? Where would you go to learn? What would you be taught? These questions have been answered in very different ways over the years, suggesting very different ideas about art and artists. ¶ Many of us think that the artist is the prime example of the creative, imaginative, exceptional type, while the rest of us just plod along. After childhood, art is usually left to professionals. How surprising, then, to see that many cultures assume that talent and creativity accompany everyone throughout life. Each person is involved in some way. ¶ In places where everyone makes art, the skills and techniques are passed down through observation. Boys learn from their fathers, and girls learn from their mothers. Youngsters develop skills by repetition, under watchful eyes. Traditional techniques, patterns and designs provide starting points. No one need ask what to make or how to make it.

## APPRENTICESHIP

In many parts of the world an expert, typically outside the family, takes a novice under his or her wing. The novice performs routine tasks and may also pay the expert in money or goods. In return, the master teaches the novice, or apprentice, all that he or she knows. Lessons take the form of demonstrations. Learning is a matter of imitating the master's technique and style. When these are absorbed, after months or years, the apprentice is ready to strike out independently. ¶ Robert Brumbaugh, who spent time with the Telefomin in Papua, New Guinea, observed several carvers and their apprentices.[1] The system was informal, with interested boys gathering around the several old men who were experts to learn their trade. However casual the atmosphere, the older

artists nevertheless expected their pupils to do exactly as they were shown. Iron-ically, each of the carvers had developed individual versions of the traditional designs, and each thought his own way of carving the only right way of doing things.

Apprenticeships, while informal as to methods of instruction, are structured by traditional, unwritten codes of behavior. Master and apprentice know pre-cisely what is expected of each. Frequently a kind of "character building" is built in to the training, as the humble tasks and rigorous criticism of the master craftsperson discipline and chasten the student. In the end, the apprenticeship period may lead to a warm personal relationship between master and disciple that can last a lifetime.

# WORKSHOPS

A great many people are born into the business of art. Families of artists and craftspeople have been common around the world, right up to the present. In this photo (Fig. **16-1**) taken in 1988 in the central Sahara desert, a Tuareg girl, Atyi, watches her mother Andi at work on a camel saddlebag. Atyi is the third named generation to learn the art of making and embellishing these prized objects. Teabowls like that in Fig. 8-7 were usu-ally made in hereditary family workshops. Certain families of painters in Japan also extended for many generations. Even in Renaissance Italy, painters' and sculptors' shops were commonly inherited. Trade secrets, vital where workshops

16-1
Andi Ouloubou
making a leather bag
and watched by her
daughter Atyi, 1988. ©
Thomas K. Seligman.

competed for products, were more safely kept because they were family secrets as well.

Not all workshops were hereditary. Many were organized by the state, such as in Rome, which either wooed or forced people into service. Some European workshops in the Middle Ages were hereditary, though most were not. The medieval workshops were organized according to traditional practices and supervised by independent associations of tradesmen, called *guilds*.

Every workshop had a master, who supervised the workers and apprentices. Often, workers and master performed little more than skilled manual labor. Apprentices learned by following formulas, simply repeating what was done before. Creativity, vision, and inspiration had little to do with the process or the product. Still, some situations tolerated variations or even encouraged them.

# THE EUROPEAN GUILDS

In Europe, there were guilds for bakers, barbers, and barrel makers, as well as for painters and sculptors. These professions were considered equally important until the Renaissance, when individual artistic achievement began to be honored above the work of trades.

Guilds combined the functions and responsibilities of a modern trade union and a social club. They set and maintained the standards of the trade, regulated prices, organized the labor. They looked after members who were sick, buried them when they died, and supported their widows and orphans.

The guilds were a visible force in the town. Guild members orchestrated the so-called "morality plays," which were prominent features on festival days. Guilds marched together in processions under banners showing guild insignia. Some guilds put up lavish buildings to impress the townsfolk. Guild houses still standing in Brussels vie with one another for prominence on the town square, with symbols representing each guild adorning the facades.

Frequently, related trades were grouped within a single guild. Painters, at least for some years, were joined with other trades. In Florence they were grouped with doctors and apothecaries; in Brussels, with goldsmiths and printers. As late as the seventeenth century, artists who painted in England belonged to the "Painters-Stainers' Company," along with coach and house painters.

In addition to supervising the workshops, the guilds also saw to the training of apprentices.[2] Most guilds restricted the number of entering apprentices to one or two at a time in order to ensure that each received proper attention. Apprentices typically entered painters' shops around the age of thirteen or fourteen, though some were as young as ten. The parents of the apprentice signed a contract and paid the master of the shop. The youth was fed, clothed, and perhaps housed by the master. At the shop he performed basic chores such as grinding pigments into paint, making brushes, and preparing panels for painting. As the apprentice proved himself, the master gave him more responsible

tasks. He began by transferring the master's drawings to the panel or canvas. Later he painted in the preliminary stages of the painting and he sometimes finished the less demanding or less important parts. Eventually, he produced his own work under the master's supervision. In this way, the apprentice learned first-hand all aspects of his craft.

After five or six years in the shop, an apprentice began to receive pay. At this point, his apprenticeship was over. He was now an assistant, or *journeyman* (from the French *jour*, or *day*, because journeymen were originally paid by the day). A journeyman could travel freely from workshop to workshop. Some eventually entered the guild and opened shops of their own.

To join a guild and be considered a master craftsman, an applicant submitted a sample of his work to the guild members for evaluation. That object was known as his "master piece." Following acceptance of the work, the craftsman paid a fee and became a member of the guild. His entrance was celebrated at a banquet, for which he often paid.

A wealth of knowledge was stored up within each guild and was transmitted by demonstration and by word of mouth. Much of it was jealously guarded from outsiders, and apprentices were sworn to secrecy. "Trade secrets" were a fact of life in European guilds; indeed, they have characterized guilds, workshops, and corporations everywhere to this day.

The training provided in the guilds was, above all, technical. The novice was neither expected nor encouraged to experiment. Doing the job well meant doing it predictably, just as if one were learning to make a suit of clothes.

# DRAWING LESSONS

Besides involving the apprentice in all technical aspects of painting, the master also taught him how to draw. Shops collected drawings and sketches, most often of the faces, poses, and costumes that could be used as models for paintings by the master or his workers. Learning to draw meant learning to copy these drawings accurately. A steady hand and a good eye were the best assets of the student painter.

Few drawings remain from the Middle Ages; most were worn out from continual handling. The drawings shown in Figure **16-2** are from the sketchbook of a thirteenth-century French architect, Villard de Honnecourt. The geometrical patterns inside the figures reflect the medieval taste for harmonies perceived in nature. Perhaps unintentionally, they also provided a learning method. Constructing a face or a horse from simple geometric forms remains a feature of how-to-draw books to this day.

Compare de Honnecourt's horse to the one shown in Figure **16-3**, by the fifteenth-century Italian painter Pisanello. Pisanello's drawing exemplifies a new direction in art. His horse is not made from geometrical shapes, nor is it derived from someone else's drawing. Instead, it's based on a careful look at the real thing. From the Renaissance on, learning to draw meant learning to make

16-2
Villard de
Honnecourt, page
from a notebook, *c.*
1240. Bibliothèque
Nationale, Paris.

16-3
Antonio Pisanello,
*Horses' Head*, fifteenth
century, Italy. Drawing
from the Department
of Graphic Arts,
Louvre, Paris.

drawings accurately, directly from nature. This presented artists with a new challenge: to make things look convincingly three-dimensional.

How might that be done? Look carefully at Pisanello's drawing and you will see short lines, called hatchings, that he uses to make the form appear round. The hatchings build up shadows to give the form solidity and to show subtle changes along its surface. Hatching is an effective way to communicate roundness of form in a drawing. The technique was refined by later artists (Fig. **16-4**) and continues to be a mainstay of training in drawing to this day.

16-4
Albrecht Dürer, *Self-Portrait at Age Twenty-Two, with Hand and Pillow*, 1493. Pen and ink. The Metropolitan Museum of Art.

Take pains and pleasure in constantly copying the best things which you can find done by the hand of great masters. . . . If you follow the course of one man through constant practice, your intelligence would have to be crude indeed for you not to get some nourishment from it. Then you will find, if nature has granted you any imagination at all, that you will eventually acquire a style individual to yourself, and it cannot help being good; because your hand and your mind, being always accustomed to gather flowers, will ill know how to pluck thorns.

—Cennino Cennini, from *The Craftsman's Handbook*, c. 1390s[3]

**16-5**
Jean Cousins,
Illustration from *Livre de Perspective*, 1560, Paris, LeRoyer. Woodcut. Museum of Fine Arts, Boston.

Linear perspective was another system developed in Renaissance Italy. This technique, as you will recall from Chapter 6, enables an artist to draw a room that appears to surround the people inside it, or to draw a building or street that seems to go back in space. Eventually, diagrams demonstrating the system became a staple of art education, as they are today (Fig. **16-5**).

# ARTISTS' SHOPS

By the late Renaissance, the guilds still functioned, but painters had grown more independent. Many set up workshops apart from the guilds. But artists still needed help with preparation, so they took on apprentices when possible and taught them all they would have learned in the guild shops. So valuable was the hands-on learning within the painters' and sculptors' shops that the apprenticeship system persisted in Europe for hundreds of years, continuing into the nineteenth century.

Painters also took on assistants, for help with more demanding tasks than could be entrusted to apprentices. Some assistants specialized in still-life objects, such as flowers or fruit; others specialized in landscape; and still others were drapery specialists. Sometimes the master would do just the faces (which may be why portrait painters in eighteenth-century England were dubbed "face painters"). The engraving shown in Figure **16-6** gives us a look inside a painter's shop. The master appears at the center, with apprentices and assistants surrounding him like planets revolving around the sun. On the right, two men grind and mix pigments. At the table, one apprentice scrapes a palette clean; another draws a bust. On the left, an assistant works on a portrait.

Assistants were expected to emulate a master's style while working in his studio. Sometimes it's possible to tell from the quality and the character of the brushwork in a painting which areas were painted by the master and which by an assistant. Rubens (Fig. 4-25), whose work was in great demand, had many assistants in his studio in Antwerp. Several, like Van Dyck (Fig. 10-10) and Snyders, went on to establish their own studios. Rubens, whose output included many figure paintings of billboard size, allowed Van Dyck to paint in faces, while Snyders did the still life portions. Because Snyders's brush handling is tighter and more detailed than Rubens's, it's fairly obvious who painted what. Rubens scrupulously indicated to buyers exactly which portions of a painting were painted by his assistants. He did, however, have some problems as a consequence of his massive output. Several customers returned his paintings and asked for new ones, demanding more Rubens in the Rubens.

Sculptors took on apprentices and assistants too. The routine work included hauling the quarried stone, setting it up, and blocking it out in preparation. After the sculptor finished the carving, his apprentices or assistants applied polishing compounds. In some shops, skilled assistants did entire pieces from the master's models. Assistants were also called upon to duplicate previous sculptures, which they did with the help of ingenious contraptions made for the purpose.

Throughout the eighteenth century, artists' shops (now called by the more elegant name, "studios") still commonly took on apprentices and assistants. The system declined in the nineteenth century, when demand for large-scale paintings and painting projects waned. Smaller canvases lessened painters' need for extra help. The development of ready-made paint in portable tubes, and prepared varnishes, also affected the studio system. In addition, the Romantic movement fostered a spirit of individuality that made assistants seem outmoded.

16-6
Theodore Galle, after
Johannes Stradanus,
*A Dutch Studio
in the Sixteenth
Century*. Engraving.
Bibliothèque Nationale,
Paris.

Some painters and sculptors, however, continued to hold classes in their studios. These were primarily opportunities for drawing from a model, and a way to absorb the styles and techniques of the master. Rembrandt had studio space for students on the top floor of his comfortable house, where several roomed as well. He also rented a warehouse for a class in life drawing. Some prominent artists in the nineteenth century still held classes in their studios. At present, the practice is rare. Generally today, if you want to learn art, you study it in school.

# THE ACADEMIES

In the heady world of the Renaissance, education and intellectual accomplishment were social assets. Artists were anxious to separate themselves from the long tradition of art as manual labor. Desiring that painting and sculpture be seen as liberal arts, like logic, rhetoric, and geometry, they stressed the intellectual aspects of their practice: scientific knowledge of perspective, geometry, anatomy, combined with familiarity with history and classical literature, which would become subjects for their art.

None of this would have taxed the guild system of education, where competence meant knowing your business thoroughly. But evolving concepts about the artist and his art meant that, for the advanced painter or sculptor at least, the communal, collaborative workshop of the guild was outmoded. These new ways of thinking revised the traditional view of the artist as a humble craftsperson. Now the artist was thought of as exceptional, and in some ways superior to other people. Imagination, inspiration, even a "divine madness," were attributed to the artist.

Artists aligned with these ideas established institutions called *academies* (after Plato's academy in ancient Greece) where like-minded artists could gather, promote the new artistic ideology, and foster the talented. Originating in Italy in the sixteenth century, artists' academies were formed eventually in major cities throughout Europe. By the nineteenth century, over one hundred academies educated virtually every professional artist in Europe, and a number of Americans as well.

Did the academies stoke the fires of creativity and genius? Were experiment and exploration encouraged within their lofty walls? Unfortunately, the joys of creativity were more talked about than taught. Academic training was rigid and restrictive, directed more toward perfecting drawing techniques than nurturing imagination. Ironically, academic training, which was intended to liberate students from the guild, ended up regimenting them in its own narrow system.

# THE CURRICULUM OF THE ACADEMIES

Renaissance Humanism promoted an art centered on the human form and human experience. What better preparation for this art than the study of the human figure? Students entering the academy began by copying drawings or engravings of figures and faces, line for line. In this way they absorbed the styles of many artists, as well as their analytic skills. The students used sharply pointed sticks of chalk or fine-tipped quill pens for precision and detail.

We all know what an eye looks like. But how does one draw it? If you've ever tried copying a face from a photograph, you know the problem. The photograph doesn't indicate what lines to put down, or where. Shadows, and even light areas, obliterate information. Beyond the outlines, you can be at a loss to know what to do. Copying the drawing of a master gives needed guidance. The drawings analyze the forms and reduce them to clear, simple statements. The process may not be creative, but it is instructive.

Eventually, students moved on to plaster reproductions, as well as small copies in marble and bronze. These copies were mainly of Roman statues, which introduced the students to ideal types whose proportions were "improvements" over mere mortals. To academicians, these statues embodied the noblest ideals of beauty and dignity (Fig. **16-7**).

16-7
Cornelius Cort, after
Johannes Stradanus,
*The Academy*,
1578. Engraving.
Bibliothèque Nationale,
Paris.

Finally, after many months, students were permitted to draw from live models. The models, always men, took heroic poses based on Roman statues. Once the drawing master selected the pose, the model returned to it over a period of weeks or even months. The students were directed to correct any "deficiencies" in the anatomy of the model by improving them in the drawings

according to the Roman ideal. Only by idealizing nature could art fulfill its mission as an instrument to elevate the thoughts of the viewer. Academic theory held that images conceived in the mind, combining beauty with high moral content, alone could truly inspire the viewer and communicate truths.

In the nineteenth century, students were encouraged to blend or smudge pencil or charcoal lines into smooth, subtly toned surfaces with sharp contours, like the highly finished paintings of the time. They were told to begin their drawings with the lightest possible pencil or charcoal, and do the entire figure. Then they developed the drawing in layers, with each successive tone imperceptibly darker than the one preceding it. The darkest tones were reserved for the end. As the drawing progressed, the student gradually introduced surface details where desired. This time-consuming technique guaranteed a virtually photographic effect (Fig. **16-8**).

Learning drawing was, as it had been in the Middle Ages, learning to copy. The students were also encouraged to draw and paint copies of appropriate paintings, which were collected by the academy or an art museum. Within the walls of the academy, the figure classes constituted the core of the training. In addition to teaching these classes, academicians lectured the students on perspective, anatomy, and geometry. Painting and sculpture techniques continued to be learned in artists' workshops and studios.

Academy training focused on technique and surface appearance. The student's job was to copy and to idealize according to classical forms. This training produced an art of exceptional beauty and consummate technical quality. But it didn't encourage individuality, and it steered attention away from images of day-to-day life and social concerns. The academy, which was launched to foster great and daring men, wound up instead training students how to paint them.[4]

During the nineteenth century, artists began to react against the ideas and rigid methods of the academy. Imbued with the ideals of Romanticism, they elevated a concept that academic training had tended to suppress: the individuality of the artist. They believed that art arose from inspiration, or feeling, which they felt the academy squelched. Nature and the real world — real people, places, and events — not the classroom, were the true source of art. They believed that art could be vital only if artists chose what and how to paint. This affirmation of individuality became a principle of modern art schools.

16-8
Alfred Stevens, *Academic Figure Study: Male Nude Holding Staff*, 1844. Charcoal and estompe, 23⅓" × 16". Inscription Pencil: 1.1.: "Atelier Roqueplan"; l.r.: "10 Febrier 1844." Sterling and Francine Clark Art Institute, Williamstown, Massachusetts, Acc. No. 1982.36.

# LANDSCAPE PAINTING IN CHINA

Another great painting tradition developed aims and methods at variance with those of the West. An investigation of this tradition can provide perspective on Western academic practices.

In contrast to Western representational painting, Chinese landscape painting sought to penetrate appearances to evoke the essential character of mountain, tree, water, and sky (Fig. **16-9**). Our discussion in Chapter 10, which contrasted the appearance of Western and Chinese landscapes, referred to the concept of "spirit resonance" in Chinese landscape painting. The principle that a painting must aim to evoke spirit resonance was first stated in the fifth century, when the landscape tradition in China was already centuries old. This principle continued to govern the landscape painting tradition until modern times.

Grasping spirit resonance wasn't easy: Artists had to be receptive. The counsel of an eleventh-century landscape painter, Kuo Hsi, characterizes the traditional attitude: "An artist should identify himself with the landscape and watch it until its significance is revealed to him."[5] Artists prepared themselves by developing an attitude of modesty and humility before nature. Some suggested that meditation would help. Kuo Hsi prepared for painting by washing up, putting his house in order and quieting his mind, as though he were welcoming a guest.

16-9
Ch'iu Ying after design of Li T'ang, *Landscape*, sixteenth century, Ming dynasty. Detail. Ink and color, 120¾" × 10". Courtesy of the Freer Gallery of Art, Smithsonian Institution, Washington, D.C., Acc. No. 39.4.

This is very different advice from that given at the end of the fourteenth century in Italy by Cennino Cennini, who wrote a well-known manual for painters. In it, he advised painters needing landscape backgrounds to go out and find some rocks, bring them inside, and use them as models. Cennini was restating a longstanding practice. If you look at the paintings by Giotto (Fig. 4-13) and Duccio (Fig. 4-18), you can see the results of Cennini's advice.

Given the emphasis in China on openness to nature, it's noteworthy that Chinese artists, like the European academicians, encouraged copying of earlier models. The Europeans spoke of "noble styles," and the Chinese spoke of styles that embodied "spirit resonance." Both of these traditions believed that by copying exemplary styles, artists would fuse the inherent character of those styles with their own work. Furthermore, since all of these painters worked in their studios, imagining the scenes they painted, they relied heavily on paintings they had seen previously for guidance and inspiration.

For the Chinese artist, painting scenes from nature wasn't simply a matter of copying its outward forms. In the words of one Chinese painter, "Painting must be sought for beyond the shapes."[6] Brush and ink led the painter beyond the shapes to the essential character of mountain, water, and tree. The Far Eastern brush is the most delicate of tools, responsive to the subtlest movements of the wrist and hand. Distinct strokes, crisp tugs of energy, make nature come alive. Manipulating the brush takes practice and patience. The brush is held upright, but the hand does not rest on the paper or silk. Once the mark has been made, it can not be changed. As in Chinese writing (*calligraphy*, upon which ink painting technique is based) the aim is to combine control with expressive spontaneity.

Learning to draw meant mastering a variety of strokes. The famous *Mustard Seed Manual of Painting*, published in 1679, describes and illustrates sixteen types of brushstrokes. It encourages students to practice them and then to create their own variations. The brushstrokes have names derived from their appearance: one is like sesame seeds, one like big axe cuts, another like wrinkles on a devil's face, another like ravelled rope. The manual provides practical advice on painting objects from a landscape, such as mountains, rocks, trees, buildings, and people, and it illustrates its suggestions (Fig. **16-10**).

The purpose of this routine training was to ready painters for their moment with nature. They aimed for an unhesitating response; feeling and action had to be simultaneous. Alone in their studio, the bare silk or paper stretching before

16-10
Chinese landscape, *How to Paint a Waterfall*, from *The Mustard Seed Garden Manual of Painting*.

them, the painters would perhaps have been reassured by the words of Confucius: "He who is in harmony with Nature hits the mark without effort and apprehends the truth without thinking."[7]

# NEW FOUNDATIONS: BASIC DESIGN AND COLOR

Artists in Europe in the late nineteenth and early twentieth centuries reacted against academic training, which they felt was stultifying. They demanded that art education nurture creativity, rather than suppress it through indoctrination and routine. These concerns raised certain questions: Can creativity can be taught? If so, how can this be done? Where should art education begin?

Germany's Bauhaus sought answers to these questions. Bauhaus teachers shared a concern for creativity, and rejected the idea that the business of an art school was to teach an inherited style. They asked what makes something art, and whether there are underlying principles of art. If so, what are they, and how can they be discovered? In a collaborative effort based on guild traditions, students and teachers worked together to find the answers.

People at the Bauhaus believed in beginning anew, rather than working in inherited styles. But where to begin? The preliminary course allowed materials themselves to become the starting point. This course was taught for many years by Josef Albers (Fig. 11-35). Albers turned his back on academy practices and told his students to experiment. He gave them paper and encouraged them to explore its potential as a material. Cut and folded, the paper became a means of investigating three-dimensional form. Albers encouraged economy. In the most effective studies, all parts interacted with each other. Quality could be measured, in Albers's words, by "the ratio of effort to effect."

This approach of purposeful play aimed to unlock creativity, whatever the material. Experiment. See what you have. Think of where you can go with it. Students persistently asked: Does the piece give voice to the material? How do the parts relate one to another? How do you get from one point of a design to another? Are all the shapes and spaces, positive and negative, active? Is the design economical and efficient?

This approach can be applied to the art illustrated in this book. The Parthenon (Fig. 7-2), the Etruscan drinking cup (Fig. 8-12), and the paintings by Cézanne (Fig. 11-8) and Vermeer (Fig. 11-31) hold up especially well. You can try it on these or other works of art and craft.

Albers began teaching at the Yale Art School in 1950. Besides basic design, he introduced a ground-breaking course in which students used sheets of silk-screened, commercially produced paper to study the mysteries of color. The students glued torn or cut pieces of paper with rubber cement to investigate the

relativity of color, that is, how a color is affected by the color next to it. Besides investigating specific problems, students made "free studies," pasting papers, and sometimes leaves, in abstract compositions to create color "performances" (Fig. **16-11**).

As basic design focused on the fundamentals of form, the color course focused on the fundamentals of color. Albers rejected the idea that certain colors

**16-11**
Eva Hesse, *Free Study*, from Joseph Albers's color study course at Yale University. By permission, Robert Miller Gallery, New York.

go well together and others do not. He claimed that this was merely taste or preference, and that color was more than that. Students taking the course were able to demonstrate to themselves that any colors can be made to "work" together. The course opened up the world of color to the students, and suggested virtually unlimited possibilities for its use.

Before the Bauhaus, the concept of design (distinct from composition) hardly existed. Today basic design is taught in art schools everywhere. Many schools offer a color course as well. Often these courses are taught in much the same way as the courses conceived by the Bauhaus.

# EXPERIMENTAL APPROACHES

While the Bauhaus approach to basic studio arts courses remains popular, alternative approaches are being explored as well. We find them more in American than European schools. This may reflect America's openness to free-wheeling creativity, coupled with the fact that many college art courses enroll students majoring in other areas. Basic studio courses have in many places shifted away from the carefully calibrated approach to design, with its emphasis on esthetics, to more open-ended approaches that emphasize imagination and a wider range of experience.

Experiment and imagination are called for in Roy Johnston's workshop at Skidmore College, where Johnston presents beginning students with a variety of dissimilar objects and materials, such as grass cuttings, coat hangers, feathers, flour, audio cassettes, and paper. The students are asked to work in an open-ended, collaborative activity, forming new associations with the materials. The students' own physical activity becomes a part of the piece as well. Students develop visual ideas as they go along, and may need to alter their ideas as they interact with others in the group. This project provokes creative thinking by emphasizing improvisation over the usual goal-oriented approach, process over product, and group over individual creative activity.

At Montana State University, Willem Volkersz's students make a life-sized charcoal self-portrait, including background, and then explore what happens when it is subjected to a battery of other media. Each stage of this "accumulative self-portrait" becomes raw material for the next. Along the way, students get involved with duplicating machines, commercial photo booths, drawing, painting, clothes, body casts, slide projections, and performance. In a five-week project, students also create a full-scale "memory room"—a constructed space fitted out with objects that evoke an important childhood memory or dream. In another five-week project, Volkersz asks students to pick a medium of their choice and use it to document themselves daily. For this "daily documentation" project, students have used color photocopies, images taken with a pinhole camera, photo booth images, and photocopies of decorated envelopes mailed daily to friends.

At Northwestern University, the Integrated Arts Program combines theater, visual arts, music, and dance. Each segment includes lectures by a historian and studio work with an artist, so that students absorb both analytical and experiential approaches. The self-portrait is a starting point for Lorraine Peltz's students in the visual arts studio segment. The students' apprehensions are eased with "user friendly" materials, such as scissors, black and white construction paper, and rubber cement. Peltz asks her students to reflect on "who you are," and to create a work that communicates this. Having experienced the theater segment of the course, students often come up with surprising results. Another assignment asks students to choose a site on the campus and create a work of art that reveals it in a new way. One student converted an impersonal elevator into a homey room by installing comfortable old furniture.

At California State University, Beverly Naidus encourages her students to be aware of their social responsibilities. Showing slides of art projects that draw attention to urgent social and political issues, she discusses strategies to get messages across. Her students, often working collaboratively, have developed projects focused on unemployment, women's rights, rape, child abuse, race and ethnic group relations, recycling, and environmental pollution. These projects are brought into the community as site pieces and installations, murals, posters, books, and mailings. Though the pieces themselves may be fragile and non-permanent, the students learn that their art can live by being relevant.

# CONCLUSION

The apprenticeship, workshop, and guild systems based instruction on imitation and repetition. Here, the goal was mastery of skills in the art or craft. In some areas of art and craft, there is no good substitute for hands-on experience under the critical eye of the master. Thus these systems still flourish in many places in the world today.

Individual excellence was extolled in Renaissance Europe and in China. Both cultures were confident that conservative training following earlier masters would promote true individuality. Like the apprenticeship, workshop, and guild systems, both stressed that discipline is necessary for achievement.

To draw or paint today is, as in the Renaissance, a way to discover the visible world. But it is also a means to find out what is inside us. While no one teaching in an art school nowadays is likely to insist that all students work in one style, conflicts over aims and methods of training remain. Is art school a place to explore, or to learn something specific that will help later? To what extent should students be directed? Should the projects be structured? Or should teachers just provide a starting point and be there when students need them? Trial, not tradition, characterizes the direction of art schools at present.

Art students today have several advantages over students in the past. Art materials are abundant and easily obtained. Students don't have to grind their

own pigments. Slides, photographs, and art museums make available as never before the art of other times and places. Artists and art students can mine that art, quote from it, and use it as a point of departure. Advanced technologies, such as film, photography, video, and computers, open the doors to new images and art forms. In the past, students were subjected to the rigors of narrow discipline. The question today is whether students can survive the joys of limitless possibilities.

# 17
# MEANING AND MEANINGS

All of us have stood in a museum or looked at a reproduction and wondered: What does this mean? How can I judge the quality of what I see? How can I be certain that my interpretation or my judgments are right? In this chapter and the next we will investigate some of the ways in which art has been interpreted and evaluated. We will also discuss some of the factors affecting our understanding of works of art. Much of what you or I might admire was disparaged in the past out of prejudice or simple ignorance. Clearly, it is critically important to inspect the ideas that we bring to the art we experience. ¶ Traditionally in Western culture, painting and sculpture illustrated a story. Not surprisingly, interpretations of art tended to identify the significance of a painting or sculpture with its subject matter; at times, in fact, it seems like the art and the subject matter were thought of as the same thing. ¶ Paintings and sculptures were particularly acclaimed when they combined exacting detail with elevated themes. David's *Oath of the Horatii* (Fig. 4-14) was an immensely popular painting. Its success derived as much from the ideas and associations generated by its subject as from its esthetic qualities. Viewers of the painting thought of it as an example for human action. The story of the three Roman brothers who pledged to fight to the death for their country conveyed a social and political message cast in terms of high moral purpose. That message—patriotism, courage, heroism, and duty—carried special weight for the French in those years just before the Revolution. The painting attracted crowds of people wherever it was exhibited, and flowers were placed in tribute before it. ¶ The great success of Hiram Powers's *Greek Slave* (see Fig. 7-14) is attributed to the viewers' sympathetic identification with the subject,

a Christian victim of tyranny sold into slavery (and thus charmingly naked through no fault of her own). Her nudity — a subject of some anxiety in Western art and culture — was defended by a minister who wrote, "Brocade, cloth of gold, could not be a more complete protection than the vesture of holiness in which she stands."[1] A contemporary account in a magazine reported the effect that the virtuous statue had on viewers:

> They look at the beauteous figure and the whole manner undergoes a change. Men take off their hats; ladies seat themselves silently, and almost unconsciously; and usually it is minutes before a word is uttered. All conversation is in a hushed tone, and everybody looks serious on departing.[2]

Powers himself had encouraged this kind of response. In a statement accompanying the statue's tour of the United States in 1847, Powers referred to the statue as though it were an actual person:

> The Slave has been taken from one of the Greek Islands by the Turks, in the time of the Greek Revolution, the history of which is familiar to all. Her father and mother, and perhaps all her kindred, have been destroyed by her foes, and she alone preserved as a treasure too valuable to be thrown away. She is now among barbarian strangers, under the pressure of a full recollection of the calamitous events which have brought her to her present state; and she stands exposed to the people she abhors, and waits her fate with intense anxiety, tempered indeed by the support of her reliance upon the goodness of God. Gather all the afflictions together and add to them the fortitude and resignation of a Christian, and no room will be left for shame. Such are the circumstances under which the "Greek Slave" is supposed to stand.[3]

When Frederic Church exhibited his huge (3½′ × 7½′) painting *Niagara* (Fig. **17-1**) in 1857, people were invited to bring opera glasses and scan it as though it were the real thing. An early viewer said, "It was there before me, the eighth wonder of the world." Another was "fascinated as before the reality itself." In an age when God's presence was associated with glorious works of nature, this painting was experienced in almost religious terms. While the painting has intrinsic artistic merit, it is undoubtedly the falls themselves, and what *they* represent, that accounted for the painting's extraordinary popularity.

Today we are careful to distinguish between a work of art and its subject matter. We are attuned to meanings in the work other than those conveyed directly by the theme or story. It is understood that a work of art has multiple meanings. It can mean one thing to the artist and another to the audience. It can mean something different to each person. We no longer think of there being a "right way" to look at it. Every person brings his or her own thoughts to a work of art, and draws out of it something unique. The possibility that different people will draw different meanings from a single work of art does not suggest the weakness of the piece but its richness and strength.

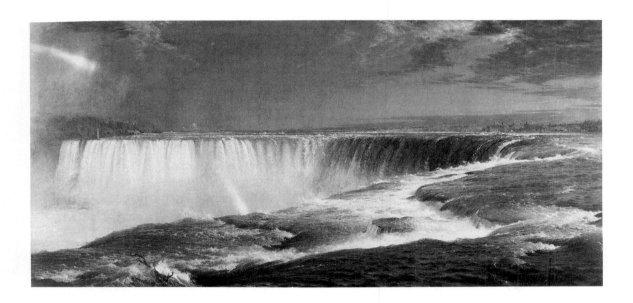

# GUERCINO:
# *ESTHER BEFORE AHASUERUS*

17-1
Frederic Edwin
Church, *Niagara*. 1857.
Oil on canvas, 42″ ×
90″. In the collection of
The Corcoran Gallery
of Art, Washington,
D.C. (Museum
Purchase, Acc.
No. 76.15.)

The various meanings a work of art may contain could be demonstrated by any painting or sculpture. We have already discussed some of the many ideas raised by Picasso's *Sheet of Music and Guitar* (Fig. 11-33) and Christo's *Running Fence* (Fig. 12-14). Now let's consider an older, more traditional work of art, Guercino's *Esther before Ahasuerus* (Fig. 5-1), which is located in my home town. This painting illustrates the Bible story of the Jewish queen who entered the pagan king's chamber unannounced and hence at risk to her life, to plead for her people's safety. In holding out the scepter Ahasuerus indicates his sympathy for her and suggests to the viewer the ultimate success of her mission. What significance might this painting hold? What special meanings might it contain?

- We can admire Guercino's remarkable powers of representation. The excellent drawing; the solid, convincing volumes; and the brush technique that suggests the textures of cloth, fur, skin, jewels, and pearls create the illusion of an event taking place before our eyes.

- We might react to the beauty of the painting and consider such formal aspects as Guercino's arrangement of the figures and their poses, the lush color, or the soft light.

- Guercino's preparatory drawings, which we studied in Chapter 5, reveal his preoccupation with the composition. His adjustments and rearrangements of the figures show his concern with telling the story in the most

effective way. By limiting the figures to four, and bringing the viewer close to them, Guercino gives the scene an intimate, personal quality. Thus he encourages us to react to the human drama in the painting, enjoy the expressiveness of faces and gestures, and speculate on the feelings of the characters.

♦ We can focus on the theme and see the painting as exhorting us to accept challenging situations such as speaking out for what we believe in. Or we might see in it the theme of faith in human love, or as a religious tale with a moral.

♦ The cardinal who commissioned the painting would have seen it as a part of the contemporary program of the Catholic Church, which favored a religious art in which people could identify with the characters. He would certainly have interpreted it as a Christian allegory: an Old Testament queen finds herself singularly able to act as intercessor, or spokeswoman, to save lives, just as the Virgin Mary intercedes in Heaven for those who pray to her for help.

♦ A feminist critic might find the lesson that women have had to play games to get what they want from men. Another might find in the painting the statement that men dominate and women faint.

♦ Marxist critics might see the painting as a celebration of kingship, with its throne, scepter, and luxurious garments. Or they might see it as a celebration of the power of the ruling class, which identified itself with the gracious and benevolent king. Or they might see it as a depiction of class conflict.

♦ A psychologist might react to the dynamics of the relationships between the people, or study the painting for what it reveals about the painter, his personality, and his state of mind.

♦ Art historians might see the painting as an example of a popular Baroque theme, and note the attention to drama, character, and allegory that characterized that period. They might be interested in it as a point in Guercino's stylistic development or as exemplifying the Baroque style. They might find in it influences of other artists or discover in it signs of Guercino's individuality. Their interest might center on Guercino's concern with psychological states. Or they might see it as a response by Guercino to the prevailing taste for noble subject matter.

Guercino's *Esther* passed into the collection of Pope Urban VIII (1568–1644). It would not likely have occurred to the audience of that time to consider the painting from all the points of view you have just read. Contemporaries would surely have noted

1. the beauty of the painting
2. the exactness of the imitation
3. the appropriateness of the depiction

4. the religious or allegorical meanings

5. the style and technique of the artist

and they would have regarded the painting as satisfactorily exemplifying the Church's program of Counter-Reformation. Any other meaning the painting might have held for its viewers is a matter of speculation.

While art critics since the Renaissance insisted on convincing representation, they also looked carefully at the distinctive personal styles and techniques of the artist. They expressed admiration for drawing, brushwork, and handling of color, as well as for imagination and inventiveness. But they did not overlook the content (any more than we do today, when we go to a museum or look at a movie). Any art worth talking about conveyed some content, and that content never ceased to interest artists and critics alike.

# THE CHANGING CONTENT OF ART

The content of art—the ideas and meanings it contains—varies from place to place, and changes over time as well. The West has seen a gradual expansion of art's content, as artists, reacting to new situations and striving to express themselves in new ways, brought new meanings into their work. The following will give you an idea of this process.

The Egyptians conceived of figures that were idealized, abstract, and otherworldly; the Greeks developed an art of idealized images of human beings capable of action in this world; the Romans saw value in an art that could communicate specific ideas in literal terms. Early Christian artists infused symbolic meanings into art and converted the worldly scenes of Rome into the spiritual images of Christianity.

In the Middle Ages art was closely integrated with patterns of life. It was regarded as primarily functional: secular art consisted of the creation and embellishment of useful objects, while religious art served the Church. Although a sense of the supernatural clung to images, writings from the later Middle Ages attest to changing attitudes toward art, out of which evolved more objective, esthetic responses.

During the Renaissance an interest in classical antiquity manifested itself in art. Human figures, outwardly beautiful and powerful, implicitly blended pagan antiquity and Christian themes to create the optimistic scenarios of Renaissance art. At the same time, perhaps also inspired by classical sources, artists adopted a more objective—in a loose sense, scientific—attitude toward the natural world, and attempted to present ever more accurate and convincing images.

These two aims for art—ideal beauty and truth to appearances—were united in the work of artists in the High Renaissance, in the years roughly between 1500 and 1520. Artists like Leonardo, Raphael, and Giorgione selected the most beautiful examples in nature as their models and then improved upon them. They established an ideal for art: the beautiful and imaginative handling of natural forms, faithfully represented while also expressive of an ideal state of being.

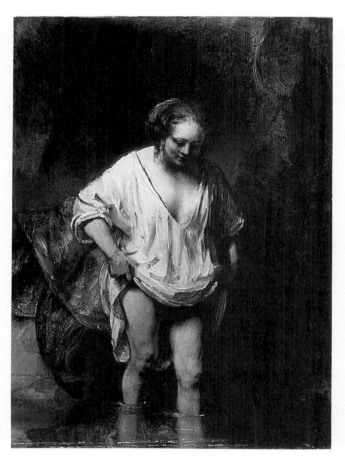

17-2
Rembrandt van Rijn, *Hendrickje Bathing in a Stream*, 1654. Oil, 24⅜″ × 18½″. Reproduced by courtesy of the Trustees, The National Gallery, London.

In the sixteenth century artists infused works of art with individuality, often coupled with a taste for the bizarre. Artists of the seventeenth century expanded the range of subject matter beyond the noble and idealized to include landscape, still life, and prosaic subjects. The depiction of psychological states was of particular interest (Fig. **17-2**). It was in the late Baroque period that the word "pleasure" was first used as a critical term for art. In 1719 the French critic Jean Baptiste Dubos wrote that "the first aim of painting is to move us," and in 1760, a prize was established in the French Academy for the depiction of "expression"—that is, expression of emotions.

Eighteenth-century critics insisted that noble subject matter and elevated feelings alone provided art with its proper content, but in the nineteenth century, Romantic artists and critics exalted *all* human feelings, not just the noble or heroic ones, and broadened the range of subject matter to include what was exotic, mysterious, morbid, and frightening (Fig. **17-3**). Romantic painters found new meaning in nature. Romantic landscapes were given a character that carried them beyond the merely descriptive; at times, as in the work of Caspar David Friedrich (Fig. 17-13) and Frederic Church (Fig. 17-1), landscapes were experienced as manifestations of the grandeur of God.

The idea that art was first and foremost a vehicle for the self-expression of artist, musician, author, or poet occurred during the Romantic period. Around

A good painter has two chief objects to paint — man and the intention of his soul. The former is easy, the latter is hard, for it must be expressed by gestures and the movement of the limbs. . . .
A painting will only be wonderful for the beholder by making that which is not so appear raised and detached from the wall.

— Leonardo da Vinci[4]

1830, Friedrich wrote, "A painter should not merely paint what he sees in front of him, he ought to paint what he sees within himself." The public began to look for individualism, daring, and passion in works of art. By mid-century, the more temperate qualities of "sentiment" and "feeling" would also be admired.

Fine works of art would never become dated if they contained nothing but genuine feeling. The language of the emotions and the impulses of the human heart never change.

—Eugène Delacroix, 1854

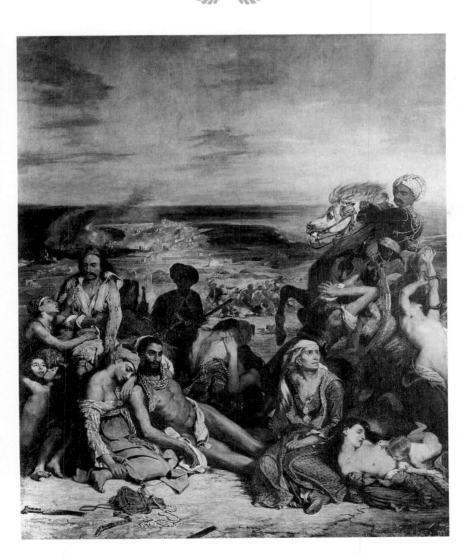

17-3
Eugène Delacroix, *Massacre at Chios*, 1822–1824. Oil on canvas, 13½" × 11¾". Louvre, Paris.

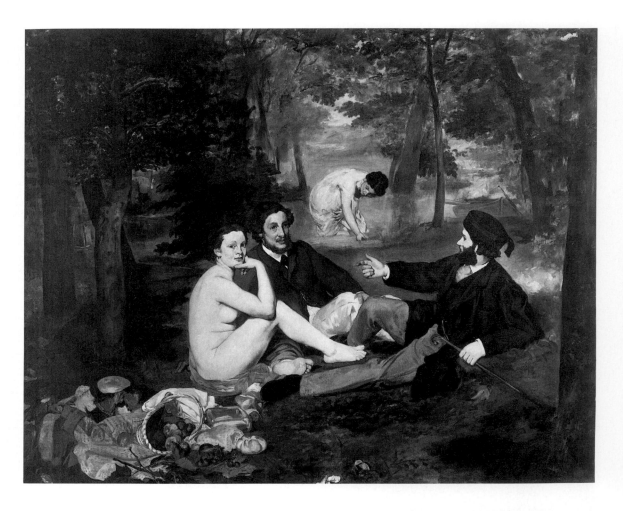

17-4
Édouard Manet,
*Luncheon on the Grass
(Le Déjeuner sur
l'herbe)*, 1863. Oil on
canvas, approx. 7′ ×
8′10″. Musée d'Orsay,
Paris.

At mid-century, Realist painting spurned the exotica of Romanticism and connected art with truth, which it promoted as the core content and sole interest of art. Realist artists such as Courbet (Fig. 13-3) and Millet (Fig. 18-15) expanded the content of art by focusing on the working class and on peasants. In painting these subjects without trivializing them, these artists brought political consciousness to art. The Realist movement also fused shock value with the content of painting. Manet's paintings *Luncheon on the Grass* (Fig. **17-4**) and *Olympia* showed contemporary people with their clothes off, scandalizing a public unaccustomed to the indelicateness of truth.

Manet went on to paint pictures in which the narrative, or story, was of so little importance that people thought he had emptied his paintings of content. But he had found new meaning in experiments with form. His flattened volumes, seemingly casual compositions, and direct brush technique seemed fresh, immediate, and modern. They inspired the Impressionist painters who followed him. To the public, Impressionist paintings felt unfinished. Their surfaces looked like a jumble of paint, and they didn't seem to have any message. But before long people learned to look at those paintings in a new way. They discov-

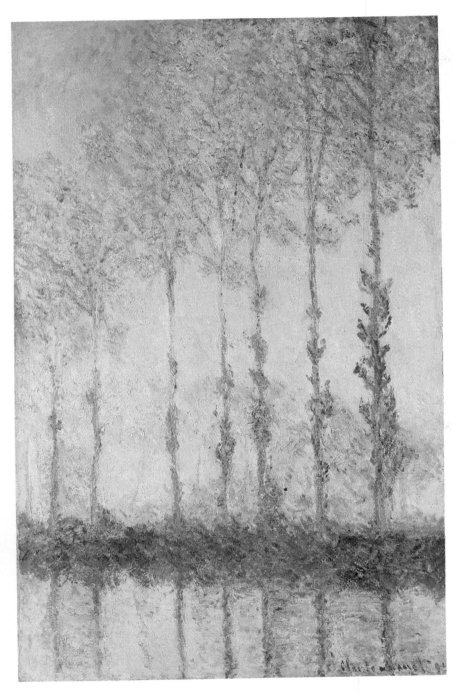

17-5
Claude Monet, *Poplars on the Bank of the Epte River*, 1891. Oil on canvas, 39½" × 25¾". Philadelphia Museum of Art. (Bequest of Anne Thomson as a memorial to her father, Frank Thomson, and her mother, Mary Elizabeth Clarke Thomson.)

ered worlds of light and color and atmosphere that no painting had previously achieved. People realized that dramatic subject matter was not essential to a painting, and they discovered that the action of the paint itself could be beautiful and uniquely expressive (Fig. **17-5**).

In the late nineteenth century, artists found that meaning could be communicated by abstracting natural forms. This idea was investigated further by artists in the twentieth century. Abstract art initiated its audience into the life of form; to the inherent expressiveness of paint, shape, line, and color. As painters explored paint, sculptors likewise explored material and space, and architects became interested in exploring pure architectural form, rather than in reviving older styles.

As music is the poetry of sound,

so is painting the poetry of sight, and the subject-matter has nothing

to do with harmony of sound or of color.

— James Abbott McNeill Whistler, 1890

Like abstract art, Dada and Surrealism were involved with mystery and ambiguity. Dada opposed esthetics and made absurdity a subject (Fig. **17-6**). Later, Surrealism brought dreams and the unconscious into the content of art (Fig. **17-7**).

Abstract Expressionist painting became the first American style to exert influence abroad. Developed in New York City in the 1940s and 1950s, Abstract Expressionism involves us with the creation of the painting — an intuitive, open-ended activity that is finished only when the painting locks together through a

17-6
Man Ray, *Enigma of Isadore Ducasse*, 1920. Construction of sewing machine wrapped in cloth tied with cord. No longer extant. Photograph courtesy of The Museum of Modern Art, New York.

17-7
Salvador Dali, *The Phantom Cart*, 1933. Oil on wood, 6¼″ × 8″. Yale University Art Gallery, New Haven. (Gift of Thomas F. Howard.)

logic of its own. That give and take between painter and painting, as old as art itself, is powerfully expressed in the canvases of Jackson Pollock (Fig. **17-8**). There, accident and spontaneity play key roles. Pollock spread large, bare canvases on the ground. Then he worked around them like a dancer, pouring paint directly onto the surface or trailing ribbons of paint across the composition from

17-8
Jackson Pollock, *Number I, 1948*, 1948. Oil on canvas, 5′8″ × 8′8″. Collection, The Museum of Modern Art, New York. (Purchase.)

17-9
Willem de Kooning,
*Woman I*, 1950–52. Oil
on canvas, approx. 6′4″
× 5′. Collection, The
Museum of Modern
Art, New York.
(Purchase.)

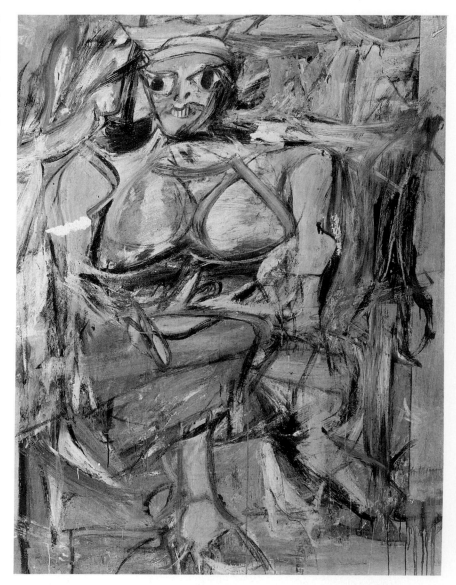

the ends of paint-dipped sticks and worn brushes. Perhaps no other painter had ever been so closely involved with the canvas — Pollock referred to himself as being "in" the canvas when he painted. Nor had painting ever presented as content the process of its own creation.

Abstract Expressionist painters such as Franz Kline and Willem de Kooning (Fig. **17-9**) continued to work with the idea of paint as a vehicle of content. Their rapid-fire, slashing brushstrokes and sudden shifts of direction brought a sense of gut level instinct and raw energy to their art.

Minimalist painters in the 1960s and 1970s took overt emotion and its vehicle, the spontaneous gesture, out of painting, and seemed to empty painting of the

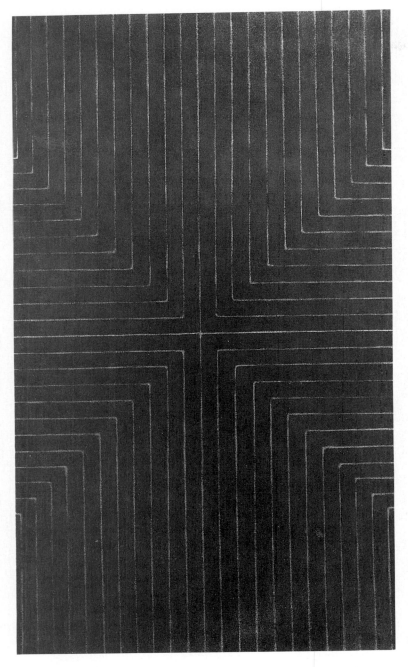

17-10
Frank Stella, *Die Fahne Hoch*, 1959. Black enamel on canvas, approx. 10' × 6'. Collection of the Whitney Museum of American Art. (Gift of Mr. and Mrs. Eugene Schwartz and purchased through the generosity of Peter M. Brandt, The Lauder Foundation, The Sydney and Frances Lewis Foundation, Philip Morris Incorporated, Mr. and Mrs. Albrecht Saalfield, Mrs. Percy Uris, and the National Endowment for the Arts, Acq. No. 75.22.)

presence of the artist. Even content, ever open to question in abstract art, seemed dismissed, as artists insisted on the absence of allusions to either subject matter or values outside the painting itself. However, by this rejection of ulterior meanings, these artists believed that they were better able to focus on the idea of the painting as its own content (Fig. **17-10**).

17-11
Andy Warhol, *100 Cans*, 1962. Oil on canvas, 72" × 52". Albright-Knox Art Gallery, Buffalo, New York. (Gift of Seymour H. Knox, 1963.)

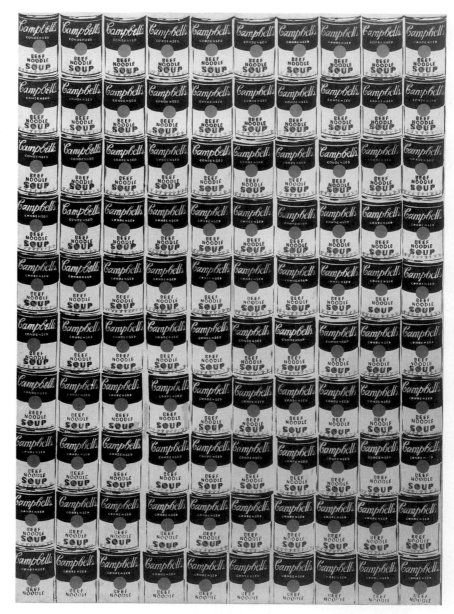

Concurrent with Minimalism in the 1960s, Pop Art broke onto the scene. Like Dada before it, Pop Art found content in everyday objects of the real world. Pop Art parodied life, and even parodied art itself with its images based on advertising art, comics, and even fine art. Like the Dadaists, Pop artists such as Tom Wesselmann (Fig. 13-8), Andy Warhol (Fig. **17-11**), and Claes Oldenburg (Fig. **17-12**) brought a new kind of wit and humor to art: not by depicting wit and humor, but by making witty and humorous objects. Oldenburg's giant sculptures, some of them realized as public monuments, celebrate the droll objects

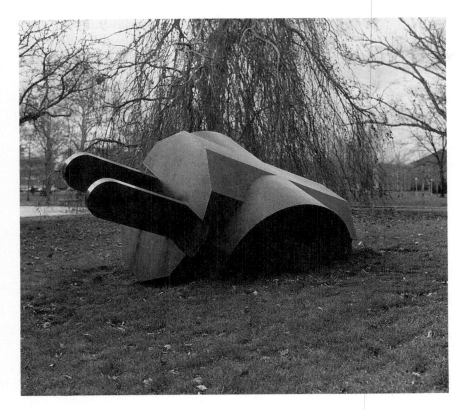

17-12
Claes Oldenburg, *Giant Three-Way Plug*, 1970. Cor-Ten steel and polished bronze, 60⅞″ × 120⅝″ × 78″. Allen Memorial Art Museum, Oberlin College. (Gift of artist and Fund for Contemporary Art, 70.38.)

that mark the days of our lives: lipstick, Good Humor ice cream bars, electric light plugs, ice bags. His sculptures function as visual puns. In his public appearances Oldenburg invites the audience to contribute their own ideas about what his sculptures mean.

Although the public could easily perceive the humor in Pop Art, there was a dark, satirical side as well. Perhaps it was this combination of humor and irony that gave Pop its power.

The legitimacy of personal investigation is fundamental to postmodern art. At the same time, some postmodern artists have used their work to impart impersonal, "nonartistic" information. The content of art is as important as it always has been, but it now falls to individual artists to decide for themselves what their art will say. Ideas about what art can mean, and how it can communicate meaning, are among the issues engaging artists today. Currently, postmodern "image appropriation" comments on the layers of meaning contained within images, and speculates on the nature and multiple purposes of art itself.

Over the years, ideas about what art can encompass have changed considerably, just as ideas about what is meaningful or significant have changed in the culture as a whole. The exchange is reciprocal: art reflects, but also influences these changes. While changes in the content of art are inevitable, it is well to remember that they are made by individuals, each of whom struggled to extract meaning from experience and incorporate it into tangible form.

# BLIND SPOTS

We have all heard people say things like, "Art is a matter of taste," and "I know what I like." Beneath these statements is the simple truth that people tend to enjoy what is familiar to them and to shun what is unfamiliar. Those who say, "I don't like that," may very likely be saying, "I don't understand that."

How far can we go to untie ourselves from what we know about and are sure of? Art history is filled with examples of the rejection of artists, of styles, and of the treasures of entire cultures, either through misunderstanding of their aims and standards or because they conflicted with prevailing taste. As you read these examples, ask yourself: what were the blind spots that prevented understanding?

- The Aztec and Inca empires produced spectacular objects in gold and silver. Looted by the Spanish in the sixteenth century, these objects were valued not for the art, but for their metal. Consequently, practically all of them were melted down for bullion. It is reported that in 1533 Pizarro's soldiers melted down eleven tons of Inca gold objects. Those few objects spared and sent to Spain were reduced to bullion in the Royal Mint by order of the king.

- Michelangelo reportedly said in conversation that Flemish painting (see Fig. 17-14) "will appeal to women, especially to the very old and the very young, and also to monks and nuns and to certain noblemen who have no sense of true harmony," and added that it was "without substance or vigor."

- In 1566 El Greco offered to cover Michelangelo's *Last Judgement* with a mural of his own that he claimed would be more modest and just as well painted.

- In 1644 John Evelyn, an educated Englishman on tour in Europe, described Gothic churches (see Figs. 7-1, 7-3, and 9-9) as "congestions of heavy, dark, melancholy, and monkish Piles, without any just proportion, Use or Beauty."

- In 1724 the Spanish painter Antonio Palomino called El Greco's late work "contemptible and ridiculous" (see, for example, Fig. 11-4).

- Early in the seventeenth century, Caravaggio (see Fig. 6-10) was said by the Italian art critic Giovanni Battista Agucchi to have "deserted Beauty."

- In 1809 German art theoretician and critic F.W.B. von Ramdohr wrote that he saw in Caspar David Friedrich's altar painting, *Crucifixion in the Mountains* (Fig. **17-13**), a tendency "dangerous to good taste . . . and the dreadful omen of a rapidly onrushing barbarism."

- Vincent van Gogh (see Fig. 4-5), who is among the most popular artists in the world today, sold only one painting in his entire life. After his death in 1890 his brother Theo was unable to arrange for an exhibition of his paintings.

17-13
Caspar David Friedrich, *The Crucifixion in the Mountains*, 1808. Oil on canvas, 46″ × 44″. Staatliche Kunstsammlungen, Dresden.

We learned the artist was a woman, in time to check our enthusiasm. Had it been otherwise, we might have hailed these sculptural expressions as by a great figure among the moderns.

— From a published review of Louise Nevelson's first major gallery exhibition, New York, 1946.[5]

In addition to limited understanding, religious and political zealousness have played a major role in the condemnation and destruction of art. Chapter 3 mentioned the pillaging of art by reformers of various persuasions anxious to purify a religion or a society. But the ideological hatred of art is not a thing of the distant past. In the twentieth century, modern art has been regarded as subversive in the United States, suppressed in the Soviet Union and in China, and destroyed in Nazi Germany. United in their condemnation of modern art, Nazis,

Communists, and certain conservative Americans created a curious situation: the Nazis condemned it as "degenerate," "Bolshevik," and "Jewish"; the Communists labelled it "decadent" and "bourgeois" (that is, Western); and the Americans saw it as "communistic."

All of these examples should prompt us to ask what blind spots we might have as a society. What might we — all of us — be neglecting, dismissing, condemning, or destroying because we are unprepared to find meaning in it?

# ART HISTORICAL RESEARCH

The art of the past is constantly reappraised in light of what contemporary artists teach the public to see. Once having slipped into the past, however, the content of art can never be the same. We can't possibly experience the bulls of Lascaux (see Fig. 3-3); the statue of Mycerinus (see Fig. 10-3); or the legs, garters, and pink-ribboned shoes of Louis XIV (see Fig. 4-16) as they were experienced by their intended audiences. We wonder: What meanings might have gotten lost? Can the original meanings be retrieved?

Art historians attempt to provide answers to these questions. They uncover and interpret information that adds to our understanding of what we see. As an example, let's return to Velázquez's *Las Meninas* (Fig. 1-1). Studies of this painting have investigated the reasons for the paintings that are shown hanging on the back wall. These paintings are illustrations of Greek myths that include themes pertaining to the arts. On the basis of Velázquez's selection of these paintings, scholars have concluded that the painter intended *Las Meninas* to celebrate the dignity of the art of painting, and by inference, to elevate his own social status — not a small matter for a painter in seventeenth-century Spain. In support of this idea, one scholar pointed to the fact that Velázquez placed himself on the same floor as the royal family instead of elevating them on a platform.

Another good example of art historical work is Erwin Panofsky's investigation of Jan van Eyck's unusual double portrait of the Arnolfini couple (Fig. **17-14**).[6] This painting, discovered in Brussels in 1815 by an English officer, was believed to be one described in earlier accounts, in which the couple was identified as Giovanni Arnolfini and Jeanne de Cename — but those early descriptions did not match the present painting. Was it the same painting? And if not, who is the couple? Panofsky's detective work reveals the earlier descriptions were written by individuals who had not actually seen the painting, but who were simply repeating what they had read about it. Panofsky traces these accounts to an original unknown source who did see the painting. He conjectures that the confusion occurred when a Latin legal term used by that source to describe the couple joined "by faith" in marriage was misunderstood to indicate the presence of a third figure — "Faith" — who conducted the ceremony.

Why might that term, "by faith," have been used in the original description? Panofsky points out that the Catholic Church at that time recognized the legitimacy of a marriage of "mutual consent expressed by words and actions." The

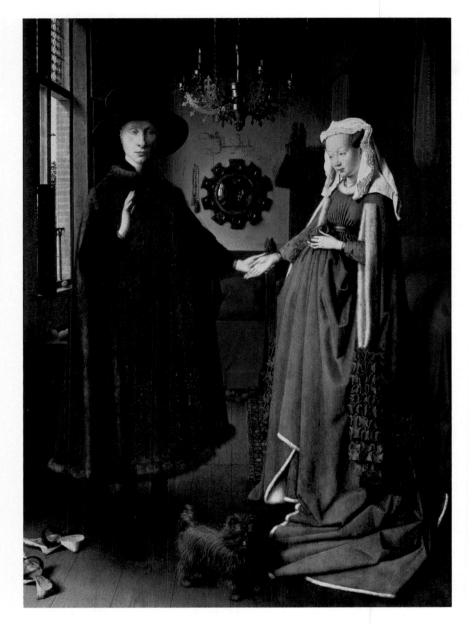

marriage was formalized by (1) the pronouncement of a formula by the bride
and repeated by the groom, which the groom confirmed by raising his arm; (2) a
pledge generally represented by a ring; and (3) the joining of hands. As you can
see, all of these are depicted in the painting.

Above the mirror on the back wall we find the curious inscription, in Latin,
"Johannes de Eyck fuit hic (Jan van Eyck has been here) 1434." The meaning of
both the inscription and the painting now becomes clear. Van Eyck not only
signs the painting as the artist, but identifies himself as a legal witness to the

ceremony. The painting can be understood, in Panofsky's words, as a "pictorial marriage certificate."

Panofsky suggests that this "certificate" further confirms the identity of the figures. Since neither of them had relatives in Bruges, where they lived, the usefulness of a portrait that is also a document is understandable.

Panofsky then inquires about the remarkable realism of the painting; its meticulous revelation of an interior, the objects within it, and the minute descriptions in paint of a variety of materials and their precise textures. Do these objects just happen to have been there, as Van Eyck seems to imply? Is the realism, then, an example of a modern attitude, where a painting is made for the pleasure it gives us? Or may we find here the medieval interest in allegorical or symbolic meaning in objects we see? How would the scene have been understood in its time?

Panofsky reminds us that the scene takes place in a bedroom and not in a living room, and thus relates to the sacrament of marriage. Symbols are indeed abundant. The single candle burning in the chandelier, having no practical usefulness since daylight fills the room, represents both the wisdom of God and, more specifically, the marriage ceremony. On the back of the armchair is a carving of St. Margaret, patron saint of childbirth. The couple has removed their shoes, an allusion to the biblical verse in which God admonishes Moses to remove his shoes, "for the place whereon thou standest is holy." The dog, like the candle, is a symbol of faith.

But these objects and their meanings are not thrust upon us in a way that would make them obvious or intrusive. Rather, there is a *disguised* symbolism here. Everything seems natural, seems to belong. Still, it is not a casual event we observe. Van Eyck's symmetrical composition brings a sense of solemnity and hints that deeper meanings reside in the scene.

The fitting together of the symbolic and the realistic gives the painting its special charm. In Panofsky's words, "medieval symbolism and modern realism are so perfectly reconciled that the former has become inherent in the later."

This account of Panofsky's investigation shows how art historical research can illuminate a work of art. Panofsky takes a lovely but puzzling painting and gives it a context and a history; tells us who is in it; explains why it was painted, how symbols were incorporated, and their meaning; analyzes the effect of the composition; and reveals a number of the aims of the painter. This information helps us to see beyond the surface of the painting and to appreciate all that we are seeing.

# NEW CRITIQUES OF ART

Currently, a great deal of interesting work is being done by art historians and critics who are inquiring into works of art from the standpoints of gender, race, and social class. These critics are asking such questions as: How have women been portrayed in art? What roles have been defined for them? How have women represented themselves in paintings?

How have paintings and sculptures treated people of color, or native Americans? What stereotypes do we find? What are the ideological bases of those stereotypes? How are class distinctions represented in works of art? These new critiques are less concerned with form, style, or creativity than with examining the interpenetrations between art and the rest of the culture.

Many feminist historians have questioned traditional approaches to art history. They point out that until very recently, few if any women were included in major textbooks of Western art history. Their research has shown the difficulties women faced as artists. Women were denied access to the art schools of Europe; their work was often denigrated because they were women; and when the work was of outstanding quality, it was frequently misidentified as the work of a man. Many who persevered as artists were characterized as deviants.

Feminist historians and critics have not only revived interest in long-neglected female artists, but have demonstrated that the biases of male art historians often caused that neglect. Much of the work with which women have been associated — needlework, or design, for example — was disparaged because of its association with women, or because women weren't able to promote or market their products as men could promote or market theirs. Male art historians identified "feminine" qualities in women's paintings, such as "delicateness," or "fondness for detail," which in their eyes automatically depreciated the work. Often the same qualities, when appearing in the work of men, were praised.

Many feminist critics propose a restructuring of the principles of art history to account more fairly for female artists and their contributions. By asking a different set of questions about the art, they assert, we can better recognize and hence appreciate the art that women produced. Such questions would include: What responses have women made to the constraining circumstances of their time and place? In what ways have women artists articulated their experiences differently from men? How have social constructs of femininity made it difficult for critics to understand women's work? How has the heroicizing of the artist in popular and critical imagination disadvantaged women? How have traditional criteria for works of art hurt female artists? For example, consider the effect on women of the elevation of fine art over craft, or innovation over skill.

The most signal omission of feminist art history to date is our failure to analyze *why* modern art history ignores the existence of women artists, why it has become silent about them, why it has consistently dismissed as insignificant those it did acknowledge. To confront these questions enables us to identify the unacknowledged ideology which informs the practice of this discipline and the values which decide its classification and interpretations of all art.

— Rozsika Parker and Griselda Pollock, *Old Mistresses: Women Art and Ideology,* 1981

Contemporary critics point out that women and minority artists today continue to suffer from inherited standards of evaluation. They contend that criteria emphasizing esthetic or formalist concerns, as well as politically neutral content, effectively marginalize much of these artists' work. Must good art be esthetic or tasteful above all? Must the message always be "universal"? Can't art speak for difference—for specific personal and social experiences, or political points of view? Isn't immediacy or intensity of the message an important component? These issues have become hot, and somewhat divisive, topics in the art world today. In light of these new avenues of inquiry, the components of "quality" or "artistic excellence" will likely be debated for a long time.

Time and again I have been asked, after lecturing about this material, "But you can't really think this is Quality?" Such sheeplike fidelity to a single criterion for good art—and such ignorant resistance to the fact that criteria can differ hugely among classes, cultures, even genders—remains firmly embedded in educational and artistic circles, producing audiences who are afraid to think for themselves.

—Lucy Lippard, *Mixed Blessings: New Art in a Multicultural America*, 1990

The new critiques have brought about a significant shift in the practice of art history and criticism today. They have changed the way we see and interpret works of art. Recent exhibitions by major museums have made it possible to examine traditional works of art in light of these new perspectives. Other exhibitions have featured the art of women and minority groups that is out of the mainstream. Whether these exhibitions reflect the mood of the moment remains to be seen. Women and minorities are still under-represented in museums and galleries. But in response to the challenges of new critics, discourse will likely continue within the field of criticism, which like art itself is never static.

# OTHER STUDIES

Other areas besides art historical studies have helped us to understand works of art. Science and technology, for example, have broadened our understanding of art and its meanings.

Microscopes, X-rays, and infrared light are tools essential to the restoration of art. Knowledge of chemistry has helped not only to restore pieces that are damaged, darkened, or decayed, but to ensure their preservation. Along with the preservation of art, science and technology have contributed information about

the art itself. When conservators remove damaged frescoes from the wall on which they were painted and transfer them onto a stiff backing, they may discover the artist's underdrawing. Comparing that drawing to the final painting can sometimes reveal surprising changes made by the artist as the painting took shape.

Restoration of paintings sometimes reveals figures long lost to layers of dirt and darkening varnish. Recent cleanings have shown that many painters long thought to have used a narrow range of dark colors in fact used a broad range of bright colors. The recent cleaning of Michelangelo's painting on the Sistine Chapel ceiling revealed an unexpected range of luminous colors. The cleaning of Rembrandt's painting popularly called the *Night Watch* (Fig. 2-1) revealed that this painting in fact depicts a daytime scene.

Chemical analyses of paint and canvas can tell us precisely what materials were used. This helps to determine who did the painting, where it was painted, and when. We can even learn *how* it was painted, as X-rays and infrared light reveal where the artist changed his or her mind along the way and added or subtracted something. One X-ray revealed the whereabouts of a missing Picasso by showing that Picasso had painted over it. An infrared photograph of Van Eyck's *Portrait of Giovanni Arnolfini and His Bride* (Fig. 17-14) revealed in the underdrawing a slightly less elegant positioning of Arnolfini's raised hand (see Fig. 5-8).

Autoradiography — exposing a painting to atomic radiation so that it becomes slightly radioactive — can identify pigments. It can also show what X-rays miss, and likewise reveal the stages of a painting's development. Studies using radioactive isotopes are also used to obtain information about pigments and can indicate when later applications of paint were made to a canvas. In the case of antique sculptures, they can tell what part of the world the metal came from.

Studies in the psychology of perception have also contributed to our understanding of art and have shed light on the development of artistic styles. Perceptual psychologists have attempted to explain reactions to lines, shapes, composition, and color. Psychological studies have attempted to answer questions such as: What are the limits of artistic freedom? How does art communicate feeling? What psychological factors affect our response to works of art?

The psychological approach has not only brought insight into art, but it has also encouraged the study of the history of esthetics, of taste, and of criticism. Psychoanalysis has also made contributions to our understanding of art. A number of psychoanalytical studies of artists have been made based on their work, including a famous study of Leonardo da Vinci by Sigmund Freud.

Historical scholarship and documentation have contributed to our understanding of the contexts in which art occurs. Translations and publications of documentary materials — books, newspaper accounts, speeches, letters, diaries, even contracts between artist and patron — have proliferated in recent years. The interpretation of historical data by art historians is gradually revealing more and more about art and artists of the past. Consider the following example:

In the early 1980s, the Australian architect and art historian John James pinpointed on a map over one thousand Gothic churches built between 1140 and

1240 in the Paris Basin, an area containing many towns and cities. James's map revealed something curious. He discovered an unsuspected density of building in the region of Soissons, northeast of Paris — a density exceeding that of Paris and its region. What could account for all that building in Soissons? After examining a number of possible explanations, James investigated the economy of Soissons in the twelfth and thirteenth centuries. He found that, unlike today, Soissons contained many vineyards, which were very successful commercial enterprises. Further research revealed that the summers between c. 1200 and 1250 were extremely hot and dry — excellent weather for grapes. Records testified to enormous wine production in Soissons between 1180 and 1250, and James realized that this thriving economic base, and the cash surpluses it generated, had contributed to the boom in building.

Anthropology is yet another field that has given us insights into art, by providing keys to understanding the arts and crafts of cultures different from our own. Most of the world's art is non-European. Much of that art — the art of Africa, Oceania, and the pre-Columbian Western hemisphere — has been labelled in the West by the disparaging term "primitive." Anthropological investigations of works of "primitive" art have shown them to be sophisticated responses to cultural requirements. In form and detail, the art communicates precise and often complex messages within the community. Moreover, the art has been shown to conform to esthetic systems different from, but no less exacting than, Western systems. In sum, anthropology helps us to see the art through the eyes of the culture, to recognize its meanings, and to appreciate its quality. Studies of non-Western art allow us to step outside our own culture for a while, imagine what it would be like to live a very different life, and bring back lessons we can apply to our own lives.

Not only have all of these investigations given us a stronger grasp of art, but they have also helped us to strip away our naive prejudices and misunderstandings. Enlightened people today are changing the old snobbish attitudes toward foreign cultures by recognizing that each culture in its own way makes sense. By overcoming prejudice we can feel our way toward others and appreciate, enjoy, and learn from their art.

# CONCLUSION

The meaning of a work of art is always open to interpretation. There is no key to the absolute meaning because, to the best of our understanding, there can be no absolute meaning. But we can do a number of things to help ourselves understand the multiple meanings that a work of art can hold. One of them is to be willing to reflect upon the piece afterwards. By turning it around in our minds, by letting it work on our imaginations, we give it a chance to take hold. For art of the past, or of other cultures, an awareness of the context can help unlock meanings. We can learn what the artist intended for the piece, and what it meant to its original audience.

Don't overlook the value of reading about art, even the art of our own time. In a culture as diverse as ours, books help make connections we can't possibly make on our own. We should neither expect nor want books to "explain the meaning" of works of art, but they can provide background information and point to some possible meanings.

Our grasp of a work of art seems to strengthen as the object begins to recede in time. Distance and objectivity help us to discern the framework of ideas in which the art is located. For contemporary art the going is a little rougher. Here we must rely more on speculation and intuition. What makes contemporary art worth knowing about is that it is the expression of our time — the artists are alive and working in our world. More than any other art we see, contemporary art talks about us, and we can interpret it in terms of our own experiences.

A work of art that is too easily understood may hold little for us. Often the works of art that mean the most to us are those that we find challenging. We may not understand them at first and we may never understand them completely. But with study and reflection, we may find ourselves moving toward insight and comprehension.

It may be that every work of art contains at its core a mystery that defies explanation. If so, it is well to remember that however private or obscure, every work of art has in it something universal, and, in some way, touches us all.

# 18
# EVALUATING ART

 elefomin people, Papua New Guinea: About once in a generation the doorboard that marks the entrance to a house needs to be replaced. The Telefomin have only two basic designs, and only one of these is appropriate for the decoration of a doorboard (Fig. **18-1**). The owner of the house will carve and paint the design. His problem is to rearrange the traditional design so that his own doorboard will be distinct. There are rules as to what symbolic elements must be included. Working out a unique and attractive design within these restrictions isn't easy, but getting a good result is a matter of pride and self respect. It may take him weeks of planning and consideration. If he gets stuck he will wait for a dream to show him the way. ¶ *Meko, Nigeria:* Duga, the master carver of the Yoruba town of Meko, was described at work in 1950 by the anthropologist William Bascom: "Duga had an

artist's dedication to his work. One could tell when he was concentrating intently on it by watching his bare feet, which became tense with his toes spread tautly apart. So that I could photograph him at work, Duga moved out into the sunlight from the shaded veranda where he normally carved, but he was oblivious to the noonday African sun. He sometimes became so absorbed in what he was doing that he remained there, intent on his carving, after I had said good-bye and driven away.' (Fig. **18-2**)[1] ¶ *New York, N.Y.:* In a 1971 interview, the American painter Helen Frankenthaler described her own creative process: "I've used many different methods: pour, sponge, use the brush. I generally work with the canvas on the floor, and from pails of paint. . . . I usually don't like to work over pictures, because very often, not always, what I want to accomplish in the picture can't be experienced by

worrying the canvas, reworking, salvaging. I try never to let the event and the result become a beautiful trap. . . . One prepares, bringing all one's weight and gracefulness and knowledge to bear: spiritually, emotionally, intellectually, physically. And often there's a moment when all frequencies are right and it hits."[2]

All artists have some idea of what to aim for in a work of art — but what about the audience? What do you look for in a work of art? How do you evaluate what you see? When you are at a museum, are you tempted to read the title before you say anything about the painting? Do you wait until the tour guide says something about it? Do you always agree with what you hear?

All of us wonder about the judgments we make. We're not always sure we've got it right — or sure that the other person has it right either. What determines whether the work is good? Is it only a matter of taste? Is it a matter of tradition? Or can artistic value be judged objectively? And if so, what criteria can guide us in making those judgments?

18-1
Doorboard on house, Telefomin, Papua New Guinea, 1978.

18-2
Shango staff by Duga of Meko, Nigeria. Yoruba, Ketu substyle. Lowie Museum of Anthropology. Courtesy of Mrs. Berta Bascom Kensington.

Many people believe that artistic judgments are wholly subjective — a matter of personal preference. We tend to allow our own taste to serve as the final arbiter of what is good in art. After all, what more needs to be said for a painting than that you like it? That it means something to *you*? What could be more compelling, more solid, than that? Surely no appeal to objective standards carries the same weight as our own gut feelings.

Of course nearly everybody thinks he or she has good taste. But if subjective judgments are challenged, they fail to provide convincing arguments for quality. What would you say to someone who loves a painting you think is about the worst thing you've seen? How can you convince someone to like what you like? Whose standards are better or higher, and how would you determine this? Whose taste would you trust? Do you trust your own taste? How would you defend it?

# OBJECTIVE STANDARDS

Sooner or later, any reasonable discussion of artistic quality must appeal to objective standards. Personal preference by itself does not provide a basis by which to judge art. Simply to say that you like something doesn't mean that it is necessarily good, nor does it explain *why* it is good.

The argument for objective standards is a compelling one. It makes sense that a work of art is good because of some quality it has — and not because you like it. And that quality is there forever. After all, can a work of art be good today and bad tomorrow?

Universal standards would provide a solid foundation for evaluating artistic quality. The most common criteria — beauty, realism, an idea or message, originality, and skill — seem good guides to the discernment of artistic merit. They do have their problems, however. But for now, let's see what they provide.

1. Beauty is commonly thought of as a measure for art. Most people will agree that a sunset is lovely and not ugly, that the prince is handsomer than the toad, and that the Parthenon is more beautiful than a newspaper stand. So we find it sensible to conclude that beauty is self-evident and exists beyond the caprice of individual preference, fad, or local tradition.

2. The capacity of art to mimic reality is universally recognized. Vivid, lifelike images inevitably command attention and admiration. Anybody can make simple designs or sketches, but it is not easy to represent solid figures in deep, believable space, or to compel a figure with thoughts and feelings to emerge from stone or clay. So the power of the illusion, and our awareness of how difficult it is to achieve, argue for imitation as a criterion of art.

3. Works of art have frequently been evaluated in accordance with their messages. Does the piece communicate an idea or message? Is the message important? Does it have a moral? Is it educational? If so, the piece is valued highly.

4. Another criterion for art is originality. Anybody can copy someone else's ideas. Indeed, most artists conform to popular or inherited forms or styles. Those artists who broke through conventions, who developed new insights, are relatively few. So it seems appropriate to place originality on our list of criteria for art.

5. The most widespread criterion for artistic merit may be skill. Around the world, the well-executed piece stands out and is acclaimed. The ancient Greeks admired technical skill; people in the Middle Ages praised it, and the academies of Europe enshrined it. Today it is still drummed into the heads of art students. It is hard to imagine art of quality that is carelessly done.

But a closer look reveals that beauty, realism, significance, originality, and skill are undependable measures of artistic merit. Let's examine them again, one by one.

1. *Beauty*. The central problem with beauty is that no one can agree on what it is. The study of art history, or just a visit to a museum, makes us aware of considerable differences in concepts of beauty. None of these concepts has ever been indispensible. None has ever been applied universally. The existence of various and conflicting ideas of beauty suggests that beauty is not as self-evident as we might have supposed, and casts doubt on the reliability of any of the criteria by which it may be determined. Which idea of beauty is truest? Whose criterion is the right one?

Beauty is something that one adds to buildings for ornament and richness, as occurs in gilded roofs, in precious marble incrustations, in colored paintings.

— Isidorus of Seville (c. A.D. 570–636)

[Beauty is] a certain regular harmony of all the parts of a thing of such a kind that nothing could be added or taken away or altered without making it less pleasing.

— Leon Battista Alberti (from *De Re Aedificatoria* [On Architecture], 1450)

There is no Excellent Beauty, that hath not some strangeness in the proportion.

— Francis Bacon (from *Of Beauty*, 1612)

It is solely the power of *character* that makes for beauty in art.

— Auguste Rodin, 1911

2. *Imitation*. As we saw in Chapter 4, *no* painting simply imitates its subject. Illusions of reality are created by various means, and widely disparate versions of the same subject may *all* strike us as being "truthful" or "realistic."

   In Chapter 11, we saw that artists have never been content with imitation alone, but sought to inject something of the imagination into whatever they depicted. At times — as in the Middle Ages, in the work of abstract artists, non-Western artists, and individualists such as El Greco — imitation was regarded as an impediment to the effective expression of ideas.

   Imitation is also open to cultural interpretation. For example, realism in the West implies representation of volume and space. But in Far Eastern art, realism means evocation of personality and essence. In China and Japan, figure and space may therefore be depicted as flat, yet still be thought of as realistic.

   To Western eyes, a landscape may be generalized and still appear realistic. In traditional Japanese painting, a landscape must be very specific as to the season of the year, including the appearance of the trees at that time and the appropriate flowers. You will recall that in the Chinese tradition "spirit resonance" is essential or the landscape will fail, no matter how closely it imitates nature. These examples suggest that what seems realistic is less a matter of seeing than of cultural convention.

3. *A message*. Modern art and modern esthetic sensibility have called into question this venerable criterion. Modern artists have struggled against the idea that a painting is a visual adaptation of a literal statement. Visual ideas can be evocative, multi-layered, and open-ended.

4. *Originality*. Works of art are almost never created in isolation, but are to some extent the result of influences exerted upon the creator by other artists. Works of art may be seen as a result of the mingling of ideas, and even of groups of artists working toward an idea. Impressionism was produced by a group of artists in close contact with each other. Braque and Picasso together produced Cubism. The Dadaists spurred each other on. These communal efforts produced highly original work.

   On the other hand, in some cultures tradition exerts so great an influence that originality is severely limited. Egyptian statues, Shaker chairs, and certain African masks, however beautiful, were made according to well-established rules. Originality, then, is a relative and imprecise term.

5. *Skill*. Sometimes skill gets in the way of quality. Certain paintings and sculptures strike us as being overly refined and lifeless. At times a rougher or looser handling of the materials can be more effective (consider the paintings of Tintoretto, Manet, Van Gogh, or Picasso, certain African sculptures, or the sculpture of Rodin.) Critics have deplored their techniques, which ought to suggest to us that skill is not always self-evident and therefore is not a reliable criterion of quality.

Moreover, while skill of execution can elevate an object into the category of art, it does not by itself guarantee great art. Objects of no great artistic value may be skillfully made.

Because each of these criteria is dispensable, their reliability as a basis for judgment is cast into doubt. As we have seen, art doesn't always aim at a traditional concept of beauty. Some art aims at truth. Are truth and beauty always the same? Some art aims at expressiveness, like Käthe Kollwitz's drawing, *Unemployment* (Fig. **18-3**). Is expressiveness always beautiful? Art may be picturesque, or charming, rather than beautiful; it may be humorous, like comic strips or animated cartoons. In art that aims to explore ideas, or to convey messages, in art that aims at supernatural efficacy or touches the faith of the viewer, beauty may be irrelevant.

The other criteria are similarly dispensable. Most of the world's art, while attuned to things seen, has not required exact representation. Many beautiful works of art and craft are not representational at all, and may not transmit precise messages. Does a vase, an abstract sculpture, or a building, have a moral?

18-3
Käthe Kollwitz,
*Unemployment*, 1909.
Drawing. National
Gallery of Art,
Washington, D.C.

Should buildings or films be automatically considered inferior to paintings because they were made by a group of people rather than by one? Are only "polished" paintings and sculptures worthwhile?

Another thought: If we don't need all of these criteria to insure quality in a work of art, how many do we need? In what combination?

# WHOSE CRITERIA WOULD YOU USE?

Identifying objective standards is complicated by the diversity of art. As we saw in Chapter 2, art serves many functions. Which art is best? Whose criteria shall we use to determine this?

- ◆ Renaissance Europe developed representational painting to a high degree of excellence, and took the human figure as the chief subject. But the Islamic world produced a complex art of abstract forms, condemning figurative images as idolatrous.

- ◆ Creativity and originality are highly valued today in judgments of artistic quality. In ancient Rome, however, exact copies of statues were thought of as no less valuable than the original model.

- ◆ In eighteenth-century Europe, the fine arts were distinguished from the "lesser," or "decorative," arts by virtue of their having no utilitarian purpose. That distinction was inconceivable in the Islamic world, where artists' best efforts were devoted to the enrichment and embellishment of useful objects such as books, lamps (see Fig. 8-16), pitchers, plates, beakers, rugs, and tiles.

- ◆ In the Tiv society of central Nigeria, most of the arts and crafts are produced communally. Designs initiated by one person are completed by others without any prearranged plan. In Chinese art, on the other hand, individuality was cultivated to such an extent that the very brushstrokes characteristic of an artist would be subject to discussion.

- ◆ The greatest art of the Middle Ages aimed to draw people closer to God. Since the Renaissance much of the art has been secular in orientation.

- ◆ In eighteenth-century Europe great importance was placed on the subject matter of a work of art. Modern art has tended to stress form.

- ◆ In nineteenth-century academic art, technique and skill of execution were highly valued. In our culture, art may be produced by a camera or even by a photocopier.

These examples undermine the reliability of artistic standards as absolutes. But they demonstrate that artistic standards are a reflection of specific cultural preferences and traditions. Every culture ascribes values to art in accordance with its own particular needs and interests. Thus, critical judgments reflect the outlook of their time, just as the art does. This helps us to understand why

changes in criteria for art must occur as inevitably as the changes in art itself. These criteria can give us insights into the culture, as well as provide a basis for understanding and appreciating the art.

# THE CHANGING FORMS OF ART

In the last chapter we saw that art in Western civilization gradually expanded to include wider possibilities for content. As this occurred, the forms of art also changed. Since form is a means through which content is conveyed, a change in one necessarily meant a change in the other. New ideas about what art could contain meant new ideas about how art should look, and new criteria for artistic quality.

Once again, let's take a brief journey through Western art. This time we will look at some of the visual answers provided at different times to the questions: What constitutes artistic quality? What should artists aim for? What looks right? Of necessity, we will survey the art that is most characteristic of its time.

18-4
*Poseidon (or Zeus), c.*
450 B.C. Bronze, 6′10″
high. National
Museum, Athens.

The ancient Greeks focused on the human form. They simplified it, but at the same time created images that were amazingly lifelike. They placed a great value on beauty, and to this end sought not only to imitate but—as in the statue of Poseidon (or Zeus) in Figure **18-4**—to idealize the human form. This was realized in terms of harmonious proportions of the parts, as well as overall gracefulness. Architectural beauty was conceived in similar terms; proportion, balance, simplicity, and order were all greatly admired (see Fig. 7-7).

Greek sculpture of the early and classical periods aimed at ideal types. Later, a taste for particularity was developed, and the first statues of individual types appeared. The idea of art as images of reality brought to perfection was revived sporadically in the Roman period and again in the Renaissance.

The Romans based their art largely on that of the Greeks. But while they appreciated an art of ideal forms, their taste was for something more down to earth. They liked portraiture and believed that facial expressions should communicate principles of conduct such as dignity, piety, and honor. Their art told stories and described events. Like their architecture and their engineering, it was valued for usefulness as well as beauty. On the Column of Trajan, for example (Fig. **18-5**), the campaigns in Dacia (now modern Romania) were depicted in careful detail for the people back at home.

In late Roman art, classical principles of imitation and beauty gradually were replaced by a more abstract art capable of making succinct statements. Solid, sculptural

volumes in a three-dimensional space yielded to a preference for flat shapes and ambiguous space; harmony and proportion gave way to a crowding of figures or to methodical repetition.

The medieval Christian world, oriented to the afterlife, regarded art that represented the beautiful things of this world as improper and out of place. Thus it fostered an art of abstract images with symbolic meanings (Fig. **18-6**).

Throughout the Middle Ages — a period of roughly a thousand years — we find a great diversity of styles. Early Christian art was based on classical principles of balance and uniformity, and it perpetuated the classical interest in the human figure. The so-called barbarians (a term used by the Romans to designate the Germanic tribes not under their influence) developed an art characterized by vigorous, abstract linear designs. The fusion of these two traditions — classical and Germanic — was complete by the Romanesque period (roughly the

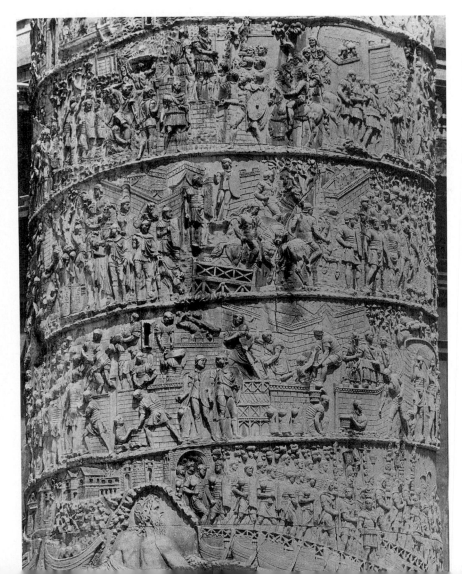

18-5
Column of Trajan, detail of the four lowest bands, A.D. 113. Marble, bands approx. 36″ high. Rome.

18-6
*Angel Locking the Damned in Hell*, Psalter of Henry of Blois. Mid-twelfth century. British Library, London.

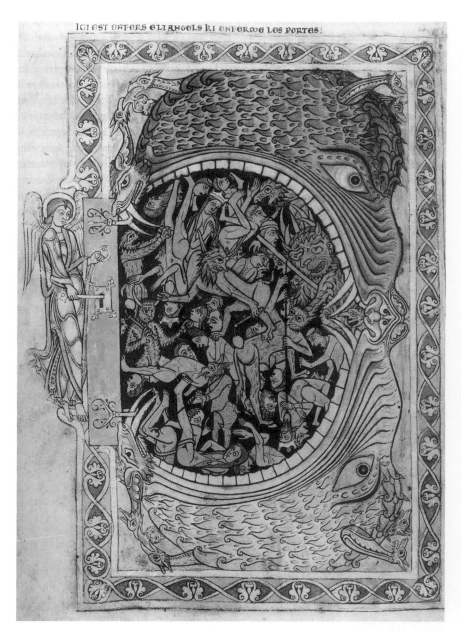

eleven and twelfth centuries). Artists of this period were expected to follow prescribed formulas in the depiction of sacred subjects, but for nonreligious subjects, they were freer to draw upon the earlier, Germanic artistic traditions, as well as upon their own imagination (Fig. **18-7**).

Statements from the Middle Ages about quality in art tended to focus on the workmanship and on the costly materials used. Rich colors and substances that

18-7
St. Pierre, Romanesque
capital from cloister.
Mosaic, twelfth
century.

transmit or reflect light, such as gold, precious stones, or, in the Gothic period, stained glass, were especially admired (see Fig. 7-5).

Medieval painters and sculptors tended to copy earlier models, though some artists introduced their own variations. Medieval art was heavily symbolic, communicating concepts and beliefs as well as stories. While this remained true to the end of the Middle Ages and even into the Renaissance, we find in the Gothic period a growing interest in recording the actual appearances of things.

In the thirteenth century, Gothic architecture—light, airy, and spatially unified—grew out of the darker, heavier, more compartmentalized Romanesque. The Gothic cathedral became a symbol of the Heavenly City of Jerusalem. Its integration of innumerable, variegated forms (see Figs. 7-1 and 7-3) accords with a concept of the universe as an immeasurable, multiform pattern.

Renaissance taste rejected the Gothic tendency toward elaboration, and set simplicity, measure, and proportion as a value. Renaissance architecture was

18-8
Raphael Sanzio, *The School of Athens*, 1509–1511. Fresco in lunette, 25′3¼″ at base. Stanza della Segnatura, Vatican Palace, Rome.

inspired by the forms and details of Roman architecture. Roman statuary provided models for Renaissance painters and sculptors. The return to art as imitation that began in the late Middle Ages was assiduously pursued in the Renaissance. Classical principles of balance, harmony, and order, having found their way back to painting, now gave images of an ideal world, perhaps nowhere more clearly stated than in Raphael's mural *The School of Athens* (Fig. **18-8**).

The balanced and unified world of Renaissance art was countered by conflicting principles in the sixteenth century. An independent style, Mannerism, altered the calm, harmonious relationships of Renaissance art and architecture to create drama, diversity, and surprise (Fig. **18-9**). In painting and sculpture, conception and imagination seemed preferable to the Renaissance ideals of imitation and the perfection of things observed.

The Baroque style of the seventeenth century continued the Renaissance celebration of the material world, though in forms that were far more sensuous.

18-9
Tintoretto, *Miracle of the Slave*, 1548. Oil on canvas, approx. 14′ × 18′. Galleria dell'Accademia, Venice.

Human figures attained heroic proportions and were placed on a stage even more grand than that of the Renaissance (Fig. **18-10**). Baroque architecture created splendid, theatrical settings for public events. Complexity, both visual and psychological, was valued, and contributed to a preference in art and architecture for movement, vivacity, and exuberance.

Some seventeenth-century artists and critics condemned the untidiness of this particular Baroque esthetic and rallied around classical values of restraint and decorum. Deploring sensuous color and voluptuous shapes in painting, artists like Poussin promoted a more austere style of precise edges, grayed color, and stable forms in a clear atmosphere (Fig. **18-11**). In architecture, ornate Baroque decoration was discarded in favor of spare, measured, classical forms.

In the eighteenth century, resistance to the sober classical esthetic was vigorously maintained, and sensuousness found expression in a style called Rococo. Emanating from the court of Louis XV, it soon became fashionable throughout aristocratic Europe. Essentially a more delicate and decorative version of Baroque, Rococo sought to please the eye rather than address the mind. The value of a painting was measured by the pleasure and delight it gave. With its pastel colors; graceful, curvilinear lines; and innocuous scenes, the Rococo style is associated with elegance to this day (Fig. **18-12**. See also Figs. 8-13 and 13-2.).

But the classicizing tendency persisted throughout the eighteenth century. During this period it was reinvigorated by the discoveries of the buried Roman cities of Pompeii and Herculaneum. By the time of the French Revolution, Rococo painting had given way to an art of hard, clear, stable forms deriving

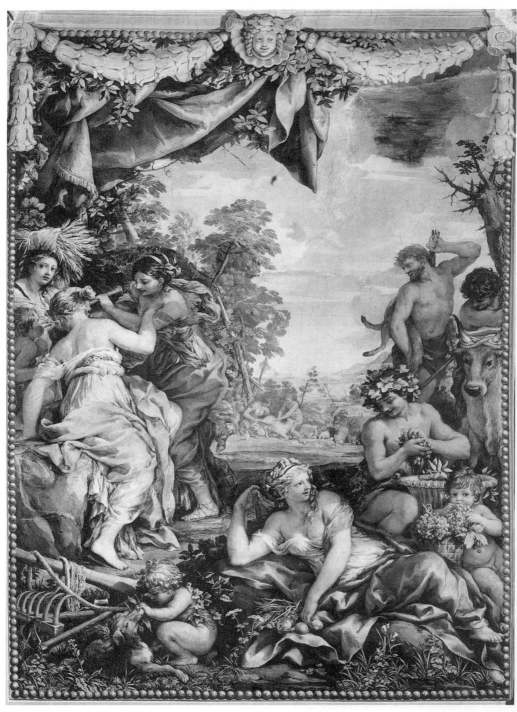

18-10

Pietro da Cortona, *Age of Silver*, 1637. Fresco. Palazzo Pitti, Florence.

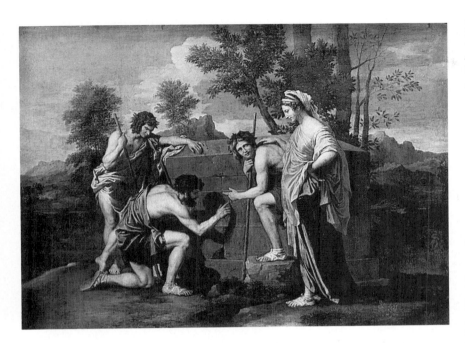

18-11
Nicholas Poussin, *Et in Arcadia Ego*, c. 1655(?). Oil on canvas. 32½″ × 47⅝″. Louvre, Paris.

18-12 (below)
Antoine Watteau, *Embarkation from the Isle of Cythera*, 1717–1719. Oil on canvas, 50″ × 76″. Louvre, Paris.

18-13
Jacques Louis David,
*The Oath of the Horatii*,
1784. Detail. Oil on
canvas, approx. 10′ ×
14′. Louvre, Paris.

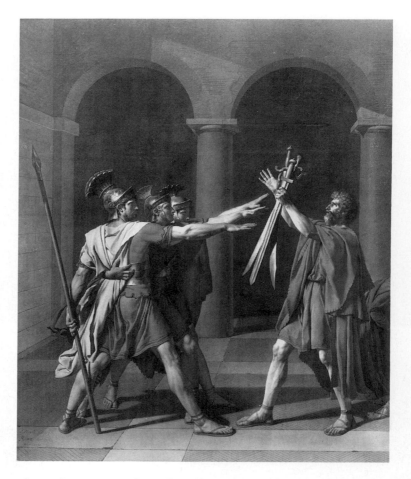

from classical antiquity and recalling the paintings of Poussin. This style, called Neoclassicism, consciously aimed to evoke the dignity and moral seriousness it found in Greece and Rome, and thus to infuse a high moral tone into art (Fig. **18-13**). Because it seemed an appropriate expression of the ideals of the Revolution, Neoclassicism became the official style of the French Academy.

Neoclassicism became dominant throughout Europe. But in the early nineteenth century it was opposed by the Romantic painters, who valued an art that was more subjective, and whose forms conveyed the feelings of the artist through bright colors, wild shapes, and rough-and-tumble brushstrokes. The Romantics saw their art as less artificial and more natural. In their desire to escape the increasingly dry themes of the Academy, they tended to shun classical antiquity, preferring instead the more exotic Middle East, the Middle Ages, and the natural landscape (Fig. **18-14**).

Some artists of the mid-nineteenth century regarded both Neoclassical and Romantic art as escapist. Instead, they sought to record life as it was. Committed to painting the truth, the Realists, and related artists, showed ordinary landscapes, unidealized and unromanticized, and treated plain, working-class

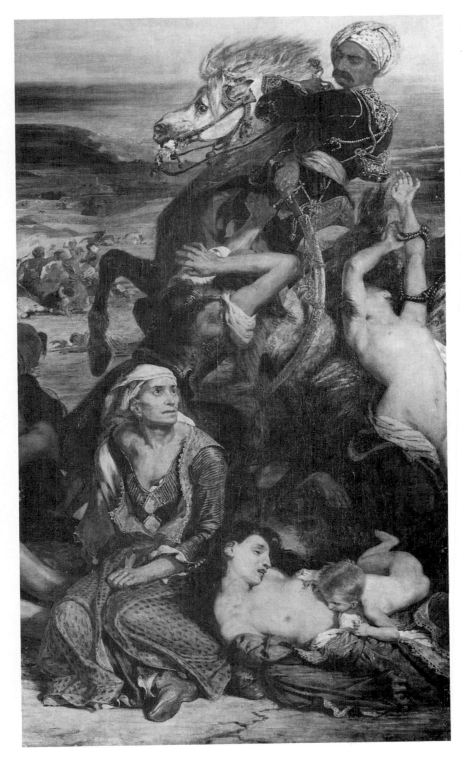

18-14
Eugène Delacroix,
*Massacre at Chios*,
1822–1824. Detail. Oil
on canvas, 13½′ ×
11¾′. Louvre, Faris.

18-15
Jean Francois Millet,
*The Gleaners*, 1857. Oil
on canvas, approx. 33″
× 44″. Louvre, Paris.

people and peasants with similar objectivity (Fig. **18-15**). Their use of direct, unrefined brushstrokes brought a sense of immediacy to the subject and emphasized their belief that the message contained in art is more important than the beauty of the image.

Impressionists in the latter part of the nineteenth century questioned the idea that a painting had to talk about something important. Aiming above all to show the landscape as we truly see it in the sparkle of atmosphere, they dabbed on bright paint in tiny, opaque strokes that coalesced to produce luminous color when viewed at a distance. Viewed up close, their paintings were a mass of flat colors, surging in loosely defined shapes (Fig. **18-16**).

Almost as soon as Impressionism asserted itself a number of artists associated with the movement began to reject its principles. These artists were subsequently known as Post-Impressionists. Some, like Cézanne (see Fig. 11-8) and Renoir, wanted to restore the solidity and compositional integrity of traditional painting. Others, like Van Gogh and Gauguin (see Figs. 4-5 and 11-7), wanted to make their art a more personal statement that would transmit feelings and thoughts about the subject. These artists all based their work on the idea that the subject is not there simply to be copied but is a springboard to the imagination.

18-16
Claude Monet, *Poplars on the Bank of the Epte River*, 1891. Detail. Oil on canvas, 39½″ × 25¾″. Philadelphia Museum of Art. (Bequest of Anne Thomson as a memorial to her father, Frank Thomson, and her mother, Mary Elizabeth Clarke Thomson.)

Abstract art of the twentieth century subordinates the subject or rejects it altogether, placing value on form. In Dada and in postmodernism, however, the esthetic aspect of the piece may be of little or no interest; the art is evaluated by the impact of its ideas. In recent figurative painting, a raw, sometimes ugly look achieves a kind of primitive power.

Our survey reveals considerable variation in esthetic theory. Indeed, if we inspected any of these theories at closer range we would find further variation and diversity. We also see the recurrence of tastes, styles, and esthetic ideas,

especially those developed in the classical period. Well-thought-out artistic theories provide useful criteria for evaluating some kinds of art, but not others. The various theories that have been used to evaluate art help us to look more carefully at the art of a particular period. They help us to better understand it and to gain insight into the culture. But, however appealing, no one of these theories provides principles that apply to *all* art work.

# The Value of Criticism

Criteria for the evaluation of art, like art itself, have changed over the years and have differed from place to place. Thus it appears that the search for absolute and universal standards is futile. Yet in the absence of absolute standards we continue to evaluate *and* enjoy the art we experience. The existence of conflicting ideas of quality may be frustrating to those who require certainty above all, but the appreciation of art is not conditional on our being certain.

Despite the efforts of critics and theoreticians, the intrinsic quality of a work of art remains elusive. Artistic quality just can't be proven like a geometrical theorem. Our affection for a work of art is never a matter of logic; our reasons for finding a piece appealing are always partially subjective.

There are any number of reasons to like a work of art, not all of them necessarily "good" reasons. You might like something that you realize isn't very good. And there may be any number of things you judge to be good but just can't warm up to.

In evaluating art we ordinarily move between objectivity and personal preference. If I liked something I would naturally want you to enjoy it as well, so I would try to show you why it pleases me. My first appeal would be to objective standards. If you didn't agree with me, we'd probably conclude that my affection for the piece is "a matter of taste."

It's problematic whether I could persuade you to change your mind about what you like or dislike. But talking about our disagreements can be useful. We must be able to justify our arguments in terms we can both accept. That makes us look more carefully at the object of our discussion and reinspect our own attitudes toward it. Whatever our conclusions as to the merits of the object, we will have learned a lot more about it, and about art in general.

Ultimately, the question of artistic quality is one you will have to answer for yourself. Your own values and experiences will inevitably influence your conclusions. There is room for intuition. But you will never be certain that your hunches aren't wide of the mark without some understanding of the context in which the art was produced. And if you are interested in formulating a respectable idea about the quality of the art, context is a good place to start. What aims and purposes were intended for the piece? What were the values and beliefs of the society? How was artistic quality identified? What did the *other* art look like? And what made this piece different? Only by trying to understand what the

artist was aiming for can you begin to judge how close he or she came to achieving the goal.

Disagreement over quality is inevitable in a culture as complex as ours. It reflects our diversity of interests and values. Within the art world, debate over works of art is tempered by the understandable desire to be careful. As we saw in the last chapter, people have made faulty judgments about art. Few of us today would care to draw the lines of our theories so rigorously as to make similar errors.

With this as a caution, I'll offer some of my own ideas about what artistic quality consists of. In making up a list it seems to me that I should mention only what I have actually experienced in the art I have seen. So while my list implies that "this is the way it has to be," it is really just a way of saying that "this is what I have recognized."

If the art is of high quality it will have at least some of the following characteristics. Lack of some of these can be balanced by the strength of others.

- It will say something. You should be able to sense the presence of an idea behind it.
- The idea will have some significance. At least the piece should be able to convince you of its importance.
- The concept of the piece will be unique, original. It will strike you as imaginative and fresh, and not a restatement.
- The parts, details, formal elements, and materials of the piece will be expressive of the idea.
- There will be a substantial formal unity of those elements so that they contribute to, rather than detract from, the whole. That unity will give a feeling of rightness, a sense of the inevitable, to the piece as a whole.
- The piece will be executed with skill. Even if accident or chance play a part in it, we should feel that the artist knows what he or she is doing.

As a caution I would add that not all of this may be apparent all at once. Good art grows on you, and offers you more than you can catch in one sitting.

Good art may break rules, and as it does, it sets new standards. What you or I look for in a work of art is bound to change as well. So not only might my criteria be different from yours, they might be different from my own in the future. The criteria I draw up tell me more about what's in my mind than about the art. Using the criteria to decide whether I like or should like a piece is, of course, pointless; but I can use my criteria to better understand the piece and why I like it.

Art is an activity in which individuals test their limits. The chanciness of the performance gives it an exciting edge. Like athletes, artists are not always successful, and may fall short of their goals. But even if the Yankees are behind in the seventh, is that any reason to leave the game?

At the same time, we should try to be discriminating, so as to allow ourselves the best opportunity to experience the best that art has to offer. Our greatest and worthiest challenge is to apprehend quality and meaning to the fullest extent possible. To this end, the task of criticism is not simply to decide between good and bad, but to help us gain understanding.

# 19
# VISITING MUSEUMS

How many times have you been to an art museum? Do you visit them regularly or do you put it off? It's not unusual for people to think of going to a museum as a chore. After all, museums can seem intimidating or stuffy. But museum visits can be enjoyable. Sometimes it's just a matter of handling them in the right way — in a way that works for you. ¶ If you go to museums infrequently, the visit can be exhausting. Chances are you feel bound to do the whole thing at one time. That's probably not a good idea. Unless the collection is small, don't try to look at everything at once. If you do, you're more likely to be aware of "museum fatigue" and your aching feet than the art you've seen. ¶ You needn't spend too much time in a museum. Beyond a certain point, you're just not going to be fresh enough to get anything out of what you see. Use the museum directory to help you choose where to go. Consider a time limit for your visit. If there's something in particular that you want to see, go there directly and look at it first, before you get tired. Spend as much time with it as you like, and consider saving the rest for another visit. ¶ Not everything you see in a museum will interest you — nor should you expect it to. You probably will feel more strongly for some things than for others. Some people who go to museums regularly look forward to seeing particular things they like. They think of them as old friends. But if you go infrequently or are visiting a new museum, you have the opportunity to make new discoveries, and you may be surprised by what you discover. You may find something altogether new, or see new things in an old friend. It's exciting to be surprised by a piece of art that comes alive for you. And that, of course, is what really counts. What you'll remember above all is the connection you make with a piece or two, or

perhaps a small group of things. That's probably a lot more valuable than trying to see everything in the building.

Rather than a chore, a visit to a museum can be a refreshing break in routine. Just follow your nose, with no specific goal or intention. Let yourself be surprised by something unexpected. It will release you from the usual pattern of programmed time that most people maintain. In addition, you will be doing something for yourself. There are few more pleasant ways to add to your knowledge and understanding of human experience than at a museum, whose objects are there precisely because they're special in some way.

Now that you have, I hope, agreed that a museum visit can be an *enjoyable* experience, I'd like to convince you that a museum visit is an *important* experience.

# WHY VISIT A MUSEUM?

In the first place, what you see in a museum contrasts strikingly with what's around you every day. Museum objects are, typically, unique. Each one is done or finished by hand. Very little that is one-of-a-kind is left to us today. We are surrounded by mass-produced things that have little or no intrinsic value apart from their function. They have little character. Perhaps they only accommodate a fashion or taste. They are impersonal. They are not often made with pride, or made to last.

Objects and artifacts now turned out by machines were once made by hand. The craftsmanship that went into them demanded considerable skills. Many hand-made objects are, by modern standards, technically sophisticated, and can't be duplicated by machines or machine processes. Many such objects are envied by contemporary craftspeople, both for their technical qualities and for the rightness of their design. Museumgoers may be awakened to the triviality of many contemporary commercial designs when compared to examples from societies that have not experienced technological progress.

A fine hand-worked art object is precious. It can't be replaced. In addition to its excellent craftsmanship it will have a personal quality, a character not found in machine-made things. This quality will enable the object to "live" long after its usefulness as an artifact is over.

The objects gathered in a museum generally represent the best that someone could do. They are nearly always the products of years of training and development. We see in them the skill and vision of exceptionally talented individuals. They may contain qualities of genius or inspiration. So rarely do we see *anything* that we can call superb, or anything of lasting value, that we may find ourselves wondering whether such things exist. They do—in works of art.

Among the great achievements of the human race are the works of art that men and women have produced. Perhaps it is *because* they are superbly done that we regard them as works of art. Current events can discourage us. This makes it especially important to experience works of art, for they come down on

the side of life, testifying to the wisdom, energy, and aspiration to achievement of all peoples in all times.

A second reason to go to a museum is to see the real thing. Many people never see art — they see reproductions of it. Students viewing slides in art appreciation or art history classes will not see art unless they go to a museum or gallery. Art is reproduced in books and magazines, in posters, in calendars, and even occasionally on television, but rarely do we experience a work of art as it really is. The problem with reproductions can be simply put: they distort whatever they show you. Color and light, which are the very substance of painting, are altered. Brushwork and texture are replaced by a smoothed-out flatness. The size of every painting, sculpture, or building is reduced to a common standard. Details disappear. Subtleties are lost. The impact of scale is gone. These distortions alter the character of a work of art.

The experience of space, which is basic to the enjoyment of architecture, cannot be achieved through reproduction. A photograph collapses the solid reality of a sculpture into two dimensions. Our need to move through a building or around a sculpture is thwarted. And, of course, the point of view from which a sculpture or a building is photographed is out of our hands. Whatever we see reflects the photographer's interests, not necessarily our own.

Clearly, unless you experience the real thing you're just not going to get as much out of it. A work of art is a delicate interplay of relationships, *all* of which count. A reproduction reduces it to bits of information, and not much more. In this condition it can hardly be appreciated.

People who go to a museum for the first time are surprised by the unexpected vigor of original works of art. For the first time they become aware of the life that is in them. They may, for the first time, really *enjoy* looking at a work of art.

A third reason for going to a museum is that you can be with a work of art for as long as you like. Art that is reproduced in magazines, on television, or on a screen in a lecture hall is often hurriedly seen. Looking at a good painting or a good piece of sculpture is like reading a good book — it takes time, and you may not absorb it all at once.

To some readers this may sound unusual. Many people, perhaps accustomed to television, expect art to communicate immediately. But art is more than just a story or a message. It can mean something on many levels, and these meanings may disclose themselves to us gradually. Over time there will be more and more to see in a solid work of art. Most television stories become less exciting with each viewing. How can we get the most out of a work of art? To begin with, trust that it's worth the time just to sit for a while in front of it. Relax, open your eyes, and look. Then think about it later.

Museums are designed to show off art in the best possible way. Museums give great attention to placement, to the space around each piece (whether on the wall or free-standing), to the creation of an environment, and to the lighting. All of these influence your perception of the art. Paintings require good light and ample space around them. The color and texture of the walls should not be intrusive. Sculpture too needs space and carefully planned lighting, and must be displayed at the right height.

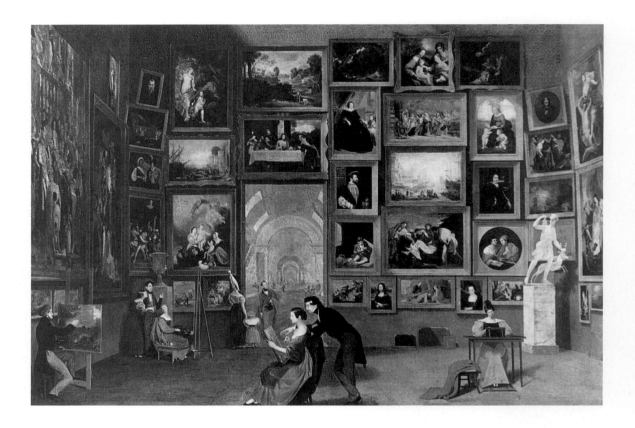

19-1
Samual Finley Breese
Morse, *The Gallery of
the Louvre*, c. 1832,
unfinished. Oil on
canvas, 76″ × 106½″.
Terra Museum of Art,
Chicago.

We tend to take the exhibition for granted—after all, we are there to look at the art, not the walls behind it. But the environment in which we see a work of art affects the way we respond to it. It is helpful to remember that many objects now placed in museums were intended for very different situations. African masks were meant to be worn, and to be seen in motion. Mosaics, now flattened in the blank glare of the museum light, once shimmered on the walls of churches. Panel paintings of saints once glowed softly in the light of candles. Sculpture placed out of doors, such as totem poles, fountain or garden statuary, and components of architecture, loses impact when dismantled and brought inside (often for the sake of preservation). To compensate, museums sometimes provide photographs showing the object in its original context. In addition, an environment suggesting that context may be created to help you get a better feel for the object.

Museum interiors have altered considerably over the years. Until the twentieth century, gallery walls were ornate and richly colored. Paintings were crowded side by side and one above the other up to the ceiling. It is hard to imagine anyone looking carefully at the paintings. Some were hung so high they could hardly be seen (Fig. **19-1**).

In the late-nineteenth century, the Impressionists made a radical departure by hanging all of the paintings in their exhibitions side by side. In the 1920s another change in the exhibition of paintings took place. Stark, white walls pro-

19-2
László Moholy-Nagy,
exhibition at the Neue
Kunst Fides Gallery,
Dresden, 1926.
Courtesy of Hattula
Maholy-Nagy.

vided the background for a limited number of paintings that were widely spaced. These exhibitions emphasized the idea that a painting is not something you take in at a glance, but is an object to be contemplated (Fig. **19-2**).

Today a larger museum may create a different environment in each room or gallery. Some rooms may have white walls, others may have richly textured cloth of a soft color, while some may suggest or even recreate environments from other periods. Many larger museums have "period rooms" reconstituted from actual buildings, occasionally with the interior furnishings exactly as they were (Fig. **19-3**).

Another reason to visit a museum is that it can help you get more out of what you look at. Not only is the physical environment important but also the arrangement of the paintings in the rooms. Typically, rooms are devoted to a particular historical period, or to a geographical area within that period. This helps you to recognize the style and the concerns of that period. It also helps you to distinguish what is unique to an artist or piece. In addition you may begin to recognize differences in the quality of work that you see, as when a group of portraits or still lifes or landscapes from the same period invite comparison. Thus a good display can help to inform you and sharpen your eyes.

Frequently a handbook or guide to the collection is available at the museum desk or store. Some museums provide background information to their exhibits in the form of papers or brochures. A minute's reading can help place the art in context, and can bring significance to an otherwise negligible piece. Slides and films may introduce special exhibitions. Prerecorded tours, available on tape, can be rented for use while viewing the exhibition.

In an effort to reach out to the public, many museums schedule free public tours. Trained docents—lecturers—provide useful information on both the

19-3
Room from the
Chateau de Chenailles,
Loire Valley, France, c.
1640. Carved, painted,
and gilded woodwork
with eighteen oil
paintings on panel and
five oil paintings on
canvas, approx. 12'6"
high; floor: 16' × 13'.
The Toledo Museum of
Art. (Gift of Mr. and
Mrs. Marvin S.
Kobacker.)

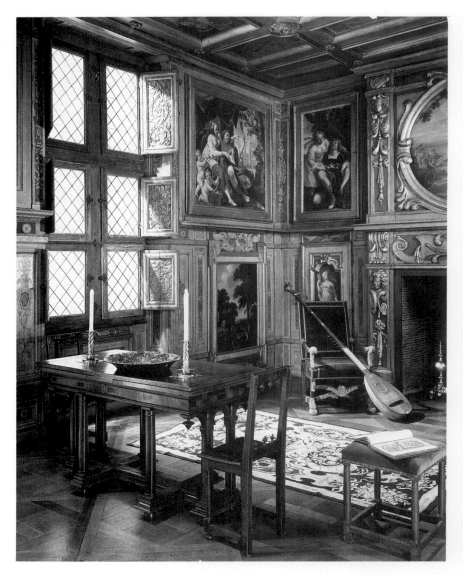

permanent collection and on special exhibitions. In addition to the regularly
scheduled tours, special tours may be arranged for a group by calling the mu-
seum ahead of time. These tours may be designed to accommodate the particu-
lar interests of the group.

Special exhibitions, planned around specific themes, are intended to provide
a greater awareness of an individual artist, a historical period, a movement, or an
idea. These exhibitions may be made up of art collected from a number of
museums, private galleries, and private collections. It can take years of planning
to assemble a show of this kind.

These exhibitions are extremely valuable in that they gather in one place
pieces that may be seen together for the first time. Similarities and differences

appear that promote a better understanding of the work. Special exhibitions can help you to recognize the influence of one artist on another, as well as to clarify what is original in an artist's work. Retrospectives, which exhibit the work of one artist over a period of years, allow the best possible view of the artist's development.

A special exhibition can help us get a feel for a period of history remote from our own. Surrounded by the art or artifacts of that time, we can imagine what life was like. And of course what we see is not a Hollywood recreation of Pompeii or the court of Louis XIV, but the real thing. We are immersed, in effect, in a kind of living history that we absorb through our senses.

While some exhibitions enable us to escape the confines of our own time and place, others may focus on what is current. They may be devoted to local artists, to recent work, or to work in progress. They may include plans, notes, sketches, and other bits of information made available by the artists.

Special exhibitions have also drawn attention to contemporary material that is not ordinarily considered to be fine art. In 1934, in a major exhibition entitled "Machine Art," the Museum of Modern Art in New York presented ships' propellers, ball bearings, copper tubing, and cooking utensils, among other examples of industrial design. In 1975, the Detroit Institute of Arts held an exhibition of T-shirt designs. In 1990, the Mint Museum of Art, in Charlotte, North Carolina, celebrated Bugs Bunny's 50th birthday with drawings, paintings, animation cels, and cartoons from the Warner Brothers Studios. Displays like these attune us to the esthetic possibilities in images and artifacts not intended as serious art. In addition they remind us that *all* objects created to suit our needs shed light on who and what we are.

Museums advertise their special exhibitions. You can get this information through your local newspapers, your public library, public and private schools in your area, local radio and television stations, magazines, or other museums, or by calling the museum itself.

Another reason for visiting a museum is that museums function as a repository for objects that are significant to society. Where else can you go to see things from the past, or from remote places, as well as contemporary objects thought to be worth saving?

You can think of the museum as a place where important things are gathered. Museums store, repair, and preserve them for the future. Museum collections are not restricted to painting and sculpture, but may include prints, photographs, folk arts, crafts, popular and commercial art, and well-designed everyday objects, both historical and contemporary. Because these objects are considered to be important, they are displayed — shared, as it were — for the benefit of the public.

Why does a museum acquire a particular work of art? There is no single reason. Some works of art are acquired because they stand on their own in terms of their beauty, others because they are representative of a culture or a time period. Museums may buy the early work of an important artist because it sheds light on the artist's development. They may exhibit a piece because it is rare or unique. Or they may purchase pieces that fill gaps in their collection. In addition, there may be some intangible reason for acquiring the piece. Perhaps there

19-4
Stemcup, Ch'ing
dynasty, Ch'ien Lung
reign, 1736–1795.
Porcelain, 3⅞" high.
Yale University Art
Gallery, New Haven.
(Gift of Dr. Yale
Kuesland, Jr.)

is just something about it, some indefinable quality that sticks in the mind. Art has a way of escaping categorizing and defying attempts to pin it down. That indefinable quality may be the best reason for acquiring a work of art and sharing it with the public.

Museum personnel give careful consideration to what they buy and what they exhibit. Tastes and opinions differ and of course change over time. Not everything will be of equal quality. Not everything will be great art. But whatever you see in a museum, you may be sure that, within the limitations of availability, it is considered to be the best or most important work of its kind.

Above all, museums devote themselves to collecting what is beautiful, which brings us to the final reason for visiting them: we go to a museum to see beautiful things.

By their very existence, museums exemplify the idea that it is important to *contemplate* beauty, not just to read about it. The reaction to beauty is universal and finds expression in the art of every culture we know of. Beauty in art, like beauty in music or in nature, refreshes and inspires us. Whatever our material circumstances, our lives would be blighted without the experience and the memory of beauty.

The beauty of hand-made objects has its own special character. Whether inspired by nature or purely imaginative, works of art concentrate and preserve beauty for our contemplation and pleasure. Through the handiwork of artists and craftspeople of all times and places, a lovely color, volume, or shape, a texture or a pattern is refined into an image or object that is whole, distinct, and — unlike nature — intentionally expressive (Fig. **19-4**).

We shouldn't ever think of museums as the exclusive domain of what is beautiful or significant. Some of the things that we take for granted today will someday be in a museum. But for now they are around us, waiting to be discovered.

# 20
# ART OUTSIDE THE MUSEUM

**F**INE-TUNING OUR SENSES

One bright, sunny day a friend of mine visited a Japanese temple. When he thanked the monk who showed him through, and complimented the temple's beauty, the monk replied, "Yes, it is beautiful today, but you must come back and see it in the rain to really appreciate it." ¶ Most people love sunny days. But if we look for beauty only in sunshine and blue skies, we will overlook whatever is more subtle, but perhaps no less beautiful or interesting. Rain, fog, and snow can be annoyances, so we may not perceive them as attractive. But if we choose, we can let go of these associations and open our eyes to their esthetic possibilities. The delicate tints of color and light that we see on a gray day, at dawn, or at twilight, can also speak to us. ¶ How well we see depends on our habits. All of us tend to notice things in terms of our needs. We name things,

categorize them, and use them for something. As a result, their visual impact wears out. We may look at them, but we may not really *see* them. ¶ Paying attention to what's around us can give us a lift. Consider the architecture of roller coasters, the geometric harmonies of ferris wheels, the grandeur of grain elevators, or fireworks, neon signs, hot air balloons, or marbles. Notice the forms of plumbing fittings, steel beams, piles of bricks, stacks of ceramic pipes, kegs of nails or bolts in a hardware store. Notice children's drawings, hop-scotch diagrams, hand-lettered signs, scarecrows, or sandcastles. We may not think of these as art. They are certainly not precious. What matters, though, is to enjoy what is available to us. ¶ Enjoying what you see may mean detaching yourself for a while from everyday affairs. In some cultures, pausing to reflect on beauty in nature or in

20-1
Shōkintei tearoom,
Katsura Palace, Kyoto,
Japan.

art has been institutionalized, even ritualized. The traditional Japanese tea cere-
mony offers an example.

The tea ceremony gives its practitioners an opportunity to sit quietly and pay
attention to their surroundings. Still conducted occasionally today, the cere-
mony evolved out of Zen practice into a secular rite in which a host prepares tea
and shares it with a guest or guests. If possible, the ceremony is held in a tea
house, a small, rustic building built for that purpose (as in Fig. **20-1**). Embody-
ing the quality of *wabi*, the tea house is made of humble, natural materials such
as wood, cane, or straw that are left to weather unpainted so their true character
will emerge over time. Inside, spare, asymmetrical rooms with bare walls
heighten awareness of the color and texture of the materials. The floors are
straw mats, and there is no furniture. While the guests await the serving of tea,
they observe the *tokonoma* — an alcove, or niche, built into one wall — where the
host will have placed a painting, an arrangement of flowers, or perhaps a single
blossom in a bowl. The *tokonoma* is the focal point of the room. The movements

of the host in the preparation and serving of the tea are graceful. Conversation is subdued. Guests discuss the beauty of the painting or flower selected by the host, or comment on the tea or the utensils, which according to tradition are simple and unpretentious (see Fig. 8-7). Beyond the tea house is a small garden, whose walls separate the tea house from the clamor of the outside world. Carefully placed windows frame views of the garden and create living paintings (see Fig. **20-2**).

20-2
Interior, second room of the Shōkintei, Katsura Palace, Kyoto, Japan.

The tea ceremony creates an atmosphere of tranquility in which all the senses are awakened. A peaceful, uncluttered setting; the sight of a few objects, carefully chosen for their understated beauty; the fluid motions of the host; the sounds of the whisk making the tea, and of the tea as it is poured; the fragrance of the tea and its taste; and the feel of the tea bowl in your hand are all a part of the tea experience. By slowing the pace, the tea ceremony heightens awareness of the surroundings.

The specialized conditions of the tea ceremony might suggest that beauty is always delicate and refined. Certainly we find this concept in Western art as well as in the highly estheticized traditions of Japan or China. But this is not always the case. Look carefully at art and you will see much that negates preciousness. Velázquez showed us the sweating surfaces of earthenware jugs, anvils, and eggs poaching; Chardin painted pots, clay pipes, and laundry tubs; Monet depicted the inside of a railroad station; Van Gogh painted his boots; Matisse gave us a view through a car window. Even the utensils used for the tea ceremonies are simple and plain, based on those used by peasants.

Much of twentieth-century art has campaigned to blur the lines between art and everything else. Duchamp's readymades pointed the way to the serious consideration of found objects, and such artists as Rauschenberg, Johns, Kaprow, and Warhol explored the ramifications. As we have seen, parachutes, socks, beer cans, tires, conveyer belts, vapor trails in the sky, and Campbell soup

cans have exemplified Kaprow's assertion that "the whole world has become endlessly available."

Nature too is there for us to enjoy, but it is often art that points the way. Art opens the doors of awareness to nature's beauty and alerts us to what otherwise might have escaped notice. Oscar Wilde developed this idea in _The Decay of Lying_ (1889), where he wrote:

> Where, if not from the Impressionists, do we get those wonderful brown fogs that come creeping down our streets, blurring the gas-lamps and changing the houses into monstrous shadows? To whom if not to them and their master, do we owe the lovely silver mists that brood over our river, and turn to faint forms of fading grace curved bridge and swaying barge? The extraordinary change that has taken place in the climate of London during the last ten years is entirely due to this particular school of Art. . . . Things are because we see them, and what we see, and how we see it, depends on the Arts that have influenced us. To look at a thing is very different from seeing a thing. One does not see anything until one sees its beauty. Then, and then only, does it come into existence. At present, people see fogs, not because there are fogs, but because poets and painters have taught them the mysterious loveliness of such effects. There may have been fogs for centuries in London. I dare say there were. But no one saw them, and so we do not know anything about them. They did not exist till Art invented them.

Works of art kindle awareness that we absorb and carry with us wherever we go. In a sense, works of art are teachers whose lessons are realized not in the museum, but in the world of experience. Even if, or perhaps especially if, the subject is familiar, sensitive images give us new eyes by which to see it.

Consider Robert Mapplethorpe's photographic study of a calla lily (Fig. **20-3**). Carefully composed and cropped, the image contrasts the trumpet-like blossom with the tensile, load-bearing stem. The flower is white against a background of black; its edge crisp and cleanly defined. The profile reads like a calligraphic line drawing of variable curves, changing rhythms, and sudden angles darting into sharp points. Then we notice the contrast of that sharp, pristine silhouette with the soft transitions of dark and light inside it. The photograph persuades us that the beauty of the calla lily is in that contrast of opposites. Inside the flower's silhouette, its form becomes sculptural, as petals slip from solid to hollow and back again.

The formal order of this photograph turns flower into art. But the art has imparted a precise experience of this flower that we can carry back with us into the world outside the museum, or outside this book. The next time we look at a flower, we might bring a greater awareness to bear on our experience.

Many commercial photographs are beautiful too, and provide eloquent testimony that the lines between fine art and commercial art are indeed indistinct. Advertisements often use sophisticated techniques of photographic processing to distinguish the images from others in a magazine and to cast an allure around the subject. Stop-action photographs of liquids, often enlarged, open our eyes by showing us what only the camera can reveal. Television ads use slow motion to show the beauty of fluids being poured into glasses, or basketball players floating

20-3
Robert Mapplethorpe,
*Calla Lily*, 1984.
Copyright © 1984. The
Estate of Robert
Mapplethorpe

through the air. Computer-generated images appear increasingly in magazine and television ads and are ever more striking as technology improves.

Like commercial photography, film and television pervade our culture. We may think of them as popular entertainment, but they are also art forms with distinct visual languages. Film images work their own magic around the visible world. They are in many respects larger than life. The film *American Grafitti* (George Lucas, 1973) payed tribute to the glory days of car culture. Set at night, its luscious images of reflected light gliding over graceful fenders and polished chrome made us feel that nothing more beautiful than those old "dreamboats" ever graced the streets of America. Woody Allen's *Manhattan* (1979), shot in black and white, gave us unforgettable images of the city (and connected it forever with Gershwin's romantic *Rhapsody in Blue*). The long, patient shot of the desert sunrise in *Lawrence of Arabia* (David Lean, 1962) and the slow-motion boxing shots in *Raging Bull* (Martin Scorsese, 1980) stamp definitive images into the mind.

The MTV (Music Television) channel has contributed a new visual language (Fig. **20-4**). MTV is a conduit for a variety of music videos, which are essentially ads that combine images with the music of rock bands, rap groups, and singers. Besides music videos, the channel presents a sprinkling of other programming, including "Liquid TV," a weekly showcase of animation.

20-4
MTV (Music Television)
logo for *Liquid
Television* program.

Broadcasting round the clock, MTV is the site of cutting edge explorations of video technology. The videos collage split-second images, or transform movement into slow motion; they overlap images, flip them around, split them apart, or divide the screen to multiply them; they combine black and white with color; they use computers to create new forms and alter the colors of others. Abstract shapes, photocopied images, animations, newsreels, and old films interlace with live action and with each other.

The MTV style is typically edgy and fast-track. Rapid-fire, constantly shifting images pare each moment to a fraction as they hurtle through time. There is little chance to reflect, and little chance to tell a story. But linear narrative is usually beside the point. The music, the performers, and the images are the real subjects, and their aim is not information, but excitement.

That style has changed how we see, and what we expect to see, when we look at films and television. A cultural phenomenon since 1981, MTV has already influenced mainstream film making; television news; "filler" material between television programs, such as station breaks; and television advertising: Many television ads and movie sequences are essentially music videos. The popular police drama of the 1980s, *Miami Vice*, consciously imitated the MTV style. When you see a blitz of stunning images fired at you along with pulsating music, thank MTV.

This book has focused throughout on identifying the intersections between art and the real world. Some of them—for example, quilt making, news photographs, or the Vietnam Memorial—are more easily recognized as art forms than others. It is fun to discover those others, whatever and wherever they are. Not all

of them will move us in the same way. They will not be of equal value. We might not even identify them as art. But some of our most spellbinding experiences occur when we forget that what we see is art and become absorbed in it.

# ADVERTISING: A CRITICAL APPROACH

A key intersection between art and the real world is advertising. Advertising is found everywhere today, drawing into itself the many threads of our culture and reflecting them back. As with other art forms, we can ask: What do we see in those reflections? What lessons do they teach? To answer these questions, we must shift from an esthetic approach to one that is analytical.

Advertisements are an art form that draws on the talents of artists and writers to catch our attention and to communicate. In a magazine ad the picture must make an immediate visual impact, while a radio or television ad must capture our interest and sustain it over time. Some television ads, for example, have just thirty or sixty seconds in which to tell an entire story. Within these limitations, creative individuals have produced some remarkable and memorable results.

While we may appreciate ads for their creativity, or for their esthetic beauty, we can also approach them with an eye for meaning. Let's consider for example the Buick ad we saw earlier in Fig. 13-7. Its primary message is: Trust in a Buick. But the elements working to persuade us contain messages of their own. What longings are addressed by the statement "Something to believe in"? Why is the typeface white, plain, slender, and vertically elongated? Why is the car white? Why is there no background? Why has the woman placed her hand on the man's chest? Whose value system are we asked to share?

Pick out a magazine ad showing a group of people. Notice the choice of race, social class, age, and gender. Notice how those selected are depicted. What roles do people play? Who exercises control? Who looks at whom? What do the looks and gestures communicate? What types are glamorized? How are they glamorized? What are the signs of status? How are ethnic groups depicted? How are older people treated?

As a model of critical inquiry, let's consider a pair of images we saw earlier: Alfred Stevens's *Hide and Seek* (Fig. 10-13) and the Sprite ad (Fig. 10-14). Both pictures show idealized types of women. Young and attractive, the women serve as role models. The images define what is desirable and encourage like behavior. And we can see that women's behavior has changed. The Stevens painting hints at the presence of a man. The Sprite woman appears without a man, independent. Stevens's subject is sequestered in the home; the Sprite woman is comfortable going where men go. And her pose is sexually suggestive. To the extent that this ad is representative, the Sprite woman's appearance expresses a change in cultural attitudes toward sex and toward equality for women.

A closer look, however, reveals some ambiguity. The Sprite woman's figure is trim and athletic — a positive image of health. But she is not shown sweating on the racquetball court. Like her Victorian counterpart, she is idle. The Sprite ad *plays* with the idea of activity, and hence competition and equality with men. But its position is, in the end, equivocal. The ad is hedging its bet, and in doing so, reflects — quite accurately, I believe — ambiguities in attitudes toward women in our culture. The ad raises questions: Are these really new roles? Or are we simply seeing old roles in new clothes? Your answer will depend on your own thoughts about how women's roles are defined in our culture.

Many ads make ambiguous statements; others explicitly express a single point of view. Not surprisingly, ads often contradict one another. Some ads show women fascinated by the purported virtues of detergents while others show women scaling cliffs. Some depict men bumbling with the baby, while others show men as competent fathers. Because of these contradictions, it is dangerous to use any one ad to analyze an entire culture. But each image tells us *something*, pointing to some view of reality within the culture.

Popular images not only *reflect* cultural attitudes and values, but may help to *mold* them as well. That is why a critical investigation of ads merits attention. The social messages sent by ads percolate through the entire society. How influential are these messages? Do we shrug them off, along with the claims made for the product? Or might they affect us, perhaps even unconsciously? These questions are a part of public discourse today and will likely remain as long as ads represent us to ourselves.

# DESIGN ISSUES

Like the field of advertising, design is at the intersection of art and the real world. Everything made by human hands is designed. Lunch boxes, gym shorts, and textbooks are all designed objects (and all of these are in the collection of the Smithsonian Institution in Washington, D.C.). Design doesn't just happen. Conscious decisions determine the appearance of designed objects, and these decisions affect our feelings about those objects. Why did you choose the clothes you are wearing today? What do they say to you, or to others? How do you dress for more formal occasions? What does your car say about you? How do you decorate your house, or your room? What kind of jewelry do you buy? Do you wear a tie? The answers to these questions tell us about how we define ourselves. And they point to the influence of culture on those definitions.

Design is directly related to cultural values and concerns. The eighteenth-century clock we saw in Figure 8-13 disguises its works. The wristwatch you wear may display a high-tech array of knobs, dials, and digital readouts. These differences reflect not merely technological changes, but changing cultural attitudes. In the eighteenth century, ornamentation turned craft objects into art. The twentieth century stripped away ornament and found an esthetic in the machine. Currently we see a counter-trend to the hard, technological look in softer

20-5
1959 Cadillac (detail).

forms that express comfort and friendliness. In a related trend, watches, wall-paper, and furniture that appear old signal nostalgia for an imagined past.

Automobiles provide interesting examples of the relationship between design and culture. Though we may be guided by practical and economic concerns when we look for a car, image is also a factor. The 1950s were a golden age of image over function in automobile design. Gorgeous, oversized, overendowed with gleaming rivulets of chrome, cars were a kind of non-objective sculpture on wheels. Even then they were characterized as personifications of material success and conspicuous consumption. Some had exaggerated tail fins that swept back and soared upward from the rear fenders (Fig. **20-5**). These fins were purely esthetic, their resemblance to jet planes signalling modernism and its components: speed, comfort, power, and movement. Life became art again as George Barris developed the "Batmobile" for the 1960s television series *Batman*

from William M. Schmidt's Lincoln Futura of the early 1950s, which had back-swept fins.

In the 1960s, James Bond films prominently featured Bond's Aston-Martin, which became an almost fetishized statement linking glitzy (and deadly) technology to male sexuality. At the same time, small became beautiful, as the Volkswagen Beetle made a virtue of practicality and anti-design. Recently, pickup trucks and off-road vehicles have become popular. What kind of signal are they sending?

Designs carry the attitudes, values, and myths of the wider culture into its streets and homes. But the flow goes two ways. Ideas emerging from the streets and homes are eventually given form by designers. That two-way flow makes design an intriguing subject for study. Where do design ideas come from? Whose values are reflected in them? With some thought, and a bit of instinct, you can trace at least some of the answers.

But be prepared: these questions can never be exhausted, or answered permanently. Design today holds a mirror to a diverse and ever-changing society. Next year's car, or tomorrow's clothes, can open up new investigations.

We have seen that ads and designs, like other forms of art, impart explicit messages. I have set aside esthetics in order to concentrate on those messages and how we can spot them. But it's important to let go of interpretation at times, and just enjoy what you see. The design of a car fender can be a beautiful thing, regardless of what meanings we find in it. A beautiful image in an ad can be a pleasure. Without a sensual apprehension of art to accompany it, the enterprise of analysis would be merely empty information.

# CONCLUSION

This chapter has carried our investigation of art to what we see around us. Our discussion of differing approaches should remind us once again that art can be discovered in many different ways, all of them valid, and all of them useful.

Popular images and mass-produced goods are artifacts of modern cultures. As with painting and sculpture, we can both enjoy them and approach them analytically. Because ads and designed objects are tied to commercial interests, the messages they carry can give us fascinating insights into our life and times. Indeed, our investigation of popular images can also help us to see high art in new ways.

High art, like popular art, has its share of deplorable characterizations of women, minority groups, lower social classes, and foreigners. To blind ourselves to those realities is to collude with the viewpoints they articulate. But to dismiss the art just because of its viewpoint is naive. Must our abhorance of human sacrifice keep us from admiring the Nazca pot? If works of art seduce us into forgetting what they are saying, it is because they hold out other meanings as

well. Our task as students of art is to investigate *all* of these meanings; how we choose to use them is for each of us to decide.

Music videos may promote narcissism, sexism, or passivity. But you don't have to agree with their definitions of roles and goals in order to enjoy the music and the art. By the same token, we don't have to agree with Stevens's depiction of women as hothouse flowers, or believe in the social order on which it rests, in order to enter the world he has created, and even to enjoy our visit. And we don't have to like the product, or buy into the covert messages, to appreciate the wit, humor, or imagery of an ad.

At some point, the message of a work of art could indeed taint it irrevocably. But short of that, we would do well to approach works of art with open minds. Thoughtful observation extends our reach. Ultimately, how well we come to understand who we are depends on how well we allow ourselves to see.

# ENDNOTES

**Chapter 5**

[1]Mary D. Garrard, *Artemesia Gentileschi: The Image of the Female Hero in Italian Baroque Art* (Princeton, N.J.: Princeton University Press, 1989), 79.
[2]Ward Bissell, as yet unpublished catalogue entry.

**Chapter 7**

[1]John G. Neihardt, *Black Elk Speaks/Being the Life Story of a Holy Man of the Oglala Sioux* (Lincoln, Nebr.: University of Nebraska Press, 1988), 194–95.

**Chapter 8**

[1]From a poem on Yue ware teabowls by Xu Yin, late ninth or early tenth century.
[2]Richard F. Townsend, "Deciphering the Nazca World: Ceramic Images from Ancient Peru," *Museum Studies*, The Art Institute of Chicago (Spring 1985), 117–39.

**Chapter 9**

[1]Beaumont Newhall, *The History of Photography* (New York: New York Graphic Society Books, 1988), 91, 94.

**Chapter 10**

[1]Hsieh Ho, *Treatise on Ancient Painting*, fifth century A. D., cited in Osvald Siren, *The Chinese on the Art of Painting* (New York: Schocken, 1963), 19–22.
[2]Michael Baxandall, *Painting and Experience in Fifteenth Century Italy* (New York: Oxford University Press, 1982), 61.
[3]Robert Enggass and Jonathan Brown, *Italy and Spain 1600–1750*, Sources and Documents in the History of Art Series (Englewood Cliffs, N.J.: Prentice-Hall, 1970), 164.
[4]Elizabeth Gilmore Holt, *The Triumph of Art for the Public* (Garden City, N.Y.: Anchor Press/Doubleday, 1979), 45.

**Chapter 11**

[1]Josef Albers, "Prophet and Presiding Genius of American Op Art," *Vogue*, 15 October 1970, 127.

**Chapter 12**

[1]*Christo: 10 Works in Progress*, Michael Blackwood Films, New York, 1978.
[2]Allan Kaprow, *Assemblages, Environments, and Happenings* (New York: Abrams, 1966), 183.
[3]Calvin Tomkins, *The Bride and the Bachelors/Five Masters of Avant-Garde* (New York: Viking Press, 1968), 199.
[4]Sibyl Moholy-Nagy, *László Moholy-Nagy/Experiment in Totality*, 2nd ed. (Cambridge, Mass.: MIT Press, 1969), 72.

## Chapter 13

[1]*Adrian Piper: Reflections 1967–1987* (New York: Alternative Museum, 1987), quoted in Lucy Lippard, *Mixed Blessings: New Art in a Multicultural America* (New York: Pantheon Books, 1990), 238.

## Chapter 14

[1]I am indebted to Mirra Bank for the explanations of Harriet Powers's *Bible Quilt*, for the quotation on page 254, and for the inscriptions on Hannah Cohoon's drawing (Fig. 14-10), which appear in Mirra Bank, *Anonymous Was a Woman* (New York: St. Martin's Press, 1979), 94, 110, 119, and which also appear in Bank's film of the same name.

[2]Ruth Wolfe, "Hannah Cohoon," in Jean Lipman and Tom Armstrong, eds., *American Folk Painters of Three Centuries* (New York: Arch Cape Press, 1988), 58–65.

[3]David Handelman, "Holy Art!," *Rolling Stone*, 20 April 1989, 66.

## Chapter 15

[1]Holt, *The Triumph of Art*, 283–84.

[2]Holt, *The Triumph of Art*, 296.

[3]Vasari, *Lives of the Artists*, trans. E. L. Seeley (New York: The Noonday Press, 1963), 150.

[4]Lucy R. Lippard, *Eva Hesse* (New York: University Press, 1976), 29, 33.

[5]Cindy Nemser, *Art Talk* (New York: Charles Scribner's Sons, 1975), 203.

[6]Nemser, *Art Talk*, 222.

[7]Nemser, *Art Talk*, 207.

[8]Marge Goldwater, Roberta Smith, and Calvin Tomkins, *Jennifer Bartlett*, 2nd ed. (New York: Abbeville Press, 1990), 10.

## Chapter 16

[1]Robert Brumbaugh, in 1984; personal communication, 1990.

[2]Although women were active in many crafts, especially in the Middle Ages, social conventions often restricted their participation in the guilds.

[3]Cennino Cennini, *The Craftsman's Handbook*, trans. Daniel V. Thompson Jr. Quoted in Elizabeth B. Holt, ed., *The Middle Ages and the Renaissance*, Vol. I of *A Documentary History of Art* (New York: Doubleday Anchor Books, 1957), 140.

[4]Women occasionally were given honorary membership in the academies, and in this manner several women were admitted. However, they should be regarded as token exceptions to the rule. Those women who were admitted were excluded from drawing classes. As a result, many women painters were forced to concentrate on portraits and still lifes. European society was still a "man's world," and accordingly it suppressed the talents of half its population.

[5]Kuo Hsi, *An Essay on Chinese Landscape Painting*, trans. Shio Sakanashi (London: John Murray, 1959), 38.

[6]Chang Yen-yuan, quoted in Siren, *The Chinese*, 28.

[7]Confucius, quoted in Siren, *The Chinese*, 24.

## Chapter 17

[1]Wayne Craven, *Sculpture in America* (New York: Thomas Y. Crowell, 1968), 118.

[2]Craven, *Sculpture in America*, 118.

[3]Craven, *Sculpture in America*, 117.

[4]Anthony Blunt, *Artistic Theory in Italy, 1450–1600* (New York: Oxford University Press, 1964), 34.

[5]Whitney Chadwick, *Women, Art, and Society* (New York: Thames and Hudson, 1990), 308.

[6]W. Eugene Kleinbauer, *Modern Perspectives in Western Art History* (New York: Holt, Rinehart, and Winston, 1971), 194–201. (Originally published in *Burlington Magazine*, LXIV 1934, 117–27.)

## Chapter 18

[1]From a paper presented as an address at the First International Congress of African Culture in Salisbury, Southern Rhodesia (now Harare, Zimbabwe), in 1962. Quoted in William Bascom, "Creativity and Style in African Art," from Daniel Biebuyck, ed., *Tradition and Creativity in Tribal Art* (Berkeley and Los Angeles: University of California Press, 1969), 115.

[2]Helen Frankenthaler, interview with Cindy Nemser in *Arts* (November 1971). Quoted in Ellen H. Johnson, ed., *American Artists on Art, From 1940 to 1980* (New York: Harper and Row, 1982), 54.

# GLOSSARY

**abstract art** Any art that is not subject to the limits imposed by representation. In modern abstract art, the emphasis is on form rather than on subject matter; in fact, in some abstract art there is no recognizable subject matter at all.

**Abstract Expressionism** Also known as Action Painting. A style of abstract painting originating in New York in the 1940s and 1950s. An Abstract Expressionist painting is developed spontaneously and intuitively rather than according to studies and drawings; hence it provides a direct record of the gestures of the painter.

**academic art** Art associated with academies, especially the French Academy of the nineteenth century. The academies endorsed art that tended toward illustrative, frequently classical subject matter; exacting detail; and refined technique. Academic art also refers to any art that accords with institutionalized doctrines or theories.

**academy** An organization devoted to training and advancement of knowledge in a particular field. In art, academy refers to official, often government-recognized schools for artistic training. Academies of art originated in Italy during the Renaissance.

**allegory** A story that functions on two levels, one of them symbolic. Typically, the characters in an allegory represent ideas, such as Truth, Liberty, or Time.

**appliqué quilting** A form of quilting in which patches of material are cut out and stitched onto a single sheet, which becomes the top layer of the quilt. Appliqué quilting allows for greater variety of individual shapes than patchwork quilting.

**apprenticeship** In an art, craft, or trade, a system of education in which a master provides hands-on training to a novice or small group of novices. The apprenticeship system, as a method of artistic training, is found on every continent.

**appropriation (image appropriation)** In the 1980s and 1990s, the borrowing of a previous image and its prominent incorporation into a new work of art.

**Arts and Crafts Movement** A movement, originating in England in the latter nineteenth century, that opposed mass-production and called for a return to handicrafts and simple, traditional design. The movement spread to continental Europe and the United States in the early twentieth century.

**assemblage** A work of art consisting of everyday objects removed from their usual context and stacked, heaped, or otherwise arranged.

**avant-garde** Describes artists or individuals who appear to be ahead of their time. From the French military term meaning "the vanguard."

**axis** An imaginary line around which things are placed roughly equally. Vertical axes appeared frequently in Renaissance painting, when balanced, dignified compositions were in favor.

**Baroque** A seventeenth- and early eighteenth-century style of art and architecture, characterized by an intense physical presence, and in painting and sculpture, by dramatic light effects and a wide range of emotional states. In painting, three distinct tendencies can be seen: one ornate and dynamic, one more classical and restrained, and one more realistic.

**The Bauhaus** An influential German art school, open from 1919 until 1933. The Bauhaus stressed the unity of fine art, architecture, crafts, and industrial design, and sought to apply principles of good design to all of these areas.

*bulto* In Hispanic New Mexico, a religious statue. *Bultos* typically were assembled from carved pieces of cottonwood, which then were painted and often clothed.

**Byzantine** The art and architecture of the Eastern Roman Empire, beginning in the sixth century A.D. Byzantine art developed out of classical forms into a highly conventionalized, abstract, frontal style, reflecting the influence of near Eastern traditions. Byzantine architecture, based on Roman types, favored a centralized plan topped by a large dome. Although the Byzantine Empire ended in the fifteenth century, the Byzantine style persists in the art and architecture of Eastern Orthodox religions to this day.

**canon** A system of proportions used when drawing a figure or designing a building. Canons vary depending on the culture and the time; they were used in ancient Egyptian painting and sculpture, in ancient Greek sculpture and architecture, in Byzantine painting, in Renaissance architecture, in certain Buddhist traditions, and elsewhere.

**celadon** A lustrous, silver-green pottery glaze developed in China in the ninth century.

**classical** The ancient civilizations of Greece and Rome. The "classical period" of Greek art refers specifically to Greek art of the fifth century B.C., a period in which the art was subsequently believed to have reached its highest development.

**classicizing** The use of artistic forms and principles based on those developed in ancient Greece and Rome.

**collage** A work of art that is made wholly or partly by gluing down flat materials such as paper or cloth.

**composition** The organization of a work of art.

**compositional line** In a painting, an actual or implied line that divides sections of the work. Compositional lines are often used to direct the eye through the painting.

**conceptual art** A kind of postmodern art that emphasizes the concept or idea of a work of art, rather than its form. Conceptual art is based on the proposition that a work of art is essentially an imaginative entity, and that form is merely the vehicle. Hence conceptual pieces are typically intended to stimulate thinking rather than to be admired as esthetic objects.

**content** The meaning or meanings of a work of art; the ideas that it contains.

*contrapposto* In a sculpture or painting, a pose in which the weight of the figure is shifted, allowing the torso to twist.

**convention** A traditional form, procedure, or approach.

**crafts** Handmade objects traditionally distinguished from fine arts because they were utilitarian, and hence less purely imaginative. Today crafts are commonly made as esthetic objects, and the line between art and craft is not always clear. In many non-Western cultures, no distinction is made between art and craft.

**criticism** An evaluation of a work of art. Because it may investigate what the artist is attempting to do or to say, criticism can help to interpret, as well as to evaluate, the art.

**Cubism** An abstract style of painting developed between 1910 and 1912 by Pablo Picasso and Georges Braque. In a Cubist painting, both the objects and the space around them are fragmented and reassembled in ambiguous relationships.

**culture** The sum total of a people's shared ways of doing things and understanding things; their way of life.

**Dada** A nonsense word coined by a group of artists and writers during World War I. Reflecting the outrage and cynicism engendered by the war, the Dada group staged

**Dada** *(continued)*
events intended to shock the public. Dadaists claimed to be anti-art; they purged their work of esthetics and promoted irrationality, absurdity, and aggressive humor.

**drypoint** A printmaking technique related to etching in which lines are drawn directly onto the metal plate with a strong, needle-like tool. The lines are filled with ink and printed, just as with an etching. The drypoint technique raises a burr on the edges of the lines, giving a soft tone to the image.

**environment** A work of art in which objects are arranged, often casually, in a space large enough to walk through.

**esthetic(s)** The beauty or attractiveness of an object. Esthetics may refer to the quality of beauty in general.

**etching** A printmaking technique in which acid bites through ("etches") lines drawn on a wax-coated metal plate. The lines are then filled with ink, and with the aid of a press, reproduce the drawing in reverse on dampened paper.

*ex-voto* From the Latin, "out of thanks." Since ancient times, a devotional image made in gratitude for deliverance from accident or illness, and offered to a god, saint, or holy personage.

**figurative painting** Painting in which recognizable images can be perceived.

**fine art** Art whose primary function is esthetic rather than utilitarian. The classification of the fine arts was first made in eighteenth-century Europe; the distinction between fine art and other art does not necessarily appear in pre-Renaissance art or in non-Western cultures.

**focal point** The place where the viewer's eye comes to rest in a painting.

**folk art** Typically, art produced by nonprofessionals, based on traditional styles and techniques. Folk art is produced in the same societies that produce fine art, but remains separate from it.

**foreshortening** The illusion created in a picture when an object of some length is depicted as extending toward the viewer. The foreshortened object appears correct, though noticeably compacted.

**form** The appearance of a work of art; how it looks. Form may be determined by necessity, tradition, or the artist. Form also refers to what we can see of an object or representation of an object.

**formal analysis** An investigation of the form of a work of art. A formal analysis is usually conducted by isolating the formal elements that can be identified in the piece and assessing their function and impact on the whole.

**formal elements** In a painting, these include color, light, texture, volume, shape, line, space, and composition. In a sculpture, these include mass, space, material, texture and color. In architecture, these include space, light, material, color, ornamentation, and the site.

*fraktur* From the word for German script. In the United States, a handwritten certificate of birth, baptism, marriage, etc., often in German script. Once common in areas of German immigration, *frakturs* were frequently embellished with watercolor drawings.

**freestanding** Describes a sculpture that is free of the wall or of the block from which it was carved; one that the viewer can walk around.

**fresco** A mural in which the colors are mixed into the wet plaster and painted directly on the wall.

**frontal** Describes a painted or sculpted figure that faces the viewer directly.

**glaze** An extremely thin, transparent film on a painting, usually applied as a finishing touch. In pottery, a smooth, glassy coating that seals and colors the surface.

**Gothic** The last expression of medieval art. The Gothic style flourished mainly from the twelfth to the fifteenth centuries. In contrast to the earlier Romanesque style, Gothic architecture is lighter and airier, and space is more unified. Gothic painting and sculpture moved toward realism.

**ground** A coat of paint covering a surface, such as canvas or board, on which a painting is to be executed. A ground may be white or toned.

**guild** An independent association that maintains standards and provides for training of apprentices. Artists' guilds are found around the world. In medieval Europe, artists shared guilds with other trades.

**Happening** An art form consisting of an event in which the participants perform pre-planned or agreed-upon activities.

**hatchings** In drawing, small lines applied in clusters that create the illusion of roundness. Hatchings often, though not always, appear where shadow occurs on the object.

**high art** A contemporary term used to distinguish the art of galleries and museums from "low," or popular, art, such as advertising, illustration, or quilting. While it is a more inclusive term than "fine art," which has esthetic implications, its use is likewise criticized by some as arbitrary and elitist.

**icon** A holy image. Specifically, images used in Byzantine, Greek, or Russian Orthodox churches. In loose usage, an icon may be any image of a revered subject.

**iconography** The depiction of figures and objects according to certain conventions or traditions so as to make them recognizable, and hence, to communicate specific meanings.

**idealism** The presentation of a subject in its most beautiful, refined, or exalted form. Idealism in art was encouraged by Plato's belief in the existence of Forms or Ideas that are perfect and eternal. The perfected figure or object in art was believed to reflect ultimate reality, as opposed to the world of appearances.

**image** A recognizable representation of something; specifically the representation of a person. Image also refers to the way something appears in a work of art or in the imagination.

**impasto** A thick, pasty, hence opaque layer of paint applied to a canvas.

**Impressionism** In the later nineteenth century, a style of painting that aimed at capturing light and atmosphere as perceived in a precise moment of time. Toward that end, Impressionist painters applied bright colors in tiny dabs of opaque paint, which from a distance combine to produce a sparkling effect.

**industrial design** The designing of objects that are produced by machine rather than by hand. Industrial design, while contemporary with industrial objects, emerged as a field at the end of the nineteenth century, when machine technologies had largely replaced craft production.

**interpretation** A statement or a work of art intended to clarify or reveal something. To interpret a work of art is to explain its meaning or meanings.

**kantharos** A type of large-handled drinking cup; used by ancient Greeks and Etruscans.

**linear perspective** A mathematically-based perspective system in which parallel lines moving into the distance appear to join at a point on the horizon. The fifteenth-century architect Brunelleschi is believed to have formulated the rules of linear perspective.

**Mannerism** A sixteenth-century style of art and architecture that consciously violated Renaissance principles through its excessively complex compositions, distortion of space, elongation of figures, and harsh combinations of colors. This style is sometimes characterized by extreme elegance.

**mass** The three-dimensional, solid aspect of a sculpture.

**medieval art** The art of the Middle Ages, extending roughly from the dissolution of the Roman Empire in the fifth century to the Renaissance in Italy in the fifteenth century. Medieval art developed out of late Roman art and was influenced by the native traditions of Northern Europe. Generally, the style is abstract, frequently figurative. Religious art represented the Church and communicated its teachings; secular art was largely utilitarian; and in both, art was frequently used as a decorative embellishment.

**miniature painting** A tradition of small, intimate watercolor or tempera painting characterized by rich colors and fine detail. Miniature painting flourished in medieval Europe and in Turkey, Persia, and India.

**Minimal Art** (also **Minimalism**) A development of abstract art in the 1960s that reduced to a minimum the lines, shapes, or colors in a work of art.

**modern art** A general term referring to art from the latter part of the nineteenth century through the twentieth century that is characterized by an interest in form and a determined rejection of past art.

**mosaic** An image or pattern made up of small pieces of colored stone, glass, or tile embedded in concrete.

**mural** A painting applied directly to a wall or ceiling.

**Negoro** A lacquer technique developed at the Negoro-ji temple in Japan in the thirteenth century. In this technique, a red lacquer is applied over a black undercoating. With use, the red wears away to reveal the black underneath.

**Neoclassicism** An eighteenth- and nineteenth-century style of art and architecture. In part a reaction against the ornateness and sensuality of Rococo, this style found inspiration in the art of ancient Greece and Rome. Neoclassicism attempted to express the moral seriousness found in Greek and Roman civilization using classical forms and subject matter.

**nonobjective art** Abstract art that contains no recognizable images.

**outsider art** The strongly individualized art of self-taught individuals who are outside of and often isolated from any particular tradition.

**patchwork quilting** Quilting in which the top layer is made of patchwork, that is, individually shaped pieces stitched to one another. Patchwork quilting became a folk art form in the United States, where it has been practiced from colonial times to the present.

*pentimenti* From the Italian, meaning "I repent." In a painting or drawing, marks showing a place where the artist changed his or her mind and altered the original image.

**perspective** The depiction of receding space on a flat surface.

**photogram** An art form invented and named by László Moholy-Nagy. A photogram is made by placing an object on photosensitive paper and shining a light on it, so that a silhouette of the object appears on the paper when it is developed.

**photomontage** A darkroom technique in which negatives are combined to create new images.

**plane** A flat surface.

**Pop Art** A movement beginning in the early 1960s that focused on everyday objects, and that frequently used the techniques and imagery of commercial art.

**Post-Impressionism** A term used for a number of late nineteenth-century painters who retained the bright color and light of Impressionism, but who reacted against its amorphous compositions and its emphasis on optical effects. The Post-Impressionist painters were involved with the exploration of form; some emphasized its structural aspects while others explored its expressive possibilities.

**postmodern art** A general term for the work and interests of a number of artists who, beginning in the 1960s, reacted against the formal and esthetic concerns associated with modern art. Postmodern artists share the aim of moving art closer to life, and hence to a broader range of experience. To this end, many have explored new forms of art, some of them nearly indistinguishable from non-art.

**ready-made** Invented and named by Marcel Duchamp, who bought ordinary manufactured objects and placed them in an art gallery. Duchamp insisted that these objects — "ready-mades" — were works of art because he chose them to be.

**realism** Art that corresponds closely to visual perception. Also refers to that aspect of a painting or sculpture that has to do with its exacting and scrupulous depiction of the visible world. Not to be confused with Realism, below.

**Realism** A mid-nineteenth-century movement affirming that artists should depict life as it is. Generally, Realist painting depicts the more mundane aspects of life.

**Regionalism** A movement in American art in the 1920s and 1930s that aimed to celebrate the spirit of America mainly through scenes of rural or small town life.

**relief** A sculpture that is nearly flat. Relief sculpture is usually set into, or placed before, a wall.

**Renaissance** A period in Western culture following the Middle Ages. The Renaissance was characterized by a revival of interest in classical antiquity, and by more rational, objective attitudes toward human beings and their place in the universe. These interests and attitudes are reflected in Renaissance art in the realistic though idealized images of men and women in an orderly world.

*repoussoir* In a painting, a large object placed in the foreground that acts to frame the action and to emphasize the recession of space.

**representational art** Art that aims to create convincing illusions of objects.

**Rococo** A delicate, decorative style that evolved in the eighteenth century out of the Baroque style. Rococo is characterized by pastel colors; graceful, curvilinear lines; and light-hearted subject matter.

**Romanesque art** Medieval art of the eleventh and twelfth centuries. Romanesque art represents the fusion of classical and Northern European traditions. Romanesque architecture is solid and massive. The art is abstract and mainly figurative; sculpture is frequently integrated with architecture in an overall decorative scheme.

**Romanticism** An early-nineteenth-century movement, in part a reaction to the intellectualizing tendency of Neoclassicism. Romantic artists regarded works of art as an expression of their feelings. In painting, the Romantic style is characterized by bright colors; movement; and exciting, exotic, or mysterious subject matter.

*santero* In Hispanic New Mexico, a painter or carver of holy images. *Santeros* are typically folk artists.

*santo* In Hispanic New Mexico, a devotional image for church or home. *Santos* developed as a folk art form in colonial times in a tradition that extends to the present.

**site piece** An art form in which a natural environment is intentionally altered in some way.

**Social Realism** A movement among artists in the 1930s that focused on themes of social concern, such as unemployment, poverty, and hunger. Social Realists believed that artists should devote their work to raising social consciousness.

**solarizing** In photography, a darkroom technique that reverses dark and light tones around the edges of a form.

**space** In a painting, the illusion of depth. In a sculpture or a building, the voids or cavities between or around the solids.

**spirit drawing** In the nineteenth-century Shaker community, a drawing, typically in ink and watercolor, that records a spiritual vision. An accompanying text specifies the details of the vision.

**squaring up** A method of transfering a preliminary drawing to a larger surface, such as a canvas, for painting. The drawing is gridded into squares, and the canvas is likewise gridded into an equal number of squares. By copying the lines on the corresponding squares, the drawing is easily reproduced on the canvas.

**state** In etching, a print that represents a stage in the development of the final version. States are typically numbered in sequential order.

**style** The characteristic appearance of art in a particular time or place. Style is determined both by cultural conventions and the initiative of individual artists.

**subject matter** The story, theme, characters, or objects represented in a work of art.

**Surrealism** A movement in art flourishing between the 1920s and 1940s that sought to evoke dreams and the unconscious. Surrealist painters worked in both abstract and representational styles.

**symbol** An image or object that stands for something else. The meaning of a symbol is usually quite specific: a cross symbolizes Christianity, a heart symbolizes love, a yellow ribbon symbolizes faithfulness.

**symmetrical** Describes a composition in which one half is more or less a mirror image of the other.

**tapa** A cloth made in tropical regions from the inner bark of certain kinds of mulberry trees. Tapa cloth has a wide range of uses and is frequently decorated with designs.

**tea ceremony** In Japan, a traditional, highly stylized ceremony in which tea is prepared by a host and shared with guests in an atmosphere of tranquility.

*trompe l'oeil* ("fool the eye") A painting intended to trick the viewer into thinking the objects or scenes depicted are real.

**Western art** The art of Western civilization. It originated in ancient Greece, evolved in Europe, and later spread to the Western Hemisphere. Today its influence is seen throughout the world.

**vernacular** In architecture, the style that is typical of an area, or that reflects local traditions in its forms.

*wabi* In Japan, an esthetic that finds beauty in the aging and weathering of natural materials, especially as they appear in simple, humble objects.

# PICTURE CREDITS

ner. **13-12** Photo by Michael Alexander/© Judy Chicago, 1979. **13-14** © Public Art Workshop. **13-15** © 1990 Delores Neuman. **CO-14** © Dan Baliotti. **14-2** © Bob Daemmrich. **14-3** Courtesy of Bronx Council on the Arts/© Martha Cooper. **14-4** © Dan Baliotti.

**CO-15** Lauros-Giraudon. **15-2** Lauros-Giraudon. **15-5** MOMA/Film Still Archives. **15-6** © S.P.A.D.E.M., Paris/V.A.G.A., New York, 1984. **15-9** Photo: James Dee.

**CO-16** The Metropolitan Museum. **16-1** © Thomas Seligman. **16-3** Photo: Archives Photographiques, Paris. **16-10** Courtesy of the author. **16-11** ©The Estate of Eva Hesse, Permission Granted.

**CO-17** Reproduced by courtesy of the Trustees of The National Gallery, London. **17-2** Reproduced by courtesy of the Trustees of The National Gallery, London. **17-3** Cliché des Musées Nationaux, Paris. **17-4** Cliché des Musées Nationaux, Paris. Giraudon/Art Resource, New York. **17-5** © S.P.A.D.E.M., Paris/V.A.G.A., New York, 1984. **17-6** Photograph courtesy of The Museum of Modern Art, New York. **17-7** © S.P.A.D.E.M., Paris/V.A.G.A., New York, 1984. **17-11** © S.P.A.D.E.M., Paris/V.A.G.A., New York, 1984.

**CO-18** Alinari/Art Resource, New York. **18-1** Courtesy Robert Brumbaugh. **18-2** Photo by Eugene R. Prince, Berkeley. **18-4** Hirmer Foto-archiv. **18-5** Fototeca Unione, at the American Academy in Rome. **18-6** Copyright The British Library. **18-7** Caisse nationale des monuments historiques, Paris. **18-8** Alinari/Art Resource, New York. **18-9** Alinari/Art Resource, New York. **18-10** SCALA/Art Resource, New York. **18-11** Alinari/Art Resource, New York. **18-12** Cliché des Musées Nationaux, Paris. **18-13** Cliché des Musées Nationaux, Paris. **18-14** Cliché des Musées Nationaux, Paris. **18-15** Cliché des Musées Nationaux, Paris. **18-16** © S.P.A.D.E.M., Paris/V.A.G.A., New York, 1984.

**CO-19** The Toledo Museum of Art. **19-2** Courtesy of Hattula Moholy-Nagy Hug.

**CO-20** Courtesy of the Archives: The Coca-Cola Company. **20-2** HBJ Picture Library. **20-4** Courtesy of MTV Networks. © 1991 MTV Networks. All Rights Reserved. The LIQUID TELEVISION logo is a trademark of MTV Networks, a division of Viacom International, Inc. **20-5** Photo by Curtice Taylor.

# INDEX

C 3
D 4
E 5
F 6
G 7
  8
H 9
I 0
J 1